Fright Xmas

Alan-Bertaneisson Jones

authorHOUSE®

AuthorHouse™ UK Ltd.
500 Avebury Boulevard
Central Milton Keynes, MK9 2BE
www.authorhouse.co.uk
Phone: 08001974150

First published by AuthorHouse 8/2/2010

ISBN: 978-1-4520-6199-3 (sc)

This book is printed on acid-free paper.

Introduction

(In-terror-oduction!!!)
Abandon ho-ho-hope all ye who enter here!

Hello there boils and ghouls and welcome to this festive fright fest; this seasonal slayride; this...well, you get the picture! Collected together here – for the first time ever as far as I am aware! – is a Santa sack of unholy horrors (supplemented by the weirdest and wackiest that seasonal cinema has to offer), all of which celebrate the festive season in their own inimitable, sometimes shocking, sometimes schlocky, occasionally spinetingling, often hilarious (advertently or otherwise!), usually entertaining, but occasionally all-but-unwatchable way.

This book is intended to be a light-hearted trawl through the merry mélange of seasonal spinetinglers that have been produced over the years. It is not intended to be anti-Christmas or to attack the Christian faith in any way, shape or form. Like it or lump it though, Christmas is now more than a religious festival (though the devout may mourn that fact); it is a secular celebration too – and one which encompasses not only a decidedly mixed bunch of Christian and Pagan symbols and traditions,[1] but one which, as a result of its evolution, manages to maintain a dynamic ambivalence at its heart – usually encompassed in the God vs. Mammon debate (or as I like to think of it, prophets vs. profits!).

1.In truth, early leaders of the Christian church all but invited this themselves when they decided to celebrate the birth of Jesus on 25th December (not thought to be the actual birth date of the historical figure). This date was already associated with several mid-winter festivals that celebrated the births of various deities in then extant Pagan religions and the early Christian Church thought that synchronising the date for celebrating the birth of Christ with the date of similar celebrations in various Pagan religions might entice, or at least make it easier for, Pagan Romans to convert to the newer religion of Christianity (as they would not lose their already established winter celebrations!). And the incorporation of older, Pagan traditions into Christian Christmas celebrations continued from there. Just think of holly and ivy for instance: these traditional Christmas evergreens (that even have a famous Christmas Carol written about them) are actually steeped in Druidic lore! So in some ways, it seems that the Christian Church, having somewhat sowed the storm, is now rather reaping the whirlwind in having its own midwinter religious festival bastardised and stolen out from under it by purely secular revellers! Just as Jesus Christ replaced the Babylonian Ishtar, the Persian Mithras, and various 'solar deities' (such as the Syrian Elah-Gabal and the Roman Sol) – all of whose 'birthdays' were celebrated on 25th December previously – so perhaps the modern conception of Santa Claus is usurping or replacing Jesus at the heart of secular Christmas celebrations!!! (Just watch *The Christmas Path (1998)*! ...But that's getting a bit heavy man, and is a discussion for an entirely different book altogether. For this one, let's just stick with the flicks shall we? – and have us a bit of fun!

Regardless of individual beliefs or convictions, a modern Christmas purports to be the season of 'Peace on Earth and Goodwill to All Men' – though you might sometimes be hard-pressed to accept this, what with the execution of despotic leaders,[2] ongoing wars and skirmishes and political chicanery; not to mention the smaller scale fallings out in familial gatherings. And for many 'the holidays' have become a time of enormous pressures and stress, or indeed loneliness and exclusion. Some get next to no time off work to celebrate anyway; others have bickering or dysfunctional families, tight budgets, seemingly never ending shopping lists, gifts to buy, culinary extravaganzas to plan and prepare, you name it! to deal with! And they still insist that everyone settles down in front of the box dressed in bright coloured jumpers with bold snowflake and reindeer patterns cradling glasses of eggnog to watch yet another re-run of **Miracle on 34th Street** on TV on Christmas Eve! (Or have I just slipped into one of those innumerable twee TV sit-com Christmas Specials there for a moment?!) ...Either way, it must seem to some that the vast majority of humankind semi-loses its sanity at this time of year and turns into a sort of desperate, slavering collection of Christmasochists! ... Some of them so determined that they 'simply must have a good time' that they slap strained smiles on their (often alcohol-induced) rosy-cheeked faces and set to celebrating come what may!

If you are one of those disdainfully obdurate onlookers on such occasions; or if your delights are found in rather darker delectations; if you are a Horror-head and like your film fare X-*messy* as much as X-massy; or even if you love **Miracle on 34th Street** but just fancy something a bit different every once in a while, then this book may well be of interest to you. Forget all those TV advertisements for the latest impossible-to-get-hold-of-anyway 'must-have' (and will have to pay through the nose for) *zeitgeist* gadgets and toys. If when you think of a 'flexible friend' at Christmastime, you imagine a contortionist sex partner; or if you think it would be cool or funny to wake up Christmas morning and find that Santa had left a dismembered leg filling your Christmas stocking, this book is definitely for you!

Some of the films offer genuine thrills and chills; some visceral *frissons*; others howls of laughter, derision or disdain. Some are wonderful, some are woeful; some are weird and wacky, others woebegone; some are all but unwatchable (to all but fans of this particular type of movie – and they do exist, believe me). These latter movies really scrape the bottom of Santa's sack when it comes to production values: they are bigger turkeys than the one you'll find on your dining table this Yule – and contrary to accepted culinary norms, they are usually stuffed to the brim with ham, corn and cheese!

Some are 'Christmas Movies' proper, others are just movies with a Christmas setting, sequence or scene that I think deserve to be included in this merry mix; this menagerie of masterpieces and Psychotronic[3] claptrap! So, whether you are a hardcore 'splatterhead' fan

2. Former Romanian leader Nicolae Ceauşescu was executed on Christmas Day 1989 when a revolutionary coup removed him from power.

3. See *The Psychotronic Encyclopedia of Film* (Plexus Publishing Limited, London 1989 by arrangement with Ballantyne Books, New York) and *The Psychotronic Video guide* (Titan Books, London, 1996) both by Michael Weldon for a definition – but basically horror/sci-fi/exploitation

of visceral grue, goo and gore, or just a sometime softcore dabbler in the merry macabre who enjoys the more refined terrors of expectancy and ever-mounting tension that can result from a tautly directed scene in which that which is *not seen* can be even more frightening than anything that is, I think that this selection of seasonally themed movies will have something to float your boat (...or should that be fly your sleigh?).

Last year I heard some friends bemoan the fact that the festive TV listings contained multiple screenings *'yet again'* of the *'same old, same old'* Christmas classics: films like **Miracle on 34th Street**, **Santa Claus: The Movie** and **It's A Wonderful Life**. Now, I personally love **It's a Wonderful Life** – often cited as one of the all-time great 'feelgood' movies (if not the greatest). I just love the fact that it centres on a man whose life of semi-Christ-like self-sacrifice has led him to the very point of suicide and whose only consolation is for the loss of his aspirations and ambitions to travel and become an architect or engineer and benefit mankind is the good he has done others. What is more, it's great to see good old Jimmy Stewart getting all cross and nasty with his cutesy-wutesy kiddlywinks – because that's just something you wouldn't expect to see good guy Jim do, isn't it? (Not outside the 1950s Westerns directed by Anthony Mann perhaps, anyway!). And then there's the dark vision of Pottersville that George Bailey's little white picket fence middle American heaven hometown could have become if Jimmy's character had left it behind; a dirty, scuzzy, nasty, neon-lit hellhole presided over by the bitter, warped, crippled old Plutocrat with a mind only for money, not people or their well-being (profits vs. prophets again!). And this curmudgeonly old monster gets away with the theft (by finding) of the Bedford Falls Building and Loans money (left wrapped in a newspaper in his bank by George Bailey's dotty old uncle who was meant to deposit it) – that sort of thing rarely happens in Hollywood films from the period; the bad guy getting away with something Scott-free! And even when all George's family and neighbours contribute to the pot to make up the Building and Loans' shortfall and save George's reputation when the missing money has been discovered by the auditor, George is left with old man Potter and his vast wealth to continue to fight; with the same life that he had before – the life that drove him to the point of suicide. Sure, he has a new outlook or understanding; he realises (in the words of a Sheryl Crow song) that "It's not getting what you want, it's wanting what you've got"[4] but what he's got is still a life of self-sacrifice for the benefit of others, while the others pretty much get what they want! (I know, I know; that's the whole point! But you try selling that to someone these days – even if you are an angel second-class – and see how many takers you get! It's more likely to work out like the skit in **Beavis and Butthead Do Christmas**!

But I digress, what I hope is that, if like my friends, you find yourself stuck for something *different* to watch this Christmas...but you still fancy something that's – well if not exactly *Christmassy* per se, that's at least connected to Christmas in some way – well, I'm sure you will find something n this guide. ...After all, a good ghost story is traditional for Christmas, isn't it? Just look at the evergreen popularity of Charles Dickens' *A Christmas Carol* (or to give it its full title *A Christmas Carol in Prose, Being a Ghost Story of Christmas*). Tell me you haven't seen one of the innumerable film versions of this! ...Indeed, Dickens' own "Contemporaries noted

4. *Soak Up the Sun* 2002 from the album *C'Mon C'Mon*

that the story's popularity played a critical role in redefining the importance of Christmas and the major sentiments associated with the holiday."[5]

Now, naturally, I cannot *guarantee* that this guide will include *absolutely every movie that has ever been produced which might fit the bill*, so I will apologise now if I have omitted your own personal tinsel-tinged fave 'rave from the grave'. But I reckon the collection of titles I have stitched together Frankenstein-like in these pages represents a pretty good start. I hope that I am able to give enough information for each one to give you some idea whether you are likely to enjoy the experience of watching it for yourself (or not, as the case may be). Of course, you don't have to actually agree with my individual assessment of the movies; but my personal reaction might give you some idea of how *you* will be likely to respond. I have always found that that is the best way to try to use such guides and critiques anyway (e.g. if Barry Norman hated a film because it was crass and juvenile, I'd take that as a pretty darn good recommendation and go watch it for myself!). It's a bit like getting a feel for the person who sets the crossword in the newspaper – when you've done a couple, you jut somehow *know* when a particular clue is going to be an anagram etc.

So anyway, if the Christmas Spirits you fancy this year aren't likely to be provided by the usual suspects – i.e. the kinds of festive films that are sickly-sweet enough to induce a coma even in a non-diabetic viewer! – and they aren't the kind of Christmas Spirits that come out of a bottle; If they are the kind of Christmas Spirits that have more of grave than of gravy about them, and you crave them as an antidote to the apparently all-pervading Jolliness, General Good Cheer and Bonhomie, that you're sure is only surface-deep half the time anyway, then read on! Because in these pages we have Nazi-elves, witches, ghosts and ghouls, axe-wielding Santa Clauses, and all manner of other cruel Yule Crimbo treats you won't want to miss(-letoe) this Christmas. Altogether now...

♫♪♫ "Hear those *slay* bells ring-a-ling,
Ring-ling-a-ling-a-ling do
It's lovely weather
For a *slayride* together
With you" ♫♪♫

So *Scary* Christmas boils and ghouls, Santa *Claws* is almost here (...Or is it *Satan* Claus?)... Either way, he's sure to have something in his sack just for you. A large lump of coal? ...A de-capitated head? ...An evil toy possessed by a criminal's soul? ...Whatever! ...Just remember, you are sure to be all right just so long as you are good little boils and ghouls and...

5. See Wikipedia http://en.wikipedia.org/wiki/A_Christmas_Carol

DON'T OPEN TILL CHRISTMAS!!!

Alan-Bertaneisson Jones

A QUICK NOTE ABOUT FILM LISTINGS

At the end of each chapter (in which films are usually discussed in chronological order) I have listed the films featured with selective credit details. These listings are presented in alphabetical order rather than chronological order, however (with the exception of those featured in chapter 9, where such an arrangement did not seem to make sense). This should help those who are looking to use this book as a kind of viewer's guide to identify a particular film and track down the information given about it. (Where two or more films in the same chapter have *the same title*, within the alphabetical listing they are listed in chronological order).

Contents

CHAPTER 1

Festive Frissons and Silent Shivers

Yule ghouls and creepy Christmases didn't feature too much in earlier film outings – except perhaps the familiar ghosts in adaptations of Charles Dickens' classic seasonal spook story *A Christmas Carol*, of which I am aware of several silent versions that were produced in the UK and USA.

Christmas was still widely celebrated as a predominantly religious festival when movies (as we understand them) began to make their first appearances at the very end of the nineteenth century. Victorian families were still revelling in their fairly recently adopted festive traditions (which were actually readopted in many cases from older traditions that had fallen out of favour before Mr Dickens' tale and Prince Albert's personal proclivities and preferences rekindled them)... the kinds of celebration that we now take for granted and which have become enshrined in our own, often more secular celebrations of Christmas. The Christmas tree with it decorations, turkey or goose centred feasts, plum puddings, family gatherings, holly and ivy and party games.

There were versions of *A Christmas Carol* released in 1901, 1908, 1910 and 1923 among others, but as far back as 1897 fantasy films showing Father Christmas or Santa Claus (depending upon whether they were English or American) were making appearances to fill audiences with wonder and delight. I have seen a British movie called **Santa Claus** from as early as 1898, showing Santa magically arriving and delivering presents (and it was a real treat). Pioneering British filmmaker (director/cinematographer) George Albert Smith shot a similar primitive (by modern standards), short silent called **Santa Claus** aka **The Visit of Santa Claus** in 1899, while pioneering French filmmaker and actor Georges Méliès (an ex-stage magician who brought some very inventive trickery and technical jiggery-pokery to the early cinema screen), produced **A Christmas Dream** in 1900, though he is more usually associated with big scale (again for the time) fantasy and proto-Science Fiction films (like **A Trip to the Moon (1902)**[6] and

6. Original French title *Le Voyage dans la lune*

1

***20, 000 Leagues Under the Sea (1907)*.**[7] As well as Santa himself delivering Christmas gifts, Méliès' movie also featured a host of angels helping the jolly old man out popping pressies down the chimneys on Christmas Eve.

But it really was down to those pesky apparitions pestering poor old Scrooge to introduce a real *frisson* of the supernatural to cinema-going audiences of the time – the ghost of dead business partner Jacob Marley and the Spirits or Ghosts (depending which version you watch) of Christmas Past, Present and Future (or indeed Christmas Yet To Come as he, or perhaps more properly it, is sometimes known).

I know little of the 11-minute1901 version of *A Christmas Carol* that was actually entitled **Scrooge, or Marley's Ghost** directed in Britain by Walter R. Booth and distributed by pioneering British filmmaker R.W. Paul; save that it is the earliest film version of this evergreen Christmas classic that I am aware of, and that it was based on a stage adaptation of Dickens' tale by J.C. Buckstone, which dispensed with the Ghosts or Spirits of Christmas and promoted Marley's ghost as the single spiritual visitor showing his miserly ex-partner the error of his miserable ways on Christmas Eve. Only around half of this film apparently survives now at the British Film Institute. (So, perhaps this – by modern standards – stilted, tableaux-style telling of the tale is more gangrene than evergreen!).

Nor for that matter do I know a great deal about the 1908 American produced version entitled **A Christmas Carol**, that starred English actor Tom Ricketts (one of the best Shakespearean stage actors of his day) as Ebenezer Scrooge. Moving to America, Ricketts starred in a whole host of movies, and progressed to writing and directing also. I guess his main claim to historical fame though may well be that, although it is generally accepted that American film directing legend D.W. Griffith directed the first film to be shot in Hollywood,[8] Ricketts was the first man to direct a movie in Hollywood for a studio that was permanently based there.[9]

But the 1910 American version of **A Christmas Carol** produced by the Thomas Edison Company starred Charles Ogle (who can also boast a first: he was the first actor to play the Frankenstein Monster in a film, **Frankenstein** released the same year 1910). If you have ever seen Ogle's Frankenstein's Monster (even in stills) you will see that it is a weird, wild-eyed, furry critter with a hairy, clawed hand (no Karloff green flat-top with bolty neck here! With its wild mane, wide eyes twisted chops it looks more like Joan Rivers with no makeup on a bad hair day!).

Ogle played Bob Cratchit in **A Christmas Carol** and an Australian actor called Marc McDermott played Scrooge. Originally a stage actor, McDermott eventually appeared in over 140 films for Edison before leaving to join the Vitagraph Company in 1916, and was a popular leading man of his time.

7. Original French title *20000 lieues sous les mers*

8. *In Old California (1910)*

9. *The Feudal Debt (1912)* produced for Nestor studio

In this version of **A Christmas Carol**, besides Marley only one other ghost appears to torment and transform the old miser. (Oh, and there's no Tiny Tim!). Such were the limitations of the time I guess.

The film only consisted of 5 scenes with the camera anchored rock- solid, and very few inter-title cards. I guess the story was familiar enough for audiences to follow even then! (Although so-called 'silent' films were seldom actually silent, and if they did not have musical accompaniment, they often boasted either accompanying sound effects, someone reading the inter-titles or someone explaining what was going on onscreen or giving an accompanying talk or lecture).

In the film, miserly old Scrooge is perplexed (as I guess he has every right to be) when the face of his dead partner, Marley, appears in his doorknocker, and then when he appears again as a transparent (early super-imposed) image in the old miser's bedchamber. The bedchamber scene is the longest in the 17-minute film and when Marley's ghost spirits itself away, the Spirit of Christmas appears to Scrooge (again as a superimposed, transparent being, with a long robe and a wreath in its hair). He shows Scrooge a series of superimposed images – including, eventually, his own miserly death, and... Well, you know the rest!

The same year that Edison produced his US version of **A Christmas Carol** the only silent adaptation made in Italy was produced too. **Il sogno dell'usuraio (1910)** (aka **Il sogno del vecchio usuraio**, **Dream of Old Scrooge** and **Old Scrooge**) is now thought lost, but an account of it in *The Bioscope* following its release in Britain appears to confirm that it was a reasonably faithful screen adaptation given the limits of the medium at the time of production.

Before we consider the next version of the Dickens Dusey that was produced (at least that I am aware of currently) – a British film released in 1913 called **Scrooge** but also known as **Old Scrooge**[10] when released in Britain – there are a couple of interesting celluloid asides that I think deserve a place, or at least a mention in this book.

First is an American film from 1908 entitled **A Christmas Eve Tragedy**. Described by author Frank Thompson[11] as "perhaps the bleakest film of the period," **A Christmas Eve Tragedy** presents the tale of a sailor who leaves his wife. She "grieves for him but soon takes up with another man. When, on Christmas Eve, she spends the night with her new beau, her husband arrives home unexpectedly, beats the man senseless, puts him into his wagon, and backs the wagon – with the horse – over a cliff." *Variety* critic "Sime" wrote in the April issue, "The picture is both suggestive and repulsive. It is as well conceived for children as an interior view of a slaughter house would be." Nice eh?

10. The film was thought lost but was found and re-released in 1926 by Pathé Exchange under the title *Old Scrooge*.

11. In *American Movie Classics' Great Christmas Movies*,

Next, another American production, ***A Christmas Spirit (1912)***. This deserves a mention because not only was it a colour film (utilising an early American colour – or should that be color? – process called Kinemacolor, but it claimed to be the first to have utilised double-exposure successfully with colour film stock (something previously believed to be impossible) to produce its festive spectre!

Then we come to our first Russian film, ***Noch pered Rozhdestvom*** also known as ***Christmas Eve*** and ***The Night Before Christmas***. Released in 1913, this 41-minute movie was based on a story by Nikolai Gogol. Set on Christmas Eve, it centres on a love quest set by a Cossack with a craving for vodka for a suitor for his daughter's hand, the village blacksmith Vakula. But the Devil and a witch called Solokha are apparently featured too and get up to some mischief upsetting everybody's Christmas plans. I doubt it's particularly scary, but I figure any Christmas Movie that features the Devil and a witch deserves at least a mention!

And staying in Russia for the time being, we come across a very early puppetry stop-motion animated little weird Weihnachts whimsy. (I know that's German, but it fits the alliteration and I haven't got a clue what the Russian for Christmas is!). ***Rozhdestvo obitatelei lesa*** (Alternatively spelt ***Rozhdestvo obitateley lesa***) and known in English as ***The Insects' Christmas*** was released in 1913 also. At only 6-minutes long, it is a short rather than a feature, but I include it because it is rather weird and wonderful...and it is readily available on DVD![12]

The movement is a little jerky and not entirely smooth at times, but considering when it was made it is a brilliant job and still incredibly watchable even today. Indeed, like ***King Kong (1933)*** and other movies featuring Willis O'Brien/Ray Harryhausen stop-motion animation, the slight 'clunkiness' of the stop-motion animation only adds charm. What's it all about? Well, on Christmas Eve, a Father Christmas ornament climbs down from a decorated Christmas tree in a bourgeois house, waking a doll sleeping beneath the tree and goes to the snow-clad forest. There, using a magical staff the diminutive Father Christmas creates and decorates a Christmas tree for the forest creatures. He then invites all the insects he meets – a 'ladybug', Miss Dragonfly (who looks more like a cricket!), and a family of beetles to celebrate with him around the Christmas tree he has created for them. A friendly frog, who breaks up through the ice on a pond to stand and dance on its rear legs in an anthropomorphic fashion is invited too. At the gathering around the Christmas tree, Father Christmas makes gifts of the ornaments. The insects then go skiing down a wee snow slope (followed by Father Christmas sliding on his bottom!) and ice skate on the frozen pond, before Father Christmas returns to the house early in the morning and climbs back up the Christmas tree to resume his place as an ornament on one of the branches. This film was apparently available in black-and-white or tinted versions.

Ok, back to old Scrooge now...well sort of... The same year as these Russian romps were released, the UK produced a movie based on a stage play by Richard Ganthoney that premiered on London's West End in 1899. Although a kind of comic sci-fi whimsy, the plot of

12 On a compilation entitled **The Animals Christmas**

both the film and the play it was adapted from (by the director Wallett Waller) was very much influenced by Dickens' *A Christmas Carol*. **A Message from Mars (1913)**, which stars the then famous stage actor Charles Hawtrey (not the one of **Carry On** fame, nor any relation[13]), sees a wealthly but selfish and miserly Earthman called Horace Parker visited by a Martian high official called Ramiel, who (as punishment for a crime on Mars) has been sent to Earth to redeem a lost soul.

Although this sounds like sci-fi, Ramiel is actually more like an angel – or indeed a combination of the Spirits of Christmas Past, Present and Future. He travels across space without a spaceship, just materialising in front of Parker when the earthling, an amateur astronomer who has fallen asleep after stargazing through his telescope, has fallen asleep (presumably some kind of mental teleportation). What is more, the Martian-on-a-mission then transports Parker along with him to witness various scenes where they are both invisible to everyone onscreen, and when the horrible Horace is still unmoved, his extra-terrestrial visitor actually somehow manipulates reality to make the miserly earthman lose his fortune and see what it would be like to be a penniless pauper.

But wouldn't you know it?...the whole thing turns out to be a dream![14] Still, it is a very vivid one for Horace Parker, as it is enough to ensure that he gets the Christmas Spirit, mends his ways and becomes a pleasant Parker rather than a horrible Horace.

Another version of this tale was produced in America in 1921, updating the action to the post-WWI period, but for now lets get away from a pseudo-Scrooge and back to the old miser himself...

Scrooge or **Old Scrooge** as it also became known following its re-release in 1926 under that title, was a pre-WWI British-produced movie of 1913. Again it is readily available on DVD[15] and at 40-minutes doesn't outstay its welcome. It's a bit of a strange mixed bag this one though, for although the snowy exterior location shots are excellent, in other ways this production seems really rather crude and primitive. And being based on the J.C. Buckstone[16] play that the first Carol adaptation was based on it only features one ghost – that of Scrooge's dead partner Jacob Marley. In this adaptation (penned by the actor playing Scrooge – a celebrated British thesp called Seymour Hicks, who went on to become knight of the stage, Sir Seymour Hicks, as his billing informs us by the next time he assayed the role of Scrooge in 1935! But more of that later) it is Marley's ghost who presents Scrooge with visions (rather than whisking him off on visitations), "representing", as he informs us via an inter-title, the Ghosts of Christmas Past, Present and Future!

13 **Carry On**'s Charles Hawtrey was actually christened Charles Hartree

14 I guess cinema audiences weren't quite ready for sci-fi space travel just yet. Even the 1921 American remake, though updating the action to the post-WWI period still kept the dream plot twist, and the superb Russian **Aelita** (aka **Aelita Queen of Mars**) produced in 1924 posited its superb Martian sequences as fantasies.

15 On a double bill with another silent version of *A Christmas Carol* from 1923

16 Playwright Buckstone also appears in this screen adaptation of his play based on Dickens' tale

Which is all well and good, save for the fact that in one of the super-imposed or double-exposed "vision" sequences, Scrooge seems to be less substantial and more transparent than the vision he is watching! And, what is more, all wrapped in a white sheet and with his face painted in stark black and white makeup, Cratchit's ghost looks more like a Japanese Kabuki actor than a supernatural spectre! (Scooby-Doo and the gang would have had him pegged straight away! I can see him saying "...And I'd have gotten away with it if it wasn't for those pesky kids!" Via inter-titles of course!). Even stranger though is the fact that he has nary a chain in sight...and that despite the fact that it is the scraping and rattling of chains that alert Scrooge to his presence initially!

As for Seymour Hicks performance? Well, maybe it does demonstrate something of his versatility as a youngish actor (He was a fit young, bulldog of a bloke when this was made; not what I'd expect of Scrooge at all!), but he just doesn't really look right. He was much better in the 1935 version when he fitted the role better! And that film has a much better overall look and style to it; kind of dark, grimy and creepy. This is certainly not my favourite filmic version of *A Christmas Carol* – indeed, it is not even my favourite silent version! – but it *is* definitely interesting, and one that all 'Carol Completists' (they are out there, I promise you!) will want to catch I'm sure[17].

The next time old Ebenezer got bum-hugged (or was it his hum- bugged) by those pesky spectres of Christmases Past, Present and Future on the silver screen (as far as I am aware at least) was in an American movie called **The Right to Be Happy** from 1916, which was known as **Scrooge the Skinflint** in Britain (although it started shooting under the working title **A Christmas Carol**). This was directed by Rupert Julian, who also starred as Scrooge and is apparently lost now, so I don't know a great deal about it; a great pity as it was apparently the silent era's only feature-length adaptation of Dickens' apparently timeless tale. Though it is possible to surmise from the extant credits that the usual Ghosts of Christmas Past, Present and Future, as well as Jacob Marley did put in an appearance, so to speak.

And in 1921 the Martians put in another appearance too! In the American made remake of the 1913 British movie based on an 1899 play by Richard Ganthoney, **A Message from Mars**. This time the setting has been updated to post-WWI Britain, but the story otherwise remains pretty much the same, with a Martian-on-a-mission visiting a wealthy, selfish Scrooge-like Englishman in a snowy London at Christmastime to try and get him to repent of his wicked ways and redeem himself. (Santa Claus might 'conquer the Martians' in 1964, but the Martians got in first with their bit of Christmas Spirit type conquering...twice in fact!).

And so, once again, from a pseudo-Scrooge to the real McCoy...A British production from 1922 entitled **Scrooge** followed. I don't really know anything much about this version though, save that it was originally 1280 ft in length and the only known copy left in existence is an 825 ft print held by the US Library of Congress! Oh, and George Wynn who directed,

17. And they might want to look out for Fred Guida's book *A Christmas Carol and its Adaptations: Dickens Story on Film and Television* in which he explores the pros and cons of almost 200 film and television adaptations. (Rather more than I intend to do in this book!).

appeared in the first (silent) screen version of W.W. Jacobs spooky tale *The Monkey's Paw* the following year.

But as well as *The Monkey's Paw*, 1923 also saw the release of yet another version of *A Christmas Carol*[18]. (It's a bit like buses, isn't it? – You wait ages without seeing one, then all of a sudden a couple turn up one after the other!). The 1923 version of *A Christmas Carol* (also known as *Scrooge*) was again a British production, and was adapted for the screen by Eliot Stannard, who wrote the scenario for Alfred Hitchcock's 1927 thriller *The Lodger* about Jack the Ripper. It was directed by Edwin Greenwood, who co-wrote Hitch's 1937 thriller *Young and Innocent* and appeared in the master of suspense's 1939 Du Maurier adaptation *Jamaica Inn*. (Rum lot of old nepotists these filmmakers!).

Russell Thorndike, lesser know brother of Dame Sybil, plays Scrooge. He is a tall, thin, white-haired, hunch-backed, big nosed, crabby, miserable old cuss with a beetling brow, and comes across like some kind of ghastly spider stuck in the centre of the wicked web it has woven. The visuals are dark and brooding, at times reminiscent of the contemporaneous German horror classic *Nosferatu* (produced the previous year).

The ghastly ghostly appearance of Scrooge's long dead partner Jacob Marley on Christmas Eve is beautifully handled with a dissolve and through utilising double-exposure: the spectre, bedecked in his chains and cash boxes, appears wonderfully transparent. When he sits across the fireplace from Scrooge, Marley's high-backed chair is plainly visible through his phantom body.

The Spirits of Christmas Past and Present are interesting too, for the former appears in Scrooge's chamber as a tiny figure, perhaps 3ft tall (again through use of a dissolve); while the latter is a veritable giant, maybe 8ft tall, who appears spectrally by the fireplace afterwards, looking like a towering Father Christmas with his white beard and hooded robe. Neither whisks Scrooge away to relive visions in this movie. Instead the images from his past and the present appear like R2D2 laser hologram projections at centre screen while Scrooge cowers watching from the side. But these 'screening a movie' style effects for the visions are very well handled.

The third Spirit – of Christmas Future – appears deathlike, as you might expect, and the black robe and hood are effective and fit in well with the dark tone of the piece. This ghost does beckon to Scrooge to follow him before backing out of the room, and when Scrooge follows, it is through a fade to black and into a graveyard in daylight (which makes the death-like spirit seem much less distinct, more spectral).

Even though it was produced as the 5th in a "Gems of Literature" series of films and has some pretty wordy inter-titles, this is an atmospheric, interesting version of the tale with some nifty ghosts and a pretty iconic Scrooge.

18. The one on the DVD double bill with *Scrooge* aka *Old Scrooge (1913)*

And 1928 saw yet another short (9-minute) British-made version of the hoary old Christmas cracker released. This time called **Scrooge** rather than A Christmas Carol again; and once again written by the actor who played the eponymous lead – this time one Bransby Williams (who, like Sir Seymour Hicks before him, assayed the role again several years later in a 1950 two-hour British TV production). The short 1928 version's claim to fame is that it is the first 'talkie' screen adaptation![19] Unfortunately it is believed lost with no known prints in existence.

So that brings us to the end of our introductory trawl through the silent seasonal spine-tinglers, dominated as you might expect by adaptations of Dickens classic 'ghost story for Christmas.' It would be much, much later that filmmakers' tastes turned real festive fright-fests – from the 1970s onwards. But in the ensuing decades there were at least some merry morsels of tinsel-tinged terror and Psychotronic Santa schlock produced. This seasonally themed smorgasbord is on the menu in our next chapter.

19 Produced by British Sound Film Productions Ltd.

THE FILMS

The Sound of Silent Screams

*** For all chapters, credits information is selective ***

A Christmas Carol 1908 USA B&W Silent (15mins)
Cast: Tom Ricketts

A Christmas Carol 1910 USA B&W Silent (17mins)
Directed: (uncertain) J. Searle Dawley or Ashley Miller or John H. Collins Cast: Marc McDermott (Ebenezer Scrooge), Charles Ogle (BobCratchit)

A Christmas Carol 1923 UK B&W Silent 27mins
Directed: Edwin Greenwood Written: Eliot Stannard Cast: Russell Thorndike (Ebenezer Scrooge)

Aka Scrooge

A Christmas Eve Tragedy 1908 USA B&W Silent

A Christmas Spirit 1912 USA Colour Silent
A Kinemacolor Production

A Message from Mars 1913 UK B&W Silent
Directed & Written: Wallett Waller (based on Richard Ganthoney's play)
Cast: Charles Hawtrey (Horace Parker), E. Holman Clark (Ramiel)

A Message from Mars 1921 USA B&W Silent
Directed: Maxwell Karger Written: Arthur Maude & Arthur J. Zellner
(based on Richard Ganthoney's play) Cast: Bert Lytell (Horace Parker), Alphonz Ethier
(The Messenger)

Noch pered Rozhdestvom 1913 Russia B&W Silent 31mins
Directed & Written & Cinematography & Design: Wladyslaw Starewicz

Aka Christmas Eve and The Night Before Christmas

The Right to Be Happy 1916 USA B&W Silent
Directed: Rupert Julian Written: Elliott J. Clawson Cast: Charles Rock (Ebenezer
Scrooge)

Aka Scrooge the Skinflint (in Britain) and A Christmas Carol

Rozhdestvo obitatelei lesa 1913 Russia B&W/Tinted 6mins
3-D stop-motion animation

Aka Rozhdestvo obitateley lesa and The Insects' Christmas

Scrooge 1913 UK B&W Silent 40mins
Directed: Leedham Bantock Written: Seymour Hicks Cast: Seymour Hicks (Ebenezer
Scrooge), Leedham Bantock, J.C. Buckstone

Aka Old Scrooge (1926 re-release title).

Scrooge 1922 UK B&W Silent
Directed: George Wynn Written: W. Courtney Rowden Cast: H.V. Esmond (Scrooge)

Scrooge 1928 UK B&W Talkie 9mins
Directed: Hugh Croise Written: Bransby Williams Cast: Bransby Williams (Ebenezer
Scrooge)

Scrooge, or Marley's Ghost 1901 UK B&W Silent (11mins)
Directed: Walter R. Booth

Aka *Scrooge; or Marley's Ghost* (US release title)

Il sogno dell'usuraio 1910 Italy B&W Silent
Credits unknown

Aka *Il sogno del vecchio usuraio* and *Dream of Old Scrooge* and *Old Scrooge*

CHAPTER 2

Creepy Carols Continue

It seems the one thing that seekers of cinematic festive thrills could rely upon throughout the decades has been the ongoing popularity of Dickens' classic tale *A Christmas Carol*. So many versions have been produced over the years – Fred Guida, author of *A Christmas Carol and its Adaptations: Dickens Story on Film and Television*[20] has identified almost 200 of them made for film and television! – that at least cinema-goers knew, if they were going to get no other kinds of ghosts, spirits, spectres, ghouls or whatever, there would always be a new chain-rattling Jacob Marley and the Ghosts of Christmas Past, Present and Future just round the corner in another new version of the hoary old Dickensian Christmas cracker! Of course, not all of them would have ghosts that would set the spine a-tingling as if the viewer behind you had dropped their ice-cream down your back, or in any way equivalent to find yourself sat in one of showman-producer-director William Castle's buzzer-rigged seats for ***The Tingler (1959)***.[21] But hey, you couldn't have everything!

As *A Christmas Carol* is without doubt the Big Daddy of all Christmas ghost stories and so many film versions have produced over the years, although I have no intention of trying to hunt down all of Mr. Guida's almost-200, I thought that we should have a little trawl through some of the versions and explore the festive frissons that their various ghosts might afford.

20 Published by McFarland & Company, 1999

21. Castle, who was noted for his gimmicky showmanship, produced several low-budget, often exploitative horror films, several of which he tried to hype with gadgets (e.g. for ***The House on Haunted Hill (1959)*** he had some cinemas rigged with an inflatable skeleton that was drawn over the audience's heads on a line at a particular moment in the film. He called this novelty Emergo). For ***The Tingler (1959)***, a film starring Vincent Price about an invisible spinal cord snapping creature that could only be defended against by screaming, he had some seats in the theatre wired with a buzzer, then when the creature escapes into a cinema auditorium onscreen, the onscreen character would implore the real life audience to scream if they felt the Tingler's touch – and of course "buzz" those sat in the wired seats to get the ball rolling!

The last chapter ended with a 1928 9-minute short that was the first 'talkie' version of the tale to hit the silver screen; but back in 1913 Britsh thesp Seymour Hicks assayed the role of miserly old misery-guts Ebenezer in a production called **Scrooge**, which was re-released in 1926 as **Old Scrooge**. Though he was probably a very fine actor in the mode of the time and added years to his appearance for the role, he was quite a burly young bulldog of a bloke in reality, which I personally found detracted from his portrayal.

However, as I said in the previous chapter, after another 22 years had passed (during which time he had been knighted), Sir Seymour Hicks was back to have another go; this time in a British 'talkie' once again entitled **Scrooge** from 1935. This film may still look quite creaky to a modern audience, but nonetheless it is in fact a pretty well made movie for its time. This time round, more physically aligned with the viewer's expectation of the role (thanks in no small part to the ravages of time), Hicks makes a rather splendid job of portraying the eponymous character. This Scrooge is a dark, hunched, crabbed (and crabby!) ugly monster of a man with scruffy hair and unkempt appearance – a little reminiscent of Fredrick March's Mr Hyde from **Dr. Jekyll and Mr. Hyde (1931)**.

The film is very atmospheric, and lighting, scenery and costume are all excellent. Unusually though, we do not actually get to *see* Marley's ghost in this version. We hear and witness all sorts of spooky manifestations – tinkling bells, chiming clocks, doors opening and closing themselves – and we hear a disembodied voice; moreover, the camera pans around as if following the movements of some invisible, disembodied entity...but Marley's ghost doesn't actually make an appearance. Seeing Marley's ghost remains Scrooge's privilege alone!

And in another twist on the norm, when the Spirit of Christmas Past presents Scrooge with scenes from bygone times, these seem to be viewed by the old miser in his own mind's eye; transmitted as it were by some form of mystical osmosis (rather than having Scrooge magically transported to revisit them as a disembodied observer himself). This seems to me quite a thoughtful way of presenting the scenes from the Past for, being passed, they no longer exist as such outside of Scrooge's mind, or memory.[22]

The Ghost of Christmas Present comes across as some kind of face-feeding, less than jolly Friar Tuck figure in this version, ready to tuck into the festive fare that surrounds him like Henry VIII at one of his own wedding banquets. He does actually transport Scrooge to witness scenes from the present.[23] While the Ghost of Christmas Yet To Come, though not really terror-inducing, is pretty much as you might expect.

22 That is, unless you want to get into some pretty esoteric quantum physics and multiple universe dimension theories!

23 Though Scrooge's face always seems to appear in the shadow of his own

Old school and klunky though this film might appear to many a modern viewer, it still beats the first Hollywood produced 'talkie' version of ***A Christmas Carol (1938)***[24] into a cocked hat! That film, which stars Reginald Owen as Scrooge (in some decidedly dodgy makeup) boasts all of Hollywood's Tinseltown Dream Factory gloss, with Victorian London recreated on a studio backlot, people with a bustling throng of beautifully costumed extras and all manner of detail clearly and cleanly visible in the usual high standard high-key studio lighting. Well, with high production values and high tech superiority, MGM/Loew's undoubtedly wanted viewers to actually see all this (and their pretty decent cast, which included Leo G. Carroll as Marley's Ghost, Lionel Braham as the Spirit of Christmas Past, Ann Rutherford as the Spirit of Christmas Present, D'Arcy Corrigan as the Spirit of Christmas Future, Gene and Kathleen Lockhart as the Cratchits and an uncredited June Lockhart[25] as one of their children). But while the usual high-key lighting of Classical Hollywood ensures that everything is well lit and visible (this is before the influence of *film-noir* and Italian Neo-Realism), it also lends both a surface polish and blandness that are detrimental to the spookier aspects of the tale.

Marley's Ghost does not seem very terrifying (even to Scrooge) and his weighty chains do not seem very weighty; the Spirit of Christmas Past comes across as almost some kind of 1930s Christmas tree fairy - a precursor of Glinda from ***The Wizard of Oz (1939)***. She is pretty, but her tremulous, melodramatic voice – like Bette Davis full-tilt in one of her weepies – is a tad ripe, and when she flies off with Scrooge to visit shadows of Christmases past, the strings are clearly visible!

For his part, the Spirit of Christmas Present seems to have been 'at the Christmas Spirits' (he comes across as half-cut!), but the initial appearance of the Spirit of Christmas Future is pretty spooky. From being at home in bed, enjoying his reminiscences of the sights he has seen with Present, Scrooge suddenly finds himself transported. He stands alone in a windy, misty environment with bare, dark trees and craggy peaks – somewhere straight out of a Universal horror film, like James Whale's ***Frankenstein (1931)*** or ***Bride of Frankenstein (1935)*** perhaps. The Spirit of Christmas Future appears as an ominous figure draped in black approaching and pointing the way for Scrooge to follow. Unfortunately though, this atmosphere borrowed from or influenced by a Universal Horror movie is not maintained, and while there is much to enjoy about this film, there is also a surfeit of Brussels sprouts to be shuffled to the side of the plate too!

There was one other British production entitled ***A Dickensian Fantasy (1933)*** in which, some gent reading *A Christmas Carol* dreams that the characters come to life, but apart form that, I think we'll leave the 30s behind. And as for the 40s, there is one cinema version I want to mention: an 80-minute B&W Spanish production entitled ***Leylenda de Navidad (1947)***...and then only really to point out that it exists and that the popularity and influence of Dickens' tale was not confined merely to the English speaking world. Scrooge, Marley's Ghost and the Spirits of Christmas haunted and continue to haunt other countries and cultures too. And even if cinematic versions were a bit thin on the ground in the United States through the 40s, at least 3 versions were made for the up and coming new mass entertainment medium, television.

24 . Aka ***Charles Dickens' A Christmas Carol***
25 . Who would later find fame on television as the mother of the Robinson family in **Lost in Space**

A 1943 production of **A Christmas Carol** with a running time of 60-minutes became the longest TV play ever broadcast, while a couple of cinematic horror stalwarts added their weight to two others: John Carradine (father of **Kung Fu** and the **Kill Bill** movies' David, and already a Hollywood veteran) played Scrooge in a 1947 version (which also featured a young Eva Marie Saint 7 years before she starred opposite Brando in **On the Waterfront (1954)**); and Vincent Price acted as host and narrator for another in 1949.

The 50s saw the release of more made-for-TV adaptations, including a 2-hour B&W British version starring Bransby Williams as old Ebenezer again – he had previously played the role in the silent **Scrooge (1928)**, and an hour- long American version starring the aptly monickered Noel Leslie as the penny pinching reprobate who finds redemption via the visitation of the Christmas Spirits. But what many people (myself included) believe to be the best version of the tale committed to film so fa, was produced in Britain in 1951. Once again named for its central character, **Scrooge** (though it was known as **A Christmas Carol** in the States), this film stars the inimitable Alastair Sim as Ebenezer – surely the part this weary-faced actor with a hang-dog expression, bulging eyes, morose voice and sharp, biting, intelligent wit was born to play! He has an absolute penchant for conveying in the drollest way the indignation of the put upon, and there is a wonderfully sardonic edge to his voice. Moreover, while Sim simply *is* the screen Scrooge *par excellence*, the production values and stellar cast of Brit character actors who support him make this originally B&W (though it is often screened on TV nowadays in a colourised version) British movie an absolute *must-see* treat any time...but especially at Christmastime.

With the likes of George (**Minder**) Cole, Mervyn Johns, Hermione Baddeley, Michael Hordern, Patrick (**The Avengers**) MacNee, Jack Warner, Miles Malleson, Ernest Thesiger, Kathleen Harrison, Hattie (**Carry On**) Jacques and Noel (**Please Sir!**) Howlett on board in support, you just know you've got to be onto a winner. The ever-excellent Michael Hordern's Ghost of Jacob Marley is a highlight; all white, with suitably weighty chains and coffers and a chilling banshee wail that is truly spinechilling. Hordern gives a distant portrayal, as if distracted or entranced, utilising his voice very well. And there is a brilliant use of sound to support the eeriness of his appearance, a grating and clanging which must grate with the viewers' nerves (like fingernails on a blackboard!). Both Sim and Michael Hordern reprised their roles 20-years later in an excellent animated version from 1971 called **A Christmas Carol** this time.

Ein Weinachtshied in Prosa oder Eine Geistergeschichte zum Christfest (known internationally as **A Christmas Carol in Prose, or a Ghost Story of Christmas**, revisiting Dickens' full original title for his tale) was produced for West German[26] TV in 1960 (in B&W of course at the time) and the 46-minute **Karácsonyi ének** was produced for Hungarian TV (still in B&W) in 1964; again testifying to the widespread popularity and appeal of this tale. While 1962 saw myopic animated actor Quincy Magoo appear in the 53-minute **Mister Magoo's Christmas**

26. The country was still divided then

Carol on American TV. And while Jim Backus[27] provided Magoo's inimitable dulcet tones, Roayl Dano manifested Marley's vocalisation.[28] Surprisingly, this tale sticks reasonably close to the original, and although the animated Ghosts aren't going to scare anyone, this little movie is extremely entertaining and boasts some cracking songs from Jules Styne (music) and Bob Merrill (lyrics).[29]

Since then, a whole bunch of cartoon characters have turned their (usually 4-fingered!) hands to their own versions of Dickens' festive rave from the grave fave! These have included Mickey Mouse in *Mickey's Christmas Carol (1983)*, a 25-minute Disney animation featuring Scrooge McDuck – who else! – as Ebenezer, Mickey as Bob Cratchit, Goofy as Jacob Marley's Ghost, Jiminy Cricket as the Ghost of Christmas Past, Willie the Giant as Present and roughty-toughty, big, brawling dog Pete as Future. Director Burny Mattinson was Oscar nominated for Best Animated Short Film for this one. Hanna-Barbera's Jetson and Flintstone families took turns in made-for-TV festive specials *A Jetson Christmas Carol (1985)* and *A Flintstones Christmas Carol (1994)* respectively. In the former, George's tightwad boss, Mr Spacely, gets the Scrooge treatment after demanding George work over Christmas and his deceased part-ner Jacob *Mars*ley (Geddit?) visits followed by a disembodied robot head as Past, a talking Christmas present as Present (Geddit?) and a menacing green mainframe as Future! While in the latter, loudmouth Fred gets cast as Scrooge in the Bedrock Christmas play.

Brer Rabbit got his go in another made-for-TV 58-minute feature *Brer Rabbit's Christmas Caro*l in 1992 and the Looney Tunes cartoon characters took a turn in 2006 in *Bah Humduck!: A Looney Tunes Christmas*, which features everyone's favourite crazy black canard, Daffy Duck, as Scrooge, with Sylvester the cat as Marley, Grannie and Tweetie as the Ghost of Christmas Past, Yosemite Sam as Present and manic marsupial Taz as Yet-To-Be. Even Cruella DeVil, villainess supreme from Disney's *One Hundred and One Dalmations (1966)* got to as-say the Scrooge role in an episode of 1997's *101 Dalmatians: The Series* entitled *A Christmas Cruella*. While Little Orphan Annie got to turn her hand to Dickens in *Little Orphan Annie: A Very Animated Christmas (????)* and the monstrous imaginary friends of the excellent animated TV series **Foster's Home for Imaginary Friends** got their go in the festive special *Foster's Home for Imaginary Friends: A Lost Clause (2005)* and even everyone's favourite sniggering, hormonally-challenged teens, Beavis and Butt-head, took a turn in *Beavis and Butt-head Do Christmas (1996)* (also known as *Beavis and Butt-head's Christmas Special*). Their riff on Dickens within this film is entitled **"Huh-huh-Humbug"** and, like everything else, even old Scrooge's expletive gets twisted round when one of the lads refers to all things Christmassy as "Bum-hug!"

27. Who played James Dean's dad in ***Rebel Without a Cause (1955)*** and millionaire shipwreck survivor Thur-ston Howell III on the long-running American TV comedy **Gilligan's Island**

28.While Tiny Tim turns out to be none other than contemporaneous cartoon kiddywink **Gerald McBoing-Boing** (although he can talk here rather than just do vocal imitations and "Boing")

29. To give an idea of the quality, Styne wrote songs for films like ***Anchors Aweigh (1945)*** and ***Three Coins in a Fountain (1954)*** with Sammy Cahn, while Merrill wrote 50s hits like *Mambo Italiano, If I Knew You Were Coming (I'd Have Baked a Cake)* and *How Much is that Doggy in the Window*.

One-off animated adaptations, often feature length, have also proliferated. In 1971 a 28-minute made-for-American-TV animated version of *A Christmas Carol* starring the vocal talents of Alastair Sim and Michael Hordern reprising their roles of Scrooge and Marley respectively from the all-time-classic British 1951 movie is an absolute gem. Others have varied immensely in quality. While 1978 heard that Hollywood grump with a face like an over-stuffed sofa, Walter Matthau, vocalising Scrooge in a 51-minute adaptation from Rankin-Bass[30] entitled *The Stingiest Man in Town*.[31]

A 1994 video-released outing featured animals as all the main characters, while the somewhat dire 1998 *An All Dogs Christmas Carol* featured the cartoon canines from Don Bluth's *All Dogs Go To Heaven (1989)*. Unfortunately this flea-bitten Paul Sabella directed take on the Crimbo classic is a bit of a dog's dinner and simply wastes the vocal talent involved (Dom DeLuise, Ernest Borgnine, Bebe Neuwirth, Sheena Easton)...though it is far from alone in this respect! The 1997 animated *A Christmas Carol* criminally wastes the vocal talents of Tim (*The Rocky Horror Picture Show (1976)*) Curry, Michael (*Logan's Run (1976)*) York, Edward (*Lou Grant*) Asner and Oscar winner (as Best Supporting Actress in *Ghost (1991)*) Whoopi Goldberg. While the UK/German co-produced, mostly animated (but with an excellent live-action prologue starring Simon Callow as Dickens reading his tale on a lecture tour of America) has animation so awful that it somehow conspires to make merry manure out of the vocal talents of Oscar winner (as Best Actor for *Leaving Las Vegas (1995)*) Nicolas Cage, Jane Horroccks, Michael Gambon, Rhys Ifans, Juliet Stevenson, Robert (Kryton in TV's **Red Dwarf**) Llewellyn (who also wrote it!) and Kate Winslett (though she did have a surprise hit[32] single off the back of it!).

Naturally, none of these are particularly scary (though the 1969 Australian/American produced *A Christmas Carol* did see the Ghost of Jacob Marley as a skeleton with flames spouting from his head, a bit like the comic book character *Ghost Rider*!) but they do feature spirits and ghosts in various forms. As does the excellent Muppet take on the tale from 1992, *A Muppet Christmas Carol*. But this one really does have a spooky Ghost of Christmas Yet To Be – in fact, in my book, one of the death-figure spirits in any of the cinematic adaptations of the tale – a really creepy, cowled, skeletal harbinger of doom! And the casting of chain-rattling Statler and Waldorf (the two aged hecklers from the Muppet theatre balcony) as the floating Ghosts of the Marley brothers (!) with a fantastic spooky song to sing is a stroke of genius on a par with casting Michael Caine as Scrooge (and eliciting one of this Brit screen legend's finest performances).

30. The production/direction team responsible for a whole succession of high class animated and stop-motion animated Christmas classics like *Rudolph the Red-Nosed Reindeer (1964)*, *The Little Drummer Boy (1968)' Frosty the Snowman (1969)* and *Santa Claus is Comin' to Town (1970)*

31. Not to be confused with a 90 minute long US TV adaptation from 1956 starring Basil Rathbone as Scrooge and Vic Damone as the younger Scrooge which had the same title

32 .With the song 'If Only' from the film

But back to the fully live-action adaptations... The 1960s kicked off the decade with a 110-minute West German TV production entitled ***Ein Weihnachtslied in Prosa oder Eine Geistergeschichte zum Christfest*** (-Easy for you to say!), which actually revisited Dickens' own full original title for his tale, translating as ***A Christmas Carol in Prose, or A Ghost Story of Christmas***. While across the Atlantic, in North and South America the old miser continued to make his mark. In Brazil Scrooge starred in a Portuguese language TV series entitled **Velho Scrooge, O** while in the USA, 1964 witnessed something of an unusual event – a made-for-TV adaptation of *A Christmas Carol* that was shown on American commercial TV *without any commercial breaks!* This Christmas Special entitle ***Carol for Another Christmas*** (the first in a series of 5 programmes sponsored by the Xerox Company to promote the United Nations), was directed and produced by Joseph L. (***All About Eve (1950)/ Cleopatra (1963)***) Mankiewicz and written by Rod (**The Twilight Zone**) Serling, and was significantly updated to convey its modern message. It starred Hollywood actor Sterling Hayden as a modern-day Scrooge, Daniel Grudge, who, bitter having lost a son in WWII advocates American isolationism. But after his visitations, Grudge becomes somewhat less begrudging of America's involvement in world politics via the United Nations! The Ghost of Christmas Past takes him back through time to a World War I troopship and conducts him up to Christmas Day 1945, where Grudge witnesses an American doctor and a WAVE (Eva Marie Saint) trying to help sweet voiced young girls scarred by the atomic blast at Hiroshima; the venal Ghost of Christmas Present (Pat Hingle) gorges himself on food at a banquet table, while nearby Third World children starve behind a fence; and the Ghost of Christmas Future (Robert Shaw) shows him a devastated post-Atomic war future with a loony, religious zealot dictator and self-proclaimed Messiah (Peter Sellers).

On a decidedly less serious note, in Britain 1969 saw the regulars of the series of low-brow, seaside postcard humour ***Carry On*** films in the first of their festive made-for-TV Christmas Specials ***Carry On Christmas***. No serious political message here...blimey, not even any serious political correctness!...but let's face it; you pretty much know what to expect when you get Sid James cast as Ebenezer Scrooge, Charles Hawtrey as the Ghost of Past, Babs Windsor as the Ghost of Christmas Present and Bernie Bresslaw as the Ghost of Christmas Yet to Come, don't you?![33] (Yep - no real tremors, but a right bunch of titters!).

In the 1970s, 6 years after reprising his role as Jacob Marley from the 1951 classic (alongside Alastair Sim reprising his role of Scrooge) in an American animated adaptation, Michael Hordern got to play the miserable miser himself in a made-for-British-TV take entitled ***A Christmas Carol; Being A Ghost Story of Christmas (1977)***. This is beautifully acted but very studio bound, and it definitely suffers from budgetary constraints. (Hell, the exteriors aren't even sets, they're drawings!...and this from the same year that ***Star Wars*** hit the big screens!!). But if you can look past the budget barrier, it is definitely worth a watch for the calibre of performance – not just from the ever-excellent Hordern, but from the likes of Zoë (**My Family**) Wanamaker, June (Dot Cotton in **Eastenders**) Brown, Tracey (**Howard's Way**) Childs, John (**Dad's Army**) Le Mesurier, Bernard ('M' in most of the Bond films) Lee and everyone's favourite Panto Dame Christopher Biggins.

33. Terry Scott, Peter Butterworth, Hattie Jacques and Frankie Howerd were also on board

Also produced in the UK was the first Musical adaptation of *A Christmas Carol*. Entitled **Scrooge** and with music from double Oscar winner[34] Leslie Brickusse, this Ronald Neame directed big screen outing starred Brit screen legends Albert Finney as the tight-fisted terror, Alec Guinness as the ghost of his ex-partner, Dame Edith Evans as the Ghost of Christmas Past and Kenneth More as the Ghost of Christmas Present.

This is a rootin' tootin' rip roarer of a movie, with Finney giving a fine performance as Scrooge and Guinness a wonderful one as Marley's ghost – relying very much upon his own performance to convey a strange sense f otherworldliness, rather than on special effects. Although whitish- grey of hue, and entirely solid looking; the disjointed floating movements, ethereal distractedness and separation are all conveyed entirely through Guinness's own movements and performance. That is not to say that no special effects are used at all – when the Ghost becomes angered at Scrooge's refusal to believe in its existence as anything more than a hallucinatory manifestation of indigestion, Marley's Ghost wails with indignation and floats up in the air, his chains and weighty coffers floating out like octopus tentacles – making for quite a scary sight. ...And then, wrapping a chain around his ex-partners arm, Marley's Ghost takes Scrooge on a flight over the city, where Scrooge sees the flying transparent phantoms of the tormented damned, doomed to roam the earth ineffectually for all eternity. These are in fact all very good special effects. But it is definitely Guinness's performance that put the (dead) flesh on the bones of his character.

As usual, the Ghost of Christmas Yet to Be is a cowled and robed Death-figure...but unusually, rather than just show Scrooge his grave, in this production the poor, unwitting tightwad is actually transported to Hell to view the ultimate cost of his miserly ways in the form of eternal damnation as a clerk for Satan! But perhaps one of the most pleasingly dark episodes in the film occurs prior to this when the Ghost of Christmas Yet to Be shows Scrooge a whole troop of his debtors singing what is probably the movie's stand out number, 'Thank You Very Much.' It is a rousing, showstopper of a number with excellent mass choreography that Scrooge finds incredibly effective and tries to join in with, even though he is invisible to the revellers. "Thank you very much, that's the nicest thing that anyone's ever done for me" the crowd sings, with Scrooge lapping up the approbation and effusing warm-hearted goodwill... not realising that the nice thing the crowd are singing about is his dying and relieving them of the burdens of their debt to him!!! Magic!

While across the pond, our Yankee cousins strove to give 'the Carol' a colonial flavour (sort of Kentucky Fried Turkey!) with made-for-TV productions like *An American Christmas Carol* and *Skinflint: A Country Christmas Carol* both 1979. The former starred Henry (the Fonz from **Happy Days**) Winkler in the Scrooge role, playing Depression era grasper Benedict Slade; while the latter featured Country singer-songwriter-cum-actor Hoyt Axton[35] in the mi-

34. For Best Original Song for both *Dr. Dolittle (1967)* and *Victor/Victoria (1982)*.

35. Who also played the dad in *Gremlins (1984)*

ser's threadbare slippers alongside a cavalcade of Country stars of the period.[36] ***An American Christmas Carol*** isn't too bad, though a little dour perhaps, but I can't comment on ***Skinflint*** because I haven't actually seen it (and I know there are many who would rather be visited by the scariest spooks imaginable than face 2-hours of 70s Country music...so I'll leave you to try and find that one for yourselves if it sounds like your cup of tea...or glass of JD!).

The 1980s saw France produce their own made-for-TV version of ***A Christmas Carol (1984)***, which, when it was screened on American TV featured Oscar winning[37] Hollywood heavyweight actor George C. Scott in a "Read All About It" segment talking about Charles Dickens. Which is rather fitting as he starred as Scrooge in a fine UK/US made-for-TV co-production of ***A Christmas Carol*** the same year. This was directed by Clive Donner, who, in-cidentally, was editor of the classic British 1951 version which starred Alastair Sim. And here, Donner really does very effectively chart Scott's thoughtful and emotional performance in the lead, cataloguing Scrooge's progression through the course of his wondrous Christmas Eve.

The film is quite dark; its low-key lighting takes its inspiration from the actual light sources of the time in which it is set – gas flames, lamps and candles. This, along with the muted colours of the excellent period costumes, evocative sets and good location shooting[38] lend a sense of concrete realism, but also ensures quite a sombre, dark look and feel. The film also boasts a fine supporting cast, and Frank (**Bouquet of Barbed Wire**) Finlay makes a marvellous Marley: grisly and grey, with a truly chilling banshee wail. While Edward (**Callan/ The Equaliser**) Woodward as the Ghost of Christmas Past harkens back to the Pagan figure of the Green Man...and the cowering emaciated children clinging to his legs, which he re-veals under his robe, make for a truly appalling sight. Unusual-looking Angela (daughter of Donald) Pleasence cuts a strange, ethereal presence as the Ghost of Christmas Present. And the appearance of the black robed and cowled Ghost of Christmas Yet to Come (played by Michael Carter) – a personification of Death that appears backlit amidst swirling mist to the accompaniment of eerie sounds – is one of the most chilling of any adaptation of this tale. (It might put the wind up younger viewers quicker than the Brussels sprouts they have with their turkey dinner!).

David Warner, Susannah York, Roger Rees, Caroline Langrische, Lucy Gutteridge, Nigel Davenport, Joanne Whalley,[39] Michael Gough and Liz Smith (Nana from **The Royle Family**) put flesh on the bones of the rest of the main cast, ensuring that this is one very, very watchable movie...though decidedly different in tone to the three other 80s opuses I want to mention.

36. Including Lynn Anderson, Larry Gatlin, Tom T. Hall, Barbara Mandrell, the Statler Brothers, Mel Tillis and Dottie West (for any rhinestones and stetsons fans who might be interested!).

37. As Best Actor for ***Patton (1970)*** – though he refused to accept it because he did not feel himself to be in competition with other actors. (The producer accepted it on his behalf, but later returned it to the Academy!)

38. The English town of Shrewsbury was extensively used

39. Before she married Val Kilmer and became Joanne Whalley-Kilmer

The first of these is a 1986 Canadian made-for-TV take on the tale that was executive pro-duced and directed by Robert Guillaume – the butler Benson from the TV titter-fest **Soap** who went on to star in his own show. He also plays the lead part – the Scrooge-like John Grin – in *John Grin's Christmas* (aka *Christmas)* an updated adaptation that features a predominantly black cast (including Alfonso Ribeiro, who plays Kevin Banks, Will Smith's character's wealthy half-wit half-brother in **The Fresh Prince of Bel Air**).

The second is a British TV Christmas Special: *Blackadder's Christmas Carol* also from 1988. This sees a Victorian member of the infamous Blackadder family whose exploits have been side-splittingly revealed through several other eras of English history in the TV series. His name is of course Ebenezer Blackadder; but the twist here is that he is a kindly, open, generous man (the black sheep among all the other sly, self-serving, greedy members of his family featured in the series). It is only the well-meaning visitation of the Christmas Spirit – played by Robbie (the giant Hagrid in the *Harry Potter* films) Coltrane – that turns him to the Dark Side as it were...into a typical selfish, grasping Blackadder! And while this may not be scary, it will certainly tickle your chuckle-muscle!

But the final 80s adaptation I want to mention is both a side-splitter and (thanks to some excellent special effects) a real treat for fans of the festive macabre. It is the 1988 side-splitter *Scrooged*, starring Bill Murray and directed and produced by Richard Donner.[40] In this Murray plays Frank Cross, a hard-arsed, cynical TV producer and neo-Scrooge, who has rather lost touch with humanity and gone all Gordon Gekko,[41] definitely advocating the profits over prophets principle.

From the moment Santa's gingerbread-style North Pole toy-making factory home comes under attack from terrorists and Santa, Mrs C and their elves break out the automatic weap-ons to try and defend it, before action man Lee Majors[42] arrives to save the day – and it all turns out to be an advert for a festive TV-movie called "The Night the Reindeer Died" that Cross has produced, you get a darned good idea of what you're in for. But as well as laughs a-plenty all the way through, and a little romance and drama, the viewer also gets some great spook-effects: the ghoulish rotting corpse of an ex-business buddy who visits Cross Marley-like to warn of further ghostly goings-on; a slobbish, unshaven, cigar-munching, yellow cab driving, pointy-eared pixie of a Ghost of Christmas Past with plenty of attitude who takes Cross on hair-raising ghostly jaunts in his jalopy; the squeaky-voiced living Christmas tree fairy of a Ghost of Christmas Present with a penchant for socking Cross in the kisser; and the cowled and robed skeletal Death-figure with glowing eyes of Christmas Yet To Come (made even more scary by variously being multiplied across a bank of monitors and made gigantic – a huge skeletal arm reaching out for Cross from the TV screens). This is an absolute gem of

40. Director of *The Omen (1976)*, *Superman (1978)*, *The Goonies (1985)* and the *Letahl Weapon* films among others.

41. The main character from iconic Reagan-era 80s flick *Wall Street (1987)* who declared as a motto for a generation "Greed is good."

42. Of **The Six Million Dollar Man** and **The Fall Guy** fame on TV

a re-invention or re-interpretation of Dickens' celebrated Christmas classic...and proves that there's life in the old dog yet!

And the 1990s into the new century saw several other adaptations, and re-inventions to prove that point. UK TV screened a ballet version in 1994 and an updated adaptation set on a council housing estate starring ex-**Eastenders** hard-nut Ross Kemp in 2000. While Jack Palance played Scrooge as a not-so-festive frontiersman in the Canadian-produced Christmas-themed Western adaptation *Ebenezer (1997)*, which features refreshingly different Ghosts of Christmas. Past is a Native American woman and Present a ghostly horse riding Canadian Mountie!

And women got in on the act too, with the Scrooge-character becoming trans-gendered in productions like the 1995 US made-for-TV movies *Ebbie*, *Ms. Scrooge (1997)*, and *A Carol Christmas (2003).* The first of these stars the US's Queen of Daytime TV Soaps, Susan Lucci (or is it a cardboard cut out of her? – because that's the standard of acting!). Elizabeth 'Ebbie' Scrooge is a busy Chief Exec of a department store who is given a lesson in the joys of Christmas by three (also female) Christmas Spirits (who are also employees! ...Well, if they're not dead, why would the big, bad, boss think her lessons were anything more than night-mares, delusions or other manifestations of her subconscious?! And if they are, is Marley's ghost too? And is the future therefore, just part of Ebbie's imagining of a possible future, rather than the unalterable consequence if she continues on her current Anti-Santy path?). it doesn't matter anyway, because quite frankly, the film isn't worth watching...unless it's a choice between that and red hot needles in your eyes...then you would have to carefully consider the two options on the day and take your pick!

I cannot really comment on *Ms. Scrooge*, which stars Cicely Tyson as the wonderfully-monickered Ebenita as I haven't actually seen it, but there's one thing for sure; it can't be any worse than the God-awful *A Carol Christmas*, which stars Tori Spelling[43] as the Scroogey TV exec character Carol, who has the usual downer on the holidays. This is definitely not a moment of Tori Glory (nothing too unusual there then!); while co-stars like the living Dinky toy doll, Gary (**Different Strokes**) Coleman as the Ghost of Christmas Past, and the past-it hambone William (**Star Trek**) Shatner as the Ghost of Christmas Present may help dissuade the sensible from dabbling here.

But the trans-gender lady Scrooges did get a very good run out in the wonderfully re-invented, updated and sex-changed made-for-American TV[44] *A Diva's Christmas Carol (2000)*, which starred the gorgeous Vanessa Williams[45] as Ebony Scrooge, a modern day pop star diva whose visit from sexy ex-group member Marli Jacob (!) presages some more spirit shenani-gans. Like *Scrooged*, this is a very funny film and boasts some fine effects too. To all intents and purposes, the TV set in her hotel room is her Ghost of Christmas Yet To Be, playing an

43. Daughter of multi-millionaire TV producing mogul Aaron and former star of **Beverley Hills 90210**

44. Actually an MTV production

45. The first African-American Miss America who has had a successful career in music, TV, films and on stage.

MTV retrospective of her career after she supposedly dies! This one is another wise-mouthed hoot, this time set around the particularly cutthroat music industry.

But where *A Diva's Christmas Carol* sets its reinvention of the tale in the modern music industry, 2004's Hungarian/American made-for-TV co-production *A Christmas Carol: The Musical*, like Britain's *Scrooge (1970)* before it, turns the tried and trusted tale into a Musical. This one stars Kelsey (*Frasier*) as the anti-Santy penny-pincher Scrooge, with Jason (George Costanza in **Seinfeld**) as Marley, Jane (**Ally McBeal**) as the Ghost of Christmas Past, black actor/singer Jesse L. Martin as the Ghost of Christmas Present and actress Geraldine Chaplin (daughter of Charlie Chaplin and granddaughter of playwright Eugene O'Neill) as the Ghost of Christmas Future...though each of the actors cast as the ghosts double up to play a character Scrooge meets in his daily life also.

In a change to the usual cowled and robed Death-figure manifestation of the Ghost of Christmas Future, Geraldine Chaplin cuts a suitably grotesque and threatening apparition (wrapped mummy-like in tattered white rags, with pale, gaunt, drawn features). Thanks to her capability as a performer, and the fact that she looks rather like a wizened holocaust survivor, the character exhibits an ominous sense of power despite the actress's slight frame and small stature.

But whatever new twist or turn filmmakers and television producers choose to give Dickens' Christmas classic, big and small screen adaptations of the tale continue to abound. Take 2004's made –for-US-TV *Karoll's Christmas*, for example, where the ghosts visit the wrong neighbour!...though they still have an enlightening effect. Or the same year's *Chasing Christmas*, in which comic-actor and ex-Mr. Roseanne Barr, Tom Arnold, plays a modern day Scrooge who is almost screwed by the Ghost of Christmas Past who's tired of his ongoing role in trying to get grouches to reform. Fortunately, beautiful blonde Andrea Roth is on hand as the Ghost of Christmas Present to help him straighten things out...but not before a bit of time-travelling knock-about and some romance. Or the Italian straight-to-video release *Natale a casa Deejay – A Christmas Carol (2004)*, which I am assuming does not fully correspond to the original tale as the cast of characters includes 3 Medusas as well as a couple of Dik Dikenses!

But more straightforward versions of the tale persist also, giving different takes on the character of Scrooge. Like 1999s made-for-American-TV take *A Christmas Carol*, which stars ex-Shakespearean board-treader and United Space Federation starship captain Patrick (Jean-Luc Picard in **Star Trek the Next Generation**) Stewart. His is a thoughtful, rounded, subtle portrayal of a much more cerebral Scrooge, which makes the tale much more of a mental drama. In this production we see just how the intelligent, imaginative, sensitive young Scrooge evolves into the cold, flinty, hardened, bitter, gruff character we all know and love to hate (as well as how he is redeemed by a night on the spirits, so to speak!).

Some nice, effective fairly modern special effects are employed in this movie, though the Ghost of Christmas Yet To Come is a decided disappointment with pin lights for eyes under

his grey cowl. Still, Oscar winner[46] Joel Grey makes a suitably otherworldly Ghost of Christmas Past, while Desmond Barrit as the Ghost of Christmas Present gets to whisk Scrooge further afield than in most versions (he takes him to witness Christmas celebrations in a lighthouse, a prison, among miners and among sailors on a storm-tossed sea). And Scrooge does have a truly terrible end to his haunted nocturnal night class: he is literally confronted with the *ultimate* image of himself lacking all humanity – his own lifeless corpse! – rather than just his grave. It is only when he has been literally cast into his own grave and suffered a nightmarish plummet through the empty blackness of the void, locked in an embrace with his own corpse, that Scrooge wakes in his own familiar bedroom on Christmas morning.

The most recently released version – a 3-D digitally animated feature written and directed by the 'whizzkid' director of the **Back to the Future** movies, **Forrest Gump (19 94)**, **The Polar Express (2004)** and **Beowulf (2007)**, Robert Zemeckis,[47] stars rubber-faced comic actor, goofball and goon, Jim Carrey as Scrooge (portraying him at several different ages). He also plays the 3 Ghosts of Christmas. And an extremely creditable job he does of it too – not goofing it up, but playing it straight in what turns out to be a pretty classical realisation o Dickens' eternally popular tale.

Gary Oldman (portraying Bob Cratchit, among others), Colin Firth (portraying Fred) and Bob Hoskins (portraying Fezziwg) are all involved too – and instantly recognisable in the animated characters, Zemeckis continuing to present animations that capture and enhance the performers' actual features and performances (as in **The Polar Express (2004)**).

That movie was obviously technically groundbreaking – though I was left in two minds about the whole 'performance-capture' animation technique – as I am sure were many others. (And having left so many viewers in two minds, maybe that movie should rather have been called "The Bi-polar Express! Just a thought). The problem was that, while Tom Hanks was recognisable in the animated character, the nuances of his facial expressions in performance were not captured in an entirely effective manner. And that went for the other characters – especially the children – giving them a lifeless, plasticity of features and resulting in the human characters coming across as some kind of zombies almost.

But the 3-D effects were seminal, and not only has there been a burgeoning of 3-D films released in the last couple of years – live-action as well as animated – but the quality of animation and the capability of more realistically or naturalistically capturing performances (especially where human facial expressions are concerned) has certainly improved.

Despite the efficacy of some stunning 3-D effects, however (not least the dizzying sequences of Scrooge flying with the ghosts), where this adaptation really scores is in the way that it creates an astounding Victorian London as the milieu in which the fine performances

46 As Best Supporting Actor for *Cabaret (1973)*

47 Slated for a 2009 release with (subject to change) Jim Carrey voicing Scrooge and the Spirits of Christmas, and Gary Oldman, Colin Firth, Michael J. Fox, Robin Wright-Penn, Christopher Lloyd, Cary Elwes and Bob Hoskins among its vocal cast!

exist. And as for the ghosts – at times they are in fact quite eerie and scary...not only the Death-like Ghost of Christmas Yet To Come, but also Marley's Ghost (also portrayed by Gary Oldman) – especially when, his face appearing as a door knocker, he suddenly looms out and spits out several teeth.

The scene where Scrooge sees many, many lost souls out of his window is also pretty spooky, and the film as a whole carries the banner for cinematic adaptations and interpretations of Dickens' seminal festive spookfest forward most capably and with a great deal of aplomb.

THE FILMS

Christmas Ghosts A-Carolling

An All Dogs Christmas Carol 1998 USA 73mins (Animation)
Directed: Paul Sabella **Written**: Jymn Magon **Cast**: Ernest Borgnine (Carface), Dom DeLuise (Itchy/Ghost of Christmas Past), Sheena Easton (Sasha/Ghost of Christmas Present), Bebe Neuwirth

An American Christmas Carol 1979 USA 98mins
Directed: Eric Till **Written**: Jerome Coopersmith **Cast**: Henry Winkler (Benedict Slade), Cec Linder

Bah Humduck!: A Looney Tunes Christmas 2006 USA 46mins (Animation)
Directed: Charles Visser **Written**: Ray De Laurentis **Cast**: Joe Alaskey (Daffy Duck/ Sylvester the Cat/Marvin the Martian/Pepe Le Pew/Foghorn Leghorn), Bob Bergen (Porky Pig/Speedy Gonzales/Tweety Bird), Billy West (Bugs Bunny/Elmer Fudd), June Foray (Granny), Maurice LaMarche (Yosemite Sam), Jim Cummings (Taz [the Tasmanian Devil]/ Gossamer)

Beavis and Butt-head Do Christmas 1996 USA 50mins (Animation)
Directed: Mike Judge **Written**: Kristofer Brown & David Felton & David Giffels & Mike Judge & Joe Stillman & Guy Maxtone-Graham **Cast**: Mike Judge

Aka Beavis *and* Butt-head's Christmas Special

Blackadder's Christmas Carol 1988 UK 43mins
Directed: Richard Boden **Written**: Ricahrd Curtis & Ben Elton **Cast**: Rowan Atkinson (Blackadders), Tony Robinson (Baldricks), Miranda Richardson, Stephen Fry, Hugh Laurie, Robbie Coltrane, Miriam Margolyes, Jim Broadbent, Nicola Bryant

Brer Rabbit's Christmas Carol 1992 USA 60mns (Animation)
Directed & Produced & Written: Al Guest & Jean Mathieson

A Carol Christmas 2003 USA 92mins
Directed: Matthew Irmas **Written**: Tom Amundsen **Cast**: Tori Spelling (Carol), Dinah Manoff (Marla), William Shatner (Dr. Bob), Gary Coleman (Christmas Past), Nina Siemaszko

Carol for Another Christmas 1964 USA B&W 84mins
Directed: Joseph L. Mankiewicz **Written**: Rod Serling **Cast**: Sterling Hayden (Daniel Grudge), Eva Marie Saint (The Wave), Ben Gazzara (Fred), Steve Lawrence (Ghost of Christmas Past), Pat Hingle (Ghost of Christmas Present), Robert Shaw (Ghost of Christmas Future) Peter Sellers (Imperial Me), Britt Ekland (The Mother)

Carry On Christmas 1969 UK 50mins
Directed: Ronnie Baxter **Written**: Talbot Rothwell **Comedy Consultant**: Gerald Thomas **Cast**: Sid James (Ebenezer Scrooge), Charles Hawtrey (Spirit of Christmas Past/Angel / Convent Girl/Buttons), Barbara Windsor (Spirit of Christmas Present/Cinderella/Fanny), Bernard Bresslaw (Spirit of Christmas Future/Bob Cratchit/Frank N. Stein's Monster/ Convent Girl/Town Crier/Copper) Terry Scott, Hattie Jacques, Peter Butterworth, Frankie Howerd

Chasing Christmas 2004 USA 95mins
Directed: Ron Oliver **Written**: Todd Berger **Cast**: Tom Arnold (Jack Cameron), Andrea Roth (Present), Leslie Jordan (Past)

A Christmas Carol 1938 USA B&W 69mins
Directed: Edwin L. Marin **Written**: Hugo Butler **Produced**. Joseph L. Mankiewicz **Cast**: Reginald Owen (Ebenezer Scrooge), Gene Lockhart (Bob Cratchit), Kathleen Lockhart (Mrs. Cratchit), Leo G. Carroll (Marley's Ghost) June Lockhart (Belinda Cratchit – uncredited)

Aka Charles Dickens' A Christmas Carol

A Christmas Carol 1969 Australia/USA 46mins (Animation)
Directed: Zoran Janjic **Written**: Michael Robinson

A Christmas Carol 1971 UK 26mins (Animation)

Directed & Produced: Richard Williams **Executive Produced**: Chuck Jones **Cast**: Sir Michael Redgrave (Narrator), Alistair Sim (Ebenezer Scrooge), Michael Hordern (Jacob Marley), Melvyn Hayes (Bob Cratchit), Paul Whitsun-Jones, Diana Quick

A Christmas Carol 1984 UK/USA 101mins

Directed: Clive Donner **Written**: Roger O. Hirson **Cast**: George C. Scott (Ebenezer Scrooge), Frank Finlay (Jacob Marley), Angela Pleasence (Ghost of Christmas Past), Edward Woodward (Ghost of Christmas Present), Michael Carter (Ghost of Christmas Yet to Come), David Warner (Bob Cratchit), Susannah York (Mrs. Cratchit), Roger Rees, Caroline Langrishe, Lucy Gutteridge, Nigel Davenport, Joanne Whalley, Michael Gough, Liz Smith

A Christmas Carol 1984 France 90mins

Directed & Written: Pierre Boutron **Cast**: Michel Bouquet (Ebenezer Scrooge)

A Christmas Carol 1994 USA 48mins (Animation)

Directed: Toshiyuki Hiruma **Written**: Jack Olesker

A Christmas Carol 1994 UK 86mins (Ballet)

Directed: Kriss Rusmanis **Choreographed**: Massimo Moricone **Music**: Carl Davis **Cast**: Jeremy Kerridge (Scrooge)

A Christmas Carol 1997 USA 72mins (Animation)

Directed & Produced: Stan Phillips **Written**: Jymn Magon **Cast**: Tim Curry (Scrooge), Michael York (Bob Cratchit), Whoopi Goldberg, Ed Asner, Jodi Benson

A Christmas Carol 1999 USA 95mins

Directed: David Hugh Jones **Written**: Peter Barnes **Cast**: Patrick Stewart (Ebenezer Scrooge), Richard E. Grant (Bob Cratchit), Joel Grey (The Ghost of Christmas Past), Saskia Reeves, Trevor Peacock, Liz Smith, Celia Imrie

A Christmas Carol 2000 UK 75mins
Directed: Catherine Morshead **Written**: Peter Bowker **Cast**: Ross Kemp (Eddie Scrooge), Michael Maloney, Angeline Ball, Mina Anwar, Warren Mitchell, Liz Smith

A Christmas Carol: Being a Ghost Story of Christmas 1977 UK 58mins
Directed: Moira Armstrong **Written**: Elaine Morgan **Cast**: Michael Hordern (Scrooge), John Le Mesurier (Marley's Ghost), Bernard Lee (Ghost of Christmas Present), Patricia Quinn, Zoe Wanamaker, Christopher Biggins, June Brown, Tracey Childs

A Christmas Carol in Prose, or A Ghost Story of Christmas 1960 W. Germany B&W 110mins
Directed: Franz Josef Wild **Cast**: Carl Wery (Ebenezer Scrooge), Paul Arens (Charles Dickens)

Aka Ein Weihnachtshied in Prosa oder Eine Geistergeschichte zum Christfest

Christmas Carol: The Movie 2001 UK/Germany 77mins
(Animation & Live action)
Directed: Jimmy T. Murakami **Written**: Piet Kroon & Robert Llewellyn **Cast**: Simon Callow (Charles Dickens), Nicolas Cage (Jacob Marley), Kate Winslet (Belle), Jane Horrocks (The Ghost of Christmas Past), Michael Gambon (Ghost of Christmas Present), Rhys Ifans (Bob Cratchit), Juliet Stevenson (Mrs. Cratchit), Robert Llewellyn (Old Joe)

Aka Ein Weihnachtsmärchen

A Christmas Carol: *The Musical* 2004 Hungary/USA 97mins
(Musical)
Directed: Arthur Allan Seidelman **Written**: Lynn Ahrens (adapted from the stage musical written by her and Mike Ockrent) **Choreographed**: Dan Siretta **Cast**: Kelsey Grammer (Ebenezer Scrooge), Jane Krakowski (Ghost of Christmas Past/Streetlamp Lighter), Jesse L. Martin (Ghost of Christmas Present/Ticket Seller), Geraldine Chaplin (Ghost of Christmas Future/Blind Beggarwoman), Jason Alexander (Jacob Marley/Marley's Ghost), Jennifer Love Hewitt

Aka A Christmas Carol

A Christmas Carol 2009 USA 98mins (Animation)

Written & Directed: Robert Zemeckis **Produced**: Robert Zemeckis & Steve Starkey & Jack Rapke **Music**: Alan Silvestri **Cinematography**: Robert Presley **Edited**: Jeremiah O'Driscoll **Design**: Doug Chiang **Art Direction**: Greg Gabbana & Norman Newberry& Mike Stassi **Cast**: Jim Carrey (Scrooge/Ghost of Christmas Past/Ghost of Christmas Present/ Ghost of Christmas Yet To Come/Scrooge as a young boy/Scrooge as a teenager/Scrooge as a young man/Scrooge as a middle-aged man), Gary Oldman (Bob Cratchit/Marley/Tiny Tim), Colin Firth (Fred), Cary Elwes (Portly Gentleman #1/Dick Wilkins/Mad Fiddler/Guest #2/Businessman #1), Robin Wright Pen (Fan/Belle), Bob Hoskins (Mr. Fezziwig/Old Joe), Fionnula Flanagan (Mrs. Dilber)

A Christmas Cruella 1997 USA 22mins (Animation)

Directed & Produced: Victor Cook **Written**: Ken Koonce & Michael Merton

(Available on the video *Disney's Christmas Favourites*)

A Dickensian Fantasy 1933 UK B&W 10mins

Directed & Written: Aveling Ginever **Cast**: Lawrence Hanray

A Diva's Christmas Carol 2000 USA 90mins

Directed & Written: Richard Schenkman **Cast**: Vanessa Williams (Ebony Scrooge), Rozonda 'Chilli' Thomas (Marli Jacob)

Ebenezer 1997 Canada

Directed: Ken Jubenvill **Written**: Donald Martin **Cast**: Jack Palance (Ebenezer Scrooge), Rick Schroeder, Amy Locane

A Flintstones Christmas Carol 1994 USA 90mins (Animation)

Executive Produced: William Hanna & Joseph Barbera **Written**: Glenn Leopold

Foster's Home for Imaginary Friends: A Lost Clause 2005 USA (Animation)

Directed: Craig McKracken **Written**: Craig McKracken & Lauren Faust & Craig Lewis & Adam Pava

A Jetson Christmas Carol 1985 USA 22mins (Animation)
Executive Produced: William Hanna & Joseph Barbera **Written**: Marc Paykuss & Barbara Levy **Cast**: Mel Blanc

John Grin's Christmas 1986 Canada 60mins
Directed: Robert Guillaume **Written**: Charles Eric Johnson **Cast**: Robert Guillaume (John Grin), Roscoe Lee Browne (Christmas Past), Ted Lange (Christmas Present), Geoffrey Holder (Christmas Future), Alfonso Ribeiro, Kevin Guillaume, Melissa Hill-Guillaume

Aka Christmas

Karácsonyi ének 1964 Hungary B&W 46mins
Directed: Gyula Mészáros **Written**: János Csató **Cast**: Sándor Pécsi (Ebenezer Scrooge)

Karroll's Christmas 2004 USA 87mins
Directed: Dennis Dugan **Written**: David Schneider & Drew Daywalt
Cast: Tom Everett Scott (Allen Karroll), Wallace Shawn, Larry Miller

Leylenda de Navidad 1947 Spain B&W 70mins
Directed & Written: Manuel Tamayo (Castro) **Cast**: Jesús Tordesillas (Scrooge)

Little Orphan Annie: *A Very Animated Christmas* ????

Mickey's Christmas Carol 1983 USA 25mins (Animation)
Directed & Produced: Burny Mattinson **Written**: Burny Mattinson & Tony L. Marino **Cast**: Alan Young (Scrooge [McDuck]), Tony Allwine (Mickey Mouse [as Bob Cratchit])

Mr. Magoo's Christmas Carol 1962 USA 52mins (Animation)
Directed: Abe Levitow **Written**: Barbara Chain **Music**: Jule Styne **Lyrics**: Bob Merrill
Cast: Jim Backus (Mr. Magoo/Scrooge), Royal Dano (Marley's Ghost)

Ms. Scrooge 1997 USA
Directed: John Korty **Written**: John McGreevey **Cast**: Cicely Tyson (Ebenita Scrooge), Katherine Helmond

The Muppet Christmas Carol 1992 USA 89mins
Directed & Produced: Brian Henson **Written**: Jerry Juhl **Executive Produced**: Frank Oz
Cast: Michael Caine (Ebenezer Scrooge), Kermit the Frog (Bob Cratchit), Miss Piggy (Emily Cratchit), Fozzie Bear (Fozziwig), The Great Gonzo (Charles Dickens), Rizzo the Rat

Natale a casa Deejay – A Christmas Carol 2004 Italy 76mins
Directed & Written: Lorenzo Bassano

Aka A Christmas Carol

Scrooge 1935 UK B&W 78mins
Directed: Henry Edwards **Written**: H. Fowler Mear **Cast**: Sir Seymour Hicks (Ebenezer Scrooge)

Scrooge 1951 UK B&W or Colourised versions 86mins
Directed: Brian Desmond-Hurst **Written**: Noel Langley **Edited**: Clive Donner **Cast**: Alastair Sim (Ebenezer Scrooge), Michael Hordern (Jacob Marley), Mervyn Johns (Bob Cratchit), Hermione Baddeley (Mrs. Cratchit), Jack Warner, Kathleen Harrison, George Cole, Patrick Macnee, Miles Malleson, Ernest Thesiger, Hattie Jacques, Noel Howlett

Aka A Christmas Carol (in USA)

Scrooge 1970 UK 118mins (Musical)
Directed: Ronald Neame **Executive Produced & Music & Lyrics**: Leslie Bricusse **Titles**: Ronald Searle **Choreographed**: Paddy Stone **Cast**: Albert Finney (Ebenezer Scrooge), Alec Guinness (Jacob Marley), Edith Evans (Ghost of Christmas Past), Kenneth More (Ghost of Christmas Present), Paddy Stone (Ghost of Christmas Yet To Come), Michael Medwin, Laurence Naismith, Anton Rodgers, Roy Kinnear, Gordon Jackson, Geoffrey Bayldon

Scrooged 1988 USA 101mins

Directed: Richard Donner **Written**: Mitch Glazer & Michael O'Donoghue **Cast**: Bill Murray (Frank Cross), Karen Allen, John Forsythe, Bobcat Goldthwait, David Johansen, Carol Kane, Robert Mitchum, Michael J. Pollard, Alfre Woodard, Jamie Farr, John Houseman, Buddy Hackett, Lee Majors, Mary Lou Retton

Skinflint: A Country Christmas Carol 1979 USA 120mins

Directed: Marc Daniels **Written & Music & Lyrics**: Mel Mandel **Cast**: Hoyt Axton (Cyrus Flint), Mel Tillis, Lyn Anderson, Larry Gatlin, Tom T. Hall, Martha Raye, The Statler Brothers, Barbara Mandrell, Dottie West

The Stingiest Man in Town 1978 USA 49mins (Animation)
Directed & Produced: Arthur Rankin Jr. & Jules Bass **Written**: Romeo Muller **Cast**: Walter Matthau (Ebenezer Scrooge), Tom Bosley (Narrator/B.A.H. Humbug Esq.), Robert Morse

For a fuller account of all the big screen and small screen adaptations of Dickens' A Christmas Carol up to 1998 see the book *A Christmas Carol and its Adaptations: Dickens Story on Film and Television, Fred Guido, McFarland & Co., 1999*. The author has identified almost 200 of them!

CHAPTER 3

Pre-70s Merry Mistletoe Monstrosities

Even with the advent of 'talkies,' the Wall Street Crash, the Great Depression, a world taken to the brink by World War II and the dropping of the Atomic Bomb – heralding the advent of the Atomic Age; even with the Cold War, the Korean War and the Vietnam War; through a time when their seemed to be precious little 'Peace on Earth and Goodwill Toward Men', there were precious few decidedly dark or blood-spattered tinsel-tinged movies produced. Humankind – especially the Christian cohort – wasn't yet ready to start slaughtering Santa's reindeer! The world would have to wait a while yet for that...Until the drug-drenched 60s of the Summer of Love, Flower Power, world-shaking assassinations and the Manson Family murders segued into the conspiracy-conscious, Watergate-wounded, platform heels and flares wearing, discontented, discotequing 70s![48] Then, when love was no longer free, but before sex had a sting in its tail; when the Women's Movement moved and rock rolled on; as the House of Hammer made like the House of Usher and collapsed in upon itself – then the cinema-going audience of baby boom thrill-seekers was ready for some big-budget sci-fi (as evidenced initially by the success of films like Stanley Kubrick's ***2001: A Space Odyssey*** and Franklin J. Schaffner's ***Planet of the Apes*** – both 1968) and some kick-ass horror (even if the ass that was kicked was a friendly, fat one in a red suit trimmed with white fur!).

But we will get to that... For now, let us drift back through the decades and work our way forwards towards the 70s, seeing what weird, wacky and wonderful (even if not particularly scary) tinsel-tinged treats turned up prior to, what some seemed to fear would be a deca-dent decade of debauched delinquency. I warn you now, it will be a bit of a desert with very few oases and there will be scant pickings in terms of terror along the way; but we might pick up a few witches and warlocks, ghosts and spirits, and other occasional oddities if we look hard enough. OK, so they're usually so unscary, you wouldn't even mind being caught in a Christmas clinch with them at the office party (hence the title of this chapter)...but as

48. Or if you prefer, Until the drug drenched 60s when Lady Chatterley was allowed to Love, the Mersey beat, London swung, minis could be cars or skirts and a train robbery was Great segued into the Droog imitating, skinheaded, football violence of the bin-men striking, 3 day week, fuel shortage 70s.

times changed they would eventually pave the way for the real Ho-ho-horrors of the 1970s onwards. So cute, furry little dwellers of the almost desolate desert they may be, but hey, just think of them as Merry Meerkats – they're always entertaining to watch. And it is a relatively short sojourn...

And the first offering that pops its head up over the somewhat desolate sandy dunes is, believe it or not, a Laurel and Hardy opus from 1934! In their take on the Victor Herbert and Glen MacDonnough operetta starring mainly Fairytale characters, **Babes in Toyland**[49], Santa Claus makes an appearance (even though it is only July) to see how his Christmas order is progressing Toymakers Stannie Dee and Ollie-Dum (kind of like Tweedle-Dumb and Tweedle-Even-Dumber!) have been working on the order and proudly show off the hundred 6-foot toy soldiers they have produced...but (you guessed it!) Ho-ho-ho-ing through his beard, Santa confirms that they've got it completely wrong and that he ordered 600 1-foot soldiers! However, when they become suspicious that the Victorian melodrama villain-like Silas Barnaby is in possession of Mother Goose's mortgage (and is threatening to throw her and all of her children out of their house shaped like a shoe unless Bo-Peep marries him), the hapless heroes plan to utilise the fact that there are still 5 months till Christmas as part of their plan to secure the deeds. They pull the old Trojan horse trick with a festive twist. They wrap Ollie up in a Christmas present and deliver it to Barnaby's, knowing that he won't be able to open it till Christmas, which will give Ollie chance to sneak out in the night and steal the mortgage!!! Naturally the whole plan goes tits up!

But this movie deserves a mention here because Barnaby, through Machiavellian machinations, has had Bo-Peep's suitor, Tom-Tom the Piper's Son, banished from Toyland to Boogeyland, the dark demesne of the Boogeymen. These look like a cross between the native islanders in the previous year's **King Kong** and fanged gorillas in grass skirts! And they live in a dark swampy land outside the walls of Toyland and inhabit the cavernous catacombs below the city. And though adults are likely to find the whole thing a real hoot (including I suspect the now incredibly dated songs), the Boogeymen might just prove a bit scary for sensitive tykes. Still the film is enormous fun with all the usual Stan and Ollie tomfoolery and an excellent battle scene between Boogeymen and Toylanders at its climax (in which the harebrained halfwits' hundred 6-foot soldiers prove a real boon!).[50]

49. Aka *Laurel and Hardy in Toyland, March of the Wooden Soldiers, Wooden Soldiers* and *Revenge is Sweet*

50 Other versions of this tale followed. In 1961 a Disney Musical with a new score starring TV Mouseketeer Annette Funicello who made several films with Frankie Avalon; singing teen idol Tommy Sands; Ray Bolger who played the Scarecrow in *The Wizard of Oz (1939)*, Ed Wynn who everyone remembers as Uncle Albert from *Mary Poppins (1967)* whose inability to stop laughing sends him floating to the ceiling, and Tommy Kirk. In 1986 a made-for-TV movie with Drew Barrymore, Richard Mulligan, Eileen Brennan, a young Keanu Reeves, and a not so young Pat (Mr Miyagi in *The Karate Kid (1984)*) Morita was directed by Clive Donner (who edited *Scrooge (1951)* and directed *A Christmas Carol (1984)*). And in 1997 an animated feature was produced with character vocalisations by Lacey Chabert, Christopher Plummer, Jim Belushi and Bronson Pinchot. But none had any real scares or chills.

And from Boogeymen to ghosts... 1940's B&W feelgood feature **Beyond Tomorrow** (aka **Beyond Christmas**) featured three of them – though not to start with. It all starts out with three elderly, wealthy bachelor gents (played by Harry Carey, Charles Winninger and the redoubtable C. Aubrey Smith) who have been stood up for dinner on Christmas Eve throwing their wallets out of the window into the snow to test human honesty in the season of goodwill. And the young man and woman who return their wallets they invite to dinner and sort of adopt. But when the three old men die (after failing to take heed of warnings from their spooky houseguest played by Maria Ouspenskaya – the gypsy in **The Wolf Man (1940)**) their ghosts return to try and help the young couple fall in love and marry.

There's nothing scary here (overt sentimentality is rather the order of the day), but there are some nifty early double-exposure effects *a la* the **Topper** films, with the ghosts appearing transparent on screen though they are invisible to all the characters around them. It's old-fashioned; it's complete holiday hooey; it's sugary enough to send a diabetic into a state of hyper-glycaemia from 50 paces; but it's very entertaining if you like this sort of movie. I guess it's a kind of kissing cousin to festive 'angel' flicks like **It's A Wonderful Life (1946)**, which I waxed on about at some length in the introduction so won't repeat myself here, and **The Bishop's Wife (1947)**, in which Cary Grant plays a heavenly guardian called Dudley who is sent down to earth on a mission to sort out Bishop Brougham (David Niven), his marriage (though the angel falls for the wife who is played by Loretta Young) marriage, his church and his faith. Dudley certainly goes about this in an unexpected manner; with the audience (like the Bishop himself) never quite sure just how pure and holy the twinkle in his eye actually is when he looks at the wife!

The next film I want to mention is neither scary, weird, nor particularly wacky at all ("So why are you even mentioning it?" you might ask. Well...) It is a French film from 1941 – yes, made during the war...in Vichy France, under German occupation. It was the first film the Nazis allowed to be produced in Vichy France, and it does have a great title: **L'Assassinat du Père Noël** (aka **The Killing of Santa Claus** in the UK and **Who Killed Santa Claus?** In America). There is no onscreen horror – the story is a whodunit about the murder of a globe-maker who always plays Santa Claus at Christmastime in an Alpine town. The horror comes from the realisation that Harry Baur, a Yiddish actor, was taken in to custody by the Nazis shortly after release of this, his penultimate movie, and reportedly died at the hands of the Gestapo. Sometimes off-screen horrors far exceed those seen onscreen!

But let's leave all that behind us and leap forward just a few short years...and across the pond to Hollywood. There, in 1944, Val Lewton, famed producer and *auteur*[51] of low budget, highly intelligent, extremely atmospheric B&W horror films for RKO with lurid titles like **Cat**

51. This term, which sprang out of French New Wave cinema in the 1960s means 'author' or person most singly responsible for the unity of style, tone, look and feel of a film in what is usually a collaborative creative process. Understandably, the term is most often associated with a film's director, who normally has the most hands-on control of the shooting process. And the French critics and filmmakers who proposed the idea of a recognisable, individual controlling or guiding creative hand, did so with an agenda; because they wished to promote the idea of film as art rather than as commercial factory-made (even if that was Hollywood Dream Factory made!) product – a predominantly commercial undertaking.

People (1942), I Walked with a Zombie (1943), The Body Snatcher (1945) and **Isle of the Dead (1945)**, unleashed an equally lurid-sounding but highly unusual sequel on the cinema-going public: **The Curse of the Cat People**.

Although **The Curse of the Cat People (1944)** was co-directed by the little-known Gunther von Fritsch and the now much better known directorial debutante Robert Wise[52], the single most influential artistic hand in the film's whole look and feel is undoubtedly that of very much hands-on producer Lewton. The earlier **Cat People (1942)**, which he produced and which was directed by Jacques Tourneur, was a suspenseful psychological horror, in which Irena, a woman of Serbian origin living in modern America (played by beautiful French actress Simone Simon[53]), is afraid that she bears an ancient curse peculiar to her people – that, when sexually aroused, she will turn into an uncontrollable wild big game cat and have to kill before she can metamorphose once again into a human! She is therefore understandably reticent about falling in love and consummating her relationship. But a straight-thinking all-American chap, Oliver Reed (played by Kent Smith), falls for the exotic beauty and pooh-poohing all her beliefs and fears, marries her anyway...only to discover that his beautiful bride's neurosis isn't that easily dismissed.

The film, with a Written by DeWitt Bodeen (who would also write the Written for **The Curse of the Cat People**) skilfully creates an atmosphere of dread and foreboding, and indeed it was the producer's wish that Irena's actual condition – whether she did become a post-coital panther or not – never actually be resolved. He wished to maintain the tension between the potential supernatural explanation (the metamorphosis) and a possible psychological one (the fear drives Irena to act irrationally) and produce only the effects of her turning into a panther, thus maintaining viewer ambivalence and unease. But, not for the only time in his career, studio execs, not realising exactly what 'the property' was or how it should work, and nervous at having no visible onscreen monster *a la* Universal's classic **Dracula** or **Frankenstein** Monster from the previous decade, or their **Wolf Man** from the year before, exerted pressure on the filmmakers to include shots of an actual black panther in the scene where a friend of Oliver's purposely arouses Irena to prove that her fears are unfounded and she attacks and kills him. This concretised the supernatural explanation. (But just watch the swimming pool sequence in which Irena's love rival, Alice (played by Jane Randolph), gets frightened half out of her wits when the lights go out to see how unnecessary this was! The exemplary use

52. Whose credits as a director include *The Day the Earth Stood Still (1951)*, *The House on Telegraph Hill (1951)*, *West Side Story (1961)*, *The Haunting (1963)*, *The Sound of Music (1965)*, *The Andromeda Strain (1971)*, *Star Trek: The Motion Picture (1979)*), and who had edited *Citizen Kane (1941)* and *The Magnificent Ambersons (1942)* for Orson Welles.

53. Who starred alongside Jean Gabin in Jean Renoir's *La Bête Humaine (1938)*

of shadow and light, sound and performance to generate a palpable atmosphere of terror without requiring recourse to shots of an actual big game cat testify to this.[54]

These external tinkerings notwithstanding, **Cat People** is rightly regarded as a genre classic, but the sequel **The Curse of the Cat People** remains little known and certainly under-appreciated. This is probably because most viewers expect it, like most sequels, to continue in very much the same vein as its progenitor (an expectation compounded by its lurid title). But this sequel most certainly does not do that.

It features the same main stars and characters, but centres this time on the daughter of Oliver and Alice (who married following the death of Irena in the original film). Young Amy (beautifully played by child actor Ann Carter) is a lonely, sensitive girl who has an imaginary (or is she?) friend – Oliver's previous wife Irena. Amy's inability to tell reality from fantasy concerns her parents[55], and although Amy is not a blood relative of Irena's, her father seems to think that she may develop a similar 'curse' or psychological disorder/inability to conduct 'normal' human relationships.

But as well as little Amy's troubles with her own parents, she also finds herself caught in the midst of another uneasy parent-child conflict in the short 70-minute running time of this dense bobby-dazzler, when she befriends an elderly ex-actress neighbour who lives in the neighbourhood's scary, gothic house[56]. This old woman lives with her daughter, but claims that she is an impostor and that her real daughter died many years before. The 'daughter' is (understandably) incredibly frustrated, hurt and upset by the rejection of the 'mother' who is dependent upon her...and this is multiplied when she perceives little Amy as usurping the old woman's affection, which she sees as rightfully hers...potentially placing Amy in harm's way at the hands of an emotionally imbalanced adult...although this threat is beautifully overcome in the film.

"What has all this to do with Christmas?" you may well ask. Well, the filmmakers do utilise the season and the connections it has in most viewers' minds with family, love and caring – and possibly even sacrifice and forgiveness – as the movie builds to its climax. It is during the celebration of Christmas – a time when adults encourage youngsters to believe in a present-giving fantasy friend! – with the virgin white snow thick on the ground, that young Amy ex-changes gifts with her 'friend' on Christmas Eve while her parents entertain carollers. Amy gives Irena (who looks absolutely ravishing and radiant in a medieval style dress with sparkling stars and a white hooded cape) a brooch shaped like shooting stars; and Irena transforms the

54. And if the viewer is unsure to the end whether Irena is the subject of a supernatural curse or affliction, then not only is it more scary because potentially anybody could suffer from such delusions; but it becomes even more unsettling as the fear can seem contagious...If Irena's affliction is psychological, then her love rival Alice's terror in the swimming pool is also a product of her own (guilty?) mind.

55. Oliver says she has "too many fancies and not enough friends" and likens her fantasies to Irena's.

56. Which every neighbourhood seems to have – and like most, the children of this neighbourhood believe that a witch lives there!

garden into a sparkling wonderland for Amy's present. Amy also takes a gift to the old lady in the 'haunted' house on Christmas Day, making her Christmas "a very happy one."

However, when the truth about the identity of her 'friend' emerges on 12th Night as the family dismantles their Christmas tree, Oliver punishes Amy with her first spanking when she will not accept that her imaginary friend doesn't exist and later Amy runs away into the woods in a snowstorm trying to find Irena who has explained her genesis and taken her leave of the child. She ends up at the 'haunted' house of her equally dysfunctional neighbours (whose own problems derive from an inability to tell fantasy from reality or accept the truth.

But Amy does not realise just how much at risk she is, until the old lady dies on the stairs and the morbidly jealous daughter who has threatened to kill the youngster looms into view. Unlike its predecessor, however, (where the balance was spoiled by studio meddling) this film manages to maintain the ambivalence between supernatural or preternatural and the psychological explanations of events.

Anyway, love it or hate it (though the only reason I can see for the latter would be the film's not meeting your expectations, probably derived from the nature of the title and the inconsistency of its generic style with that of its progenitor!), this film remains a brilliantly realised evocation of youthful perceptions, especially surrounding alienation and divergence from the social norm. Be warned, it is definitely *not* a 'horror film' *per se*, but it is a completely compelling fantasy that explores some of the themes thrown up by its forebear in a completely different and unexpected way. It is an interesting, enchanting, endearing and beautifully realised piece of filmmaking.

Flitting back across the North Atlantic to wartime Britain (albeit the close of WWII), we *do* actually come across a full-blown classic unequivocally of the horror genre. It was produced by Ealing Studios – a studio usually and rightly associated with a series of wonderful parochial British comedies like ***Passport to Pimlico (1949)***, ***Kind Hearts and Coronets (1949)***, ***The Lavender Hill Mob (1951)*** and ***The Ladykillers (1955)*** – but this brilliant portmanteau or compendium horror film comprised of several short stories all linked together[57] by an overarching bridging tale, deserves to be recognised also as one of that studios finest achievements.

The 102-minute long B&W chiller ***Dead of Night*** boasted six segments (including the linking narrative); four directors (directing the different story segments); three writers (John Baines, Angus MacPhail and additional dialogue from T.E.B. Clarke) who adapted stories from H.G. Wells and E.F. Benson as well as developing their own material; two Associate Producers; and one producer, Michael Balcon. (But not a partridge or a pear tree in sight!).

It is the tale of an architect (played by Mervyn Johns) who is called to a gathering at an old country house one weekend by the owners who wish to have some alterations made. The architect has been suffering from nightmares, which he can only remember snippets of, but

57. A style of horror film that would find popularity in the late 1960s and early 1970s, particularly from the Amicus Production Company, who produced titles like ***Dr Terror's House of Horrors (1965)***, ***The House that Dripped Blood (1971)*** and ***Tales from the Crypt (1972)***…of which, more later!

upon first seeing the house he gets a strange sense of déjà vu, which is only compounded when he meets the houseguests. A psychiatrist who is present pooh-poohs the architect's fears – even when he is able to predict certain occurrences with uncanny accuracy – but the other guests are more inclined to believe in at least the possibility of supernatural agencies, and each relates a tale of their own experiences (though one of these is a tale of experiences supposedly related to the teller by a third party, which in fact turns out to be a comical aside intended to lighten the atmosphere. This is the tale of two golfing buddies – played by Basil Radford and Naunton Wayne, who so memorably played the cricket enthusiasts in Hitchcock's **The Lady Vanishes (1938)** – and the lady who cannot choose between them, so they play a round of golf for her hand and the loser commits suicide. Only the winner cheats, so his ex-buddy comes back to haunt him in the name of fair play! This segment is based on an original story by H.G. Wells and is one of two segments that were originally cut for US release!…The other was the 'Christmas Party' segment!).

It is perhaps not surprising that the 'Christmas Party' segment was cut along with the comical 'Golfing Story' segment (directed by Charles Crichton) for release of the film in America: it is probably the least scary of all the 'straight' tales of terror in the film. Perhaps this is partly because it is related by the youngest member of the group, a teenager called Sally (played by Sally Anne Howes, Truly Scrumptious in **Chitty Chitty Bang Bang (1968)**. But nonetheless, it does strike a chord as representing one of the more common kinds of tales of ghostly encounters – one in which the person experiencing the contact has no idea at the time that it is a ghost they are encountering, and only come to a full realisation later.

In the 'Christmas Party' segment, directed by Alberto Cavalcanti, Sally recounts how, at a Christmas Party in a large country pile recently purchased by the family of a friend, she encountered the ghost of a young child. All the children and youths at the party, which is being hosted in the main baronial living room around a beautifully decorated Christmas tree, are in fancy dress. They decide to play a particular version of hide-and-seek called 'Sardines' in which one person hides, then the others join them as they find them cramming into the hiding place like sardines in a tin. It is during this game, that Sally wanders off to an area of the house where she encounters a young boy crying in a bedroom that is decorated in an old-fashioned manner. The boy wears old-fashioned clothes too, but neither arouses any suspicion as it is an old house and all of the children are in fancy dress.

The youngster in the bedroom is upset and tells Sally he cannot settle because his older sister has threatened to kill him. But he soon settles down with Sally's comforting presence, and it is only after he has dropped off to sleep that Sally returns to the Christmas party in the main hall and recounts her tale. Moreover, it is only when she informs her hosts of the child's name, which he told her as part of their conversation, that she learns the child was murdered in the house by his elder sister over one hundred years before!

Christmas has no real special meaning here – save for its ironic value as the time of peace, love, Goodwill and familial bonding, against which the tale of familial murder is told – and it plays no part in any of the other tales; all of which are decidedly more atmospheric and spookier. Probably the most well remembered and influential of these, also directed by

Alberto Cavalcanti, stars Michael Redgrave as a ventriloquist whose dummy seems to have a life of its own. This tale has inspired several imitators.

The other tales include one about a woman buying her fiancé a mirror in which he sees the reflection of another room entirely where a murder has been committed and seems to be becoming possessed of the character of the murderer. This was directed by Robert Hamer and starred Googie Withers and Ralph Michael. There is one about a racing driver who, while recovering from a crash in hospital, receives a vision of a hearse driver whom he later recognises as the conductor of a bus he is about to board, thus saving his life when the bus, which he refuses to enter, crashes over a bridge. This segment is directed by Basil Dearden and stars Anthony Baird as the racing driver and Miles Malleson as the hearse driver/bus conductor.

Dearden also directed the superb linking narrative, which sees the whole film spin-off into a surreal nightmarish vision of chaos and murder, prior to the whole indeed being revealed as the architect's nightmare when he wakes up and receives the call inviting him to the country house; the whole film apparently zooming around a Mobius strip[58] of supernatural horror. Although **Dead of Night** is not a 'Christmas Movie' and only features one short section that is related to Christmas in any way, it is nonetheless the first out-and-out *horror* film that I am aware of that actually wilfully utilises the associations of Christmas to deliberately further the impact of its horror...albeit only fleetingly in one of the weakest of its quintuplet tales of terror. And for any viewers who might not have seen the 'Christmas Party' segment, which was deleted along with the comical 'Golfing Story' segment for the film's original American release, copies of the movie in its original entirety are now readily available on DVD. And although naturally a little dated in some ways, this classic, seminal horror movie has nonetheless stood the test of time remarkably well, with Redgrave's astonishing performance in the 'Ventriloquist's Dummy' segment probably representing the best of his illustrious career.

And now from the sublime to the ridiculous – or maybe sublimely ridiculous, depending upon your tastes. Skipping back to post-war Hollywood, 1950 witnessed the release of a very strange but amusing little 87-minute B&W fantasy called **The Great Rupert** (aka **The Christmas Wish**). This merry little sprig of mistletoe of a movie was produced by George Pal – the producer of sc-fi classics like **Destination Moon (1950)**, **When Worlds Collide (1951)**, **The War of the Worlds (1953)** and **Conquest of Space (1955)** (of which, more shortly!) and **The Time Machine (1960)**. Its director was Irving Pichel, an actor-cum-director who debuted in the directing chair in 1932 with the horror classic **The Most Dangerous Game (1932)**[59] (aka **The Hounds of Zaroff**). A character actor from the 1930s through the early 1950s Pichel also makes a cameo appearance in **The Great Rupert** as a 'Puzzled Pedestrian'.

58 .A Mobius strip is a surface with only one surface. Take a strip of paper and form it into a loop. You can run your finger along the outer surface of the inner surface. But if you put a twist in your paper loop, when you run your finger along its surface, the twist ensures that your finger covers inside and outside without ever being removed.

59. This was Pichel's directorial debut

The film stars the old 'Schnozz' himself, Jimmy Durante (who manages to squeeze in a song or two; including his own unique rendition of 'Jingle Bells') and a very beautiful young Terry Moore, **Mighty Joe Young**'s squeeze from the previous year, here being upstaged by another stop-motion animated furball – only this time somewhat smaller; the eponymous nut-muncher, Rupert the squirrel (who was billed as playing himself in the cast list! And the animation is wonderful (in that endearingly clunky old stop-motion fashion).

It's definitely not scary (and is not meant to be), but is an enchanting and decidedly wacky little Christmas fantasy in which Durante's character's low-rent showbiz family rent a dilapidated room from a miserly old skinflint and chance upon a Christmas miracle...or so they think! ...When the mother's prayers are apparently answered by cash falling from on high, only trouble is, rather than coming from the beneficence of a heavenly benefactor, the cash is in fact their landlord's! He squirrels it away surreptitiously behind the skirting board in his bedroom, but in so doing, inadvertently deposits it in the nest of house proud Rupert (the trained squirrel, who has settled there when his partner and trainer lets him go in the park, there apparently being no demand for a fluffy-tailed, improbably cute novelty act). So Rupert scoots it straight on out the other side of his new home, where it descends like Manna (or should that be Mammon?) from Heaven into the lap of the poor circus-vaudevillians who were associates of his trainer!

I won't rabbit on any further about what happens to the squirrel and his beneficiaries (one rodent per review is enough!)...I'll let you find out for yourselves what happens. Suffice it t say that though, that although it's old and hokey and has more cheese than a Christmas cheese platter, this unassuming little fantasy is also great fun and likely to appeal to kids as much as adults because of cute Rupe, the bushy-tailed binger of abundance. And so onto something of a classic year for pre-1970s festive flicks with a Psychotronic twist: 1955.

1955 saw the release of no fewer than three Hollywood films I want to mention. And while none of them are likely to raise the hairs on the back of your neck, all three are certainly worth a watch. The first one is the previously mentioned **Conquest of Space**, (aka **Mars Project**) produced by George Pal and directed by Byron Haskin (who also directed **The War of the Worlds** for his pal Pal). At the time of its release **Conquest of Space** won lots of plaudits for its technically believable vision of future space travel (adapted as it was by Philip Yordan, Barré Lyndon and George Worthing Yates from a book by Chesley Bonestell and German rocket scientist Willy Ley who fled Nazi Germany in 1935. And although he was uncredited, the film is also somewhat based on ex-German rocket scientist and designer of the V-2, Vernher von Braun's own book *Mars Project*.

This notwithstanding, the film now seems incredibly dated and some of the 'believable' space paraphernalia laughable – perhaps not least putting in charge of the mission to Mars a military hard nut who is so religious he could be the buckle on the bible belt! He even tries to sabotage the mission; sure that humankind should not be invading God's green acres (or cold, black space). As a result of this bigoted busybody's chicanery, the crew of the rocketship that lands on Mars are stranded, too low on water to survive waiting for their next window of opportunity to blast off back to earth.

But what do you know – even on Mars Christmas miracles occur!...

As the stranded men realise that it is the festive season and cobble together some quick, spirit-lifting festive decorations, one of them gazes out of the spaceship window on Christmas Day and what should he see to the accompaniment of 'God Rest Ye Merry Gentlemen' on the soundtrack?.... Why snow, of course! *Snow?!* Yes, snow. On Mars! Their water troubles are over; the men are saved. Now with plenty of good old H2O to last them until their blast-off window of opportunity, man's first venture to a neighbouring planet can be a success, instead of a corpse-riddled failure instigated by its own deluded, bible bashing commander.

I think there are probably a couple of audiences for this 81-minute Technicolor treat of an early space-opera: those interested in the history of space flight and its depiction in popular cinema; and those who like laughing at dated, cheesy old sci-fi rocket trip flicks! Still, for anyone who is into more traditional filmic Christmas fare, like **White Christmas (1954)** for instance, Rosemary Clooney does make an appearance. And a singing one at that! ...On the film clip screened on board the earth-orbiting space station prior to the launch of the Mars mission space flight. Nothing at all to do with Christmas, but I thought that it was worth mentioning.

I have no idea whether the sight of snow on Mars had anything to do with inspiring the makers of that later rib-tickling Christmas space saga **Santa Claus Conquers the Martians (1964)**, but it's snowy Martian Christmas scene certainly warrants it a mention here anyway.

The second of the 55-three I want to mention is **Night of the Hunter**; a lyrical, poetic, dark, suspenseful *noir*-ish thriller with religious overtones; probably unlike any other film you have ever seen. Directed by British actor Charles Laughton (Oscar winner as Best actor for **The Private Life of Henry VIII (1933)**, Captain Bligh opposite Clark Gable's Fletcher Christian in **Mutiny on the Bounty (1934)**, Quasimodo opposite Maureen O'Hara's Esmerelda in **The Hunchback of Notre Dame (1939)**), **Night of the Hunter** was the only film Laughton is credited with directing – probably thanks to the lukewarm critical reception it received and its poor performance at the box-office. Which is a real, *real* pity, because it is absolutely superb, and has gone on to reap critical acclaim and cult status. [60]

Beautifully shot by Stanley Cortez, utilising the deep-focus, high contrast B&W to reinforce the themes of good vs. evil (hark back in homage to the silent cinema of D.W.Griffiths – reinforced by casting Lillian (**Birth of a Nation (1915)/Broken Blossoms (1919)/Way Down East (1920)/The Wind (1928)**) Gish in a pivotal role – and the angular sets of German Expressionist cinema, as well as utilising the ultra-modern like helicopter shots) **The Night of the Hunter** is a sophisticated, tense, suspenseful, idiosyncratic, lyrical, poetic, in some ways experimental, expressionistic and avant-garde, film with an absolutely unforgettable villain in itinerant, self-proclaimed "Preacher" Harry Powell – probably one of the best performances in Hollywood legend Robert Mitchum's career (though all the performances are excellent – including the children's).

60. Apparently *New Yorker* film critic Pauline Kael once described it as being one of the scariest movies ever made.

Though the film is not a 'Christmas Movie' (as we might understand or categorise them nowadays) *per se*, it does feature a short coda set at Christmastime, which crystallises some of the films central themes. Set in the Depression era South and based on a popular best-selling debut novel by Davis Grubb (which was itself inspired by real life characters and events) and adapted by a famed author and screenwriter James Agee, the film sees an impoverished farmer, Ben Harper – played by Peter (**Mission: Impossible**) Graves – get involved in bank robbery and murder to try and provide a future for his young children John and Pearl. With the police hot on his trail, Ben manages to hide the $10,000 dollars ill-gotten gains from his robbery in his daughter's doll and make the children swear never to reveal its whereabouts – not even to their mum - before he is shot and arrested.

Awaiting execution, Ben shares a prison cell with an itinerant, self-proclaimed "preacher", Harry Powell (Robert Mitchum on truly chilling charming form), whose deviant reading of the holy book and personal relationship with God (the religion he professes is one he and God "worked out between" themselves!) actually covers his amorality (he is jailed for stealing a car) and homicidal tendencies – especially towards women, whom he seems readily able to charm (God keeps directing him to widows with cash, whose throats he cuts to further his 'ministry'!). Powell tries his best to charm Ben into disclosing the hiding place of the stashed cash, but to no avail, and Ben takes his secret with him to the gallows. So when preacher Powell is released, he insinuates himself into widow Willa Harper's life and community, eventually marrying and murdering her in his attempt to get his tattooed hands on the stolen cash.

When the children are finally forced to reveal the hiding place and realise the full extent of their own peril, they make a dash down river in a row boat, but the determined pseudo-clergyman follows doggedly like some inescapable, unstoppable force; a juggernaut of doom. (His relaxed, easygoing but diabolical approach is memorably heralded by his singing 'Leaning on the Everlasting Arm' – reflecting his own warped cock-sureness and faith and cleverly warping this religious song's original meaning. Indeed the use of songs – religious, children's – and music throughout this production makes it a truly memorable audio-visual experience!).

The children are eventually taken in by a kind but in some ways stern old widow Rachel Cooper – beautifully played by silent screen legend Lillian (***Birth of a Nation (1915)/Broken Blossoms (1919)/Way Down East (1920)/The Wind (1928)***) Gish – who has adopted a whole brood of lost little Depression-era chicks and whose down-home religious convictions and common sense attitude enable her to be the only woman in the film to see right through the charming surface of preacher Powell when he shows up seeking his lost lambs. Rachel protects the children from the 'ravening wolf' false prophet, sitting in her rocking chair in silhouette like Whistler's Mother – but cradling a shotgun! – while the persistent preacher leans on the fence singing his creepy signature song awaiting his chance...and even shooting him in the rear, causing this wolf to squawk and scatter like a frightened chicken when he does finally enter the house!

Following his arrest and conviction, a lynch mob gathers in the nearby town at Christmastime, but Rachel leads her brood of children away like a quail leading a line of

chicks. Then, safe and secure back in the haven of her snow covered home, simply decorated and with a Christmas tree strung with popcorn, the children give their good, kind and guiding mother-mentor the token Christmas presents they have managed to acquire for her...and she points them in the direction of the gifts she has wrapped for them. This short coda (disliked by many viewer, it would appear), underscores one of the central themes of the film, which was actually introduced with shots of Rachel superimposed against a starry night sky talking to her children (their own heads similarly superimposed – marking the whole as a tale with a much broader significance than that of just John and Pearl's story).

"Lord," Rachel muses aloud, stirring a pot of food on the stove, "Save the children. You'd think the world would be ashamed to name such a day as Christmas for one of them and then go on in the same old way. My soul is humbled when I see the little ones accept their lot. Lord save the children. The wind blows and the rain's a-cold. Yet they abide...They abide and endure." It is a call to arms (and maybe to alms – though the robbery money turns out to be unimportant; when John sees Powell being arrested like his father was, he spills it from the doll offering it up to his persecutor – it is Rachel's nourishing love that counts in the end).

But though *The Night of the Hunter* has a definite edge of dark humour running through its memorably chilling veins, the third of the 55-three – a decidedly dark Technicolor comedy set at Christmastime – takes the biscuit (or should that be mice pie) on the humour front. Directed by Oscar Winner[61] Michael (*The Charge of the Light Brigade (1936)*, *The Adventures of Robin Hood (1938)*, *Angels With Dirty Faces (1938)*, *Casablanca (1942)*, *Yankee Doodle Dandy (1942)*, *Mildred Pierce (1945)*, *White Christmas (1954)*) Curtiz and adapted from a French stage play, [62] *We're No Angels* is a hugely entertaining dark delight.

It's storyline sees three prisoners who have escaped from the French penal colony of Devil's Island (when they introduced a guard to the one's poisonous pet snake Adolf!) stuck in the port of Cayenne in French Guiana at Christmastime awaiting the arrival of a ship, which they hope to secure passage aboard back to France, get employment at a general store hoping to steal clothes to ease their flight. The convicts are winningly played by Humphrey Bogart (cast against type), Aldo Ray and Peter Ustinov in quite urbane fashion; adding to the humour, as all are notorious murderers.

Working on the roof of the store though, they overhear the problems of the mild-mannered manager Felix Ducotel – played by Leo G. Carroll (Mr. Waverley in TV's **The Man from U.N.C.L.E.** and TV's haunted banker **Topper**) – and his family, wife Amelie – played by Joan Bennett (whom Bogie's character Jospeh seems to have a connection with) and daughter Isabelle – played by Gloria Tallbot (with whom Aldo Ray's character Albert becomes smitten). Peter Ustinov's character Jules just dreams about one of the larger-framed customers!

61 As Best Director for *Casablanca (1942)*

62 Adapted by Ranald MacDougall from the play *Le Cuisine des Anges* by Albert Husson (explaining the film's working title *Angels' Cooking*)

Felix Ducotel is managing the store for his cousin Andre Trochard – excellently played by Basil (Sherlock Holmes in a series of films co-starring Nigel Bruce as a bumbling Dr. Watson and the sneering Sheriff of Nottingham opposite Erroll Flynn's Robin Hood in *The Adventures of Robin Hood (1938)*). Trochard is a contemptible, discourteous, grasping wretch of a man whose son Paul – played by John Baer – Isabelle Ducotel is in love with…and both are due to arrive any second to investigate why the shop has not been turning a profit.

When the criminals realise what a nasty old bird Andre Trochard is, and that his son Paul is in fact a chip off the old block and doesn't really care about Isabelle as much as he does his father's estate, the decide to stay and help the Ducotels out with their Christmas houseguests, acting as servants, while planning to cook the store's books for Felix and make a more suitable match for Isabelle.

They steal the governor's Christmas decorations and acquire and cook a magnificent turkey…but unfortunately, they also lose Adolf…and eventually both nasty cousin Andre and equally-unpleasant Paul make the deadly serpent's acquaintance; resulting in the best possible Christmas for the Ducotels! And even though the three non-angels fail to make good on their escape (deciding to give themselves up, as they can always try again the next year and, as Joseph says thinking of the Trochards, "I'll say one thing about prison: you meet a better class of people.") they concede to their hosts "It's been many years since we've had as nice a Christmas"…and they do receive animated halos as they turn to walk away along the dock and hand themselves in, even though they confirm "We're no angels!"

Yes, it is studio bound and its humour may not be quite as out and out dark as a modern viewer of films like *Bad Santa (2003)* may be used to; but it is decidedly dark for it time (killing and stealing your way to a Merry Christmas!) and it is all done with aplomb by an extremely talented and eminently watchable cast and a top-notch director, and all presented in the best possible bad taste – which is to say, delivered with an urbane civility that is sometimes lacking nowadays.[63]

Still, leaving behind the 55-three, which were all ahead of their time in some ways, I would like to pause briefly again in Hollywood, this time in 1958, before taking a short trip south of the border to Mexico in 1959.

This short Hollywood hiatus is again not to consider a horror movie, but a stylish, light romantic-comedy; and one that's as fluffy and pleasing as receiving a teddy bear as a Christmas gift. So what's it doing getting a mention in this book? Well, the movie in question does have an extended opening set during Christmastime and several of its main characters are witches and warlocks! The film is *Bell, Book and Candle[64]*, directed by Richard Quine and adapted from John Van Druten's popular stage play, which ran for 233 performances on Broadway

63. And on a personal note, *We're No Angels* remains one of my own personal Christmas favourites because it was my one of my deceased father's faves. Merry Christmas dad.

64. The title refers to items required in Roman Catholic faith to perform an exorcism

between 1950 and 1951, by screenwriter Daniel Taradash. Its co-stars are Kim Novak and James Stewart (who had very recently co-starred in Hitchcock's superb *Vertigo (1958)*), supported by Jack Lemmon, Elsa Lanchester,[65] Ernie Kovacs, Hermione Gingold and Janice Rule. So no stodgy Christmas pudding here; more a light and fluffy festive soufflé.

The plot sees a beautiful, but somewhat sad ad depressed witch, Gillian (pronounced with a hard G, and played by the luminous Novak) – the most talented in an underground coven inhabiting the Big Apple all but unnoticed (like Polanski's more nefarious urban coven in *Rosemary's Baby (1968)*) – falling in love with the handsome publisher, Shepherd Henderson (played by Stewart), who has recently moved into one of the apartments above her chic boutique, which sells tribal art and artefacts. But such love comes at a cost for Gil, as it means she must lose her witch's powers.

Of course, Shep is unaware that Gil is a witch at all initially, and he already has a fiancée, Merle (played by Janice Kitteridge) who used to be one of Gil's tormentors at college. But whether through the intercedence of Gil's familiar – a Siamese cat called Pyewacket – or Gil's spells and potions; or indeed as a result of natural chemistry, the two do eventually all in love, despite all obstacles.

There is some nice light humour, mostly inspired by Gillian's family – brother Nicky (played by Jack Lemmon) and dotty aunt Queenie (played by Elsa Lanchester) – her witch friends, like Bianca de Passe (played by Hermione Gingold), and an author and supposed expert on the supernatural, Sidney Redlitch (played by Ernie Kovacs) who is planning an exposé of urban witches for his next bestseller, which Shep is due to publish (Gillian having summoned the author to New York from Mexico when Shep expresses a wish that he could meet him). And there is a nice romantic core and some sub-screwball shenanigans to boot. And although there is no horror, there are some nice otherworldly touches, mainly thanks to Novak's performance.

It is all terribly chic[66] – though perhaps not as wacky and out-and-out fun as French director René Clair's Hollywood-made 1942 comedy *I Married a Witch* with Veronica Lake and Fredric March; though both films probably jointly inspired the long-running TV hit **Bewitched** with Elizabeth Montgomery and Dick York (and later Dick Sargent). And it is fun (if a tad strange) to see the witches celebrating Christmas and swapping festive gifts! – Gillian having a stylised representation of a Christmas tree (created out of diminishing sized hoops separated by chains) in her boutique. But perhaps that's a sign of just how non-threatening these particular witches are...underscored by the fact that their powers seem rather limited (Brother Nicky getting a kick out of making street lights go out; Aunt Queenie unlocking doors; Bianca whipping up a gross potion for poor old Shep to swallow down). The witches' nightclub – the Zodiac club – is also good fun, with Nicky whipping up some bongo beats as the percussionist in the witchy jazz band; but audiences would have to wait the best part of another couple of

65. The original ***Bride of Frankenstein*** in 1935's Universal horror directed by James Whale

66 The film received 2 Oscar nominations – for Best Art Direction/Set Decoration and Best Costume Design

decades before witches and demons started to actually become a serious cinematic threat to the festive season!

And so, let us head to Mexico for the following year's equally unthreatening schlock classic ***Santa Claus (1959)***, which, despite featuring a devil trying to upset the holiday applecart, turns out to be a largely unintentional laugh-fest. This bizarre south of the border claptrap fantasy (with an added American narrator for US release) directed by Mexican director René Cardona, sees Santa (whose cloud-borne North Pole castle bristles with hysterical, clunky observation equipment allowing him to decide which children deserve his beneficence) pitted against Satan's minion, the devil Pitch (complete with horns, red face paint, goatee, trident, pantaloons and ballet tights!) after Satan decides to put a stop to the jolly, white-bearded benefactor's annual joy-bringing gift deliveries.

In Santa's castle, which has a decidedly Mexican slant to its decorations, kids of all nations (dressed in stereotyped costumes – including African kids with bones through their hair!) toil to make the toys for Santa to deliver and sing what seems like an interminable and God-awful song, while snow falls indoors and strange, robot-like dollies wander pointlessly across misty, cloudlike floors. The whole thing – not least the earth children's dreams that Santa can 'witness' – is like some weird LSD trip in painfully-slow slow-motion! And when Santa does get to make his Christmas Eve delivery run, it is aboard a sleigh that travels across the sky like the alien spaceship from ***It Came from Outer Space (1953)*** in a fiery ball of sparks, pulled by cackling clockwork reindeer because it is really a giant toy!

Throughout the course of the night, Santa has a pitched battle with Pitch who tries t stop him from completing his deliveries. (At one point Santa even shoots the devil in the butt with a toy missile launcher!) And even though it looks like Pitch might succeed in his mission, getting a dog at one of the houses to trap Santa up a tree with dawn approaching (having already made Santa lose his magic sleep dust and the flower which makes him invisible and visible again) what odds do you reckon you'd get on Betfair of Pitch winning?

Santa's friend Merlin the Magician (who lives with him in his space palace!) knows if Santa does not return home by dawn, his reindeer turn to dust and he will be trapped on earth hears Santa's cries for help in the castle observatory and assists the jolly fat one in ensuring everyone gets their gifts and his red-clad chum gets home before sunrise.

Leaping lunacy Batman! – It's complete and utter twaddle and will probably only be really enjoyed by those looking for a Christmas turkey! (Or tripe, perhaps!). But hey, I figure any film that pits Santa against a devil definitely deserves a mention in this tinsel-tinged tome... even if the film is about as frightening or threatening as a lick from an Andrex puppy! Director René Cordona, who co-wrote this twaddle with Adolfo Torres Portillo, must have had rather too much peyote in his eggnog I feel, and so I suggest we leave him to sleep it off and whiz across the globe to the Soviet Union...

There, on the frozen steppes, the devil shows up at Christmastime again. This time in another version of the Gogol tale previously filmed as a Russian silent feature in 1913 (see ***Noch***

pered Rozhdestvom, Chapter 1). Produced in 1961, and written and directed by Aleksandr Rou, *Vechera na khutore bliz Dikanki* (aka *A Night Before Christmas* internationally) is a 69-minute colour remake of the story described in Chapter 1, which, although it is not a spine-tingler, does feature both the devil and a witch. Something of an evergreen popular classic in its homeland, it was remade again later under the same title as the 1961 version as a Russian/ Ukrainian co-produced TV movie in 2001 (Although this time its informal interational title would be the somewhat less than catchy *Evenings on a Farm near Dikanka*). Still, seems you just cannot keep a good devil – or witch for that matter – down at Christmastime! And so, let's press on into the Swinging Sixties and see what strange delights that decade has in store for us on our long march to the 1970s and the genesis of Christmas horror movies proper...

One horror movie proper of 1964, Italian director Mario Bava's[67] portmanteau or compendium movie *I Tre volti della paura* (aka *Black Sabbath*, *The Three Faces of Fear* and *The Three Faces of Terror*) is also sometimes called *Black Christmas*; but this is a complete misnomer as, brilliant movie though it is (and I would urge anyone who is a fan of the macabre who hasn't seen it to rectify that oversight at their earliest convenience), Christmas doesn't feature at all. I can only guess that perhaps it received a video or DVD release near to Christmastime as a collection of ghost stories (a festive favourite)...but I do not know for sure. Still, at least it is well worth watching...which is more than can be said for some...

I will just mention the Rankin-Bass made for US TV stop-motion animated classic *Rudolph the Red-Nosed Reindeer* in passing, for although this was made for a family audience and contains no real scares (and I am sure that every single reader is familiar with it and seen it at least once)[68] it does feature the adorable Abominable Snowman among its cast of characters. Though it transpires that the hairy, giant, white monster is only so abominably behaved because he has a toothache he cannot get rid of!

1964 also saw the release of *Santa's Enchanted Village*, a short supposedly family-orientated festive fantasy directed by Mexican Manuel San Fernando, and co-scripted from his own story with American producer K. Gordon Murray, who rather specialised in the exploitation niche of taking foreign shot dreck and releasing it in the States with a re-dubbed soundtrack. Indeed, it was he who provided the narration for the north of the border release of the Mexican made *Santa Claus (1959)* under the pseudonym Ken Smith! And 1964 also saw him cited (or maybe he should have been cited!) as producer for *Santa Claus and His Helpers*, which was also directed by San Fernando! – parts of which were re-edited together with parts of *Santa Claus (1959)* and released as *Santa's Fantasy Fair* (aka *Brothers Grimm Storybook Fair*), which was released in 1969!

The usual suspects (or should that be culprits) also wrote, produced and directed (as was their wont) *Santa's Magic Kingdom* in 1966, a short intended to be shown at Santa Villages and festive theme parks as a kind of commercial! And Murray was back to his usual old tricks

67 Co-directed with Salvatore Billitteri

68 And if not, why not? – It is not only a Christmas classic, but also a real gem that still holds up today, over four decades later (much as *A Charlie Brown Christmas (1965)* does).

in 1969, not only with his patchwork-quilt trash-rehash of *Santa Claus (1959)* and *Santa Claus and His Helpers (1964)* to make *Santa's Fantasy Fair (1969)*, but also in re-editing the German made *Hänsel und Gretel (1954)* along with other material into *Santa's Giant Film Festival of the Brothers Grimm* (which was aka *Santa's Film Festival of the Brothers Grimm* and *Santa's Gala Film Festival*!...Different names, same old hacked together claptrap!!!). I have to admit, I have never seen any of these (and quite frankly, I think I could quite happily live out my life without that honour!), but I include them as examples of the weird, wacky and possibly not so wonderful, as I understand they pretty much all feature among their merry mayhem, a menagerie of fantasy creatures and so forth (even if their budgets are so restricted as to not always make it possible to actually show them onscreen!!!). As far as I am concerned, this kind of exploitative festive fare is for Christmasochists only!

For the epic grandeur of full-scale onscreen science-fiction wonders, the audience of 1964 would have to turn instead to the legendary *Santa Claus Conquers the Martians* (aka *Santa Claus Defeats the Aliens*)!

I am being somewhat facetious and ironic of course, as this micro-budget, z-grade schlock spectacle of crass ineptitude was listed as one of the worst movies of all time by both Harry Medved and his co-authors[69] and John Wilson.[70] Too pathetic to entertain children, it is the kind of twaddle that will only appeal to wholehearted fans of "turkeys." Indeed, I first got to see it when it was shown on the UK's Channel 4 television channel one Christmas Eve as part of a whole season of God-awful films inspired by the Medveds' Golden Turkey Awards book.

This silly 86-minute slapstick knockabout space opera, directed by Nicholas Webster, executive produced by Joseph E. Levine[71] and written for the screen by Glenville Mareth from a story by Paul L. Jacobson (lets name 'em and shame 'em!) sees Santa Claus kidnapped by jealous Martians because they have no-one like him on the angry red planet to give a little fillip to their listless, little, green, antennaed kids, who spend all day glued to the TV set watching Earth kids' programmes! Fortunately though, the silly old extra-terrestrial Santa-nappers also take along a couple of Earth kids they don't want blabbing about what has happened. (They've had to get directions from the kids to the 'real' Santa's North Pole home, as they have been confused by all the street Santas!).

69. In his books *The Fifty Worst Movies of All Time (and how they got that way)* co-written with Randy Dreyfuss (Warner Books, 1978) & *The Golden Turkey Awards* co-written with his brother Michael Medved (Putnam, 1980)

70. Founder of the Golden Raspberry Award and listed as one of The 100 Most Amusingly Bad Movies Ever Made in his book The Official Razzie © Movie Guide (Grand Central Publishing, 2005)

71. Who has been an executive producer on some stunningly good films too through the years e.g. Jean-Luc Godard's *Le Mepris (1963)*, *Zulu (1964)*, *Darling (1965)*, *Sands of the Kalahari (1965)*, *The Producers (1968)*, *The Lion in Winter (1968)*, *Soldier Blue* and *A Bridge Too Far (1977)* so lets not throw the baby out with the bath water!

An automated workshop is created for Santa on Mars and he sets to work producing a plethora of playthings for the little green sprouts of Mars. But when the Martians see how unhappy the Earth kids have become, they relent and agree to let Santa and the kids return to their own planet...but not before they help fend off an attempted coup by a group of incompetent insurrectionists. And when they do finally leave, it is having made some little green friends and found Mars its very own Santa stand-in!

The whole thing is a veritable celluloid smorgasbord of brain-cell numbing ineptitude; with any entertainment value it has stemming from the viewer's realisation of just how awful, imbecilic, amateurish and inept the whole thing is! The terror-inducing Martian robot Torg looks like it was cobbled together out of a couple of cardboard boxes and some ventilator pipe (even the dials on his chest are painted on); the chlorophyll-green make-up on the Martian characters is applied so variably as to make them look like cabbages (which is actually quite fitting because they act like vegetables most of the time anyway); a moustachioed Martian villain called Voldar is more hammy than **Tales of the Riverbank**'s Hammy Hamster on Ham-phetamines; and absolutely the best of thing of all...it features what is quite probably the worst movie song (and Christmas song for that matter) ever written – "Hooray for Santy Claus". Worse even than the rock and roll theme song for that other outer space classic ***The Green Slime (1968)***. And what is more, the producers of ***Santa Claus Conquers the Martians*** were so pleased with their delirious little ditty, sung at the beginning of the film by a monstrously schmaltzy chorus of tuneless children, that they repeat it at the film's close, complete with lyrics super-imposed over a shot of outer space so that viewers can sing along! (And I bet you any money that you do!!!...The song is just so awful, it's impossible not to!):

♫ ♫♫♫ Hang up that mistletoe
Soon you'll hear "Ho! Ho! Ho!"
On Christmas Day
You'll wake up and say
"Hooray for Santy Claus"
S-A-N-T-A C-L-A-U-S
"Hooray for Santy Claus"
You spell it
S-A-N-T-A C-L-A-U-S
"Hooray for Santy Claus"
"Hooray for Santy Claus"
"Hooray for Santy Claus" ♫♫♫

And if this isn't brilliantly bad enough for you, then there's always what is quiet possibly the most lusciously ludicrous slapstick battle sequence ever committed to film; where the united Earth and Mars kids (all four of 'em!) and a bunch of barely animate animated toys overthrow the villainous Voldar in a bubbly pandemonium of a scene that really does have to be seen to be dis-believed!

Oh yeah, and this was the first film of 9-year-old Pia Zadora, later sort of raunchy star of **Butterfly (1982)**[72]: you can never be allowed to forget that little snippet of trivia! She plays Girmar the Martian girl (Girl/Mars ~ Girmar, geddit?...Ho! Ho! Ho!). **Santa Claus Conquers the Martians** was a Jalor production...and many believe that all concerned should indeed have been jailed! It is truly awful – and you will either love it or loathe it for that very reason!

...And I still can't get that darned song out of my head...

♪♪ "S-A-N-T-A C-L-A-U-S
Hooray for Santy Claus"♪♪!!!!!

And so to 1965, when things don't get much better! This year saw the release of **The Magic Christmas Tree**, a 60-minute American family-orientated feature in colour and B&W directed by Richard C. Parish, isn't scary; but it does feature a witch...as did **The Wizard of Oz (1939)**... And with delusions of grandeur, like that film **The Magic Christmas Tree** starts off in B&W and only goes into colour when the protagonist falls out of a tree, and only returns to B&W at the end when all the action – which has been in the boy's imagination (?) – is over.

Described in its advertising tagline as "The enchanting story of a magic tree that made a prisoner of Santa Claus and opened the heart of a boy to the true meaning of Christmas," it is the tale of a cocky youth who is given a magic ring by an old witch for saving her cat from a tree, and the problems the greedy tyke causes when he uses the powers to bring on a magical Christmas and grant himself three more wishes. I am not sure why the witch didn't simply use the ring or her magic power to get the cat down herself! But apparently this film represents the kind of z-grade cheapjack crapola you only watch to laugh at (if you are that way inclined!). You can see a clip online in a 6 minute presentation by Mark Jordan Legan entitled *The Best Merry Scary Christmas Movies* at www.npr.org/templates/story/story.php?storyId=98517732 - including a scene with a what is I guess meant to be a salutary message for miscreant minors (as the boy escapes the clutches of a giant in some woods, the lumpen lumbering ogre says, "Well I lost him, but I'll find another greedy child to be my slave..." – then straight to camera in close-up – "...Maybe YOU!").

1965 also saw the screening on TV of a festive fairytale, **The Dangerous Christmas of Red Riding Hood**[73], which re-invented the tale by telling it from the Wolf's point of view – who (according to him at least) was rather hard done by, with Red being the real villain of the piece due to her selfishness and greed and him being more of a victim of circumstance. It isn't scary or horrific in any way (in fact it isn't even really dangerous, despite the title) – indeed Cyril Ritchard who plays the Big Bad Wolf, portrays him as rather urbane and almost effeminate. But I guess I mention because it does try to recast villain as (anti-)hero – and it

72 Thanks mainly to an infamous topless scene in a bath with incestuous overtones – her character seduces the man she believes at the time to be her father, allowing him to caress her naked breasts!!! Ah, them's the good old 80s for ya!
73. Subtitled **Oh Wolf, Poor Wolf!**

is quite entertaining if you get a chance to see it or want to pick it up on DVD. A young Liza Minelli plays Red – and a belting good job she makes of it too – and British band The Animals (of 'House of the Rising Sun' fame) make a guest appearance too; with crooner Vic Damone rounding out the main cast as the Woodsman!

Still on the little screen...1966 saw the release of an absolute classic in the form of a 26-minute animated feature co-directed by the legendary Chuck Jones and Ben Washam and featuring the vocal talents of legendary Hollywood hooror-meister, talented Brit actor Boris Karloff, the original Universal Frankenstein Monster of the 1930s[74]! The film ***How the Grinch Stole Christmas!***[75] was an adaptation of Dr. Seuss's[76] famous tale of a heartless, green, hairy Anti-Santy critter who lives alone up a mountain overlooking a town of happy creatures who love Christmas. So incensed is the Grinch by the residents of Whovilles' noisily joyous celebrations, that he decides to dress up as Santa and descend from his mountain to steal Christmas from them by taking all of their presents.

Beautifully animated, with a superb vocal performance from Karloff as the monstrous green-furred meanie and the narrator, and boasting some cracking songs (like 'You're a Mean One Mr. Grinch' that was so good, they used it again when Ron Howard came to direct a live-action remake of the tale starring Jim Carrey in 2000), this festive film is a five star treat. And even though, the hairy, green grump gets all gooey in the end; it was great to have a sort of monster as the star of a Christmas movie – even a short animated one![77]

Meanwhile, back on the big screen, 1967 saw the release of a Christmas movie by cult gore-horror schlockmeister Herschell Gordon Lewis, 'The Wizard of Gore'[78]; director of such gruesome, blood-spattered opuses as ***Blood Feast (1963)***,[79] ***Two Thousand Maniacs! (1964)***, [80] and ***Color Me Blood Red (1965)***. [81] Surely this would be it! – the genesis of the Christmas Horror Movie proper... Ah, but sadly no! Lewis was perhaps above all else, an exploitation filmmaker; and while his cheap and cheerful, murderous mutilation and mayhem movies made great drive-in and flea-pit fare for a sensation-hungry audience (of often perhaps sneak-in youths!), he was always looking for some way to cash-in and turn a quick buck. And

74. Karloff played the Monster in three Universal horror films of the 1930s: *Frankenstein (1931)* , *Bride of Frankenstein (1935)* and *Son of Frankenstein (1939)*

75. Aka *Dr Seuss's How the Grinch Stole Christmas!*
76. Real name Theodor Geissel

77. Another, little known video-release version was also produced in 1992 featuring illustrations from the original book with the story narrated by naturally –grumpy-faced Walter Matthau

78. The title of one of Herschell Gordon Lewis's films from 1970

79. Aka *Feast of Flesh* and *Egyptian Blood Feast* (reissue title)

80. Aka *2,000 Maniacs*

81. Aka *Model Massacre*

his Christmas opus, ***Santa Visits the Magic Land of Mother Goose (1967)***[82], was just one such attempt. Exploitation really is the key word here; for this film is little more than a second-rate kiddies stage show (almost in the mode of a pantomime) that the director shot and tried to pass off as a movie! Indeed, Christmas tie-ins were inserted afterwards to try and cash-in on the holiday market with a Christmassy-sounding title and December release date!

Oh, well…so much for great expectations – looks like fans of the fantastic and horrific were pretty much still stuck with Dickens' other tale, centred on Scrooge hitting the Christmas spirits, for their little titillations and frissons! Though that other perennial festive favourite (certainly the ballet version at least!) ***The Nutcracker***, based on E.T.A. Hoffman's fantastical tale did see a film version produced in Poland in 1967.

The 84-minute long ***Dziadek do orzechów***[83] written and directed by Halina Bielinska was one of several versions that have been made over the years, though many try to play down the scarier, darker elements of Hoffmann's original tale. I will attempt to give a brief overview of the productions I am aware of in the next chapter. But for now, as the swinging sixties drew to a close, even the absolutely compellingly titled Brit flick ***Death May Be Your Santa Claus (1969)*** didn't cut the ice – let alone slice 'n' dice the virgin flesh.

Far from being the Ho-ho-horror opus it sounded, this X-rated[84] 50-minute movie was actually a film made by one of the black militant youths in Jean-Luc Godard's documentation of late 1960s western culture (and counter-culture) featuring the Rolling Stones, ***Sympathy for the Devil (1968)***.

It is a kind of would-be artistic political diatribe with lots of sex thrown in. Written and directed by Frankie Dymon Jr., ***Death may Be Your Santa Claus*** has been rediscovered and rescreened fairly recently through the British Film Institute's (bfi) 'Black World' initiative. It basically presents the nihilistic visions of a young black European militant at the close of the 1960s. And it's a bit hippy-trippy too from what I can gather. But I'll leave you to make up your own mind whether it sounds like your kind of joint or not!

For my part, I have one further film from the 1960s I would like to mention before we take a brief Nutcracking detour prior to seeing what holly- jolly changes the 1970s would bring in terms of marrying Christmas and horror on the silver screen! And that film is the French-Italian co-production with an American star, written and directed by a Shanghai-born Brit who first brought James Bond to the big screen for producers Albert Salzman and Albert R. 'Cubby' Broccoli back in 1962[85], and directed the first two sequels[86].

82. Aka *The Magic Land of Mother Goose* and *Sarah Visits the Magic Land of Mother Goose*!
83. Aka *The Nutcracker*

84. In the UK – for adults only

85. In *Dr. No* (aka *Ian Fleming's 'Dr. No'*) starring Sean Connery

86. *From Russia with Love (1964)* (aka *Ian Fleming's 'From Russia with Love'*) and *Thunderball (1965)* (aka *Ian Fleming's Thunderball*) both also with Sean Connery

The film, adapted for the screen from a novel by French author Michel Bataille, by director Terence Young is *L'Arbre de Noël* (aka *The Christmas Tree* in the US and UK, and *L'Albero di Natale* in Italy; not to mention *When Wolves Cry* for US video release!). And a pretty strange little number it is too! It builds to a Christmas climax or culmination, and there is horror, but of a particular variety...not the slice-'em-dice'-'em graphic horror of the later slasher movies; nor the showy onscreen horror of the old monster movies: this film's horror is psychological. The film centres on the relationship between a father and his ten-year-old son in exceptional circumstances. The millionaire European father (who was schooled in America – explaining his American accent) is played by Oscar-winner-to-be William Holden[87] - in a bit of a change of pace from the same year's Sam Peckinpah-directed *The Wild Bunch*. His young son, who doesn't get to see enough of his busy father, chooses to holiday with dad in quiet Corsica so that the two of them can share some quality time together. Only, when they are out in the clear, blue Med in a dinghy fishing, there is an explosion high overhead, and as daddy dives to unsnaggle juniors line, falling, flaming debris and something on a triple parachute spells disaster for the boy.

The explosion was a military jet mishap and the parachuting equipment a radiation-leaking bomb. Junior is doomed, while daddy was protected by being underwater! The doctors can do little and give no hope. They advise dad to take his son out of school and spoil him rotten for the last six months of his life. And daddy takes them at their word, buying his son whatever he wants – and when he can't buy it (e.g. wolves from the zoo, which his son develops a peculiar affinity with), well he and an old Resistance buddy just steal them!

As Christmas approaches and junior deteriorates, with ugly blue bruises appearing, livid against the pallor of his grey skin, the Christmas preparations are afoot. Junior chooses the Christmas tree he wants and all seems set fair for one final festive celebration. Ah, but no... In a very effective and touching finale (though the music is as rich as a rum-laced Christmas pudding at times!) returning from a shopping trip with his girlfriend, daddy discovers the nipper has opened all his presents and scattered the gift-wrap all over the room. He sets about gently chiding the child who has obviously tuckered himself out and is lying on the floor beside the lovely Christmas tree...Only he isn't just tired...and the howling of the wolves with whom he has formed such a peculiar bond, makes for an emotional end to this highly unusual film!

Italian screen siren Virna Lisi and irrepressible French comic character actor Bourvil fill out the international cast as the millionaire's girlfriend and ex-Resistance buddy; while fresh-faced Brook Fuller, who comes across a little too sickly sweet and wussy, gives a performance that actually seems to work rather in spite of itself. It is not as mannered as Macauley Culkin's in *Home Alone (1990)*; he is more like Mark Lester in the more contemporaneous *Oliver! (1968)*. But there's a hard to define strangeness about his performance, which, considering the nature of the story, is probably somewhat serendipitous. However, as defining that particular quality is proving such a hard nut to crack, let us move on... To *The Nutcrackers*!...

87. As Best Actor for *Network (1976)*

THE FILMS

The Wicked Wassail is on its Way

L'Arbre de Noël 1969 France/Italy 110mins
Directed & Written: Terence (based on Michel Bataille's novel) **Music**: Georges Auric
Cast: William Holden (Laurent Ségur), Brook Fuller (Pascal Ségur), Virna Lisi, Bourvil,
Maria Schneider (uncredited)

Aka *L'Albero di Natale* (Italy) and *The Christmas Tree* (UK/USA) and
When Wolves Cry (USA Video release)

L'Assassinat du Père Noël 1941 France B&W 105mins
Directed: Christian-Jaque **Written**: Charles Spaak (from a novel by Pierre Véry **Cast**: Harry
Baur (Gaspard Cornusse)

Aka *The Killing of Santa Claus* (UK) and *Who Killed Santa Claus?*
(USA)

Babes in Toyland 1934 USA B&W 77mins
Directed: Gus Meins & Charley Rogers **Written**: Frank Butler & Nick Grinde & Hal Roach
(uncredited) (based on the operetta by Victor Herbert & Glen MacDonagh) **Produced**:
Hal Roach (uncredited) **Cast**: Stan Laurel (Stannie Dum), Oliver Hardy (Ollie Dee)

Aka *Laurel and Hardy in Toyland* and *Wooden Soldiers* and *March of the
Wooden* (US reissue title) and *Revenge is Sweet*

Bell, Book and Candle 1958 USA 106min
Directed: Richard Quine **Written**: Daniel Taradash (adapted from the play by John Van
Druten) **Cinematography**: James Wong Howe **Cast**: James Stewart (Shepherd 'Shep'
Henderson), Kim Novak (Gillian 'Gil' Holroyd), Jack Lemmon (Nicky Holroyd), Elsa
Lanchester (Queenie Holroyd), Ernie Kovacs, Hermione Gingold, Janice Rule

Beyond Tomorrow 1940 USA B&W 84mins
Directed: A. Edward Sutherland **Written & Associate Produced**: Adele Comandini (and story with Mildred Cram) **Cast**: Harry Carey (George Melton), C. Aubrey Smith (Allan 'Chad' Chadwick), Charles Wininger (Michael O'Brien), Helen Vinson, Richard Carlson, Maria Ouspenskaya

Aka Beyond Christmas

Conquest of Space 1955 USA 81mins
Directed: Byron Haskin **Written**: James O'Hanlon (adapted from Chesley Bonestell's and Wily Ley's book by Philip Yordan & Barré Lyndon & George Worthing Yates and Wernher von Braun's book *Mars Project* uncredited) **Produced**: George Pal **Cast**: Walter Brooke (Gen. Samuel T. Merritt), Mickey Shaughnessy (Sgt. Mahoney), Eric Fleming (Capt. Barney Merritt), Benson Fong, Rosemary Clooney (doing a musical number – archive footage)

Aka Mars Project (working title)

The Curse of the Cat People 1942 USA B&W 70mins
Directed: Gunther von Fritsch & Robert Wise **Written**: DeWitt Bodeen **Produced**: Val Lewton **Cast**: Simone Simon (Ghost of Irena), Kent Smith (Oliver Reed), Ann Carter (Amy Reed), Jane Randolph (Alice Reed), Eve March, Julia Dean, Elizabeth Russell, Sir Lancelot (Edward, the Reeds' Butler/Cook)

The Dangerous Christmas of Red Riding Hood 1965 USA (TV) B&W 50mins
Directed: Sid Smith **Written**: Robert Emmett **Music**: Jule Styne **Cast**: Liza Minnelli (Little Red Riding Hood), Cyril Ritchard (Big Bad Wolf), Vic Damone (Woodsman), The Animals (Pop group): Eric Burdon (Head of the Wolf Pack) & Alan Price & Barry Jenkins & Danny McCulloch & John Weider

Aka The Dangerous Christmas of Red Riding Hood or Oh Wolf, Poor Wolf!

Dead of Night 1945 UK B&W 102mins
Directed: Alberto Cavalcanti & Charles Crichton & Basil Dearden & Robert Hamer **Written**: John Baines & Angus McPhail (with additional dialogue by T.E.B. Clarke) (from stories by H.G. Wells & E.F. Benson & John Baines & Angus McPhail) **Produced**: Michael Balcon **Music**: Georges Auric **Art Direction**: Michael Relph **Cast**: Mervyn Johns (Walter Craig), Michael Redgrave (Maxwell Frere), Roland Culver, Googie Withers, Sally Anne Howes, Basil Radford,
Naunton Wayne, Miles Malleson

Death May Be Your Santa Claus 1969 UK B&W 50mins
Directed & Written & Produced: Frankie Dymon Jr. **Music**: Second Hand
Cast: Ken Gajadhar (Raymond), Donnah Dolce, Second Hand

Dziadek do orzechów 1967 Poland 84mins
Directed: Halina Bielinska **Written**: Halina Bielinska & Maria Kruger (based on the tale *The Nutcracker and the Mouseking* by E.T.A. Hoffmann)

Aka The Nutcracker (International title)

The Great Rupert 1950 USA B&W 88mins
Directed: Irving Pichel **Written**: Laslo Vadnay (additional dialogue by James O'Hanlon & Harry Crane) (from a story by Ted Allen) **Produced**: George Pal **Cast**: Jimmy Durante (Mr. Amendola), Terry Moore (Rosalinda), Tom Drake (Peter Dingle), Queenie Smith, Rupert (Himself the Squirrel)

Aka The Christmas Wish

How the Grinch Stole Christmas! 1966 USA 26mins (Animation)
Directed: Chuck Jones & Ben Washam **Written**: Dr. Seuss's book (with additional material by Bob Ogle & Irv Spector) **Produced**: Chuck Jones & Ted Geisel (Dr. Seuss) **Music**: Albert Hague **Cast**: Boris Karloff (Narrator & The Grinch)

Aka Dr Seuss's How the Grinch Stole Christmas

The Magic Christmas Tree 1965 USA B&W and Colour 60mins
Directed: Richard C. Parrish **Written**: Harold Vaughn Taylor **Cast**: Chris Kroesen (Mark), Valerie Hobbs, Dick Parrish

The Night of the Hunter 1955 USA B&W 93mins
Directed: Charles Laughton **Written**: James Agee & Charles Laughton (uncredited) (from a novel by Davis Grubb) **Cinematography**: Stanley Cortez **Music**: Walter Schumann **Cast**: Robert Mitchum (Harry Powell), Shelley Winters (Willa Harper), Lillian Gish (Rachel Cooper), Billy Chapin (John Harper), Sally Jane Bruce (Pearl Harper), Peter Graves (Ben Harper), James Gleason, Evelyn Varden, Don Beddoe

Rudolph the Red-Nosed Reindeer 1964 USA 47mins

(3-D stop-motion Animation)

Directed: Kizo Nagashima & Larry Roemer **Written**: Romeo Muller (from a story by Robert May) **Produced**: Jules Bass & Arthur Rankin Jr. **Cast**: Burl Ives (Narrator, Sam the Snowman), Billy Richards (Rudolph)

Santa Claus 1959 Mexico 94mins

Directed: René Cardona **Written**: René Cardona & Adolfo Torres Portillo **Cast**: K. Gordon Murray (Narrator – English dubbed version, as Kent Smith) José Elías Moreno (Santa Claus), José Luis Aguirre 'Trotsky' (Pitch), Armando Arriola (Merlin)

Santa Claus and His Helpers 1964 USA

Directed: Manuel San Fernando

Santa Claus Conquers the Martians 1964 USA 86mins

Directed: Nicholas Webster **Written**: Glenville Mareth (from a story by Paul L. Jacobson) **Executive Produced**: Joseph E. Levine **Cast**: Pia Zadora (Girmar), John Call (Santa Claus)

Aka Santa Claus Defeats the Aliens

Santa Visits the Magic Land of Mother Goose 1967 USA

Directed: Herschell Gordon Lewis

Aka Santa Visits the Magic land of Mother Goose and Sarah Visits the Magic Land of Mother Goose

Santa's Enchanted Village 1964 USA

Directed & Written: Manuel San Fernando (story by K. Gordon Murray)

Santa's Fantasy Fair 1969 USA

Presented by K. Gordon Murray

Aka Brothers Grimm Storybook Fair

Santa's Giant Film Festival of the Brothers Grimm 1969 USA 80mins
Aka Santa's Film Festival of the Brothers Grimm and Santa's Gala Film Festival

Santa's Magic Kingdom 1966 USA
Directed & Written: Manuel San Fernando (based on a story by K. Gordon Murray)

Vechera na khutore bliz Dikanki 1961 USSR 69mins
Directed & Written: Aleksandr Rou (based on a story by Nikolai Gogol)

Aka A Night Before Christmas

We're No Angels 1955 USA 106mins
Directed: Michael Curtiz **Written**: Ranald MacDougall (based on the play *La Cuisine des Anges* by Albert Husson) **Cast**: Humphrey Bogart (Joseph), Aldo Ray (Albert), Peter Ustinov (Jules), Basil Rathbone, Joan Bennett, Leo G. Carroll, Gloria Talbott

Aka Angels' Cooking (working title)

CHAPTER 4

Nutcrackers...and Cracking Nutters!

The Nutcracker, and in particular Tchaikovsky's ballet version of E.T. A. Hoffman's fantastical tale, has proven an enduring festive favourite over the years, and although I don't think as many versions or adaptations have been committed to film as there have been of Dicken's classic Christmas spooky story *A Christmas Carol*, there have still been a few – live-action, ballet and animated. And I think they deserve a mention, for although many are aimed at a family or young audience and water down, skirt around or jus blatantly excise the more scary and sinister elements of Hoffmann's original tale *Knussknacker und Mausekönig*[88] (e.g. a seven-headed rat and a princess turned ugly with a huge head, gurning grin and beard[89]!); while others do at least preserve some of the darker (Grimmer?) fantastical elements as well as the more hairy-fairy fairytale ones.

The earliest screen adaptation that I am aware of is a rare 1925 animated sound short directed by Dave Fleischer (brother of **Betty Boop** creator Max and uncle of movie director Richard). The Fleischers directed several animated shorts and bouncing ball sing-alongs utilising the early sound-on-film De Forest Phonofilm system, which predated some of the other sound-on-disk and sound-on-film systems being experimented with prior to the release of what is generally regarded as the big breakthrough in talking pictures, Warner Brother's **The Jazz Singer (1927)**, which used the Vitaphone system to ensure that those cinemagoers who "ain't heard nothin' yet"[90] got to hear Al Jolson talk a few lines and sing some songs in his own inimitable style. (Nothing is as straightforward or simple as it first seems, eh?!)

88. *Nutcracker and the Mouseking* (published 1816)

89. Rather like Princess Fiona in the recent **Shrek** movies

90. Jolson's character's first line in the film is "Wait a minute, wait a minute, you ain't heard nothin' yet!"

Fleischer's ***Nutcracker Suite (1925)*** was inspired by Tchaikovsky's classical score for the ballet, which he composed in 1891-1892 (the ballet premiered on 18 December 1892 at the Mariinsky Theatre, St. Petersburg). The silent live-action movie of the following year, ***The Nutcracker (1926)***, had nothing to do with Hoffmann or Tchaikovsky – it was about a hen-pecked husband faking amnesia after hitting his head (cracking his nut!) being run down by a tram!

A 2-hour version of the Tchaikovsky ballet called ***The Nutcracker***, with Dame Margot Fonteyn as the Sugar Plum Fairy, was produced by the BBC for British TV in 1958 and screened on 21 December; while a more condensed 1-hour West German/US-produced version shot in Germany and called ***Der Nußknacker*** (but also known as ***The Nutcracker***) was screened on American TV in 1964, hosted and narrated by Eddie **"Green Acres"** Albert. Apparently, the condensed storyline was also somewhat revised, making the production more reminiscent of ***The Wizard of Oz (1939)***! And other versions of ***The Nutcracker*** ballet produced through the years have included a 100-minute long British production starring Rudolf Nureyev as Drosselmeyer/The Prince from 1968; [91] a 1977 US-produced version filmed in Toronto and starring Mikhail Baryshnikov as the Nutcracker/Prince; and in 1978 a 100-minute Soviet pro-duced version.

But the dance doesn't stop there – oh, no!... in 1985 yet another version of Tchaikovsky's ***The Nutcracker*** ballet was produced for British TV...and this time Oscar winning[92] actress Joan Fonatine (not to be confused with prima ballerina Dame Magot Fonteyn!) was on hand to introduce and host the production. Then in 1986, a version of the tale entitled ***Nutcracker: The Motion Picture***, made it to the screen. This 89-minute long version of the ballet directed by Carroll Ballard (the director of ***Fly Away Home (1996)***[93]) was criticised for cuts on the danc-ing breaking the continuity – but as it is actually entitled ***Nutcracker: The Motion Picture***, I am not surprised that the director tried to utilise cinematic techniques to try and privilege the cinematic elements. Maurice Sendak designed the costumes, which apparently have a slightly malevolent edge to them, undercutting the usual syrupy candy-cane sickly twee sweetness.

In 1988, the French got in on the act and released another version of the ballet on video, again entitled ***The Nutcracker*** (but aka ***Rudolf Nureyev's The Nutcracker***) as the great, twin-kle-toed defector updated the storyline somewhat (as he had done in the previous produc-tion which he starred in. But this time, instead of starring, he directed. (Shame...the scariest thing on view would probably have been the bulge in his tights!).

1989 saw another Russian-produced version released on video – and they must really like Old Nick in Russia, because The Devil appears as a character in this one! But 1993 witnessed

91. Nureyev is also credited with revising the story and this version featured Wayne Sleep as the Nutcracker

92 .As Best Actress for *Suspicion (1942)*

93. For which Caleb Deschanel, father of **Bones**' Emily and **The O.Z.**'s Zooey) was Oscar nominated for Best Cinematography

the release of probably one of the most accessible of all versions of the ballet committed to film. **The Nutcracker** (aka **George Balanchine's The Nutcracker** after the celebrated choreographer) was directed by Emile Ardolino and had a couple of storm-in-a-teacup controversies squalling around it for a while. One concerned the narration provided by Oscar winning[94] actor Kevin Kline (purists didn't like it!) and the other concerned the casting of **Home Alone**'s Macaulay Culkin in the role of the Nutcracker/Prince/Drosselmeier's nephew. Now, I have to admit, I'm not the biggest fan of Culkin myself – he always somehow seems so limp and lugubrious at the same time as being over-the-top, mechanical and cartoonish. You can always kind of see the cogs grinding. But I have to admit also, that I think this is probably is best screen performance. Some people cooed over his cute blue-eyed, blonde-haired cherubic looks; while others maintained that he had a sort of creepy slyness about him, more disdainful than mischievous – his grin sometimes appears more of a smirk.

As it happens, however, these qualities are pretty much exactly what are required in this production, which does try to convey some of the darker elements of Hoffmann's tale, and to maintain a certain degree of ambivalence. Some of the visuals, for instance, bear the influence of German Expressionist Cinema; particularly in depicting the fantastical Drosslemeier (he is introduced through the use of a huge stalking shadow on the wall, and later perches surreally atop the grandfather clock, his cape outstretched like the wings of the glowing-eyed wooden owl that normally perches there, with which his bat like presence merges).

1994 saw the Russians back on their toes with the release yet another version of **The Nutcracker** on video; and in 1999 the Germans got in on the action too when they released their own version of the ballet on video. (Oh, pliés! Will it ever end? ...Well, certainly not yet...) At the turn of the century, the year 2000 saw France release yet another version of the evergreen festive fave. This time a 102-minute version – and guess what it was called? ...Yep **The Nutcracker** (YAWWWWWN! ...It's all getting tutu much, isn't it?).

Well, how's this for a change of step? ...2001 even witnessed the production of **The Swinging Nutcracker** for Canadian TV. But that's not all (oh, no –not by a long way!) ...that year also saw the plastic princess, just about every little girl's[95] favourite doll – you got it! Barbie ©! – star in her own computer-generated animated version of the tale (in her very first feature film). And guess what? ... Barbie © is a ballerina who relates the tale to cheer up a depressed little lass...and the film includes our blonde-haired, definitely-not-a-bimbo performing some pretty spectacular animated ballet[96].

I'm thinking it won't really matter what I think or say about **Barbie in the Nutcracker (2001)**: because those who love her will hear no bad about the movie, and those who loathe her will hear no good. But just for the record, I thought this movie (which was obviously

94. As Best Supporting Actor for *A Fish Called Wanda (1988)*

95. And probably many little boy's too (just to tip my hat to Political Correctness!)

96. Motion capture animation was utilised (i.e. ballet dancers did the dancing for real, then the animators used this as a basis for their animation in order to get the movements and flow as realistic as possible)

predominantly aimed at children) was pretty good – perhaps better than I had expected, and certainly not as bad as I feared and dreaded. The addition of a nutty, knockabout bat character helped; as did having the vocal talent of Tim Curry in the cast. And Kelly Sheridan gave Barbie © the kind of voice I am sure her manufacturers wanted (and not at all like Lene Nyström Rasted's from plastic Danish Euro-pop band Aqua!).

Perhaps needless to say, 2001 did also see yet another version of the ballet produced: this time once again by the BBC for British television. Their 2001 version of **The Nutcracker** was 115-minutes long and was hosted and introduced this time by Oscar winning actress[97] Julie Andrews. Then in 2003 British TV produced a modernised version of the ballet – and you could tell it was more modern and trendy, because **Nutcracker!** Not only dropped the 'The' in its title, it also added an exclamation mark!!! This version is apparently a kind of comical Dickensian adaptation of the old slippers-and-tights warhorse, that moves from a Tim Burton-esque orphanage to a Willy Wonka-esque fantasyland of sugary sweets and fairytale princes and princesses! So purists (dentists and diabetes sufferers) be warned!

Ok, if that's as many of the ballet versions that have been committed to film or video and broadcast on TV that I know of, what next. Well, how about ice-ballet versions of the trusty tinsel-tinged tale? Have such shows been produced? Bet yer bottom dollar! Indeed, 1983 saw *The Nutcracker's* first televised ice-capade that I am aware of…That year, **The Nutcracker: A Fantasy on Ice** was produced for American TV. This 85-minute outing starred Brit Winter Olympic figure skating gold medallist[98] Robin Cousins as the Nutcracker/Prince and American figure skating World Champion and Winter Olympic gold medallist[99] Dorothy Hamill as Clara. The narrator was none other than **Bonanza**'s Ben Cartwright and the original **Battlestar Galactica**'s Commander Adama, Lorne Greene. They don't do things by halves, our colonial cousins across the pond!

But that's not the only version that's iced the Sugar Plum, so to speak. 1995 witnessed yet another ice-skating holiday spectacular… **Nutcracker on Ice** was produced for American TV that year (…though I expect the ice was probably the only thing that would raise a shiver in such a family-orientated treatment of the tale!). And the familiar characters were strutting and toe-looping their stuff onscreen again in 1998, when yet another **Nutcracker on Ice** – a 58-minute long US production – was released on video.

And don't think the fun stops there! Because, since the 84-minute Polish movie **Dziadek do orzechów** (aka **The Nutcracker**), which was mentioned in the previous chapter, was released,[100] there have been all sorts of other versions produced to satisfy the cinemagoing, video-and-DVD-buying and TV-watching public's craving for Sugar Plum Fairies and enchanted

97. As Best Actress for *Mary Poppins (1964)*

98. He won an individual gold at the 1980 Winter Olympics

99. She was the 1976 World Champion and won an individual gold at the 197 Winter Olympics

100. On Christmas Day 1967

implements of kernel extraction! 1973, for instance, witnessed the release of first animated version of the tale that I am aware of (of anything approaching featurette length anyway) with the 27-minute Soviet-produced **Shchelkunchik** (aka **Nutcracker**). This was directed by Boris Stepantsev for Soyuzmultfilm.

While 1979 saw the first feature-length animated (stop-motion) version of the tale produced in Japan and entitled **Nutcracker Fantasy**. This one was directed by Takeo Nakamura, an animator on the Rankin/Bass Christmas classic **Santa Claus is Comin' to Town** in 1970, and its eclectic vocal cast included Hammer horror's very own Count Dracula, Christopher Lee, Zsa Zsa's sister, Eva **"Green Acres"** Gabor, **Knot's Landing**'s Michele Lee, Roddy (**Planet of the Apes**) MacDowall, Dick Van Patten and **Little House on the Prairie**'s Melissa Gilbert!

This film is apparently quite dark and mystical, eschewing the usual brightly coloured kiddie-vision visuals and mixing some 1970s electro-pop with the usual Tchaikovsky classical music! It's pretty trippy man! – though the rascally rodent here has only two heads rather than Hoffmann's original seven. Still, I understand the (possibly fever-induced) dream/nightmare world of young Clara is more than ably conveyed.

But from the sublime, to the ridiculous...1988 even saw **The Care Bears** have a go...**Care Bears Nutcracker Suite** (aka **Care Bears: The Nutcracker** in the USA) was released on video (but nothing too scary there, I dare say!...doubtless all furry, fluffy cuddles and, well...caring!). Indeed, being aimed at a predominantly youthful audience (market?), many of the animated adaptations of Hoffmann's tale would naturally skirt the darker more disturbing elements. And so it was with 1990's **The Nutcracker Prince**. This Canadian production, directed by Paul Schibli for cinematic release, despite being one of the better feature-length animated movies based on the familiar story and featuring the vocal talents of Kiefer Sutherland, Megan Follows, Peter O'Toole and madcap Phyllis Diller, purposely excises many of the more disturbing elements of the tale – or else camps them up into goofball kiddie cartoon fun. But I still like this version quite a lot. At least it's well made and entertaining.

The 1995, 47-minute long, Japanese/American co-produced video released animation **The Nutcracker** is cheaper and less fulfilling, being so definitely aimed at really quite young youngsters, that the tale's unsettling elements are more watered-down than a child's wine at a festive French Christmas dinner!

While 1997 witnessed a rather BIG disappointment in the 37-minute adaptation entitled **The IMAX Nutcracker** with Miriam Margolyes as Sugar Plum, a 1999 computer-animated release proved that animated takes on the tale – even if they pretty much lost both Hoffmann and Tchaikovsky along the way – could be enormous, anarchistic fun.

The Nuttiest Nutcracker, released that year on video, is an absolutely madcap reinvention of the tale (I guess familiarity, while it didn't exactly breed contempt for the writers of this one, sent them spinning off in their own surreal little direction!). It features a bunch of animated nuts (no, not nutters – though that too – but nuts ...Macadamia, Peanut, Brazil nut etc) lampooning the whole thing. It has very little to do with Hoffmann – or Tchaikovsky for

that matter – and is a tad irreverent; but what the hey, it's good fun...and with vocal talents like Jim Belushi, Cheech Marin[101] and loopy Phyllis Diller (again!) aboard, you probably know not to take it too seriously, right? (I actually quite liked this nutty reinvention...even if they only used the kernel – pardon the pun – of the original story. It certainly lives up to its title though).

And what could follow that? ...Well, how about a 45-minute long animated version of *The Nutcracker* directed by Toshiyuku Hiruma Takashi and released on video by Good Times[102], which – although it is definitely aimed at kids – manages to keep many elements of Hoffmann's original tale that other (even more adult-orientated) productions eschew... like the all-but-unchewable Krakatuk nut, the 15-year search for this all over the world, and even the seven-headed Mouse King? Sure, all these elements are conveyed in kiddie-friendly, brightly-coloured, not particularly inspiring, cheap-as-chips animation style that's certainly of no better a standard than some of the stuff you used to see on Saturday morning kids TV... but hey, at least it's there.[103]

A shorter (25-minute) animated version entitled *Katya and the Nutcracker: A Christmas Fantasy*, produced in the USA showed up in 2001. The opening of this one seemed to promise a fairly faithful adaptation too, with a sharply realised 1910 computer animated St. Petersburg...but the crisp sharp, colourful, child-friendly graphics soon veer off in their own direction. And the mouse army even have anachronistic uniforms and weapons for the period setting – gas masks? Bazookas?!

An 82-minute long US/German/Russian co-produced animation followed, which was released on video in 2004. This production, whose title harkens back to Hoffmann – *The Nutcracker and the Mouseking* (aka *Nussknacker und Mäuskönig* in Germany) – features Leslie (the *Airplane* and *Naked Gun* movies) Nielsen, Robert (the *Airplane* movies too) Hays and Eric (**Monty Python's Flying Circus**) Idle among its vocal cast.[104]Once again though, it is aimed very much at children, and although pleasant enough and enjoyably whimsical, there are no shivers to be sent down the viewer's spine here (unless the person sitting behind you drops their ice cream down your back!).

And so swiftly onwards... I won't even stop to mention the 25-minute made-for-American-TV kiddies show **Nutcracker Sweeties** featuring a character called 'The Sugar Rum Cherry' – oh, damn, I have done! Well, never mind. Now that I have mentioned it, I suppose that I should also mention the wickedly disappointing 2007, 47-minute long, video released animated effort *Tom and Jerry: A Nutcracker Tale*... Not that I particularly want to, because it's a bit of a dog – neither *The Nutcracker* nor *Tome and Jerry* really...just a cheap-jack, slapped

101. Of Cheech and Chong fame (or should that be notoriety?)

102. I don't know for sure, but I have listed it as an American/Japanese co-production

103. I did have to laugh at the Mouse Queen's evil spell, which was meant to turn Princess Perlipat from
104.a beautiful young girl into a ghastly, obscene vision of horror though...it made her look like nothing more than the old **Spitting Image** puppet version of the Queen! For the English language version

together non-entity (from a story by Joseph Barbera surprisingly). The story sees Jerry Mouse use a magic spotlight to bring some toys to life in a theatre following a performance of the famous Tchaikovsky ballet at Christmastime. Tom and a roguish group of alley cats who have gained entry to the theatre try to take over and a battle ensues. It's nowhere near as good as the classic old T&J cartoons I'm afraid.

There have been a few straightforward, non-ballet, live-action adaptations of the tale too. In 1961, a 50-minute B&W production based on Hoffmann's tinsel-tinged treat was made for US TV. Entitled **The Enchanted Nutcracker**, it starred Robert Goulet.

Don't be fooled by 1982's **The Nutcracker** (aka **The Nutcracker Sweet**). This isn't a version of the ballet, nor even of the Hoffmann tale. It is a fairly dire Joan Collins post- **The Stud (1978)/The Bitch (1979)** bit of British-produced twaddle set in a ballet milieu which concerns a defecting Russian ballerina. It co-stars Carol White, Paul (**Just Good Friends**) Nicholas, William ("Shhhh, you know who!"[105]) Franklyn, Leslie ('The Lip'[106]) Ash, Murray Melvin and Cherry Gillespie (ex-of Pan's People!).

Perhaps the real turn up for the readers of this book though (if not necessarily 'a turn up for the books' *per se*!) was 2001's **Nutcracker** (aka **Nutcracker: An American Nightmare**). This was not actually based on the Hoffmann tale at all, but references it visually and shares (if rather obliquely) some of its darker themes. This "Nut cracker" is a egocentric psychiatrist who cracks the cases of 'nuts' he accepts as patients and cures them! (Don't look at me PC police – I didn't write it!). This kook, who is as nutty as his headcase patients in many ways, utilises hallucinogenic drugs and personality-melding machinery on his patients. And the film not only features a murderous psycho, but boasts the presence of David Hess (psycho-killer Krug from Wes Craven's seminal revenge slasher **Last House on the Left (1972)** in its cast. I will come back to this movie later – in the chapter that deals with the "naughty noughties."

A live-action Canadian TV production of 2007, called **The Secret of the Nutcracker**, directed by Eric Till (the director of **An American Christmas Carol (1979)** as well as the fantastic **The Christmas Toy (1986)** and **The Muppet Family Christmas (1987)**) appears to have promise; especially with a cast that includes Brian Cox (the silver screen's first Hannibal Lecktor[107] in **Manhunter (1986)**. But having not yet seen it, I cannot give a detailed account or a firsthand response.

105. This is the catch-line for a TV advertisement for Schweppes he used to do

106. A pretty blonde ex-model and actress, who starred in the TV sitcom **Men Behaving Badly**. She suffered when cosmetic surgery to her mouth left her with huge, swollen protruding lips that looked more like a guppy than Angelina Jolie – whose pouty 'look' was probably the inspiration for the intervention in the first place.

107. Their spelling (The film, directed by Michael Mann, was based on Thomas Harris's novel *Red Dragon*; which was later made into a film with that title in 2002 starring Anthony Hopkins as Dr. Hannibal 'The Cannibal' Lecter - a sequel to the 5 Oscar winning *The Silence of the Lambs (1991)* and *Hannibal (2001)*)

And although I have not seen ***The Nutcracker: A Christmas Story (2007)*** either, I thought that I had better mention this hour-long US/Hungarian/German produced video release as the penultimate entry in this chapter...mainly because it appears to be some kind of weird experiment worthy of a typical B-movie mad scientist: like Frankenstein, or perhaps more appropriately Dr. Moreau,[108] the producers have cross-fertilised two of the most popular, evergreen festive classics (Dickens' *A Christmas Carol* and Tchaikovsky's-by-way-of-Hoffmann's *The Nutcracker*). Having not yet seen it though, I cannot tell whether they have created a dance monster! ...And where the Devil comes in (see characters in the cast list above) I am not really sure.

Finally then, just to point out – this particular tale, like Dickens' *A Christmas Carol*, continues to prove inspirational to filmmakers, theatrical impresarios and TV producers...and by way of proof, I offer up yet another cinematic adaptation that is currently still in production[109] and slated for release in 2009. The UK-produced ***Nutcracker: The Untold Story*** is being directed by Andrei Konchalovsky and includes John Turturro, ***Withnail & I***'s Richard E. Grant, Nathan Lane and **Rising Damp**'s Miss Jones, Frances de la Tour in its cast (though, being still in production, these could change).

Well, I have cracked-on enough about all the different versions of *The Nutcracker* that are out there that I know of, and so on to *the meat* so to speak – the entertaining offspring of a strange connubial consummation when Christmas and horror genre and themes finally married in the 1970s.

108. Dr. Moreau is the eponymous protagonist in a novel by H.G. Wells, *The Island of Dr. Moreau*, first published in 1896, in which the amoral medico experiments with creating new breeds by surgically crossing humans with animals on his isolated island.

109 It is being shot primarily in Budapest, Hungary

THE FILMS

Some are Nuts and Others Crackers!

Barbie in The Nutcracker 2001 USA 55mins (Animation)
Directed: Owen Hurley **Written**: Linda Engelsiepen & Hilary Hinkle & Rob Hudnut
Cast: Kelly Sheridan (Barbie/Clara), Kirby Morrow (Nutcracker/Prince Eric), Tim Curry (Mouse King)

Care Bears Nutcracker Suite 1988 USA 61mins (Animation)
Aka Care Bears: The Nutcracker

Dziadek do orzechów 1967 Poland 84mins
Directed & Written: Halina Bielinska
Aka The Nutcracker (International title)

The Enchanted Nutcracker 1961 USA TV B&W 50mins
Directed: Jack Smight **Written**: Bella & Sam Spewack **Cast**: Robert Goulet (Johnny)

The IMAX Nutcracker 1997 USA 37mins
Directed & Written & Costumes: Christine Edzard **Cast**: Miriam Margolyes (Sugar Plum), Heathcote Williams ('Uncle' Drosselmeyer), Lotte Johnson (Clara), Benjamin Hall (Nutcracker Prince)

Katya and the Nutcracker: A Christmas Fantasy 2001 USA 25mins (Animation)
Directed & Design: Alistair Graham

Der Nußknacker 1964 Germany /USA TV 55mins (Ballet)
Directed: Heinz Liesendahl **Written**: Kurt Jacob **Cast**: Eddie Albert (Narrator/Host), Edward Villella (Nutcracker/Prince), Melissa Hayden (Sugar Plum Fairy)

Aka The Nutcracker (International title)

The Nutcracker 1958 UK TV B&W 120mins (Ballet)
Directed: Margarate Dale **Cast**: Margot Fonteyn (Sugar Plum Fairy), Lucette Aldous (Snow Queen), Bengt Andersson (Drosselmeyer)

The Nutcracker 1968 UK 100mins (Ballet)
Revisions to original Hoffmann tale by Rudolf Nureyev **Cast**: Rudolf Nureyev (Drosselmeyer/ Prince), Merle park (Clara), Wayne Sleep (The Nutcracker)

The Nutcracker 1977 USA TV 78mins (Ballet)
Directed: Tony Chamoli **Written** (narration): Yanna Kroyt Brandt **Cast**: Mikhail Baryshnikov (Nutcracker/Prince), Gelsey Kirkland (Clara), Alexander Minz (Drosselmeyer)

The Nutcracker 1985 UK TV (Ballet)
Directed: John Vernon **Cast**: Joan Fonteyn (Herself – Host), Michael Coleman (Drosselmeyer), Lesley Collier (Sugar Plum Fairy)

The Nutcracker 1988 France 90mins (Ballet)
Directed & story amendments: Rudolf Nureyev

Aka Rudolf Nureyev's The Nutcracker

The Nutcracker 1989 Russia (Ballet)

The Nutcracker 1993 USA 92mins (Ballet)
Directed: Emile Ardolino **Written** (narration): Susan Cooper **Choreographed**: George Balanchine **Cast**: Kevin Kline (Narrator), Macaulay Culkin (The Nutcracker/The Prince/ Drosselmeier's Nephew), Darci Kistler (Sugar Plum Fairy), Bart Robinson Cook (Drosselmeier)

Aka George Balanchine's The Nutcracker

The Nutcracker 1994 Russia 101mins (Ballet)
Directed: Yvon Gérault

The Nutcracker 1995 Japan/USA 47mins (Animation)
Directed: Toshiyuki Hiruma & Takashi Masunaga

The Nutcracker 1999 Germany (Ballet)
Directed: Alexandra Tarta **Revisions** to original story: Patrice Bart (uncredited)

The Nutcracker 2000 France 102mins (Ballet)
Directed: Ross MacGibbon **Written & Choreographed**: Maurice Béjart

Nutcracker 2001 USA 81mins
Directed & Written: Glen Grefe **Cast**: David Hess (John Gard/Clyde Fairfax), Jesse Hess (Young Clyde)
Aka Nutcracker: An American Nightmare

The Nutcracker 2001 UK TV (BBC) 115mins (Ballet)
Directed: Ross MacGibbon & Roger M. Sherman **Written** (Commentary): Wendy Wasserstein

Nutcracker! 2003 UK TV 88mins (Comic Ballet)
Directed: Matthew Bourne

The Nutcracker: A Christmas Story 2007 USA/Hungary/ Germany 59mins
Directed: Youri Vamos

The Nutcracker: A Fantasy On Ice 1983 USA TV 85mins
Directed: Ron Meraska **Cast**: Dorothy Hamill (Clara), Robin Cousins (Nutcracker/ Prince), Lorne Green (Narrator)

The Nutcracker and the Mouseking 2004 USA/Germany/ Russia 82mins (Animation)

Directed: Tatjana Ilyina & Michael G. Johnson **Written**: Ross Helford & Andy Hurst (adaptation by Ytatjana Ilyina & Andrej Knishev & Victor Perelman) **Cast** (English version): Leslie Nielsen (Mouseking), Robert Hays, Eric Idle

Aka *Nussknacker und Mäuskönig*

Nutcracker Fantasy 1979 Japan 82mins (Animation)

Directed: Takeo Nakamura **Written**: Eugene A/ Fournier & Thomas Joachim (adapted from E.T.A. Hoffmann's tale *The Nutcracker and the Mouseking*) **Cast:** Christopher Lee (Uncle Drosselmeyer/Street Singer/Watchmaker), Eva Gabor (Queen of Time), Melissa Gilbert (Clara), Michele Lee (Narrator), Roddy McDowall, Dick Van Patten

Nutcracker on Ice 1995 USA TV

Directed: Richard Wells **Cast**: Nicole Bobek (Clara), Todd Eldredge (Nutcracker/Prince), Brian Orser (Drosselmeyer), Peggy Fleming (Sugar Plum Fairy), Brian Boitano

Nutcracker on Ice 1998 USA 58mins

Cast: Tai Babalonia (Clara), Randy Gardner (Nutcracker Prince)

The Nutcracker Prince 1990 Canada 75mins (Animation)

Directed: Paul Schibli **Written**: Patricia Watson (adapted from E.T.A. Hoffmann's tale *The Nutcracker and the Mouseking*) **Cast**: Kiefer Sutherland (Nutcracker Prince), Megan Follows (Clara), Peter O'Toole (Pantaloon), Phyllis Diller (Mousequeen)

Nutcracker Suite 1925 USA B&W (Animation)

Directed: Dave Fleischer

Nutcracker: *The Motion Picture* 1986 USA 89mins (Ballet)

Directed: Carroll Ballard **Revisions** to E.T.A Hoffman's original story by Maurice Sendak & Kent Stowell **Design & Costumes**: Maurice Sendak

Nutcracker: The Untold Story (in production) UK
Directed: Andrei Konchalovsky **Written**: Andrei Konchalovsky & Chris Solimine **Cast**: John Turturro (Mouse King), Elle Fanning (Mary), Nathan Lane (Uncle Albert), Richard E. Grant (Father), Frances De La Tour (Rat Mother/Frau Eva)

The Nuttiest Nutcracker 1999 USA 48mins (Animation)
Directed: Harold Harris **Cast**: James Belushi (Reginald), Phyllis Diller (Sugar Plum Fairy), Cheech Marin (Mac)

Shchelkunchik 1973 USSR 27mins (Animation)
Directed: Boris Stepantsev **Written**: Boris Larin & Boris Stepantsev

Aka Nutcracker (International title and literal translation)

The Secret of the Nutcracker 2007 Canada TV
Directed: Eric Till **Written**: John Murrell **Cast**: Brian Cox

The Swinging Nutcracker 2001 Canada TV
Directed: Shiel Piercy

Tom and Jerry: A Nutcracker Tale 2007 USA 47mins (Animation)
Directed: Spike Brandt & Tony Servone **Written**: Spike Brandt (from a story by Joseph Barbera)

CHAPTER 5

Let the Christmas Carving Commence!

From the 1970s onwards (Norman Bates having set a trend in Hitchcock's ahead-of-its-time B&W shocker **Psycho** in 1960) knife[110]-wielding slashers stalked the silver screen...and eventually the TV screens too, thanks to videos and later DVDs. Roman Polanski paved the way with his prestigious adaptation of Ira Levin's devilishly good shocker **Rosemary's Baby** in 1968; but two 'Willies' (William Peter Blatty and William Friedkin) really put the willies up the world when they gave a pre-pubescent teenager a bad case of acne, a foul mouth, a decidedly disturbing voice, pea-soup vomit, a spinning head and a funny thing to do with a crucifix! 1973s **The Exorcist** put the bejeebers up most everybody who saw it (and that was an awful lot of people, thanks to brilliant box-office and later home rentals!) ...And when Steven Spielberg's big rubber fish called Bruce[111] showed up a couple of years later in **Jaws (1975)** and Richard Donner's unpleasant, power-seeking brat Damien Thorn (cue Carl Orff's 'Carmina burana'!) in **The Omen** followed along in 1976, on the crest of a wave of scene-setting teaser trailers (that probably cost almost as much as the film!) big budget (ad big profit) horror was most definitely here.

But lower budget indie horror outings proliferated too. Many inspired by George A. Romero's B&W bargain-basement budgeted but gloriously gory and gruesome smash shot in Pittsburgh, Pennsylvania, **Night of the Living Dead (1968)**[112]. Low cost shockers like Tobe Hooper's **The Texas Chainsaw Massacre (1974)**, John Carpenter's **Halloween (1978)** and Sean S. Cunningham's **Friday the 13th (1980)** featured faceless multiple murderers; horribly inventive slayings of disposable teen characters and spawned several sequels. They are usually

110. And by degrees a startling assortment of other lethal weapons

111. The name given to the animatronic shark used in Jaws

112. Which I like to think of as horror/sci-fi's **Easy Rider (1969)** as it seemed to put the cat among the film producing pigeons in a similar way: a micro-budgeted movie hitting pay-dirt at the box-office.

perceived as being at the vanguard of the sub-genre that became known as 'slasher' flicks. ...Which, thanks in no small part to a bespectacled old busybody battleaxe in Britain called Mary Whitehouse, led onto the whole "video-nasty" fiasco.[113] But few people realise that a brilliantly made horror movie set at Christmastime with a murderous tormentor wilfully slaying a group of college sorority girls pre-empted the seminal **Halloween** and **Friday the 13th**, laying many of the 'ground rules' for the gory slew of 'slasher' flicks that would follow. ...Or that a couple of even earlier Brit flicks and a made-for-American-TV shocker gave the world the screen's first real Christmas-set out- and-out horrors and the screen's first 'Psycho Santa.'

But lets kick off with something altogether more sweet and family-friendly... Although not a horrific in any way, the 50-minute Rankin-Bass made for American TV stop-motion classic Christmas animation **Santa Claus is Comin' to Town** from 1970 gets a mention, not only because it is glorious in its own right, but because (unscary as it may be, targeted at a family audience) it does feature the wicked Winter Warlock. This is the terrible mountain entity from which the forest animals save the foundling baby lost on its way to an orphanage and deliver him to a family of elves to bring up as one of their own. A postman who looks remarkably like (and was voiced by) Hollywood legend Fred Astaire tells the tale, and the Winter Warlock – all white clothes, white claw-like hands, pointy white teeth and white skin – is wonderfully voiced by Keenan Wynn. And though he starts off as a baddy, guess what? ... Yep, by the end, when the foundling adopted by the elves grows up to be Santa Claus, the wicked old Winter Warlock is won over and he ends up being, alright as well as all-white.

But enough of the nice stuff...lets get down to the gruesome horrors, shall we? ...The earliest of the aforementioned Christmas-set out-and-out horrors was a slick British horror flick (albeit one produced by American International Productions along with Hemdale). It had long been a practice for European – and probably especially British – filmmakers to import an American star (often one whose career was perhaps fading somewhat in Hollywood) to head the castlist – usually in an attempt to secure a wider release or attract more box-office stateside and around the world. And there had been something of a boom in the internationalisation of moviemaking in the 1960s. Look at William Holden in **L'Abre de Noël (1969)** and think of the success of some of the 'Spaghetti Westerns'[114] with American leads (even if Clint Eastwood became a star on the back of some of the most famous of these[115], rather than being an established Hollywood star losing his lustre).

113 Mary Whitehouse was a self-proclaimed moral guardian and crusader. As videos became popular household entertainments, a moral backlash against supposedly degenerate movies was launched with many titles being confiscated and barred. (Though perhaps an indication of how absurd, unresearched and unenlightened this storm in D-cup was can be gleaned from knowing that auteur Samuel Fuller's gritty WWII actioner was initially confiscated because it was assumed that The Big Red One in question was something other than the 1st Infantry Battalion's numerical insignia!!!)
114 Italian made Westerns (often actually shot in Spain)

115 Sergio Leone's 'Dollars' trilogy, **Per un pugno di dollari (A Fistful of Dollars (1964))**, **Per qualche di dollaro in più (For a Few Dollars More (1965))** and **Il Buono, il brutto, il cattivo (The Good, the Bad and the Ugly (1966))**.

And American International Productions had already used the same formula with earlier productions, like the excellent **Witchfinder General (1968)** starring Vincent Price in an otherwise all-British cast – which is often regarded as one of the best British horror films of all time...and is decidedly British in nature.

Directed by Curtis Harrington, the American writer/director of 1965's **Voyage to the Prehistoric Planet**[116] (aka **Prehistoric Planet** and **Voyage to a Prehistoric Planet**) and 1966's **Queen of Blood**[117] (aka **Planet of Blood**, **Planet of Terror**, **Planet of Vampires** and **The Green Woman**) – both fairly low-rent exploitation schlockers in a sci-fi/horror vein – perhaps not a great deal might have been expected of **Whoever Slew Auntie Roo?**[118] which was released in 1971. However, the film actually turned out to be quite an effective little shocker in **Whatever Happened to Baby Jane (1962)/Hush...Hush, Sweet Charlotte (1964)** dotty-old-psycho-killer-bird vein; albeit with the additional interest of a period setting, an old, dark house atmosphere and a fairytale inspirational basis[119]!

Set in 1920s England, the 91-minute film inspired by the Brothers' Grimm grim fairytale *Hansel and Gretel* (with a Written by American Robert Blees[120] based on a story by David D. Osborn) stars double Oscar Winner[121] Shelley Winters as Mrs. Rosalie 'Roo' Forrest, a demented, wealthy old widow with a terrible, sad secret. Right from the get-go you know that she is more than some cranberry sauce short of a full Christmas dinner! The film opens, with her in a nursery full of dolls and young girl's toys, singing a lullaby to a beautiful bonny blonde baby girl rocking in a crib. But when the youngster falls asleep and Mrs. W gets up to

116. An exploitation movie - originally a film made in the Soviet Union as *Planeta Bur (1962)* (aka *Planet of Storms, Planet of Tempests, Storm Planet, Cosmonauts on Venus* and *Planeta Burg*), Harrington utilised footage to build and recut a story around, shooting further footage with American stars – the past their prime Basil Rathbone (the screens Sherlock Holmes of the late 1930s and 1940s) and Faith Domergue of *Cult of the Cobra, This Island Earth It Came from Beneath the Sea (*all *1955)* and being multimillionaire filmmaker Howard Hughes's young flame fame. (At one point he tried to promote her as the next Jane Russell).

117. Another exploitative effort – this time culling its special effects sequences from the Soviet film *Nebo Zovyot (1960)* and starring John Saxon alongside Basil Rathbone, with Dennis Hopper and Forrest J. Ackerman along for the ride!

118. Aka *Who Slew Auntie Ro?*

119. The film's working title was *The Gingerbread House* reflecting its debt to the Brothers' Grimm fairytale *Hansel and Gretel)*

120. Who also scripted genre movies like *The Black Scorpion (1957) (co-writer)*, *From the Earth to the Moon (1958)* and *Dr. Phibes Rises Again (1972)* (co-writer), as well as the early eco-revenge horror *Frogs (1972)* (co-writer).

121. As Best Supporting Actress for *The Diary of Anne Frank (1959)* and *A Patch of Blue (1965)* – she was also nominated as Best Actress for *A Place in the Sun (1951)* and Best Supporting Actress in *The Poseidon Adventure (1972)* (the same year as *Whoever Slew Auntie Roo?*)

sneak out of the room, the camera pans back round to the crib to reveal a decayed, skull! A nice shock moment and one that sets the scene for the rest of the film. [122]

The film mostly takes place in Auntie Roo's creepy, idiosyncratic country pile – a mansion with two-tone brickwork, castellation, and features that give it something of a fairytale oddness to its general appearance. Mr. Forrest, a celebrated British magician married American showgirl Rosalie and they lived there with their daughter Katherine. But Mr Forrest is long dead and Katherine disappeared without trace years ago (she was actually killed in an accident; but her mother, demented with grief, could not cope with the loss or bury her child). Since that time, Mrs. Forrest has held regular séances to try and contact her daughter...but her servants, a butler and maid (nicely played by Michael Gothard and Judy Cornwell) are a nasty pair it transpires, and they conspire with an alcoholic medium (a fine cameo by Sir Ralph Richardson[123], born in my home town of Cheltenham, about ½ mile from where I live), to provide sham (vocal) contact with Katherine's spirit and milk the devoted, guilt-riddled old girl of her money.

Although obviously driven somewhat crazy by grief, Roo does not appear to be dangerous or homicidal. Every year at Christmastime she throws a party at her mansion for ten children from the local orphanage (hence the 'Auntie' designation) spoiling them with feasts and treats and Christmas gifts. This year though there is a difference...this year two siblings not selected by the witchy head of the orphanage (well played by Rosalie Crutchley) sneak into the luggage compartment of the car that takes the children to "the Gingerbread House" – as the orphans call it – and gatecrash the party. And though the head of the orphanage is angry, kindly 'Auntie Roo' is only too happy to have two extra children along...not least because Katy reminds her so much of her dead daughter Katherine! These two cute (or should that be too cute?) tykes are Christopher – played by Mark (*Oliver! (1968)*) Lester and his younger sister Katy – played by Chloe Franks, who appeared in the Christmassy segment of the portmanteau horror *Tales from the Crypt*, released the year after *Whoever Slew Auntie Roo* (but more about that shortly).

The children have a fine old time of it at Auntie Roo's party, stuffing themselves with Christmas dinner and sweets, receiving presents on Christmas morning and watching the old girl give a performance of her ancient theatrical act. There are decorations and a Christmas tree; everything poor little orphans could want for Christmas, short of an actual (or adoptive) family. But the séances and circumstances come to make the mentally deranged matriarch believe that Katy is the reincarnation of her daughter Katherine, so when it is time for the children to leave, she secretly keeps Katy and hides her away in the secret nursery – not against the young moppet's will; the girl likes the idea of being adopted by the rich lady.

But brother Christopher, who has pegged the apparently kindly 'aunt' as a witch (casting himself and is sister in Hansel and Gretel roles, and therefore also in mortal danger), escapes from the orphanage, steals a bicycle and cycles back the 3 miles to the spooky old house to save his sister from the 'witch's' cooker.

122 Though the film's advertising tagline seems a little misleading: "The hand that rock the cradle has no flesh on it!"

123 Ralph Richardson was knighted in 1947

This film is effectively directed (in a bloodless but nonetheless *Grand Guignol* style) and beautifully shot. Some think Shelley Winter's increasingly wild, barnstorming performance is over the top (Christmas ham, perhaps!), but I disagree. I think that her bravura turn is spot on. And the proof of the pudding comes in the eating, for in the final analysis, it is not so much the little urchins the viewer feels sorry for, but the dotty old bird they too (like her servants and hangers-on) steal from, drive entirely over the edge of sanity and eventually murder.

Shelley is ably supported though, by the likes of Gothard, Richardson, Lionel Jeffries (as the police inspector who is suspicious of the second disappearance of a child at Forrest Grange), and even beetling eyebrowed Hugh Griffith in a minor role. But the Hansel and Gretel storyline does depend a great deal on the two younger actors. And thankfully they do not let the side down. Chloe Franks is quite sweet, but also demonstrates a childish selfishness that stops her character from being cloying; while Mark Lester (not my favourite actor – too limp and wet, most of the time; too cherubic, and not the best actor in the world by a country mile – a bit like a prototype Macauley Culkin!) is effective in this role, not so much because of his acting, but because (like Culkin) despite the angelic looks, there is also something creepy (almost evil) about him.

And let's not forget, although 'Auntie Roo' goes bananas, she is driven to it by grief and unscrupulous, greedy people – she never actually intentionally kills anyone (though you wouldn't put it past her when she finally goes as nutty as a Christmas fruitcake!). She is not a witch, but a victim; ostensibly a sympathetic character in many respects, until her final unhinging. ...And even then, a victim still. It is the sly little tyke rescuing his sister from a life of luxury (a strange life of luxury to be sure, but nonetheless perhaps a preferable existence to the grey, hopeless, poverty-ridden world of the orphanage), who casts 'Auntie Roo' as a witch... And who, having done so, disposes of her like one!!! Whoever Slew Auntie Roo? – Why, little Hansel and Gretel – Christopher and Katy, of course... Willingly and wilfully! (But innocently, because they are to young to understand what has driven the old bird crackers? You decide!) Either way, *they* are the actual murderers in this movie, not the old chick they help drive doolally. (Fine thanks that for a lovely Christmas party, eh?! Especially from a pair of gatecrashers!).

This underrated and little known cult horror movie set at Christmastime[124] won't be to everyone's taste I am sure. But if you do actually crave a somewhat darker take on tinsel time (a cruel Yule perhaps), and you enjoy that little sub-genre of melodramatic barnstormers featuring fading or faded Hollywood *grand dames* like Winters, Betty Davis, Joan Crawford etc. as batty old unbalanced birds (like **What Ever Happened to Baby Jane (1962)**, **Hush, Hush, Sweet Charlotte (1964)**, **Fanatic (1965)**[125] and even **Sunset Boulevard (1950)**), then this grim

124 I won't go so far as to actually call it a Christmas Horror movie, because although the festive season is nicely utilised to counterpoint the action, it could probably quite easily have been another celebration or feast day. Christmas isn't absolutely at the crux of the tale's themes.

125 .Aka *Die! Die! My Darling!*

little take on the Brothers Grimm fairytale is certainly worth a watch and is definitely a big step in the right direction for those viewers who would rather lose those oh-so-sweet 'Jingle Bells' and put a batty old bat in their belfry for Christmas.

Meanwhile, across the Atlantic that same year – but not in America, in Canada – the French-Canadians turned out...not a Christmas Horror Movie, but a festive 65-minute long Sci-Fi film... aimed predominantly at children. (So nothing to scare your socks off – or your Christmas stockings for that matter – there! But I think it also deserves a mention merely by dint of having a Martian in it... Only, this time, he's not looking to kidnap Santa, as in the schlock-crock classic ***Santa Claus Conquers the Martians (1964)***[126]- it looks, to their parents at least though, as if he *is* after their kids! ...Though for what end? To do *what* with them? ... The parents get upset when they see the friendly Martian who has befriended their children, trying to tempt them into his spaceship with sweeties!!! (In the current climate of paedophile-paranoia, he would probably be hung, drawn and quartered; have his name put on a list; have the list distributed around the town; be banned from playing Santa in the shopping mall and receive a good shoeing for his troubles! So lucky for him it was the 1970s and not the first decade of the 21st century!).

Written by Roch Carrier and directed by Bernard Gosselin, ***Le Martien de Noël (1971)*** (aka ***The Christmas Martian***) was a children's film though, so naturally the extra-terrestrial visitor is not predatory. Having won over the parents with an explanation as to his good intentions towards their kids, the Martian is invited to share in the town's Christmas festivities and he celebrates the, to him (ironically enough), alien festival with them at a great big Christmas party!

So let us leave the Canadians entertaining their friendly Martian, and return across the ocean to horror-loving Limey once again. Having kicked off the new decade so promisingly, British filmmakers pioneering the move toward fully blown Christmas horror, took another blood-soaked step forward the following year with one segment of a portmanteau or compendium horror film based on an old horror comic, which although it was co-produced by Britain and the USA, was shot entirely in England. Like ***Dead of Night (1945)*** before it, this new movie could not be considered a Christmas Movie, as only one of its quintuplet tales and their linking narrative had anything at all to do with everyone's favourite holly-jolly holiday. But oh boy, was that one segment in the vanguard of what was to follow!

The film, which bears the same title as the E.C. comic book whose stories it adapted for the big screen, was Amicus Productions' ***Tales from the Crypt (1972)***, directed by Freddie Francis[127] (a stalwart of both the Hammer House of Horror and Amicus), with a Written by

126. .See chapter 3.

127 Freddie Francis, an award winning cinematographer, also directed films like ***Paranoiac (1963)***, ***Nightmare (1964)***, ***The Evil of Frankenstein (1964)***, ***Hysteria (1965)*** and ***Dracula Has Risen from the Grave (1968)*** for Hammer; ***Dr. Terror's House of Horrors (1965)***, ***The Skull (1965)***, ***The Psychopath (1966)***, ***The Deadly Bees (1967)***, ***They Came from Beyond Space (1967)***, ***Torture Garden (1967)*** for Amicus; ***The Creeping Flesh (1973)*** for Tigon; ***Legend of the Werewolf*** (aka ***Plague of the Werewolves***) ***(1975)***, ***The Ghoul*** (aka ***Night of the Ghoul*** and ***The Thing in the Attic***) ***(1975)*** for Tyburn – all familiar production houses to horror film fans.

Milton Subotsky[128] (another Amicus stalwart – as a producer as well as a writer). It stars Sir Ralph Richardson as 'The Crypt Keeper' with Hammer Horror legend Peter Cushing, Roy Dotrice (father of Michelle, **Some Mothers Do Have 'Em**'s, Betty Spencer), Ian Hendry (Dr. David Keel in the original series of **The Avengers**), Patrick Magee,[129] Barbara Murray, Nigel Patrick and Geoffrey Bayldon (the Crowman in the **Wurzel Gummidge** TV series), among others. The only Christmassy segment (entitled *All Through the House*) stars Joan Collins (who later found renewed fame as **Dynasty**'s – or was it

Dyssentry's ? – uber-bitch Alexis Carrington) and **Whoever Slew Auntie Roo**'s little angel, Chloe Franks as her daughter, along with Martin Boddey (apt name[130]!) as her husband and Oliver MacGreevey in a seminal ro-ho-ho-le as their Christmas Eve visitor.

In my book (and lets face it, I am writing this, so it is my book!), **Tales from the Crypt** is one of the very best of the multi-story portmanteau or compendium horror movies that enjoyed resurgence in popularity in the 1960s and 1970s (thanks in no small part to Amicus). It opens with a group of people taking a tour of some crypts. They get separated from their guide and end up in a large empty subterranean crypt with a stone seat hewn out of one wall beneath what looks like a large hewn out skull. The door which they entered the dead end room through closes behind them and a mysterious Crypt Keeper who has appeared relates to each a story concerning deeds they might be capable of doing. This film not only features a top-notch cast, but some stunning cinematography.

In a house decorated in a very trendy 1970s style, on a snowy Christmas Eve, a husband places a gift wrapped present for his wife below a Christmas tree and sits back to read the newspaper as Christmas songs play on the radio. His wife promptly stoves in his head from behind with a poker, killing him; the newspaper held in front of his face stained red with his blood after the sickening thud of the blow (just one example of the excellent direction and stunning cinematography that is such a feature throughout the film!). The couple's young

128 Milton Subotsky wrote the screenplays for films like *Dr. Terror's House of Horrors (1965)* , *The Skull (1965), They Came from Beyond Space (1967), I, Monster(1971)* and *The Vault of Horror (1973)* and produced *The Skull (1965), The Psychopath (1966), The Deadly Bees (1967), They Came from Beyond Space (1967), The Terronauts (1967), Torture Garden (1967), The House that Dripped Blood (1971), Asylum* (aka *House of Crazies) (1971), From Beyond the Grave* (aka *Creatures, Creatures from Beyond the Grave, Tales from Beyond the Grave, Tales from Beyond* and *The Undead) (1973), The Vault of Horror* (aka *Further Tales from the Crypt* and *Tales from the Crypt , Part II) (1973), ..And Now the Screaming Starts! (1973), The Beast Must Die (1974)* and *The Monster Club (1980)* or Amicus (many of them portmanteau horror movies). As well as producing films like *Dr. Who and the Daleks (1965), Daleks Invasion Earth 2150 AD (1966),* the wonderful and underrated *Scream and Scram Again (1970), Madhouse* (aka *Deathday, The Madhouse of Dr. Fear, The Revenge of Dr. Death) (1974)* as well as co-producing slightly more recent films like *Cat's Eye* (aka *Stephen King's Cat's Eye) (1985) , Maximum Overdrive (1986),* the TV movie *Sometimes they Come Back (1991), Lawnmower Man (1992)* and *Sometimes They Come Back…Again* (aka *Sometimes They Come Back 2) (1996)*.

129 A stalwart character actor on stage and screen, and a favourite of playwright Samuel Beckett, who wrote the play *Crapp's Last Tape* specifically for him as a performer.

130 He plays the husband Joan Collins' character murders

daughter upstairs in her bedroom is disturbed, but her mother manages to evade detection and encourages the girl who has risen thinking Santa has arrived, to go back to bed.

As the woman contemplates clearing up after her crime, she hears a report on the radio about an escaped homicidal lunatic dressed in a Santa suit he has stolen. The woman attempts to secure the house...and it is a good job as the lunatic is right outside. This is a beautifully tense and taut short story; it utilises the Christmas music on the radio beautifully to underscore the action, the timing is faultlessly precise to ensure that the tune and lyrics are wryly apposite.

Struggling to clean up the evidence of her crime and make her husband's death look like an accident while at the same time keeping the homicidal lunatic outside at bay, the woman comes to realise that the curtain across the hallway in front of the front door is moving in a breeze, indicating that the front door may be open! ...She is horrified and approaches with terrified caution. To her great relief though, it is her daughter who steps out from behind the curtain (Phew!)

...Unfortunately though, the little cherub has been looking out for Santa, and having seen him hanging around outside, she has come down to let him in, her innocent young mind never questioning the tattiness of his suit, or his slobbering, crazy-eyed stared. She is delighted; her mother absolutely horrified; and implicitly, both of them are probably doomed to a bloody, gruesome demise at the hands of the escaped psychopath. Priceless. Wonderful. Excellent. It is all beautifully shot and entirely in keeping with the dark ironic humour of the inspirational E.C. comic books that inspired it (comic books that, incidentally, I used to absolutely adore as a kid!).

And staying in Britain for the time being, I would like to explore another film, which, although it is not really a Christmas Movie *per se,* nor indeed a frightening film by any stretch of the imagination – does, I think, still deserve inclusion in this exploration of the cinematic offbeat with Crimbo connections or credentials. True, **The Amazing Mr. Blunden (1971)** is aimed predominantly at a family audience – and especially the kids; but it does deal with the concept of ghosts in a very interesting and highly unusual way (as manifestations out of time rather than beyond death)...and it does open at Christmastime and close with a festive reference to its cool Yule opening sequence.

Adapted from Antonia Barber's novel *The Ghosts* and directed by British comedy character actor-cum-director, Lionel Jeffries – Granddad Potts from **Chitty Chitty Bang Bang** and the director of the classic **The Railway Children (1970)** – **The Amazing Mr. Blunden (1972)** opens with the eponymous solicitor (played by British character Laurence Naismith, whose last big screen appearance it was) paying a visit to the Allen family in their dingy Camden Town basement apartment one snowy Christmas Eve in Edwardian England. Mrs Allen is a widow with 3 children, one a babe in arms, who has been forced to move her family into their current cramped and dismal digs as a result of impoverishment following her husband's death and the sale of their nice middle-class terraced home. The mysterious Blunden tells the Allens of a position at an isolated, empty old country house that might prove more beneficial

to the impoverished family, including a cottage that they could live in as caretakers. He instructs Mrs. Allen to visit the offices of the law firm of which he is a partner the following day. However, when she is out of the room, he also asks her two older children[131] if they would be scared by ghosts if they looked exactly like real children of their own age, or perhaps rather like him. Then he takes his leave and disappears into the snowy night rather like a ghost as carollers sing 'We Three Kings of Orient Are.'

When Mrs. Allen reports to the law firm, the clerk is a little dumbfounded as Mr. Blunden is apparently laid up in bed ill and the position she is enquiring about has not even been advertised, but Mrs. Allen secures the job and the children do indeed encounter some ghosts at the dilapidated mansion...only they are not ghosts in the traditional sense – rather, they are children who have used a potion and charm to travel through time to seek help as they know that their wicked stepmother (played brilliantly as a human monster by Diana Dors) is planning to kill them off to ensure their rightful inheritence goes to her own bubble-headed daughter (also nicely played by Madeline Smith).

The Allen children naturally accept and return one hundred years into the past themselves using the potion and chant supplied by their new friends from long ago – becoming in a sense ghosts from the future. There they actually help change the future of their hosts (who would otherwise have died at the hands of their step-parents 100 years ago). Interestingly though, they complete their mission by inspiring Mr. Blunsden (the great-great-grandfather of the solicitor in their own age, but who looks exactly like their Mr. Blunsden) to act on the nineteenth century children's behalf – something he had signally failed to do and ended up regretting for the rest of his life. And what is more, the twentieth-century Mr. Blunsden also jaunts back in time as a future-ghost to help ensure his great-great-grandfather's action (and thereby redemption and self-forgiveness). This has been the twentieth-century Mr. Blunsden's aim and plan all along – to change the past for the benefit not only of the children, whose murder he wishes to prevent, but also to enable his own ancestor to redeem himself.

It sounds very confusing, but it is actually pretty well presented to enable the viewer to follow its convoluted, time-travelling, character-confusing plot pretty well[132]. At the very end of the film, the Allen family come to learn that the children they helped to survive were their own great-great grandparents[133] and that the house they have been looking after is in fact their own, inherited from their ancestors who escaped a horrible death at the hands of wicked step-parents! And when Mr. Blunsden himself shows up, it is with the carol "We Three Kings of Orient Are" that he identifies himself – which is apt, for as the 3 Kings gave Jesus gifts, the

131. Lucy is played by Lynne Frederick who would later marry legendary radio and screen comic Peter Sellers of **The Goons** and *The Pink Panther* movies fame in 1977 (until his death) and TV presenter David Frost in 1981 (until they divorced in 1982).

132. With the possible exception of a time paradox: see next note.

133. If the past happened (and the nineteenth century children died at the hands of their step-parents), which is what the Allens learn, then the 20th century Allens wouldn't exist as their descendants. Mr. Blunden couldn't recruit the Allens to save their ancestors, as the nineeenth century children wouldn't have survived to have had a family and descendants.

two Allen children and Mr. Blunsden gave the gift of redemption to Blunsden's great-great-grandfather by their time travelling intervention.

This whole movie is beautifully made and wonderfully set in its two historical periods. There are some nice uses of special effects – especially when the Allen children utilise their 'ghostly' powers against Diana Dors' character in the past (stemming from the fact that she cannot see them). The feel of the film is rather like **The Railway Children (1970)** with a super-natural twist, but perhaps not surprisingly, as director Lionel Jeffries also directed that film, and although it is neither a really a Christmas Movie nor a frightfest, I think that it definitely deserves a mention and is well worth a watch for those whose palette is not entirely jaded.

For those whose tastes do definitely tend toward raw meat rather than syrupy sweet, however, we need once again to cross the wide Atlantic.... (Makes you wish Concorde was still flying, all this zooming back and forth across the ocean, doesn't it?!). Anyway, the same year that we Brits were trying to unravel tales of time-travelling future-ghosts on Christmas carol missions, our burger-eating buddies Stateside were making their own little tinsel terror... only (surprisingly perhaps), it was American *TV*, not Hollywood that was leading the way. ABC Circle Films and Leonard Goldberg Productions produced what is probably one of the first in the now well-established dysfunctional family festive gathering type movies... And boy, was *this* a dysfunctional family! Forget fallings out over who gets a leg and what's on the telly; this gruesome group had murder on their merry minds. **Home for the Holidays (1972)** (aka **Deadly Desires**) aired on ABC[134] TV at more or less Christmastime[135] in 1972.

This 73-minute shocker from an Argentine-born director, John Llewellyn Moxey, who had cut his teeth directing British TV programmes and low budget horrors like 1966's **Circus of Fear** starring Christopher Lee, was never likely to be too gory or overly scary, being made for television; but what he could do, Mr Moxey did very well; indeed pre-empting some of the atmosphere and staple elements of what would later become known as 'slasher' movies. There is an isolated group of people (in this instance a family group gathered together for Christmas); there are the spooky woods that surround their familial home; there are multiple murders; tensions between some strange characters that all have their own idiosyncrasies and upon all of whom suspicion falls (at least until they are murdered); there's wet, stormy, weather; dark nights; almost hysterical melodrama; and a hooded killer running around with an axe. Yuletide cheer indeed! And all living up to the films advertising tagline: "There's nothing more chilling... Than a warm family gathering!"

Written by Joseph Stefano, who had adapted Robert Bloch's novel for Hitchcock's **Psycho (1960)**, this film is unusually dominated by female characters (and even the psycho killer is

134 American Broadcasting Company

135 Initial screening actually 28 November 1972 – near as damn it to Thanksgiving.

unusually a woman[136]). But I don't think it is fair in any way to class this as a 'chick-flick', even though it is predominantly centred on a group of female characters and their neuroses (and in one case psychosis!), with most of the elements of a Gothic Romance in place – raging thunderstorms; a wicked stepmother; skeletons in the family closet; looming death and madness in a gloomy, dark, imposing, isolated house. There is even a handsome young doctor/ hero figure. And while the performances may necessarily be heightened and melodramatic in style; the film also utilises the full panoply of other techniques for heightening and pointing-up everything in order to screw up the viewer's tension. The very use of close-up shots to privileged details – door handles turning, faces at windows and so forth, suggest or stress significance by their very selectivity.

Although being a TV movie from the early 1970s means that there is necessarily not going to be a lot of gore in this updated old-dark-house movie, the ever-present lightning and thunder (well at night anyway!) and the use of tension-heightening techniques (a stately tracking shot following a character across a dark room until they start to slowly climb a dark staircase suddenly becomes a quick pan to a door and a zoom into a close-up of a hand opening the door...), as well as some pressure-cooker performances keep this rattling along entertainingly.

The plot sees the daughters of an ailing, cantankerous old Grouch (well played by triple Oscar winning[137] veteran character actor, Walter Brennan) gathered together at their old childhood home for the first time in many years to celebrate Christmas – though begreudgingly. Their hard-nosed father has sent a note to one of them saying that he thinks his new wife is trying to kill him and this is the imperative that brings the daughters back home. Throw in the storm of all storms to wash out the road and a murderous maniac in a yellow raincoat and galoshes with a pitchfork, underscore all of the action with rumbling thunder and flashes of lightning, and what a concoction you have!

And what a cast they managed to land to pull it all off! Jessica Walter barnstorms her way through proceedings as all-but-unhinged, potentially suicidal alcoholic oldest sister Frederica (ham or bravura? – you decide); Eleanor Parker is angsty-earnest as the mother-hen sister Alex; Julie Harris is controlled and anchored in a cold-fish, brooding kind of way as the suspected murderous step-mother (over whose head past suspicions of poisoning her first husband and a stay in a mental institution already hang); Walter Brennan is grumpily anxious and suspicious as the all-but bed-ridden father who is fearful of for his life; pretty, perky Sally Field is sweetly naïve and a little tremulous as the youngest sister Christine; and hard-nosed Jill Haworth is strident and harsh as the couldn't-give-a-damn daughter Joanna. So you can see how this motley crew mixed together results in the darkest of over-ripe fruity Christmas puds! (And in Fredrica's case at least, soused with an unhealthy slosh of alcohol!).

136 Like Mrs. Vorhees in the original *Friday the 13th (1980)*. Though many people tend to forget this as her long dead son Jason shows up at the very end and takes over the slaying throughout the rest of the seemingly interminable series/franchise!

137 As Best Supporting Actor for *Come and Get It (1936)*, *Kentucky (1938)* and *The Westerner (1940)*. He was also nominated in the same category for *Sergeant York (1941)*.

None of the daughters has visited their father in 9 years, following the suspicious death of their mother and the rumour-mongering of the nearby townsfolk. And his moral stature may be gauged from the fact that he has called his clan together again at Christmastime to ask them to kill his new wife for him! (This is not a happy family! And perhaps the whole film is crying out for a Freudian interpretation!). Setting this whole monstrous melange around the Yuletide – the time for family togetherness, love, caring and sharing – just puts the icing on the (Christmas) cake! Suspicions and counter-suspicions; innuendo, rebuffs and rebuttals abound, as the characters play an edge-of-their-nerves game of cat- and-mouse with one another (and the filmmakers play the say game with the viewer!). Yes, it is so ripe that it is as likely to have you in stitches as on the edge of your seat; but either way it is entertaining.

So, which one of the "emotional prisoners" is actually wandering around, chasing people through the woods, sneaking up on them in the house and running them through with a pitchfork, or drowning their sorry pill-popping and alcohol-soused butts in the bath tub? ...Well, hang my stockings by the chimney with care! – but I couldn't possibly tell you that now could I?! Just curl up with a big glass of wine, dim the lights (put a copy of Freud or Jung near to hand) and see for yourself. Make this surprising little movie one of your guilty little indulgences this Christmas and find out for yourself[138]. Happy families eh?! So where will our little quest take us next? To Horrorwood to find a fully formed Christmas Horror perhaps? ...Well, no actually. Perhaps surprisingly the first all-out, no-stops, red-blooded Christmas Horror film (as I see it) was actually produced and shot in Canada – and by the same director who was not only to give the world the testosterone driven, low-brow comedy **Porky's (1982)** and **Porky's II: The Next Day (1983)**, but also one of the best nostalgic Christmas Movies ever made, **A Christmas Story** made in 1983, Bob Clark.

But before we get to that, a quick detour across the Bering Straits to the Soviet Union. Although the film **Eta vesyolaya planeta** (aka **Eta vesyolaia planeta** and **This Merry Planet**), which was produced for Soviet TV, is not a horror film, and is set on New Year's Eve, 31 December rather than on 25 December or thereabouts, there are two reasons I wanted to mention it. Firstly, 31 December is when Christmas is celebrated in Russia and Soviet countries influenced by the Eastern Orthodox Church (so it is a Christmas Movie in that sense) and secondly, although it is not a film of the horror genre, it does have generic sci-fi elements and it sounds completely wacky, so I think it fits into this weird and wonderful selection of tinsel-tinged oddities and Psychotronic Santa-orientated entertainment as well as it fits anywhere!

Co-directed by Yuri Tsvetkov and Yuri Saakov (who also co-wrote it with Dmitri Ivanov and Vladimir Trifonov), this 94-minute musical comedy romp starts with a UFO with a female com-mander (nice to know there's no gender discrimination in outer space!) and two male extrater-restrials called X and Y being seen through a telescope by a man about to leave for a New Year's Eve party dressed as a magician. And according to Birgit Beumer, in her essay *Father Frost on 31 December: Christmas and New Year in Soviet and Russian Cinema* in the book *Christmas at the Movies*: *Images of Christmas in American, British and European Cinema* [139] "The magician

138 You can get hold of it – I did on VHS on the internet.
139 *Christmas at the Movies*: *Images of Christmas in American, British and European Cinema*, edited by Mark Connelly, IB Tauris, London & New York, 2000

creates a link with the cosmos, and the ensuing party brings together not only gardeners and academics, but also humans and extraterrestrials, breaking both social and spatial boundaries, and enlarging the celebrations to encompass not only the globe, but the entire universe."

And if you think *that* sounds wacked, dig this – while wandering around on Earth, the three aliens from the UFO (or does Political Correctness designate that I refer to them as non-terrestrial visitors?) hide in a Christmas tree, where their glass helmets look like Christmas baubles!

Ok, back to the first (in my opinion) out-and-out, true-blue, died-in-the-wool, chocks-away Christmas Horror Movie; director Bob Clark's *other* Christmas masterpiece (than **A Christmas Story (1983)**), the Canadian-produced cult classic **Black Christmas (1974)** (aka **Noël tragique** – French-Canadian title – and **Silent Night, Evil Night** and **Stranger in the House** – US TV title). This brilliantly made movie, which features a psycho killer stalking and slaying the members of a college's female sorority house during the Christmas holiday predates the likes of **Halloween (1978)** and **Friday the 13th (1980)**, which are usually trumpeted as seminal 'slasher' movies. It is as good as the former, better than the latter. It was made in the same year as the equally brilliant (but in a different way) **The Texas Chainsaw Massacre (1974)**, which caused such a fuss and outcry (being cited as possibly the scariest movie ever made at the time, and a 'dirty, grimy' film). I have no intention of getting into all that, but what I will say is that **Black Christmas**, is an absolute Dusey[140] that definitely lives up to its advertising tagline (for once): "If this doesn't make your skin crawl... It's On Too Tight!"

And what is more, it is a Horror Movie in which the tie-in with Christmas is absolutely endemic, not merely an exploitative add-on. Even the title, with its wry humour aping that traditional sacred cow of the silver screen **White Christmas (1954)** – which I adore by the way! – encapsulates the intent...to take the usual holly-jolly connotations of Christmas and turn them inside out and on their head; to use them to heighten and underscore the shock and horror of the film's events – and often with the same dark sense of humour that the title displays (one of the gruesome murders occurring while carollers in all their wintry finery sing the joys of the season at the door, for instance).

Although the low budget shocker **Black Christmas** is really the film that first established most of the ground rules of the 'slasher' sub-genre, it is quite different from most of the movies that followed in a few important ways. For instance, it shows very little actual graphic violence – instead showing the results of the violent deaths (a corpse of one of the sorority girls rocking in a rocking chair with a polythene bag over her head; people finding dead bodies; the corpse of a cop in a car with a slit throat etc). The nearest it gets to depicting the actual graphical occurrence of violence is in the earlier mentioned carolling scene. Beautifully intercut, the scene depicts one character answering the door to a group of carol singing children, while another of her sorority sisters is being stabbed to death with a crystal unicorn upstairs in her bedroom. It is a scene which makes perfect use of the contrast between the Season of Goodwill and the awful murderous events taking place. And even in this scene, no penetra-

140 Derived from the name for the most expensive, most plush car possibly ever made, the Dusenberg!

tion of object into flesh is actually seen on screen; only a stabbing motion in a close up of the unicorn-used-as-a-knife weapon and the appearance of blood on the crystal horn.

The movie's plot is quite straightforward and sees the sisters of Pi Kappa Sigma sorority house at a festively snowy American university receiving strange phone calls from a what they assume to be a perverse caller, then being gradually slaughtered by the caller who has gained entry to their house and is operating from the attic without them knowing this. The telephone calls are excellently handled; at first something of a joke to the girls (especially the very liberated and sassy Barbie), but then becoming more and more menacing, with the caller sounding more and more deranged and talking as multiple characters in multiple voices, never giving his entire backstory, but providing horribly tantalising hints at what has caused his mental dilemma – something horrible to do with his sister and associated with Christmas.

Although the telephone calls are brilliant – with voices almost as disturbing as those in the previous year's **The Exorcist (1973)** at times, this killer is very human and very disturbed – more in the mould of Norman Bates from **Psycho (1960)** or Mrs Voorhees from **Friday the 13ᵗʰ** than her supernatural son Jason or the similarly undying Michael Myers from **Halloween**. But the film's focus is not on the killer and why he does what he does (in the final analysis, we never really learn this), but the focus is rather on the girls and why they act in the way they do – especially Jessica Bradford.

This is quite refreshing, because unlike in later movies where the victims (especially the female ones) are just a line of meat to feed to the grinder, in this film Jessica is a much more fully realised character; a character with great courage, intelligence and strength (more akin to Laurie from **Halloween**, Ripley from the **Alien** movies or Sidney from the **Scream** movies than most female victims of slashers, perhaps especially in the 1980s). This is why, despite being warned on the telephone to leave the house because the killer is inside, she goes up-stairs to help her friend who she believes is sleeping (not because she is silly, but because she will not leave a friend in danger), and why she is able to confront and kill her boyfriend Peter, whom she has every reason to believe is the killer. It is a wickedly dark irony that this strong willed, intelligent and heroic woman actually kills the wrong man; the father of the baby she is carrying who opposes her strong-willed decision to terminate the pregnancy. And along with Margot Kidder (who played Lois Lane in a similarly sassy vein in the Christopher Reeves **Superman** movies), old genre warhorse John Saxon, strar-child[141] Keir Dullea, and the ravishing, Argentinian-born Olivia Hussey (star of Franco Zeffirelli's **Romeo and Juliet (1968)** who

141. From Stanley Kubrick's **2001: A Space Odyssey (1968)** in which he played Dr. David Bowman, the astronaut who underwent the trippy transformation. His star was riding high at this time (And in case you wondered, his surname is pronounced Do-lay – apparently, rather full of his own importance, he once kept legendary Brit playwright and actor Noel Coward waiting when the great sophisticated wit asked to meet him after seeing him perform on stage. As Coward finally entered his room, Dullea turned stretching out a hand wit affectation and introduced himself. "Keir Dullea." To which the less than impressed impresario simply responded, "Yes, and gone tomorrow" before withdrawing. (I have no idea if this tale is true, but I hope so because it shows the kind of sharpness and wit you just wish you could employ sometimes. Thinking up such a response 12 hours later just doesn't cut it, does it?).

would g on to play the Virgin Mary in the influential British/Italian-produced TV mini-series **Jesus of Nazareth** in 1977) all give excellent performances in this movie.

Of course, one of the other things that differentiates **Black Christmas** from most of its dastardly (illegitimate?) screen descendants is the fact that it is actually a well made, intelligent, if manipulative thriller that is very well written and skilfully directed (with no need to resort to the typical 'cheats' of the genre. ...Although there is much in the film that would seem to suggest that emotionally obsessive musician Peter Smythe might be the killer, the film is very consistent and does make it clear for the careful viewer that he cannot be guilty).

For sure, the 1970s hair and fashions are a scream in themselves, please don't let that put you off of appreciating the excellent direction, for instance, utilising a shoulder-harnessed camera to give tracking shots of the killers point-of-view (in much the same way that Carpenter did in **Halloween**. In fact, compare the shots where the killer's POV is given as he approaches the snowy sorority house with its Christmas lights on a dark night with some of those in **Halloween** with Michael Myers approaching the house with its Jack-o-lantern – you will see the seed had already been sown!). And Bob Clark makes excellent use of camera movement and framing to heighten the tension and suspense in his film also; as well as some inspired use of sound and music, and also some brave, quiet long-held static shots. This is a serious minded suspenseful seasonal shocker.

It does have its moments of brevity and humour to lighten the tone and mood – the aforementioned early phone calls when Barbie is very challenging to the caller, assuming him to be a sexual pervert; Barb's drunken, wilful bating of one of the other sorority sister's father with her tales of tortoises on the job; even the cat's name – Claude (a pun on clawed); but funniest stand-out comedy moment is when ballsy Barb tells the somewhat-less-than-genius-IQ desk cop her telephone number. (Once upon a time, telephone numbers began with a place or area name – the exchange – followed by some digits, eg 'Nothside 777'). Barb tells the naïve cop that her new exchange is "Fellatio" and he duly writes this down and passes to the detectives (much to their amusement). "It's something dirty, isn't it?" he asks them later when they cannot suppress their laughter. Margot Kidder's character name is certainly fitting – many of her lines are decidedly 'barbed.'

But this film does not let the humour interfere with its main thrust – the threat to the girls and their reactions to their peril, especially Jessica. There is one point only I would be pernickety with the direction on, and that is the killing of the dipsomaniac sorority housemother. She meets her end when she looks up in the attic and the killer swings a block and tackle with a large hook at her. We cut from the sight of the arcing hook to a shot from below seeing her dragged into the attic, the continuity suggesting that the momentum of the hook is responsible for dragging her through the trapdoor. I don't think this was the intent – she is either knocked out by the hook or killed by it and then the killer hauls he up, but this is just the impression that is left by the edit. It seems rather implausible among the all-too-plausible presentation of other events. But this is a very minor niggle in a beautifully realised, deliciously dark project.

Andrea Martin, who plays sorority sister and victim of the psycho killer Phyllis Carlson, appears as the sorority housemother in the inferior 2006 Canadian/US-produced remake of this movie. But we will get to that in due course. For now, back to that all-important Christmas birth – that of the festive horror flick, of course...and from the sublime to the...well, not ridiculous exactly, but not anywhere near as sublime...

In the same year that Bob Clark's brilliant **Black Christmas** hit the big screen, another film was also (finally) released. This 88-minute[142] film had apparently been shelved by its producers for a couple of years (so it too might have something of a case to lay claim to being one of the first-made of the Christmas Horror Movies proper and a progenitor of the 'Slasher' sub-genre!). Co-written[143] and directed by Ted Gershuny, the fairly obscure, low budget **Silent Night, Bloody Night** (aka **Death House**, **Night of the Dark Full Moon** and **Zora**[144]) is a little seen, but actually reasonably effective little horror film whose main action occurs at Christmastime in two separate eras.

A bit like those assortments of sweets you get in the shops at Christmastime, this festive fright fest is a real mixed bag: long on atmosphere and artistic intention, short on budget and quality in many ways; historically interesting but little seen. The copy I watched on DVD was grainy and grubby looking with awful sound quality, poor lighting and variable acting to say the least. However, the use of sepia flashbacks, point of view shots, stills, Christmas songs and deliberate construction (which actually kept many of the script's secrets while providing both hints and red herrings) was nice – even if some plot elements were rather hard to swallow. (But hey, it's a horror film, so that's often par for the course, isn't it?).

I sometimes think that the very 'cheapness' of a film's – especially a horror film's – visual style (tacky, grimy looking, almost as if shot by an amateur documentarist) can add an extra dimension of creepiness and a sense of 'dirty realism' (And this has been true for a while. Just think **The Living Dead at Manchester Morgue (1974)**, or **The Texas Chainsaw Massacre (1974)**, the Italian Cannibal and Zombie movies of the 1980s, even the more recent films that enshrine and utilise this realisation as a deliberate part of their style – **The Last Broadcast (1998)**, **The Blair Witch Project (1999)**, **Diary of the Dead (2007)**[145] and **Cloverfield (2008)**). **Silent Night, Bloody Night** benefits from a something of this sense of being not too polished... albeit this may in fact be a serendipitous side effect of its penny-pinching, Ebenezer Scrooge budget!

142 Full cut (though an 81-minute cut has also been released, and even a 64-minute one (!) for the Canadian DVD release apparently)

143 Though Jeffrey Convitz and Ira Teller have 'Written' and 'story' credits and Ted Gershuny is listed as "Writer"

144 Its working title

145 Aka *George A. Romero's Diary of the Dead*

Like **Black Christmas** and **Home for the Holidays**, **Silent Night, Bloody Night** features a loopy killer who despatches victims in various gory ways – and interestingly, in a very similar mode to **Black Christmas**, it also utilises some creepy killer's-point-of-view camerawork and unsettling telephone calls to prospective victims. It opens and closes with mayor's daughter Diane Adams walking in the woods around the imposing black and white turn-of-century Butler house on the outskirts of East Willard in Arlington County, Massachusetts. She relates the main story, which harkens back to the Depression era via sepia-toned flashbacks. In one of these flashbacks we are informed that the wealthy owner of the house, Wilfred Butler, was assumed killed in mysterious circumstances on a snowy Christmas Eve in 1935, running from the building in flames (which we see). The house was thereafter willed to his grandson with the proviso that Butler junior maintain it in the condition it was in upon Butler senior's death – as a "monument to inhumanity."

For 20 years the house, maintained as per the old man's will but uninhabited, has haunted the townsfolk, (who would rather forget all about its history). But then, after 20 years and once again at Christmastime, the current owner's solicitor arrives in town to announce that Jeffrey Butler is selling the property (which is apparently now worth $1/4 million) and offering the town council the chance to purchase it first at the knockdown price of $50 000 – provided they do so immediately.

Although suspicious, they agree and the mayor sets out to a larger neighbouring town to get the money. However, while he is away, other members of the council (including veteran John Carradine[146] in a supporting role where he does not speak at all, just rings a bell or writes notes – weird! Maybe he had throat problems) start to receive strange telephone calls from someone claiming to be old Wilfred Butler's daughter Marianne (Jeffrey's mother) – who is long since dead! The calls lure the recipients to the old house, where the solicitor and his girlfriend have been murdered in bed. And the murders of all those tempted out to the Butler house continue. The town of East Willard and the house both have secret skeletons in their closets, which are coming back with a vengeance!

Jeffrey Butler himself (the descendant selling the house) makes an appearance, and though his part in the events is at first unclear and rouses suspicion, he eventually teams up with the mayor's daughter Diane (our storyteller, played by Mary Woronov[147]) to uncover what is happening and why. Are the murders related to the patient who has escaped from a nearby asylum? (You betcha! ... But there are some quite surprising, even shocking twists, turns and revelations along the way to the corpse-strewn conclusion – although one of them, relating to the social leaders of the town, is something of a stretch...and perhaps something of a political comment too).

146 Character actor and genre veteran since the 1930s and father of actor brothers **Kung Fu** and **Kill Bill**'s David; Keith, an Oscar (for Best Song for 'I'm Easy' from **Nashville (1975)** and Robert , who actually played the Younger brothers (alongside brothers James and Stacy Keach's Jesse and Frank James and Dennis and Randy Quaid's Ed and Clell Miller) in Walter Hill's **Long Riders (1980)**. Chris Carradine is a further son of John and Bruce Carradine his adopted son.

147 Wife of director Theodore Gershuny and ex-associate of pop-artist Andy Warhol

This film is definitely worth a look if you like horror movies – especially if you appreciate low-budget 'grimy' features. The actual picture, sound and acting quality of this feature – at least in parts – may well put many viewers off, and the budget restrictions might undermine realisation of the artistic intentions and vision, but elements do still shine through. The sepia flashbacks and use of stills are especially effective, and the structuring of the film is commendable. I have a feeling though that many will not be able to look past the surface and if they give this a go, might perhaps feel like the boy that Santa Claus forgot! This Christmas proto-Slasher is one that genre fans might want to see and they may well appreciate it despite its many – what shall we call them? – Santa Flaws?!

Another movie that was down and dirty with plenty of Santa Flaws, which was released in 1975 (the year after **Silent Night, Bloody Night**) hailed from Italy. Co-written and directed by Aldo Lado, **L'ultmo treno della notte (1975)** or **Late Night Trains** (which is just one of a long list of alternative titles used[148]) was ostensibly a remake of – or retake on – Wes Craven's cult 1972 shocker **Last House on the Left (1972)** – itself a modern day remake of Ingmar Bergman's Oscar winning[149] **The Virgin Spring (1960)** [150] - so you probably already have a pretty good idea of what to expect!

This movie was originally rejected for UK cinema release by the BBFC in 1976 and, perhaps foreseeably, ended up on the infamous official 'video nasty' list, so that it only eventually became available fully uncut in 2008 on DVD under the title **Night Train Murders**.

In the film, two teenage female university students (one German and one Italian) who study at a German university are going to spend Christmas in Italy with the Italian girl's parents. However, aboard the train that is taking them across the Alps, they encounter three depraved psychopaths – two salacious young male thugs (who we have already seen beat up and rob a street Santa collecting for charity) and a thirty-something woman, whose bourgeois exterior is belied by her salacious actions (drawn to the thugs, she has already had sex with one of them in one of the train's toilets).

In an extended – and rather gratuitous sequence – the three invade the girls' compartment and rape the teenagers (with a voyeuristic, middle-aged businessman type joining in in passing!) before – egged on by the older woman – eventually killing the girls in a gruesome manner and disposing of the bodies by throwing them from the moving train. All of which is counter-pointed with the Italian parents' preparations for their warm Christmas family festivities.

148 Aka **Don't Ride On Late Night Trains** (UK), **Last House – Part II** (USA Poster title), **Last Stop On The Night Train** (USA dubbed version), **The New House On The Left** (USA), **The New House on the Left** (USA), **New House On The Left** (USA), **Torture Train**, **Christmas Massacres** (USA reissue title) and **Night Train Murders** (Philippines release and DVD release title)

149 It won the Academy Award as Best Foreign Language Film
150 Original Swedish title **Jungfraukällan**

Unfortunately for the 3 perhaps not-so-wise Christmas travellers, the woman is slightly injured in the murderous shenanigans and when they disembark from the train, the Italian girl's father who is a doctor invites them back to the house to treat her cut, believing that his daughter and her friend must have missed a train connection and will arrive later. When the parents do eventually discover what has happened to the girls, however...well, I guess daddy doesn't believe in the old adage that 'revenge is a dish best served cold!'

Where this movie, which has a distinctly European style and some limited performances and psychological cohesion, really scores – and indeed obviously intends to – is in the character of the apparently well-to-do and respectable older female who instigates and indeed orchestrates much of the horror, rather than the males who are easily led and simply follow primitivistic urges. *'Cherché la femme'* indeed should be the clarion call here, for she even manages to play the innocent and escape the father's gory retribution for the evil deeds she in fact inspired, escaping even the roughest of justice.

This low-budget, wilfully gratuitous, even if thought-provoking, Euro-styled psycho revenge opus then is not the easiest or most pleasant of watches (an acquired taste that many would perhaps prefer not to acquire – a bit like pickled walnuts at Christmastime!).

And so fleeting back to Canada... three years have passed, and although the Christmas Ho-ho-horror Movie is now well and truly in existence, eager-beaver film fans would have to wait until the dawning of the "Greed is Good"[151] Ronnie luvs Maggie and Maggie luvs Ronnie[152] 1980s to get another full-on shot to the veins (for some reason). But tinsel-tinged terror was still available if you knew where to look. For although the 106-minute long Canadian thriller *The Silent Partner (1978)* (aka *L'Argent de la banque*[153]) was not a Christmas Horror Movie; it did feature one of the nastiest realistic characters in a Santa suit you are ever likely to see.

The movie, written by Curtis Hanson (the man who would later write, produce and direct *LA Confidential (1997)*) and directed by Daryl Duke (who would later direct the smash-hit TV mini-series *The Thorn Birds*) is basically a bank-heist/caper/cat-and-mouse/revenge movie starring Elliott Gould as a mild mannered bank teller, Susannah York as the co-worker he has a crush on and Christopher Plummer as the nasty, evil bank robber disguised as Santa Claus Gould's character sets up as a patsy when he robs the bank. Only Plummer's character doesn't like being duped and set up, and so he sets out to retrieve the cool Yule stash of cash from Gould's character, and he has no qualms about terrorising, hurting, maiming and killing people along the way. Indeed, Plummer puts in an absolute Christmas plum of a performance here, oozing and dripping malice. But this is beautifully balanced by glorious Gould's fantastic

151 A quote from the character Gordon Gekko played by Michael Douglas in Oliver Stone's *Wall Street (1987)* (a role for which Douglas won the Best Actor Oscar). It became somewhat emblematic of the decade.

152 Margaret Thatcher and Ronald Reagan were Prime Minister of the UK and President of the USA respective, both right wingers, who got on famously it appeared and re-cemented the Anglo-American 'special relationship' that would later, in many peoples' eyes, see Tony Blair become George Dubbaya's lapdog.

153 French-Canadian title

performance. With both of them ably supported by Susannah York, the beautiful Céline Lomez and even roly-poly funnyman John Candy in an early supporting role.

Hanson's script is more than solid, Duke's direction inspired, and this suspenseful, edge-of-the-seat, sometimes tongue-in-cheek, twist-and-turn thriller really is "A masterpiece of cunning and suspense" as its advertising tagline proclaims (before going on to suggest that its climax is "…more terrifying than a nightmare!"[154] There are some nerve-jangling scenes – Plummer's character taunting Gould's through a letter box – and some down right nasty ones – Plummer's psycho brutally slaying a prostitute. But for those who can take their X/18R rated thrillers straight, this is a much-overlooked gem of a movie that's not to be missed if you get a chance to see it. Chris Plummer really does make a Nasty Santy; his sociopath Santa crook definitely skirted the Sanity Clause!

And while we are on the subject of sanity, I think the creators of the next sci-fi flavoured piece from Japan, produced in the same year as **The Silent Partner**, 1978, might have checked theirs in at the Toho studio's door, from the sound of it. The 138-minute long **Buru Kurisumasu** (aka **Blue Christmas**, **UFO Blue Christmas**, **Blood Type: Blue** and **The Blue Stigma**) directed by Kihachi Okamoto attempts to explore the social and moral consequences of UFOs appearing in Japan at Christmastime and turning the blood of the people who see them blue, thus differentiating them from the rest of humankind. These poor people become identified by the colour of their blood alone, stigmatised, cruelly discriminated against and even eventually rounded up and interred in concentration camps. (Hmmm, sounds like a familiar tale from earlier in the century!).

The film's hero, a red (a true red-blooded male no doubt!), falls in love with a blue-blooded girl (as in, she has been altered by the aliens, not she is of royal lineage!), which in turn leads to a decidedly melodramatic conclusion. So the themes of 'Peace on Earth and Goodwill to All Men' that are usually associated with Christmas are well and truly put to the test, contrasting sharply with the events that actually occur. Alas though: for a film with such obviously serious intent, I am led to believe that it ends up being hoisted by its own stylistic petard with soapy melodrama making up the majority of its running time, turning it into something of a Christmas Turkey. Still, if you think that it sounds interesting and think that it might appeal to you, then perhaps you should watch it for yourself and make up your own mind. It might be the only time you legitimately get to ask for a Blue Movie (so to speak) for Christmas without any embarrassment!

One made-for-American-TV 97-minute long cringe-making Christmas Special that was an absolute embarrassment for all concerned though apparently, was another seasonal Sci-Fi extravaganza, **The Star Wars Holiday Special**. In this sugarcoated celebratory space-opera, Luke Skywalker (Mark Hamill) and Han Solo (Harrison Ford) try to help Chewbacca (Peter Mayhew) return home to the Wookiee home planet in time to celebrate Life Day (a kind of hairy, alien Christmas!) with his family. Carrie Fisher as spunky Princess Leia Organa and Anthony Daniels

154 The full text of the tagline, which obviously wanted to suggest some of the film's fairly explicit sexual content too, runs "A masterpiece of cunning and suspense… In a web of mounting passion, a beautiful girl is trapped and torn between two lovers, climaxing in a scene more terrifying than a nightmare"

as C-3PO are also involved; and of course James Earl Jones provides the voice of Darth Vader (with Brit muscleman and Green Cross Code road safety icon, Dave Prowse striding around in the black costume and helmet in archive footage). **Golden Girls'** Beatrice Arthur, Art Carney, Diahann Carroll and Harvey Korman also featured; though redoubtable knight of stage and screen, Brit Sir Alec Guinness wisely chose only to appear via archive footage from the film!

The debacle, which apparently features song and dance routines as well as soppy Wookiee family members mooning over missing Chewy, does I guess also have one sort of saving grace in that it introduced (via one of several animated sequences) the character of bounty hunter Boba Fett who would later appear in the live-action sequels. From what I can gather though, most viewers wished that it had remained in a galaxy far, far...*far* away!

But before we move swiftly on to the 1980s – the "I want, I want" designer-label decade of rampant consumerism and commercialism in the West, when festive frightfests really got a foothold and began to take off; the decade of having your Christmas cake and eating it too! – as we opened this chapter with a Rankin-Bass production, I thought we might end with another quick mention of a made for US TV Rankin-Bass stop-motion animated feature... and this time a full 90-minute movie.

While ***Rudolph and Frosty's Christmas in July*** is another in the highly successful and immensely enjoyable repetoire of festive features produced by this team, and as such won't contain anything to really scare anybody, it does feature a wicked wizard called Winterbolt who used to rule the North Pole but who was put into long term hibernation by the Queen of the Northern Lights, Boreal. When this frosty villain finally awakes, he decides to take over Christmas and thereby control the world![155] I figure any wicked wizard that dastardly deserves a mention among our little menagerie.

155

 Rather like Jack Frost (as played by Martin Short) in the fairly dismal 2006 sequel to 1994's ***The Santa Clause***, entitled ***Santa Clause 3: The Escape Clause***.

THE FILMS

♪♪♪...We Wish You a Scary Christmas...♪♪♪

The Amazing Mr. Blunden 1972 UK 99mins
Directed & Written: Lionel Jeffries (from the novel *The Ghosts* by Antonia Barber) **Music**: Elmer Bernstein **Cast**: Laurence Naismith (Mr. Blunden), Lynn Frederick (Lucy Allen), Gary Miller (Jamie Allen), Diana Dors (Mrs.Wickens), Rosalyn Landor (Sara Latimer), Marc Granger (Georgie Latimer), James Villiers (Uncle Bertie), Madeline (Bella), David Lodge (Mr. Wickens), Graham Crowden (Mr. Clutterbug)

Black Christmas 1974 Canada 98mins
Directed & Produced: Bob Clark **Written**: Roy Moore **Music**: Carl Zittrer **Cast**: Olivia Hussey (Jessica Bradford), Keir Dullea (Peter Smythe), Margot Kidder (Barbara Coard), John Saxon (Lieutenant Kenneth Fuller), Andrea Martin (Phyllis Carlson), Marian Waldman (Mrs. Mac), Art Hindle

Aka Noël tragique (French-Canadian title), Silent Night, Evil Night and Stranger in the House (US TV title)

Buru Kurisumasu 1978 Japan 134mins
Directed: Kihachi Okamoto

Aka Blue Christmas (International title) and UFO Blue Christmas (US promotional title) and Blood Type: Blue and The Blue Stigma

Eta vesyolaya planeta 1973 USSR TV 94mins
Directed: Yuri Saakov & Yuri Tsvetkov **Written**: Dmitri Ivanov & Yuri Saakov & Vladimir Trifomov

Aka Eta vesyolaia planeta and This Merry Planet

Home for the Holidays 1972 USA (TV) 73mins
Directed: John Llewellyn Moxey **Written**: Joseph Stefano **Cast**: Jessica Walter (Frederica Morgan), Sally Field (Christine Morgan), Jill Haworth (Joanna Morgan), Julie Harris (Elizabeth Hall Morgan), Eleanor Morgan (Alex Morgan), Walter Brennan (Benjamin Morgan)

Aka Deadly Desires

Le Martien de Noël 1971 Canada 65mins
Directed: Bernard Gosselin **Written** Roch Carrier

Aka The Christmas Martian

Santa Claus is Comin' to Town 1970 USA 48mins (animation)
Directed & Produced: Jules Bass & Arthur Rankin Jr. **Written**: Romeo Muller **Cast**: Fred Astaire (Narrator), Mickey Rooney (Kris), Keenan Wynn (Winter)

Silent Night, Bloody Night 1974 USA 88mins
Directed: Theodore Gershuny **Written**: Jeffrey Konvitz & Ira Teller & Theodore Gershuny **Cast**: Patrick O'Neal (John Carter), Mary Woronov (Mary Adams), John Carradine (Charlie Towman)

Aka Death House and ***Night of the Dark Full Moon*** (UK) and Zora (working title)

Silent Partner 1978 Canada 106mins
Directed: Daryl Duke **Written**: Curtis Hanson (from the novel *Think of a Number* by Anders Bodelsen) **Cast**: Elliott Gould (Miles Cullen), Christopher Plummer (Harry Reikle), Susannah York (Julie Carver), Céline Lomez, John Candy

Aka L'Argent de la banque (French-Canadian title)

The Star Wars Holiday Special 1978 US 97mins
Directed: Steve Binder & David Acomba **Written**: Mitzie Welch **Music**: Ian Fraser **Cast**: Mark Hamill (Luke Skywalker), Harrison Ford (Han Solo), Carrie Fisher (Princess Leia Organa), Anthony Daniels (C-3PO), Peter Mayhew (Chewbacca), James Earl Jones (Voice of Darth Vader), Beatrice Arthur (Ackmena), Art Carney (Saundan), Diahann Carroll (Mermeia Holographic Wow), Harvey Korman (Krelman/Chef Gormaanda/Amorphian instructor)

Tales from the Crypt 1972 UK/US 92mins

Directed: Freddie Francis **Written**: Milton Subotsky (adapted from original *Tales from the Crypt* and *Vault of Horror* comic book stories by Johnny Craig & Al Feldstein & William M 'Bill' Gaines) **Produced**: Milton Subotsky & Max J. Rosenberg **Cast**: (*And All Through the House* segment) Joan Collins (Joanne Clayton), Chloe Franks (Carol Clayton), Martin Boddey (Richard Clayton), Oliver MacGreevey (Maniac in Santa Suit) – (Rest of film) Ralph Richardson (The Crypt Keeper), Peter Cushing, Richard Greene, Patrick Magee, Nigel Patrick, Ian Hendry, Roy Dotrice, Geoffrey Bayldon

L'ultmo treno della notte 1975 Italy 94min

Directed: Aldo Lado **Written**: Renato Izzo & Aldo Lado (from a story by Roberto Infascelli & Etore Sanzò) **Music**: Ennio Morricone **Cast**: Flavio Bucci (Blackie), Mach Méril (Lady on the train), Gianfranco de Grassi (Curly), Enrico Maria Salerno (Professor Giulio Stradi), Marina Berti (Laura Stradi), Franco Fabrizi (Perverted train passenger), Irene Miracle (Margaret Hoffenbach), Laura D'Angelo (Lisa Stradi)

Aka Don't Ride On Late Night Trains (UK) and Last House – Part II (USA Poster title) and Last Stop On The Night Train (USAdubbed version) and The New House On The Left (USA) and The New House on the Left (USA) and New House On The Left (USA) and Torture Train and Christmas Massacres (USA reissue title) and Night Train Murders (Philippines release and DVD release title)

Whoever Slew Auntie Roo? 1971 UK 91mins

Directed: Curtis Harrington **Written**: Robert Blees & James (Jimmy) Sangster & Gavin Lambert (additional dialogue) **Produced**: Samuel Z. Arkoff & James H. Nicholson & Jimmy Sangster (uncredited) **Cast**: Shelley Winters (Mrs. Forrest), Mark Lester (Christopher), Chloe Franks (Katy), Ralph Richardson (Mr. Benton), Lionel Jeffries (Inspector Willoughby), Hugh Griffith (The Pigman – MR. Harrison), Judy Cornwell

Aka Who Slew Aunt Roo? and Gingerbread House (working title)

CHAPTER 6

Opening the Bloodgates!

Waiting for a fully-fledged Crimbo Horror was a bit like waiting for a bus, wasn't it? – Decades go by with nary a glimpse, and then you get three or for of the buggers along all at roughly the same time, one after the other!

Following a somewhat strange six-year hiatus from 1974 to 1980, however, during which time the screens remained remarkably free of instances of a nasty Natale or a nefarious Navidad in nature, the dawning of the avaricious eighties would see first the return, then practically the proliferation of psycho killer Santas etcetera! Perhaps it was in part disillusionment; a reaction against the rampant commercialisation of the holidays in Consumerist Western Society...combined with a baby-boomer generation whose tastes, like Lord Vader's affiliation, had turned to "the dark side" as censorship gradually continued to become more and more relaxed (save for some silly knee-jerk reactions like the 'Video Nasties' incidents in Britain[156]).

Or maybe filmmakers just saw some new ground ripe for exploration (and exploitation), where all the usual associations with Christmas were just waiting to have their legs (and various other body parts) cut out from under them, and moviegoers just wanted to experience

156. When moral crusaders under the ranting leadership of mouthpieces like Mary Whitehouse stirred up the press and put the government and police under pressure, new laws were hastily enacted to enable seizure of video tapes believed to have depraved or corrupting content (as it was feared such films – which included erotic movies and horror films with violent content) might easily be seen by minors as they were now viewed in the home. There were carrion calls of condemnation and demands for police to prosecute those trading in such films on video. (This all came about because there was no real regulatory system for video sales except the for the Obscene Publications Act 1959, which had a rather imprecise definition of obscenity that was very open to interpretation. The public furore surrounding the 'Video Nasties' incidents led to the introduction of the UK's first Video Recordings Act in 1984). ...However, one might have had more sympathy for these Armchair Adolfs if it appeared they had done any research into the films they were condemning themselves, never mind their supposed effects on viewers' minds and moral fibre; if their ravening hadn't resulted in the seizing of films like Sam Fuller's WWII movie *The Big Red One (1980)* (whose title referred to the coloured digit insignia identifying the American First Infantry) and the Oscar nominated Musical comedy *The Best Little Whorehouse in Texas (1982)*!

the vicarious thrill of terror they (and their parents and grandparents) had experienced for decades watching classic frightfests like the German Expressionist Horror films of the 1920s; Lon Chaney's silent American masterpieces; the Universal Horrors of the 1930s and 40s; Val Lewton's classy, intelligent chillers of the 1940s and early 50s; the cycle of Flying Saucer and

Alien Invader movies; and Atomic-radiation-created Creatures destroying practically every capital city in the world; the gimmicky, gizmo-laden treats of William Castle and the cheapo drive-in chillers of Roger Corman and crew; the Gothic Romances from the Hammer House of Horror, the classy Italian horrors of Mario Bava...like this sentence, I cold probably go on and on (but Christmas is coming!...). Lets face it, each generation has its own peculiarities and peccadilloes, and filmmakers thrive on them. Moreover, frightening films have been around practically since the genesis of the medium – if you believe it, at very early screenings showing a short film depicting a train pulling into a station, people gasped and ducked in terror.

The genre exists and proliferates because people want to be frightened safely; they enjoy it. (Mind you, not all the films made succeed in their intent – some are real dogs, some absolute turkeys!). The 1980s would see the consolidation of the festive horror film as a generally recognisable sub-genre (and would continue too to throw out weird, wonderful, wacky, tacky and sometimes just plain awful films merely tinged with tinsel terror and Psychotronic claptrap. All together now ▯▯ "Hooray for Horrorwood, Hooray for Horrorwood" ▯▯ - and that cornucopia of other filmmaking centres internationally that provide for our festive feast of slightly twisted enjoyment and entertainment of course. Why should the syrupy, sweet, sentimental, twee candy cane brigade have all the holiday fun, hey? Like the witches in 1955's **Bell, Book and Candle**, those of us who relish the macabre want to enjoy Christmas too...just in our own perverse little way!

And so to the movies... While the decade opened with some classy snowy horrors that had no Christmas ties – Stanley Kubrick's spectacularly chilling **The Shining (1980)**,[157] and John Carpenter's spectacularly gruesome **The Thing (1982)**[158] – there were also some not quite so successful snowy shockers (John Irvin's **Ghost Story (1981)**[159] for instance) and some full-on festive horrors produced too...though like the lead characters in an iconic sixties Spaghetti Western, while some of these were good, others were bad, and some were just downright ugly! One of the 'Good' ones was written and directed by Lewis Jackson and is reckoned by no less a luminary than cult movie director John Waters, of **Pink Flamingoes (1972)** notoriety and **Hairspray (1988)** fame, to be "the greatest Christmas Movie ever made."

157 Aka *Stanley Kubrick's The Shining* (based on a Stephen King novel and starring Jack Nicholson and Shelley Duvall)

158 Aka *John Carpenter's The Thing*

159 Great to see some old-time Hollywood legends strutting their stuff – Fred Astaire, John Houseman, Douglas Fairbanks Jr., Melvyn Douglas, Patricia Neal – and Star Trek 'Borg Queen' Alice Krige was effective as the avenging Alma/Eva; but the whole somehow seemed to amount to somewhat less than the sum of its parts.

You Better Watch Out (1980) was the original release title of this 100-minute long, low-budget US Indie production, but it is aka ***Christmas Evil*** (the title it seems to be most readily available under on DVD now) and ***Terror in Toyland***, and although obviously low-budget, it is inventive, darkly comical, a little gruesome and all in all a fan of the macabre's dream (or should that be nightmare?) and it surely vie's for the honour of being regarded as the first feature length psycho-killer-in-a-Santa-suit movie with the other film released the same year ***To All a Good Night*** (of which, more shortly).

Better Watch Out opens on Christmas Eve 1947 with young Harry and Philip Stadling sitting on the stairs with their mother watching through the rails as Santa (their dad in a costume) emerges from the fireplace and helps himself to the treats left out for him, before leaving presents under the Christmas tree. Later the brothers argue over Santa's identity, and although Harry is the elder of the two, it is he who maintains that what they saw wasn't dad in disguise, but the *real* Santa Claus, in whose existence he still believes – the viewer's first insight into his emotional immaturity.

As a result of the dispute, Harry storms off upstairs and smashes a snowglobe, cutting his hand – the first visual linking of red blood with both white snow and Christmas. And later that night when Harry comes down stairs, he sees Santa (dad, though naturally he doesn't realise it) getting close to performing cunnilingus on his mother! (Things had obviously moved on a bit from 1952 when Jimmy Boyd reached No. 1 on the US Billboard Charts singing Tommie Connors' song 'I Saw Mommy Kissing Santa Claus'). The vision obviously *kinda lingers* for young Harry, but though Oedipal urges may be hinted at, they are not necessarily the sole cause of Harry's killing spree later in life (we already realise that his mental condition is probably a little abnormal from his obdurate belief in the Santa-fantasy, his refusal to even consider the likelihood of its falsity, the argument with his younger brother who has already accepted this and his reactions which result in injury!).

It is in fact Harry's deteriorating mental state (excellently presented by Jackson and portrayed by Maggart) that is the essential core of this movie; making it so much more than a simplistically-motivated stalk-'n'-slash no-brainer in the mode of so many of the Christmas Horrors that would follow. Harry carries his obsession with Christmas into adult life, working his way up from production line to office employee in a toy manufacturing company, festooning his house with Christmassy bric-a-brac – festive pictures covering the walls, toys and dollies everywhere, puppets hanging all over his shed workshop – he even sleeps in red Santa suit styled pyjamas and Santa hat! This is not a normal guy. His obsession with all things Christmassy and his ineffectual arguments in favour of quality workmanship and against shoddiness believably make him an object of light ridicule at work. And colleagues take advantage of his gullibility, as his usual mild-mannered demeanour and obsession-fuelled commitment make him an easy target. For instance, one work colleague dupes him into covering a shift on the production line on the eve of the holidays while he goes out drinking with buddies.

But even though Harry seems like a harmless, mousy man, some of his obsessions have a troubling edge. Harry spies on the little children who live in his neighbourhood, peeping through their windows, carrying out surveillance with binoculars, and maintaining logs of

who has been naughty and nice (the beginning of his usurping the role of Santa Claus). And he takes this re-invention both of himself and the mythical role further when he takes it upon himself to steal toys from his company and deliver them to a children's home on Christmas Eve dressed in a Santa suit and driving a van that he has painted with festive decorations, including a sleigh right down the side to further cast himself as a modern day Santa.

When Harry misses Thanksgiving dinner with his brother and family in the house that used to belong to his parents, his brother Philip is hugely dismissive of Harry and his peccadilloes... although, under duress from his wife, Philip does superficially try to honour familial ties with Harry. However, Harry's inability to communicate his emotions is part of his problem and part of what forces a wedge between the brothers. This inability to communicate is made evident at the work's Christmas party when one colleague taunts Harry about the colleague who duped him into covering a shift while he went out drinking. "I've got you guys' number now" Harry says, then continues cryptically "...The right tune. I've been trying to find the notes to it for as long as I can remember. Well, I've found them. I can play the tune!" This metaphor, which no one else in the film understands, is one he continues throughout the rest of the movie. "I did what you always wanted me to do" he later tells Philip, "I found the right notes. I can finally play the tune now...the tune everybody dances to. It's my version, but it woks!"

And fittingly enough, it is the music that accompanies Harry's crack-up (as much as Brandon Maggert's fine performance and the director's use of canted angles and close-ups that chop visually him up) that helps to convey his 'coming apart at the seams' mentally. As well as the usual nerve-jangling finger-nail-down-a-blackboard and screw-up-the-tension kind of music and the explosive musical accompaniments as he goes on his 'slay-ride', fine use is made of Christmassy songs and carols, which sometimes bleed over from one scene to another as a transitional device. And though these carols are well known they are manipulated to sound odd – hollow, distant, or in one instance stretched (like an old cassette tape or reel-to-reel recording running slow), which reflects Harry's perceptions that are also deviant from the norm.

There are some fantastic sequences where Harry, driving his festively painted van, cracks an imaginary whip, urging on his non-existent (except in Harry's head) reindeer. And the world certainly does learn to dance to Harry's own idiosyncratic and lethal tune. For, having delivered a vanload of stolen toys to the children's home, Harry stops off at a church on Christmas Eve where midnight mass is being celebrated and when a couple of men rib the Santa-suited Harry on the snow-covered steps as the congregation (which includes his boss and some of his workmates) emerges from the church, the first murders are committed. In a shocking scene, Santa-Harry (whose beard makes him unrecognisable to those who know him) finally explodes. He stabs one man through the eye with the bayonet of a toy Nutcracker soldier he is holding, then chops the other and one of the women accompanying them with a candy striped axe. Gouts of red blood gush into the white snow, as the rest of the congregation look on in horror and scream.

This scene comes as a shock not only because it is quite graphic, but also because the film has been following Harry's slow, pressure-cooker descent into madness up to that point,

pressure-cooker descent up to that point, and there is no warning that this is where and when he will finally explode into violence. The film is something of a hybrid: it is a cross between a tense psychological study and an out and out blood 'n' guts 'Slasher'. For die-hard 'Slasher' fans, there may well not be the gore-quotient in this movie that they expect, whereas for some viewers who have become more immersed in the psychological odyssey, the overt and graphic violence might seem somewhat gratuitously depicted. I personally relished the sub-genre ambivalence. And for his part, having finally learned how to express his concerns in a manner that people take notice of, Harry continues on his Christmas mission.

There is a lovely edgy scene where he his dragged into a Christmas party by revellers who see Santa looking in through the window at them, without realising how imbalanced and dangerous the man in the festive costume is. And the rooftop sequence when Harry goes to avenge himself upon the production line worker who made a fool of him by duping him into covering a shift is a real gem. So convinced is Harry that he is Santa Claus, he mounts a ladder to the roof and tries to enter the guy's house down the chimney, but he gets stuck, and has to struggle to free himself. Like many horror movies through the decades and like the horror comic books that were so popular for many years, this film utilises wry comical elements to diffuse tension (think **The Bride of Frankenstein (1935)** as a good example, or **An American Werewolf in London (1981)**). Of course, they are not always successful, but this one I think most certainly is.

When Harry does get free from the chimney and enters the house by more mundane means, the kids who see him are young enough to just accepted him as Santa Claus and not raise an alarm, (reminiscent of the childish innocence resulting in dire consequences in **Tales from the Crypt (1972)**. Finding his former tormentor asleep in bed, next to his wife (who has presumably taken a sleeping pill!), Harry first tries to suffocate him with his toy sack, but when this is unsuccessful, he cuts his throat with a decorative Christmas star he grabs from nearby. However, in the wake of the murders and the spreading news of the psycho-killer-Santa he soon finds himself being chased through the poorer tenement area of the city by a mob of angry people with old Universal Horrors style flaming torches in their hands – a truly surreal moment– Santa Claus cast as Frankenstein's Monster!

Harry's brother Philip, who is concerned when his "emotional cripple" sibling doesn't show up on Christmas morning, and who has seen the news reports on TV about a psycho-killer dressed as Santa Claus, is not overly-surprised when Harry eventually shows up on his doorstep in his dirty Santa suit, soiled with soot from trying to lower himself down his slain workmate's chimney. "I knew it was you!" Phil exclaims. "You're right Phil" Harry replies; adding pathetically, "I'm a failure. Everyone's rejected my tune." Philip launches himself at his deviant, murderous brother, strangling him until he collapses, sure that he has killed him.

This might have been a fitting ending for many a movie...but **You Better Watch Out** is a bold little film that marches to the beat of its own drum (just as its anti-hero slaughters to the sound of his own tune) and Harry comes round, rallying and thumping his brother before taking off again in his van with its festive paint job – his very own Santa sleigh. However, he is soon confronted by those flaming-torch-wielding, Frankenstein mob vigilantes, and spinning

his van around to try and speed away from them, he bursts through the side of a bridge, the van launching in slow motion through the air...and beautifully, boldly, surreally and hysterically, not plummeting to the earth again! The final sot sees the van continue to fly in slow motion, the Santa sleigh painted on its side apparently flying as if by Santa magic past the full moon in the clear sky (and this was a couple of years before Elliot on his bike with *E.T. – The Extraterrestrial (1982)* in the iconographic image from Spielberg's blockbuster!). And as the sleigh flies out of sight, we here Harry's voice spouting the end of that old perennial festive favourite poem by Clement C. Moore, *A Visit from St. Nicholas* (aka *'Twas the Night Before Christmas*) "...But I heard him saying as he drove out of sight, 'Merry Christmas to all, and to all a good night.'" This is a priceless ending to a priceless Christmas Horror!

Yes, it is low budget, it is an Indie and the only people in it you will probably ever have heard of are Jeffrey DeMunn, who played Philip and who went on to roles in such things as *The Green Mile (1999)* and down the cast, Patricia Richardson who played Tim the Tool Man Taylor's wife in TV's **Home Improvement** a decade later. But don't be put off by any of this. If your viewing pleasure demands something unusual, well made, intelligent, gory, funny and entertaining, then this little gem could be just the ticket. In my book (and lets face it, I'm writing it, so this is my book!) this is certainly one of the best of the Christmas-Horrors of its kind so far. The humour is excellent (the police investigation of the slayings provide some side-splitting scenes: an identity parade of men in Santa suits for instance; and one detective saying to another "Maybe our Santa's gonna do some good after all...make the kids scared again; they won't think everything's coming to them so easy; they're bad... [makes throat cutting sound and gesture]"); the performances (especially Brandon Maggert's) strong; the psychological aspects interesting; the murders somewhat gory and shocking; the music very effective; and there are bold elements of the surreal fantasy. If only they were all this good! ...

...But alas, they are not. Which brings us neatly to the other American-produced movie released in 1980, *To All a Good Night*. If anything, on paper this movie, though also a low-budget Indie, would seem to have the greater pedigree. Not only was it written by *The Incredible Melting Man*, Alex Rebar – actor, writer, director and sometime producer who had played the eponymous role in *The Incredible Melting Man* penned and directed by William Sachs in 1977 – but it was directed by David Hess – star of the seminal *The Last House on the Left* written and directed by Wes Craven; in which he played the iconic psychotic convict Krug Stillo who, along with a buddy, rapes and murders a pair of teenagers, inspiring the parents of one of their victims who the criminals unknowingly seek refuge with to turn into murderous vigilantes.[160] And David Hess also makes an uncredited cameo appearance in *Too All a Good Night* too.

Unfortunately though, things didn't live up to the 'on paper' expectations, and *Too All a Good Night* turned out to be not only one of the 'Bad,' but also pretty darned 'Ugly' too, in our list of 'The Good, the Bad and the Ugly.' Why? Well, for a start it is probably the worst lit film I have ever seen – so even those wanting to see the director's cameo would be hard-

160 Hess, who had also had a stab at a pop career in the late 1950s also composed the music for *The Last House on the Left (1972)*

pressed to spot him amid the gloomy, darkness that pervades much of the screen most of the time. But that is not the only shortcoming: direction is dismal, writing dire, acting inept – in fact, it is a job to find much positive to say about this particular would-be festive frightfest. It is a by-the-numbers numbskull 'Slasher' that is practically impossible to see much of the time (which, in the final analysis, might actually be a good thing!).

The plot centres on a group of students and their boyfriends (as *sooooo* many 'Slashers' do!). The girls belong to a posh Finishing School for Girls and the majority of the action takes place in their Sorority House, where they are staying over the Christmas holidays.[161] They do the usual studenty stuff – party (with a gang of rich twerp boyfriends who fly there in the private plane owned by one's wealthy dad); get naked; blithely ignore missing buddies; do stupid things like wandering into really dark places alone; hump each other and get bumped off! (Almost everything except *act* in fact!).

In this film, the college superintendent is away, and they girls drug their House Mother's hot bedtime milk, knocking her out for 12 hours while they flirt with the flown-in twerps. Trouble is…a psycho in a Santa suit starts knocking them off using various gory means (axe, wire garrotte, arrow, knife, rock – even the propeller of the aeroplane the boys flew up in!). It sounds like it should all be enormous fun for fans of the genre, doesn't it? The fact that it isn't can only be testament to how shoddy it is. In fact, possibly its main claim to fame is that it vies with the far superior ***Better Watch Out*** released the same year for the privilege of being regarded as the first feature length film whose star attraction and central figure is a psycho-killer in a Santa suit.[162] A motif that gone on to become something of a sub-genre of Christmas Horror Movies in it's own right over the years. Why, there is even a movie called ***Psycho Santa*** released in 2003…but we will get to that…

To All a Good Night does have a high body count, but before gore-heads get too excited or cheer too loudly, they should remember that the lighting really is so poor that on most occasions the viewer can barely see what is going on anyway. The reason for the deaths is all tied in to a Sorority House stunt that went tragically wrong a few years before, ending in the death of a young girl. And as you might expect (especially if you are a seasoned slay-fest viewer aficionado) it all leads up to a twist or two in the tail. (But again, the even twists are *sooooooooooooooo* gobsmackingly inane that their sheer stupidity will take your breath away!).

One fairly unforgettable image from the film is of one of the current sorority girls driven *soooo* loopy, by the psycho-Santa's reprisal slaughters, that she ends up dementedly singing and ballet dancing around the corpses of her friends in a nightie as the killings continue! (Well, nuts are popular at Christmas I guess, aren't they?!) All in all though, this particular Santa 'Slasher' is rougher than Noddy Holder's voice shouting, "It's Chriiiiistmaaaaaas!" at the end of Slade's 'Merry Christmas Everybody.' It's advertising tagline promised "You'll scream

161 Just as it does in both versions of ***Black Christmas*** (*(1974* and *2006)*)

162 Although a psycho-killer-in-a-Santa-suit did feature in the portmanteau movie ***Tales from the Crypt (1972)***, that was only in one segment

till dawn," but I reckon "You'll scram long before the end" or "You'll yawn till dawn" would be more appropriate. I reckon "you'll have a blue Christmas, that's certain"[163], if you spend it watching rubbish like this!

And so to 1981... This year didn't see any out-and-out Christmas Horrors that I am aware of...but there were a few films released that deserve a mention. *The Hand*, adapted from Marc Brandell's novel and an early directorial outing for triple Oscar winner[164] Oliver Stone, seems on the surface to be one of a group on horror fantasies made over the years – like *The Hands of Orlac (1924)* and *(1960)*, *Mad Love (1935)*, *The Beast with Five Fingers (1946)*, *Dr. Terrror's House of Horrors (1965)*, *And Now the Screaming Starts! (1973)* – about amputees whose severed hands develop lives of their own or whose replacement hands take control of their hosts in a murderous manner. But *The Hand* is perhaps psychologically grounded than most of these. Its central character, a writer with marital problems played by Michael Caine, loses a hand in a car crash and believes that the organ, which was not found at the scene of the accident, has developed a life of its own, turned into a mindless murdering automaton and returned to haunt him.

On the plus side, the movie boasts a pretty fine performance in a challenging role from the mercurial, Quixotic Brit screen legend Caine (whose movies have veered from the sublime to the ridiculous over the years). It also has an excellent script and some inspired direction from Stone. But on the minus side, some of the special effects of the crawling, amputated hand are pretty poor. Still, what we are really interested in is that the film does also feature a decidedly edgy holiday sequence.

At Christmastime, the amputee author (whose wife has separated from him and taken his beloved daughter) is expecting his family to return to him and attempt a reconciliation. He has secured a job as a lecturer at a country university and been living in a log cabin in the woods. But he has also been having an affair with one of his students. He has given her a slinky black nightie as a Christmas present, but when he learns that she is spending Christmas with another boyfriend, he becomes jealous and she and her boyfriend (one of his work colleagues) become victims of the murderous, avenging hand he lost in the automobile accident.

When his wife and daughter show up for the holidays, he manages to explain the slinky black nightie on the bed away as his wife's Christmas present (well, they are meant to be trying to get back together!), but he soon learns that she has no real intention of getting back together with him, but intends to leave him for good and take his daughter with her. So the scenes of supposed blissful family communion at Christmastime – the child opening her presents from under the tree while mummy and daddy watch from the sofa in the fire lit lounge of the cabin – are infused with, and destabilised by an undercurrent of psychosis and threat (often from visual hints about the possible presence of the crawling killer), which finally manifests itself openly when the hand attacks the wife in her bed. ...Or *is it* the disembodied

163 Lyric from the song 'Blue Christmas' written by Billy Hayes and Jay W. Johnson and first recorded by Country singer Ernest Tubb in 1948.

164 For Best Written for *Midnight Express (1978)* and Best Director for *Platoon (1986)* and *Born on the Fourth of July (1989)*

five-fingered avenger at all? ...Is that manifestation all merely a figment of the unbalanced husband's overripe imagination? ...Is *he* actually doing the killing himself and blaming the preternatural agent as an antagonist?

Well, if it is him and not the hand, I'm not going to finger him! You will just have to watch this interesting little 104-minute film for yourself to find out. I think it is generally under-appreciated as a work anyway and probably deserves a watch or re-watch. On the whole I would class this mainstream Horrorwood[165] effort as pretty 'Good'; though some of the special effects are both 'Bad' and 'Ugly'!

Another 1981 production that deserves a mention is a 25-minute long Rankin-Bass stop-motion puppet animation made for American TV. It is perhaps a fairly minor effort in their glorious repetoire of festive animated TV featurettes produced over the years,[166] but the animation in detail is as wonderful as ever. However, this story of a cabin boy put ashore on an island to get a Christmas tree for his ship and releasing a wicked wailing banshee trapped by the tree, is probably the darkest in some respects of any of their efforts. This is because the banshee, imprisoned by the tree for trying to trick the island's Leprechaun's out of their gold, is only doing so to save her own life − if she does not obtain the Leprechaun's gold freely given before dawn on Christmas Day, she is doomed to weep until she washes herself away in her own tears...which is exactly what the cabin boy and Leprechaun's trick her into doing. Still, family-orientated as it may be, I think that we can welcome any festive feature that contains a wicked wailing Banshee into our humble assortment of way-out and wacky Yuletide entertainments.

And finally for 1981, another children's film, but this time one that definitely fits into the 'Bad' category. This is a 5-minute monstrosity made for New Zealand TV and entitled *The Monster's Christmas*. Now, I do not like to be uncharitable − especially where Christmas is concerned − but this little movie is among the worst claptrap I have ever seen. It is amateur-ish on every level. The acting is abysmal, the direction dire, the costumes criminal: it is ill conceived and irredeemably awful.

The plotline, for what it's worth, sees a young girl at Christmastime[167] hearing a noise and rising from her bed in the hope of meeting Santa, but finding herself confronted instead by a 'monster.'[168] However, this 'monster' is a person costumed in something that the **Blue Peter** 'let's-show-you-how-to-make-this-at-home' team would be ashamed of... even if they had conceived of and created it at 5am in the morning after an all-night office Christmas party!

165 The film was produced by Orion Pictures Corporation and Warner Bros. Pictures

166 These have included all time Christmas classics like ***Rudolph the Red-Nosed Reindeer (1964)***, ***The Little Drummer Boy (1968)***, ***Frosty the Snowman (1969)*** and ***Santa Claus is Comin' to Town (1970)***.
167 A sunny, mid-summer Christmastime this being set in the southern hemisphere amid unfamiliar flora
168.
Ok, I know it couldn't be really scary as this is a children's film...but nonetheless....

This 'monster' is just like the one in the children's storybook the girl has just been reading (in which medium the tale probably works much better), and from her knowledge of the events in the storybook (reinforced by the monster's inability to speak) the little girl knows that a witch has stolen all the monsters' voices (though they in turn have hidden her magic wand), so the little girl sets off to help the unscary, cheapjack monsters retrieve their vocal abilities.

Unfortunately, even the unusual New Zealand settings and flora cannot rescue this production. Thank the Lord that Peter Jackson, director of cheapo gorefests like *Bad Taste (1987)* and *Braindead (1992)*[169] as well as more major, bigger-budget productions like *Heavenly Creatures (1994)*, *The Frighteners (1996)*, the multiple Oscar winning[170] *Lord of the Rings* trilogy and *King Kong (2005)* would turn up in the not-too-distant future to reinvent the New Zealand film industry. Honestly, I would be surprised if the makers' mothers liked *The Monster's Christmas*! It is definitely more hobbled than Hobbit I'm afraid.

So let us put that particular production out of its mistletoe misery and pop up behind the Iron Curtain to the Soviet Union. There in 1982 a film called *Charodey* (aka *Charodei*, *Magicians* and *Wizards*) was released. This production, freely adapted by the Strugatsky brothers from their own Sci-Fi book (though not to the liking of many of the book's fans!), is comical rather than scary, but being something of a modern fairytale or folk myth centred on the inhabitants of an institute for magic[171] around Christmastime and being all about bewitchment, deception, intrigue and love, I think it deserves a mention.

The story is presented in a humourous manner (I understand that all of the character names even are kind of in-jokes for those who understand the language), a new magic wand plays an important role and the story emphasises the extraordinary powers humans are endowed with during the festive season.

Indeed, according to Birgit Beumer, in her essay *Father Frost on 31 December: Christmas and New Year in Soviet and Russian Cinema*[172]: "Ivan's little sister creates the Christmas tree and organizes the dinner with the magic wand. For the first time in Soviet cinema a child is portrayed as an active supporter and maker of a merry Christmas, but not as its main beneficiary. This role would only be discovered in the 1990s…It is fitting that Ivan and his sister… become the driving forces that establish happiness under the Christmas tree…Instead of

169 Aka *Dead Alive* and *Dead-Alive* on its US release and DVD release

170 *The Fellowship of the Ring (2001)* won 4 – for Best Cinematography, Best Effects, Best Makeup and Best Original Score; *The Two Towers (2004)* won 2 – for Best Sound Editing and Best Visual Effects; and *The Return of the King (2003)* won 11 – for Best Picture, Best Best Director, Best Writing (Adapted Written), Best Editing, Best Visual Effects, Best Sound Mixing, Best Art Direction/Set Decoration, Best Costume Design, Best Makeup, Best Original Score and Best Original Song.

171 Echoes of Hogwarts Academy for Harry Potter fans!

172 In *Christmas at the Movies: Images of Christmas in American, British and European Cinema*, edited by Mark Connelly, I.B. Tauris, London/New York, 2000

celebrating Christmas in private, Ivan devotes his holidays to the good of society and makes others, including himself, happy through his actions." Hmmm. Try selling this idea to most kids in a modern Western society and you might find yourself strung up from a Christmas tree...by your baubles!

The year after this Commie Christmas cracker pulled audiences into the cinemas in the east, Americans faced a storm of moral protest over the release of a Christmas Horror, which was denied a cinema run and released straight to video as a result of the outrage and uproar... and naturally went on to be a massive financial success as a result of all the 'free advertising' (and to spawn no fewer than four sequels). I refer of course to the psycho-Santa 'Slasher' ***Silent Night, Deadly Night (1984)*** (which will be covered – along with its sequels – in the next chapter). But that same year in dear old Blighty, as the 'video nasty' kafuffle drew to a close in Britain with the creation of the Video Recordings Act (1984), some exploitation filmmakers released what should have been a B-movie 'Slasher' quickie, but which ended up being a movie with so many production problems that it took a couple of years and three directors to complete. But it did have the neat idea of turning the psycho-Santa killer theme on its head, and making its nasty Christmas crackpot a vicious killer *of* Santas – that is to say, pretty much anyone dressed in Santa suits (so a major city at Yuletide is a target-rich environment!).

The film was ***Don't Open Till Christmas*** (aka ***Don't Open 'Til Christmas***), which is credited as being directed by its star Edmund Purdom, a once incredibly handsome British actor who briefly became a Hollywood leading man (winning the lead role in the Musical ***The Student Prince*** in 1954, when opera singer Mario Lanza's weight gain lost him the part – though his singing voice was still used) before basing himself in Rome and working mainly out of Italy. However, Purdom (whose only turn in the director's chair this was) didn't last the course, so the film's writer, Derek Ford (a director of mainly sexploitation movies like ***The Wife Swappers***[173]) took over the reins for a while, before Al McGoohan[174], on whose story Ford's script was based, took over, directing 'additional scenes' that apparently included all the gory slayings. Editor Ray Selfe, a bit of a British cheapjack exploitation movies Jack-of-all-trades, had the unenviable task of trying to bring all of this together coherently into a saleable finished product – though his success in this respect is dubious to say the least, and this film is definitely both pretty 'Bad' and decidedly 'Ugly'.

The film, which is quite grubby and sleazy, with a feel of sexploitation tat about it, is set in London, in and around the Piccadilly Circus area, and opens with a man in a Santa suit having sex in the back of a car being stabbed to death when he gets out to confront someone who appears to be spying on his festive frolics. Soon another Santa at a Christmas fancy dress party is murdered – this time with a spear through the throat (the Santa slayings in this movie a re gory and inventive – including one particularly grubby scene where a fat man in a Santa suit who is using a urinal is castrated by the killer and left to bleed to death and another where a stripper in a peep-show sees a peeping client slain. The killers uses a knife, a machete, a cut-throat razor, a spear, a gun...there is even one slaying where it is a face, rather than a chestnut, that is roasting on an open fire!).

173 Aka ***The Swappers***
174 Pseudonym of Alan Birkinshaw

Two incredibly inept, bumbling, brainless detectives (one, Inspector Harris, played by Purdom) try to track down the Santa slayer and find out what is going on – though Inspector Harris himself seems to be a suspect at one point and certainly to know more than he is letting on. There are eventually 14 victims and the whole thing ends abruptly in a terribly unsatisfying conclusion; the acting is perfunctory at best (and downright diabolical at worst) and the whole thing reeks with the shabby tackiness of (s)exploitation. Pat 'Blackpool Patricia' Astley, a British sexploitation starlet, gets her tits out; Bond girl,[175] pin-up, no stranger to genre roles[176] herself (and later star of Adam Ant's solo UK chart No. 1 music video for 'Goody Two Shoes)'[177] Caroline Munro appears as herself, singing a wonderfully awful disco number in a trashy-classy scene in a nightclub; and the killer turns out to be a character played by bad-boy actor, husband of Diana Dors and sometime softcore sexploitation star of films like ***Confessions from the David Galaxy Affair (1979)***,[178] Alan Lake. And it also features a scene set in the ever-popular London tourist attraction, The London Dungeon.

This film is, it must be confessed, more than a bit of a mess – but splatterheads will probably relish the gruesome murders, and its all round grubby, sleaziness is kind of nostalgic for anyone who grew up in the period of its production and frequented fleapit cinemas screening low-rent B-grade shockers, sclockers, exploitation and sexploitation flicks. You would have thought though that producers Dick Randall[179] and Stephen Minasian might have considered just how wise it was trying to produce and release such a movie in the mad climate of the 'video nasty' era, other production problems notwithstanding.

At the other end of the scale altogether (certainly with regards to budget and production values), and across the Atlantic (this time most definitely in mainstream big studio Hollywood territory), in stark contrast 1984, saw the release of an Amblin Entertainment[180] and Warner Bros. Pictures A Warner Communication Company movie that would be a worldwide box-office smash and swamp the Christmas movie-synergy market with all manner of must-have movie tie-in products. That film, definitely one of the 'Good' ones, was the 106-minute family

175 She played the sexy helicopter pilot, Naomi, who forced Bond's white Lotus Esprit into the water where it became a submarine in *The Spy Who Loved Me (1977)*, though she also played a guard (uncredited) in the unofficial Bond comedy *Casino Royale (1967)*.

176 She featured in films like *The Abominable Dr. Phibes (1971)* (aka *Dr. Phibes* and *The Curse of Dr. Phibes*), *Dracula A.D. 1972 (1972)* (aka *Dracula 1972*; *Dracula 1972 D.C.* and *Dracula Today*), *The Golden Voyage of Sinbad (1974)*, *Captain Kronos – Vampire Hunter (1974)*, *I Don't Want to be Born (1975)* (aka *It Lives Within Her*; *It's Growing Inside Her*; *Sharon's Baby*; *The Baby* and *The Monster*).

177 Released in 1982

178 Aka *The David Galaxy Affair* and *Star Sex* (which also featured tragic British softcore star Mary Millington)

179 A colourful character who specialised in knocking out trashy, low-budget exploitation flicks for 30+ years, though he started out as a writer, then distributor and even acted sometimes.

180 The film and television production company founded by director/producer Steven Spielberg, producer Kathleen Kennedy and her director/producer husband Frank Marshall

comedy fantasy with horror elements, **Gremlins**, directed by Joe Dante,[181] and written by Chris Columbus.[182]

This is an excellent horror-comic from a director who is a master at balancing chuckles and chills. It boasts fine performances, great animatronic special effects, and a sharp, witty script (even if it is illogical in parts... How can you not feed something after midnight? – It's always after midnight one way or another! ...But hey, who wants logic when you can have romping good fun, right?). The design, lighting, music, cinematography and editing are all effective too, ensuring a wonderful synthesis that results in a wham-bang whole. I know there aren't many real frights (as the film is aimed at the family – or at least those over 12 –15 in most national classification systems), and the little Mogwai Gizmo is just too-too cute...but hey, when the nasty green gremlins are finally released, it's an anarchic riot and a hoot, turning mild mannered, middle-class mums into microwave killers and shaking up the whole twee small town Christmas.

The narrative actually starts out just before Christmas, when eccentric travelling salesman and self-styled inventor (though his inventions seldom seem to work), Randall Peltzer (played by Country singer-songwriter-cum-actor Hoyt Axton), hocking his wares in a big city and on the lookout for an unusual gift for his son Billy (nice big-screen debut from Zack Galligan) finds himself led to a strange basement store in Chinatown. There he hears the sweet, melodious song of a "Mogwai" – a criminally cute, furry little creature (and a marketing man's dream!). He is determined that he must have one for Billy, and when the old Chinese shop owner (played by Keye Luke – Charlie Chan's No.1 son way back in the 1930s series of B&W detective movies) won't sell, he does a deal with the old man's grandson to get his hands on the furball behind the old man's back.

But there are 3 golden rules. A keeper of a Mogwai must obey. Keep it out of the light (They don't like bright lights, as we find out later when the furball squeaks "Bright light! Bright light!" upon having is picture taken with a flash camera by Randall's wife); keep it away from water (and the consequences of getting it wet we also see later!). And "Never, *never* feed it after midnight."

Peltzer returns home to Kingston Falls – the idyllic vision of picture perfect small town America. The town, surrounded by hills, is clad in festive snow and doesn't appear to have a single building over 3 storeys tall. In its centre, a civic garden square displays a large decorated

181 Director of funny horror and sci-fi films like *Piranha (1978)*, *The Howling (1980)*, the segment of *Twilight Zone: The Movie (1983)* in which a young boy with mystical powers traps people in his own grotesque cartoon-ish world (segment 3), *Explorers (1985)*, *Inner Space (1987)* , *Matinee (1993)* about a William Castle-esque movie producer/director/promoter, and *Small Soldiers (1998)*.

182 Writer of films like *The Goonies (1985)*, *Young Sherlock Holmes (1985)* and director of *Adventures in Babysittng (1987)* (aka *Night on the Town*), *Home Alone (1990)*, *Home Alone 2:Lost in New York (1992)* (aka *Home Alone II*), *Mrs. Doubtfire (1993)*, and the first two Harry Potter films, *Harry Potter and the Philosopher's Stone (2001)* (aka *Harry Potter and the Sorcerer's Stone)* and *Harry Potter and the Chamber of Secrets (2002)*. He did write the awful *Christmas with the Kranks (2004)* adapted from John Grisham's novel *Skipping Christmas* as well though!

Christmas tree, lit up with fairy lights and topped by a shining star. Kids build snowmen and start snowball fights as they wait for the school bus, and adults put up decorations, shop for Christmas, go about their business and buy Christmas trees from the lot in the square. ...A picture of festive bliss.

Randall's son walks along the snowy main street like George Bailey from ***It's a Wonderful Life (1946)***. And he works in the local bank (another echo of George?). At work he is asked by a pretty co-worker, Kate (the gorgeous Phoebe Cates from ***Fast Times at Rdgemont High (1982)*** and **Lace (1984)**) to sign a petition to save a local bar from a local arch-nasty, the money-grasping profiteer, Mrs. Deagle. (A bit like Potter in ***It's a Wonderful Life*** but by way of the wicked witch from ***The Wizard of Oz (1939)***. It is a fun portrayal by Polly Holliday and Deagle even hates Billy's dog, Barney and wants it put down, like Miss Gulch, the wicked witch's Kansas alter-ego!). There's even a touch of Scrooge about her. Outside the bank Miss Deagle shows her colours when a poor mother asks for more time to pay her bills. "Mrs Harris," she huffs haughtily, " the bank and I have the same purpose in life - to make money. Not to support a lot of... deadbeats!" "Mrs Deagle! It's Christmas!" the woman protests. "Well, now you know what to ask Santa for, don't you?" says Mrs. Deagle.

When Billy gets home from work, his father gives him his present and allows him to open it immediately as it is a living creature that will need caring for and attending to. (This is the first time we actually see the cute little Mogwai – a kind of cross between a Teddy Bear and a monkey, with huge expressive eyes, and large pink ears sticking out of its fur). And not only does the new pet complain when Billy's mum sets off her camera's flash, even the reflection of a light in a mirror troubles the cute critter dubbed "Gizmo" when Billy tries to show it its reflection wearing a Santa hat. "I bet every kid in America would like one of these," Billy's dad blurts (...and most of them did! ...and many of them got them thanks to the marketing tie-ins!).

Of course (just like all the viewers) Billy is smitten, and Gizmo seems like a perfect gift... Until Billy's friend Pete (1980s teen icon Corey Feldman) accidentally spills some water on him, that is. This causes the poor little Mogwai to writhe in agony, his back bubbling and boiling, until 5 balls of fur pop out of it and unfold to become 5 new Morwai.

Gizmo seems incredibly sad, and the new arrivals somehow don't seem to be quite so cute and cuddly as their progenitor. In fact, they turn out to be little (un-)Holy terrors; led by one of their number with a white Mohawk stripe on his furry head. The nasty wee beasties even string Billy's dog, Barney, up from the porch using a string of Christmas lights (though naturally, he suspects Mrs. Deagle).

Billy gets closer to Kate, who works part-time without wages in the bar Mrs. Deagle is trying to close, just to help out. Walking her home one night, he congratulates her on how well she handled his drunken, Xenophobic neighbour Mr. Futterman (an excellent cameo from ubiquitous horror cameo-meister Dick Miller), and she explains how the holidays are, for some people, the saddest, loneliest time of all. "While everyone else is opening up their presents", she muses, "they're opening up their wrists." Billy learns that Kate abhors the

holidays and why. (And Kate's monologue explaining this, to the accompaniment of a haunting instrumental version of 'Silent Night' on the soundtrack, is one of the highlights of the film. Phoebe Cates's straight-faced, deadpan delivery of her outlandish tale is an absolute comic treat).

But the trouble really begins for Billy and Kate (and Kingston Falls in general) when the tricky second-generation Mogwai trick Billy into feeding them after midnight (and the one being studied by his science teacher gets his hands on the teacher's sandwich in the wee small hours). Having eaten their late supper, they cocoon themselves in gooey green cocoons and emerge as anthropomorphised, lizard-like, reptilian mini-gargoyles – the Gremlins of the title[183]. These gremlins have bad attitudes, atrocious manners, a wild sense of humour, nasty habits and a propensity for destruction, mayhem and murder.

The Gremlins, which throw themselves into the YMCA swimming pool to multiply, go on an hysterical, nihilistic, punkish rampage through the town causing devastation everywhere. (Perhaps they are a personification of what the world could be like at Christmastime if all the little girls and boys were being naughty, instead of good so that they get lots of lovely presents from Santa Claus!). Even Billy's mum turns into a kitchen "Rambo" to destroy a couple of them in gory horror-comic fashion when they try to take over her turf (Liquidisers and microwaves come to the fore!). Though she has to be rescued herself when one of them hides in the family Christmas tree and attacks her from there – at first making it look like the tree itself is attacking her, before the conifer takes a tumble, at which point the reptilian rogue tries to strangle her with a chain of decorations!

Scenes of comical mayhem erupt and explode everywhere as the Gremlins interrupt peoples' enjoyment of the festive TV schedules by swinging from their aerials; wreck their cars and homes; attack innocent citizens; disguise themselves as Christmas Carollers; and even soup-up Mrs. Deagle's stair lift t send her zooming up her flight of stairs at break-neck speed and straight out of a second storey window into the street with her still strapped in! In short, it is Pandemonium!

Billy, rescues Kate from the bar where she is working, and where Gremlins are forcing her to serve them, binge-drinking, chain-smoking and causing violent mayhem (a bit like teenagers in my home town on a Friday and Saturday night!). One even dons a hat and mack and flashes at her!!! So Billy and Kate escape and find somewhere to hide until things quieten down.

When they do eventually quieten down, and the streets are deserted save for crashed cars, fires and an eerie mist, it is because the devilish miscreants have all gathered together in the cinema...to watch ***Snow White and the Seven Dwarfs (1937)*** no less! However, this gives Billy and Kate a chance to rid the world of the Chrstmas-wreacking gremlins by way of a gas fuelled explosion. Unfortunately for them though, the evil leader of the Gremlin gang

183 It is Billy's neighbour, Mr. Futterman (played by Dick Miller), who dubs them Gremlins after the mythical imps said to cause the breakdown of US aeroplane engines in WWII.

– the one with the white Mohawk ("Stripe") – escapes, leading to a final thrilling and funny confrontation in the town's department store. And though Billy, Kate, Gizmo and Barney (the dog) eventually take the day on the field of battle, Billy loses his cool Christmas present ("Gizmo") when the old Chinese storeowner comes and takes him away. (With a serious ecological message to boot: "You do with Mogwai what your society has done with all of Nature's gifts. You do not understand. You are not ready.").

This film is enormous fun (as is the sequel, ***Gremlins 2: The New Batch (1990)***, which has nothing to do with Christmas, and goes for out and out giggles). There's something here for everyone. Younger and more bill-and-cooey type viewers will probably fall in love with cute, cuddly Gizmo; the more jaded will probably relish the anarchistic antics of the Gremlins; those who like a few laughs will have them by the spadeful, and even those who are movie buffs will relish several homages to older movies that feature throughout the film.[184] This is one of those films you can watch again and again and always spot something you had not noticed or picked up on previously. It's the kind of film to put on when Christmas guests turn up unexpectedly and want a laugh; the kind of film that will give you a hoot at a hootenanny or tickle your chuckle-muscle any time of the year.

Though not an out-and-out Christmas Movie, the same year's US-produced, lower-budget sci-fi-horror-comedy ***Night of the Comet***, was written and directed by Thom Eberhardt, an award-winning maker of TV documentaries around social-issues before progressing to directing for the big screen and episodes of fictional TV programmes. This too is a pretty 'Good' movie, even though it comes across more as B-movie (and the fashions and hairstyles of its time, which really root it firmly in the mid-1980s are definitely 'Ugly'!).

This movie, which stars beautiful Catherine Mary Stewart (***The Last Starfighter (1984)***) and Robert Beltran (who plays Chakotay in **Star Trek Voyager**, although he looks remarkably like **ChiPs**' Erik 'Poncherello' Estrada here), is set at Christmastime, features several Christmas references and has themes of alienation, loneliness and loss set against the festive period; a time when such emotions can be experienced most poignantly. (And the loss here is a major one – most of the human race in fact! ...albeit treated comically here!) In this film, a kind of neo-nuclear-family is formed when the larger family of humankind is lost. It centres on the Californian survivors of a global catastrophe.

After the Earth passes through the tail of a comet at Christmastime, most of the population are turned into red dust immediately, but some (who experienced less exposure) first become flesh-eating zombies, on a slower route to Dustville! There is (naturally enough in this type of film) a desert complex of (mostly unscrupulous) scientists seeking an antidote to save humanity (but ostensibly only interested in saving themselves really!).

184 Robby the Robot from ***Forbidden Planet (1956)***, ***The Invisible Boy (1957)***, and **Lost in Space**, for instance; the Victorian time machine from ***The Time Machine (1960)*** in the background when Randall calls home from an inventors' convention; even "Stripe" going after Billy with a chainsaw *a la* ***The Texas Chainsaw Massacre (1974)*** in the department store.

Bursting with 1980s hairstyles, fashions and music (dig the scene where the two teenage sisters who survived dance around a department store trying on awful 80s fashion, while the soundtrack blares out Cyndi Lauper's 'Girls Just Want to Have Fun'!), this film treats its apocalyptic storyline with a light, humorous touch. (One of the scientists comments of the teenage girl survivors "Ironic; of all the great minds of the world, all the great intellects, who should survive...?"). But the irony recoils on itself, because the scientists have been exposed to the peculiar effects of the passing comet, and although they are rescuing survivors, it is only to gas them into comas and put them on life support systems to farm their blood in the search for a cure to save their own skins. But while they are unsuccessful in this, it is the bubble-headed (but sharp shooting) teen girls and the young Hispanic hunk they meet (along with the two youngsters they rescue from the scientists' facility) that live to re-propagate the Earth, while the intellectual but sinister scientists are all doomed or slain.

And much of the killing in this movie, although it is not overly gory, is instead rather glib (a step or two up from the 'no-onscreen-death-at-all' policy of TV's contemporaneous **The A-Team** to be sure, but still rather offhand). Indeed, the whole attitude towards violence in this film seems very cavalier – the girls' absent father is in the army, fighting the Sandanista in Honduras; when they arm themselves with automatic machine pistols that jam, the younger sister comments with perfunctory disdain, "Dad would have gotten us Uzis." As a matter of fact, the whole attitude of everybody in the film to life, humanity and the world seems to be pretty disposable, or throw away (perhaps a throwback to the Reagan era in which it was made). But if you can stomach that – and the God-awful 1980s hairdos and fashion (none of which prevents Catherine Mary Stewart from looking gorgeous) and the insistent 1980s music on the soundtrack – it does have some very effective sequences.

The scenes of survivors walking, riding and driving around deserted LA streets with red or violet hued skies are particularly eerie; and the scary shock moments are well realised throughout, and the talking zombies are pretty cool. I particularly liked little touches like the movie poster for the Clark Gable, Jean Harlow flick **Red Dust (1932)** being featured in a cinema, just after we have seen eerie, effective shots of piles of clothes just lying in red dust (and realised that that is all that is left of those humans who went out and partied watching the passing comet's lightshow in the festive night time sky). The scenes near the end of the film when we see the red dust washed down drains and away by a rainstorm are wonderfully horrible – almost the entire human race reduced to effluence!

I think of this film rather like one of my old Granny's Christmas trifles (– and lets face it, it is somewhat trifling to start with!). There are elements I really like about it: the scenes in the deserted streets for instance (these are the sherry-soaked sponge and the custard!). Bu there are other elements I could certainly live without: sillier plot elements; the glib attitude toward violence in general and the demise of humankind. (These to me are the jelly and multi-coloured sugar sprinkles that top the trifle - yuck!).[185]

185 Not sure about the big, horrible 1980s hairdos and **Dynasty** fashions!

The film opens with a view of space accompanied by some ominous, low-key music. A serious toned voice-over narration in the style of 1950s sci-fi movies (which the film is definitely inspired by and related to) informs us of the comet's approach: "Since before recorded time it had swung through the universe in an elliptical orbit so large that its very existence remained a secret of time and space. But now, in the last few years of the twentieth-century, the visitor was returning..." and we see the bright, glowing object zoom past before there is a cut to a view of the Earth from space. The narration then continues, "The people of Earth would get an extra Christmas present this year, as their planet orbited through the tail of the comet. Scientists predicted a light show of stellar proportions, something not seen on the Earth for 65 million years. Indeed, not since the time the dinosaurs disappeared...virtually overnight!" (So *that's* what happened to those pesky great lizards that ruled the planet for millions of years!).

On Earth, people are not only celebrating the festive season then (and Christmas trees, decorations etc are all in evidence), but they obviously haven't seen **The Day of the Triffids (1962)** – as they're all partying on down while looking up to the skies to see the celestial fireworks (wearing silly headbands with 'comet' baubles on stalks...so maybe they do actually deserve what they get!).

Seeing the Hispanic guy, Hector, wandering through the deserted streets at one point with an alien red sky above, dressed in a full Santa Claus costume and bearing flowers is a surreal sequence, funny and touching a the same time. It kind of rhymes with an earlier sequence in which Catherine Mary Stewart's character, Regina[186], is riding through the deserted streets on a motorbike and pulls up at traffic lights (which are still working) alongside an empty Mercedes with 'Jingle Bells' playing on the radio (which is still working too. At one point one of the scientists they meet, offers them a gun. "Appears to be the perfect Christmas gift this year!" she exclaims drolly.

At the evil scientists' laboratory complex Regina rescues two young children who are set to be gassed and sustained on life support machines as part of the living-braindead blood supply. "When you wake up, do you know where you'll be?" one female scientist asks the children rhetorically, before answering her own question: "...with Santa Claus at the North Pole." But Regina turns the tables on the scientists though, and gases them instead. And as she leaves them giggling semi-consciously from the effects of the laughing gas, it is with a sign she has hastily written: "Gone to see Santa".

...Which is exactly what a couple of young French kids do in **J'ai recontre le Père Noël** (aka **Here Comes Santa Claus** and **I Believe in Santa Claus**) that was also released in 1984. It is not a horror film, but it does feature an ogre, which is my excuse for mentioning it...though I think that it definitely false into the (entertainingly) 'Bad' category. It is about a seven-year-old whose parents have been kidnapped by tribal terrorists while on a mercy mission in Africa. He and a little girl determine to use their school class outing to the airport to jump a plane for Lapland and visit Santa to as if he can secure the parents' return as the youngster's Christmas

186 The new 'Queen' of planet Earth?

present. And not only do we see Santa's home and the white-whiskered, red-suited fat man wandering around Africa and encountering its flora and fauna on his mission, but we also see the nasty school janitor double-cast as an ogre, and the beautiful Gallic schoolteacher (who cannot help bursting into song at the drop of a hat...or an h) double-cast as a Christmas fairy who helps Santa on his trip to the Dark Continent. Co-written and directed by Christian Gion, the whole thing is absolutely surreal and crazy, mixing kiddie-flick, with Musical; Christmas Movie with political intrigue and fairytale with odyssey. But it does do it all with a certain strange Gallic charm and it doesn't outstay its welcome at only 79-minutes. Ok, so it is not scary in the least; but you have to admit...it certainly scores high marks on the weird and wacky scale!

And staying with the weird and wacky scale for a moment, I have to admit that I have no idea how to categorise the following year's Hong Kong-produced action-adventure-comedy-sci-fi-chop-sockey-Christmas Movie ***Sheng dan qi yu jie liang yuan (1985)*** (aka ***Christmas Romance*** and ***It's a Drink, It's a Bomb!*** on the 'The Good, the Bad and the Ugly' stakes. In this movie, Japanese criminals doing a deal with a crooked Hong Kong cop, hide a new high-powered explosive they have purloined from a scientist and are selling to him in a soda pop can to smuggle it into the country. Naturally, the lethal can gets mixed up with countless other cans of fizzy pop, and thinking that either an over-zealous female biker (played by beautiful, fit, sassy Maggie Cheung), an archaeologist (played by George Lam) or a wisecracking taxi driver – who is really a cop (played by John Sham) – has the can, the crooks try to chase them down and retrieve their package... before their hot Hong Kong Christmas celebrations go with a *real* bang.

Experienced actor-cum-producer Sammo Hung, star of American TV series **Martial Law** and a 'brother' of Jackie Chan's,[187] produced and experienced cinematographer-cum-director David Chung took the helm.

Meanwhile, Stateside, low-budget often cult genre specialist and variously writer-producer-director Charles Band[188] was knocking out the first in what would be a (so far) six film series[189] of fun sci-fi features centred on the time-travelling *film-noir*ish character of a future cop with a retro-futuristic 1940s feel, a wisecracking, all action approach and a cool name. As one of the several advertising taglines used for ***Trancers (1985)***[190] put it, "Jack Deth is back...

187 They are not blood relatives, but trained with the same Chinese Opera Company as youths and refer to each other as 'brothers'

188 Founder of Empire Pictures (which went bankrupt) and later Full Moon Pictures – a genre empire eventually encompassing Pulsepounders, Pulp Fantasy, Alchemy, Filmonsters, Moonbeam, Torchlight, Monster Island and Cult Video among other production and distribution arms until it changed its name to Shadow Entertainment early in the new millennium – Brand's movies were often direct-to-video releases.

189 The sequels are ***Trancers II (1991)*** (aka ***Trancers II: The Return of Jack Deth*** and ***Trancers II: The Two Faces of Death***); ***Trancers III (1992)***; ***Trancers 4: Jack of Swords*** (aka ***Trancers 4: Journeys Through the Darkzone***; ***Trancers 5: Sudden Deth (1994)*** and ***Trancers 6 (2002)*** (aka ***Trancers 6: Life After Deth***)

190 Aka ***Future Cop***

and he's never even been here before!" Despite its low budget, this inventive and entertaining movie is definitely one of the 'Good' ones.

Tim Thomerson effectively portrayed 23rd century Trooper Jack Deth (and his 20th century ancestor) and was ably supported by future Oscar winner[191] Helen Hunt as the romantic interest. The plot, and there was quite a lot of it packed into this 79-minute feature, saw Deth sent back from the future to capture or kill a criminal called Whistler who had time-travelled to the 1980s to wipe out the ancestor's of the future's leaders, thus cutting off their blood lines (a tad *Terminator*-esque; but this film firmly centres on the character of Jack Deth and instead of cyborgs, he has a kind of killer zombies to deal with – the eponymous 'Trancers' psychically created by Whistler, that Jack describes as "Not really alive and not dead enough").

Yes, no doubting it is fairly low-budget; but this film uses what it has brilliantly. Thomerson's wisecracking, tough-nut, "squid-head" hating retro-future cop character is enormous fun, and the film itself has much more wit, intelligence, ingenuity, verve and vivacity than many of its mega-budget counterparts; all of which help elevate it from being a merely exploitative derivative...and doubtless the reason why it has spawned so many sequels. You can just imagine the pitch, can't you? ..."*The Terminator (1984)* meets *Back to the Future (1985)* with zombies thrown in and *Dirty Harry (1971)* crossed with Philip Marlowe as the hero...at Christmastime!"

So when Jack Deth (Thomerson) is transported back to 1985 LA to take over the body of an ancestor and stop Whistler and his zombies, he finds that he/his- ancestor-whose-body-he-jumps-into has just been jumping into the body (in a different way) of an attractive young woman called Leena (Hunt). It is morning and she who gets out of bed and dresses in a short-skirted Santa style suit: she is the photographer in the Santa's Grotto at a local shopping mall. Jack drops her at work, where the mall Santa has a youngster on his knee reeling off a long "I want..." list of Zeitgeisty toys 'of the moment'. (Jack is thrown a bit; because when he left future LA it was July). But suddenly Santa starts slavering and metamorphosing. He becomes a Trancer and attacks Jack. They fight, and eventually Jack plugs him. A dismayed kids whimpers, "Mum, he just shot Santa Claus". It is a priceless little scene. Then, later in the film, past midnight on Christmas Eve, Leena gives Jack a gift wrapped Christmas present she has got for him. He is touched. Unwrapping it, he finds that it is a toy robot called 'Future Man' – "like you" Leena quips.

And from the future to the past...a past that comes back to haunt someone and invade their present. 1985 saw the premiere of a 100-minute long, above average quality made-for-American-TV Christmas-set thriller called *Deadly Messages*, in which a young woman is sure she witnesses a murder, but no one will believe her as no evidence suggests that the nefarious act has taken place. So the woman – played by **Dynasty**'s Kathleen Beller – starts playing with a Ouija board, whose messages seem to suggest that she will be the next victim! But the strange events that ensue cause her boyfriend – played by **Dempsey and Makepeace**'s Michael Brandon – question whether his other half is in fact who and what she claims to be.

191 As Best Actress for *As Good As It Gets (1997)*

Both go on to discover that she is not, and that following a period in an asylum after she witnessed a gruesome murder, the woman has created a new identity for herself after suppressing incriminating memories. ...And now the memories are returning, her life is indeed in danger and she is being stalked; at one stage through a shopping mall that is all decked out for the season, but at which she buys a gun from a 'Self Defence Boutique' that displays the most un-Christmassy of Christmas posters – it features two teddy bears in combat gear with **Rambo** style headbands and toy machine guns with the legend "Give the gifts that take care of themselves." This too falls into the 'Good' category.

While Christmas and all its paraphernalia, although a nice counterpoint to the murderous machinations of the psycho killer in the season of Peace and Goodwill to all men, is pretty much incidental in **Deadly Messages**, it is a central theme to another American-produced made-for-TV Christmas Special: the 51-minute **He-Man and She-Ra: A Christmas Special** (aka simply **A Christmas Special** in the He-Man TV slot). Ok, so this is a feature-length festive special of a massively-popular-at-the-time animated kids' TV show and as such is unlikely to scare the skin off the custard you pour over your Christmas pudding. But it is also *Conan the Barbarian*-esque fantasy featuring not only humanoid aliens, but all manner of mystical alien creatures and extra-terrestrial monsters; not least the skull-headed arch-villain Skeletor!

At the time of this particular Christmas Special's release the product synergy was unbelievable (this feature was even co-produced by Mattel Inc.) – action figures, Greyskull castles, swords, costumes, you name it, were the absolutely must-have Christmas gifts of the time if you were aged between about 10 and 15, and a live-action feature film soon followed[192] (in 1987 starring muscle-bound Swede Dolph Lundgren, who had played Rocky Balboa's steroid-enhanced Russian opponent Ivan Drago in **Rocky IV** the year before). Maybe it is my age, but **He-Man and She-Ra: A Christmas Special** is one of the 'Good' on the 'The Good, the Bad and the Ugly' ratings as far as I am concerned.

Anyone who grew up collecting all the He-Man tie-ins will doubtless receive a real nostalgic fillip from seeing **He-Man and She-Ra: A Christmas Special**...altogether now, "By the power of Greyskull!" ...And while we are on a nostalgia trip, I think that a little mention is also merited for 1985's **The Life and Adventures of Santa Claus**, which was the last 'Animagic' Christmas special produced for American-TV by the prolific Rankin-Bass team, which had produced so many animated (3-D stop-motion and traditional painted-cell) festive favourites over the years[193].

The first of this triumvirate is a lowish-budget offering from cult producer-director Sean S. (**Friday the 13th**) Cunningham, scripted by Jake and Maggie Gyllenhaals' dad Stephen. It is not a horror film, but relates the tale of teenage siblings (brother and sister) taken in by an uncle who runs a down-at-heel amusement park after their dad (an army officer) and mum die in a car accident.

192 **Masters of the Universe (1987)**

193 E.G. **Rudolph the Red-Nosed Reindeer (1964), The Little Drummer Boy (1968), Frosty the Snowman (1969), Santa Claus is Comin' to Town (1971), A Year Without A Santa Claus (1974)**

It is a big change in lifestyle, and when the girl (Abby, played by lovely Lori Laughlin) knocks back the advances of the psychotic leader of a white trash street gang (well played by a young James Spader) there is trouble brewing. Her brother tries to help, but eventually the kids have to defend their very lives as this situation escalates and they come under attack in the shoddy amusement park...with the gang members despatched in various gruesome and gory ways.

"What on earth has all this got to do with Christmas?" you may well ask. Well, very little actually – not even being set at Christmastime...but the shabby little amusement park uncle runs is Santaland, and the gory fight for survival at the film's climax takes place among the festively themed rides and stalls to amusingly ironic effect. A young Eric Stoltz also appears down the cast list.

The second of the three is a 5-minute short written, directed and edited by Tim Sullivan entitled ***A Christmas Treat (1985)***. This started life as an NYU student film and went on to win the Fangoria Fantastic Film Search Audience Award in 1984 before being remastered by Image Entertainment.

It is a cracking little film and a cautionary tale for any little kids who want to try and stay awake on Christmas Eve to see Santa. It is still currently (at the time of writing Christmas 2009) available to view online[194] and is certainly worth a watch.

The film opens with voices over a back screen as a young boy called Jason, excited on Christmas Eve, is put to bed by his parents despite his protestations. They warn him not to be naughty and advise him to go to sleep even though he doesn't want to...and although he seems to capitulate initially, as Nat King Cole sings the Christmas Song (♫"Chestnuts roasting on an open fire..."♫) and the camera takes in details of the festive lights and decorations in his home, eventually he awakens. It is still the middle f the night and when he hears a noise, he cannot resist getting up and sneaking downstairs to see the expected red-suited figure decorating the Christmas tree and leaving gifts.

However, when he approaches Santa and prods the generous elf to gain his attention, Jason is shocked at the surprise he receives. The figure that spins around is revealed to be a monster! ...And it floors him with a blow of its claws before stuffing his lifeless form in his sack and heading off up the chimney as his smiling parents look on with a shake of their heads!

Ok, so the actual Santa Claws creature is no great shakes when finally seen...but the movie is so well made otherwise, that this is no great shakes – overall, the whole project (that bore the lovely advertising tagline "'Twas the night before Christmas, and all through the house, a creature was stirring..." and billed Santa Claws as Himself) still works as a joyously dark treat.

The last of the aforementioned 1985 films, the stop-motion animated featurette ***The Life and Adventures of Santa Claus***) was the last 'Animagic' Christmas special produced for

194 At http://iconsoffright.com/news/2008/12/icons_exclusive_tim_sullivans.html

American-TV by the prolific Rankin-Bass team, which had produced so many animated (3-D stop-motion and traditional painted-cell) festive favourites over the years[195].

I must admit that I am not overly fond of the fantasy storyline of this particular production (albeit based on a book by L. Frank Baum, author of the books upon which **The Wizard of Oz (1939)** was based) although its onscreen realisation is superb, continuing in the team's long tradition and numbering it among the cohort of the 'Good'. It tells how an abandoned foundling human child is bought up by mythical magic fairy folk and, how, upon learning of his own kind's hardships and the injustice of the human world, the grown up Claus (which means "small one" in the fairy tongue) decides that he must offer what joy and hope he can by making and delivering toys to the human young. As a result of his kindness, he is declared "a saint" by humans (though no church approbation or recognition seems attached or necessary!) and the Council of Immortals grant him immortality to continue his good work.

I guess on the plus side, this 50-minute feature is a bit darker than many of the neon-bright, sugary-sweet animated festive confections aimed at families and children. It really gets a mention here because there also exist in its mythical world an evil race of monstrous creatures called Awgwa, whom Santa Claus inspires the Immortals to wage war with and defeat once and for all, and other eerie faerie creatures such as the bat-like wind demons.

Although he has his own demons to grapple with, it isn't faerie folk who haunt Ernie Blick, the protagonist of the low-budget independent American movie **Static**[196] released in 1986. No, it is Heaven and the desire to contact his dead parents (killed in a car crash a couple of years before the film begins). Ernie is very well played by Keith Gordon, the star of haunted car movie **Christine (1983)** based on a Stephen King novel, and Gordon also co-wrote **Static** with director Mark Romanek. Since the death of his parents, Ernie, who works in a crucifix manufacturing company in a desert town in the Bible Belt, has been working on an invention which the townsfolk are sure will make his fortune.

An old friend – played by Amanda Plummer, daughter of Christopher, who would go on to star in films like **The Fisher King (1991)** and **Pulp Fiction (1994)** – returns to town from the city for Christmas, and Ernie reveals his invention – a kind of television set which he believes shows scenes from Heaven – to her and several of the townsfolk, they do not see the images he claims to see in the interference 'snow.' So Ernie, desperate for others to see what he sees and recognise the importance of his invention, hijacks a busload of pensioners in the hope of generating a situation that television news crews will cover, giving him a platform to announce and demonstrate his invention to the world. Instead, something of a Mexican standoff occurs in the desert...until tragedy ensues.

Yes, it is cheaply made, but this is one of those weird and wonderful little Indies that crop up every now and again that really deserve a bigger audience, so I reckon this too deserves

195 E.G. **Rudolph the Red-Nosed Reindeer (1964)**, **The Little Drummer Boy (1968)**, **Frosty the Snowman (1969)**, **Santa Claus is Comin' to Town (1971)**, **A Year Without A Santa Claus (1974)**
196 Aka **Necessity** (working title)

to be counted among the 'Good'. The performances of Gordon and Plummer are fine and the writing and direction are quirky and compelling enough to not only hook the audience, but to reel them in. And what is more, the movie also boasts a top-notch contemporaneous soundtrack in which New Wave meets Country meets Rock and Roll, featuring the likes of The The, Japan, Brian Eno, OMD[197], Johnny Cash and Elvis Presley.

While neither a full-on Christmas Movie as such, nor a Horror Movie, I think **Static** warrants a mention as it does deal with potential preternatural elements and/or mental instability and is quite purposely set at Christmastime because the associations of the festive season are really relevant. Moreover, I really don't think I have ever seen another movie quite like it: it has all the ingredients of a real cult movie.

And so to a movie that could, I guess, also become a cult movie...but this time because it is one of only two directorial efforts by Norman Bates himself – actor Anthony Perkins, star of Hitchcock's immensely influential **Psycho (1960)**. Perkins' only other stint in the director's chair was in fact for the second **Psycho** sequel, **Psycho III (1986)**, but his here we are concerned with 1988's Christmas-Horror-Comedy **Lucky Stiff** (aka **My Christmas Dinner**, **Mr. Christmas Dinner** and rather obscurely **That Shamrock Touch**).

Written by Pat Proft, co-writer of some of the **Scary Movie** franchise, as well as all of the **Naked Gun**, **Police Academy** and **Hot Shots** movies, humour is the first order here – albeit often rather crass black humour (but none the worse for that in my book – so I class this one as one of the 'Good' on the 'The Good, the Bad and the Ugly' rating system). Those who remember a Christmas episode of **The Simpsons** in which Homer takes a part time job as a store Santa at Christmastime and tries to remember the names of the sleigh-pulling reindeer, "Dasher...Dancer...Prancer...Vixen ...Comet...Cupid......Donna Dixon!" might wonder if the loveable, obese, yellow halfwit ever saw this movie, as the drop-dead-gorgeous ex-Miss World runner-up and Mrs. Dan Ayckroyd stars here alongside Roly Poly animation vocalisation wiz and comic performer Joe Alaskey.

The plot sees Alaskey's chubby love-loser who is at a mountain ski resort on honeymoon *sans* bride (who ditched him at the altar) suddenly pursued by a blonde siren (Dixon), who invites him to spend Christmas with her family of mountain folk kin. But things that just seem too good to be true, often are, and the Mitchell clan turn out to be descendants of the infamous 19th century Donner wagon train party, who got snowed in one winter and eventually turned to cannibalism in order to survive. And having got a taste for the old 'long-pig',[198] they have passed it down through the generations, so the latest porky sap is in fact being recruited to join the dysfunctional, in-bred, hillbilly cannibal family from Hell for Christmas dinner *as the dinner,* the turkey! "You can't leave Ron," one of his gorgeous new girlfriend's family tells him, "You're the dinner." "Now I get it," the slower-than-molasses-in-winter wobbly one says, the truth finally sinking in, "I'm not a guest, I'm the buffet!"

197 Orchestral Manoeuvres in the Dark
198 Translation of a South Sea islands cannibal word referring to human meat.

A Christmas comedy centred on anthropophagy (the scientific name for cannibalism) and incest – not your *typical* festive family film, then!

Wisecracks, jibes and one-liners pepper this film like condiments ("Women don't normally gravitate towards me...unless we're on opposite sides of the couch, then they just slide down" the big fellow quips surprised at the attention from the scrumptious blonde). But there is also a good deal of slapstick and even some surreal elements thrown in too. And although the film's horror is rather more notional than explicit on the screen, it does have some quite spooky little moments thanks to the creepy redneck incestuous cannibal hillbilly family – surely one of *the* most socially dysfunctional of all dysfunctional families that have populated Christmas Movies over the years.

Perhaps an example of the kind of humour to expect from this film is when the hero almost runs over a ranting one-armed man with a wooden leg and a crutch – he is someone the cannibal family introduced to the addictive taste for human flesh, but from whom they are now withholding supplies, forcing him to gradually eat himself to satisfy his craving! And though in truth it does seem to run out of steam somewhat towards then end, none the less, this Christmas horror-comedy is definitely something of a one-off; a challenge to good taste and comfy, firelit festive bonhomie.

The same year that Joe Alaskey's hapless overweight twit tried to avoid the Christmas carving knife, another spooky family-orientated ghostly mystery also hit the screens. This film was much more cosy in its nicely observed humour, centred on the foibles of an Italia-American family in 1960s New England. But due to some excellent special effects (and a few not quite so excellent ones, as the film was somewhat showy-effects-laden) it was also capable of a few frissons, so you probably guessed, it's another one that I would put on the 'Good' list.

The story of the 112-118-minute[199] ***Lady in White (1988)*** (aka ***The Mystery of the Lady in White***) sees a ten-year-old boy (nicely played by Lukas Haas) haunted by a dead girl – one of eleven victims of a serial killer from ten years previous. The girl is searching for her mother who, distraught at the loss of her daughter, threw herself over the cliffs on the edge of town and who has supposedly haunted the area ever since. And witnessing a particularly effective spectral version of the girl's murder, the young boy is now in danger as he has uncovered evidence that could lead to the serial killer's identity.

Alongside the nice nostalgic moments detailing the period and the quirky family (which at there best are reminiscent of Bob Clark's superb ***A Christmas Story (1983)***), there are some thrills and chills and even a bit of social-conscience (a black school janitor – remember it is the 1950s when the original murders occur – is initially charged and tried, but not convicted, and as a result, he is murdered by the mother of one of the victims). And one of the most poignant moments in the movie occurs when the transparent ghost of the dead girl who is seeking her mother appears at the home of the boy she has made herself visible to at Christmastime – the

199 Depending upon which version or cut you see

time of family union and love: she simply stands or floats beside the Christmas tree the boy and his family have shared an evening decorating on Christmas Eve and sobs.

In fact the whole thing is a quite respectable tour-de-force from writer-director-producer-composer Frank LaLoggia, who also appears in the film in a small, uncredited part as the ten-year-old hero's adult self. Which brings us nearly to the end of the grasping, greedy, money-is-God 1980s. There just remain three films from the final year of that decade I would like to mention.

The first of these is the decidedly weird ***Communion (1989)*** based on author Whitley Streiber's[200] purportedly autobiographical novel about alien abduction. With a Written by the author himself, directed by French born Philippe Mora and starring off-centre, Oscar winning[201] leading man Christopher Walken, this is one weird little film. And while it is not an out-and-out Sci-fi/Horror Movie, it does have both some nice frissons and some important Christmas-set scenes as Streiber and his wife (played by Lindsay Crouse) try to come to terms with first his and then their whole family's experiences of alien close encounters of the third and decidedly personal kind.

In his search for understanding and meaning in his alien encounters, Streiber finally seems to find this in some form of Christmastime communion with his extra-terrestrial interlopers (perhaps casting them as a modern day replacement for Christ and his angels, or a modern day explanation of the apparently heavenly events of two thousand years ago?). The family spends Christmas together in their comfortably appointed log cabin in the forest, the site of Streiber's initial 'encounter' when they visited with friends. The forest is covered in snow and the cabin decorated for Christmas, with festive lights, decorated Christmas tree and a roaring log fire in the burner.

Events such as the fading of lights, as well as direction (cosy family shots of the interior are creepily intercut with cold, eerie exterior shots with the camera looming and zooming towards the cabin suggesting point-of-view shots of some kind of presence) build tension and unease, at odds with the jokey family festive fun. Then when the family are finally in bed asleep, gadgetry such as the microwave oven is apparently affected by some kind of external force, and the security lights suddenly blaze into brilliant illumination. However, the cabin also seems to be lit from above by an even more brilliant light source. "Is there someone there?" Whitley asks, sitting up in bed...

And it is then that the film segues into one of its effective, surreal montage sequences as monk-hooded, blue, wrinkly-faced Munchkin-monster extra-terrestrials take Whitley off to their 'spaceship' to carry out quasi-medical procedures as their smooth-skinned, willowy bosses, a different form of alien, watch on.

200 Whitley Streiber and his son make a kind of Hitchcock cameo appearance in the film – in the museum sequence near the end.

201 As Best Supporting Actor for ***The Deer Hunter (1978)***

At one point during one such 'experiment' by the weird "little blue doctors[202]", as if he cannot believe it himself, Whitley tells one of his tormentors who has dragged a silver-headed tube from the wall, "You look like you're about to sing 'White Christmas'!"...He doesn't sing though – the device, it transpires, is a rectal probe!). Strieber's behaviour the next day as he recalls and fears the events, leads him to stalk around and within his cabin with a loaded shotgun, until (thinking he sees one of the little 'Blue Meanies' hiding behind a vase) he nearly blows his wife away with the shotgun. Small wonder then she demands he visit a shrink!

But the psychiatrist (played by the always-watchable Frances Sternhagen) far from pooh-poohing the author's experiences, introduces him to group of other people who have had similar experiences, which she cannot understand or explain. This leads Streiber to embrace the occurrences and actually seek out his alien tormentors, resulting in a surreal confrontation with his Magician self before a Christmas tree in the alien spaceship (which is superbly surreal if you appreciate it; but will probably drive you to distraction if you like everything explained and served up to you on a plate like a well prepared Christmas dinner!). Is the guy a loony-tune? ...The victim of alien abduction? ...An exploitative con artist out to make a quick buck off the back of a gullible public? ...You decide. And while you are at it, I think I will let you decide for sure whether this one gets classed as 'Good', 'Bad', or 'Ugly' as I am kind of torn, as I think it is by turns all three!

For his part, Christopher Walken was on the big screen again in 1989 in another movie set at Christmastime, but this time his character was the real monster in the piece. Though not a Horror Movie *per se*, Tim Burton's sequel to his box-office smash of 1989, **Batman**, reinventing the camp 1960's TV hero in a whole lot darker light, does I think deserve a mention. **Batman Returns (1989)** brought Christmas to the dark concrete canyons of Gotham City – along with a couple of monstrous new nemeses for the 'caped crusader' in the shape of the Penguin and Max Shreck (played by Danny De Vito and Christopher Walken respectively), and of course the not so evil, but decidedly mixed-up and delectably dishy Cat Woman (played in skin-tight PVC by gorgeous Michelle Pfeifer!). This one is most definitely 'Good'.

The film opens at Christmastime thirty-three years prior to the main action, when the wealthy Cobblepotts give birth to a son. But unfortunately the baby (Oswald) is horribly deformed with a penguin-like appearance; a beaky face and flipper like clawed hands – it is hinted, thanks to the toxic chemical waste of entrepreneur Max Shreck's factories. Unable or unwilling to bring up such a 'monstrous' progeny, the Cobblepotts take their baby for a walk in its basket weave pram in the snowy park and dump the pram over a bridge so that the baby floats Moses-like down the stream into the sewer system. ("I was their first born, but they treated me like 'number two'" Oswald exclaims much later!).

However, this baby is not so much posited as a modern Moses, but more a mixture of a modern Christ-Devil. Yes, he is monstrous of appearance, rises from the depths of the sewers

202 There are 2 distinct kinds of aliens or extra-terrestrials in the film: the "little blue doctors" – who look like pantomime pixies or goblins (sort of Smurfs from Planet X) and the tall, willowy, large-almond-eyed over-viewers (who look like escapees from *Close Encounters of the Third Kind (1977)*

beneath the city and lacking in social niceties (having been raised by penguins in their pen beneath a disused zoo), but he is promoted as a prospective mayor of the city by Shreck – a saviour (albeit a set-up, false one) and his emergence is 33 years after his disappearance – which would make him the same age as Jesus when *he* started *his* ministry! But the Batman isn't foiled and he sets about upsetting the plans of the Victorian dressed but uncouth Penguin, Oswald Cobblepot.

Several of the films set piece action scenes are set in Gotham plaza beside the city's huge civic Christmas tree, and the associations of the Season of Peace and Goodwill are well used to underscore the nefarious plots of especially entrepreneur Max Shreck (Walken), who is undoubtedly named after the German silent screen star Max Schreck, star of the seminal silent German vampire movie **Nosferatu, eine Symphonie des Grauens (1922)** (aka **Nosferatu**, **Nosferatu the Vampire**, **Nosferatu a Symphony of Terror**, **Nosferatu a Symphony of Horror** and **Terror of Dracula**) directed by F.W. Murnau. Schreck's bald-head, talon, clawed, bat-eared vampire is one of the screens most frightening images; and **Batman Returns**' villain appears to be named after the actor because his entrepreneurial activities are basically vampiric in nature – he plots and plans to build a 'power plant' that, instead of producing energy for the city (its lifeblood), will actually suck energy from it to sell back to it later at an inflated price. Perhaps the tide was turning on the greed-motivated capitalists of the Reagan era!

Batman Returns looks great, and the role of, Oswald Cobblepott, the Penguin, gave diminutive but immensely talented Danny De Vito of **Taxi** fame – who usually played in out-and-out comedy roles in films – the chance to flex his acting muscles (which he grasped with both hands). And while the Prince of live-action and animated comedy-horrors with a dark, gothy edge, Tim Burton, would be back with more entertainingly humourous and off-kilter offerings in the next decade, the final film of the 1980s we will mention is a remake of a movie – or at least one segment of a movie – from the 1970s.

A few episodes of the American-made HBO TV series **Tales from the Crypt**[203] were cobbled together Frankenstein-like and released to cinemas as a feature length portmanteau or compendium Horror Movie, introduced and linked by the animatronic rotting corpse of a Crypt Keeper (brilliantly vocalised by John Kassir, slaying his audience with a slew of wonderfully awful horror puns). One of the segments/episodes included was the Robert Zemeckis[204] directed remake of the segment in the 1972 version of **Tales from the Crypt** set at Christmastime and entitled *And All Through the House*.

This Christmas Horror story (based upon the same comic book source as the superior 1972 take) sees a murderous wife who has just slain her husband on Christmas Eve by

203 Aka **HBO's Tales from the Crypt**

204 Director of the **Back to the Future** films, **Romancing the Stone (1984)**, **Who Framed Roger Rabbit (1988)**, **Forrest Gump (1994)**, **What Lies Beneath (2000)**, **Cast Away (2000)**, **The Polar Express (2004)** and **Beowulf (2007)** among others; several of which he had a hand in the writing and production of too – along with others also. At the time of writing, he is currently helming an animated version of **A Christmas Carol** which he has written and is producing.

embedding a poker in his head, pestered by an escaped murderous psychopath in a Santa suit while trying to cover her tracks, dispose of the corpse and keep her daughter (who is excited about Santa's imminent arrival) both in her bedroom and in the dark about her dastardly deed. The opening scene of the nice middle-class home with the wishing well in the garden, covered in snow and bedecked in lights and decorations at Christmastime with a beautifully decorated Christmas tree is idyllic, and provides a lovely counterpoint to the murderous and insane events that follow.

LA Law's Larry Drake as the slavering insane slaying-machine dressed as Santa makes a suitably bulky menace, with the events opened up somewhat compared to the 1972 version. Here, the wife plans to drop her husband's body down the well in the garden and she drags it outside in the snow, missing the radio warning about the escaped lunatic dressed as Santa. Her husband isn't dead, however, which leads to a darkly comic scene of her knocking him out then trying to line up an axe and bury it in his head with her eyes closed. (It's the old third time lucky scenario, with some nice shooting angles and some comical mileage from what you do and do not see and hear).

When the psycho Santa does finally make an appearance though, the disturbed but calculating wife manages to cold-cock him and plans to blame her husband's murder on him. Again, some fun, pantomime-style 'Where-is-he? He's-behind-you!' shenanigans enliven the situation. Until, eventually, as in the original, mum, desperately worried for her daughter's safety, is immensely relieved to find her daughter safe and well...while the oh-so-innocent daughter is just pleased as punch because Santa has arrived...albeit scruffy and crazy-looking...and she has let him in! "Naughty or nice?" the slavering lunatic asks, as he stands hand in hand with the child, axe dangling from the other hand. As the segment ends though, the comical Cryptkeeper reassures us of the innocent little girl's safety, "Don't worry about little Kerry – this Santa prefers older women!" – which was presumably a necessary footnote with the film's television origin and rating!

This remains a darkly humorous tale, which is well enough executed with some deft touches by director Zemeckis – but while I would still rate it as 'Good' on the 'The Good, the Bad and the Ugly' rating system, this version is still not *as* good as its excellent and (for my money) artistically superior predecessor. Still, it is certainly a delicious Christmas delicacy for those with a dark sense of humour, and an antidote perhaps to all the maudlin movies for minors they might have to sit through with the family during the festive season. And I think that this link with the previous decade, when true Christmas Horrors were just finding their feet, is probably a good place to progress from the 1980s into the prolific 1990s, the Crypt Keeper's infectious cackle still ringing in our ears like festive jingle bells. But before we look at the 1990s specifically, I think that a certain series of films that bridge the 1980s and 1990s warrant a chapter of their own – as they seem to be the longest series of Christmas Horrors produced so far. These are of course the films of the ***Silent Night, Deadly Night*** series.

THE FILMS

The Turkey Trot of Tinsel-Tinged Terror Continues

Christmas Evil 1980 USA 100mins
Directed & Written: Lewis Jackson **Cast**: Brandon Maggert (Harry Standling), Jeffrey De Munn (Phjlip Standling)

Aka You Better Watch Out and Terror in Toyland

To All A Good Night 1980 USA 90mins
Directed: David Hess **Written**: Alex Rebar

The Hand 1981 USA 104mins
Directed & Written: Oliver Stone (based on the novel by Marc Brandell) **Cinematography**: King Baggott **Cast**: Michael Caine (Jonathan Lansdale), Andrea Marcovicci (Anne Lansdale), Viveca Lindfors, Oliver Stone

The Leprechaun's Christmas Gold 1981 USA TV 25mins (stop-motion animation)
Directed & Produced: Jules Bass & Arthur Rankin Jr. **Written**: Romeo Muller **Cast**: Art Carney (Narrator/Blarney Kilakilarney)

The Monster's Christmas 1981 New Zealand 50mins

Charodey 1982 USSR 160mins
Directed: Konstantin Bromberg **Written**: Arkadi & Boris Strugatsky (from their own book)

Aka Charodei and Magicians and Wizards

A Christmas Treat 1985 USA 5mins
Written, directed & edited: Tim Sullivan

Don't Open Till Christmas 1984 UK 86mins
Directed: Edmund Purdom (and Derek Ford & Al McGoohan & possibly Ray Selfe – all uncredited) **Written**: Derek Ford (from a story by Al McGoohan) **Produced**: Stephen Minasian & Dick Randall **Edited**: Ray Selfe **Cast**: Edmund Purdom (Inspector Harris), Alan Lake (Giles), Mark Jones (Sergeant Powell), Pat Astley (Sharon), Caroline Munro (Herself), Dick Randall (Party Guest - uncrdited)

Aka Don't Open 'Til Christmas

Gremlins 1984 USA 106mins
Directed: Joe Dante **Written**: Chris Columbus **Music**: Jerry Goldsmith **Cast**: Hoyt Axton (Randall Peltzer), Zach Galligan (Billy Peltzer), Phoebe Cates (Kate Beringer), Dick Miller (Murray Futterman), Keye Luke (Mr. Wing), Corey Feldman, Judge Reinhold, Harry Carey Jr., Chuck Jones

The New Kids 1985 USA 90mins
Directed & Produced: Sean S. Cunningham **Written**: Stephen Gyllenhaal **Music**: Michel Rubini & Lalo Schifrin **Cast**: Shannon Presby (Loren McWilliams), Lori Loughlin (Abby McWilliams), James Spader (Eddie Dutra), Eric Stoltz (Mark)

Aka Striking Back (UK video release title)

Night of the Comet 1984 USA 95mins
Directed & Written: Thom Eberhardt **Cast**: Catherine Mary Stewart (Regina), **Robert Beltran** (Hector), **Mary Woronov** (Audrey), **Geoffrey Lewis** (Carter)

J'ai rencontré le Père Noël 1984 France 79mins
Directed: Christian Gion **Written**: Christian Gion & Didier Kaminka

Aka Here Comes Santa Claus (International title) and I Believe in Santa Claus (American video release)

Sheng dan qi yu jie liang yuan 1985 Hong Kong 95mins
Directed: David Chung **Produced**: Sammo Hung Kam-Bo **Cast**: Maggie Chung

Aka Christmas Romance and *It's a Drink, It's a Bomb!*

Trancers 1985 USA 76mins
Directed & Produced: Charles Band **Written**: Danny Bilson & Paul De Meo **Cast**: Tim Thomerson (Jack Deth), Helen Hunt (Leena), Art La Fleur

Aka Future Cop

Deadly Messages 1985 USA 95mins
Directed: Jack Bender **Written**: William Bleich **Cast**: Kathleen Beller (Laura Daniels), Michael Brandon (Michael Krasnick), Dennis Franz (Detective Max Lucas), Scott Paulin, Kurtwood Smith

He-Man and She-Ra: A Christmas Special 1985 USA 51mins
Directed: Bill Reed & Ernie Scmidt **Written**: Bob Forward & Don Heckman **Music**: Shuki Levy & Haim Saban & Erika Lane **Cast**: John Erwin (He-Man/ Prince Adam), Alan Oppenheimer (Skeletor/Man-At-Arms), Melendy Britt (She-Ra/Princess Adora/Mermista) George DiCenzo (Hordak)

Aka A Christmas Special (Original TV title as part of **He-Man and the Masters of the Universe** series)

The Life and Adventures of Santa Claus 1985 USA 50mins
Directed & Produced: Jules Bass & Arthur Rankin J. **Written**: Julian P. Gardner (from the novel by L. Frank Baum) **Cast**: Earl Hammond (Santa Claus), Earle Hyman (King Awgwa)

Static 1986 USA 93mins
Directed: Mark Romanek **Written**: Keith Gordon & Mark Romanek **Co-Produced**: Keith Gordon **Cast**: Keith Gordon (Ernie Blick), Amanda Plummer (Julia Purcell), Bob Gunton

Aka Necessity (Working title)

The Lady in White 1988 USA 118mins
Directed & Written & Produced & Music: Frank LaLoggia **Cast**: Lukas Haas (Frankie Scarlatti), Alex Rocco, Katherine Helmond

Aka The Mystery of the Lady in White (Australian poster title)

Lucky Stiff 1988 USA 82mins
Directed: Anthony Perkins **Written**: Pat Proft **Cast**: Donna Dixon (Cynthia Mitchell), Joe Alaskey (Ron Douglas)

Aka My Christmas Dinner (Working title) and Mr. Christmas Dinner and That Shamrock Touch

Communion 1989 USA 107mins
Directed: Philippe Mora **Written**: Whitley Streiber (adapted from his own autobiographical book) **Produced**: Philippe Mora & Whitley Streiber & Dan Allingham **Music**: Eric Clapton & Allan Zavod **Cast**: Christopher Walken (Whitley Streiber), Lindsay Crouse (Anne Streiber), Frances Sternhagen (Dr. Janet Duffy)

Batman Returns 1989 USA 126mins
Directed: Tim Burton **Written**: Daniel Waters (from a story by Daniel Waters & Sam Hamm – based on characters created by Bob Kane) **Produced**: Tim Burton & Denise Di Novi **Music**: Danny Elfman **Cast**: Michael Keaton (Batman/Bruce Wayne), Danny DeVito (Penguin/Oswald Cobblepot), Michelle Pfeiffer (Catwoman/Selina Kyle), Christopher Walken (Max Shreck), Michael Gough (Alfred), Pat Hingle (Commissioner Gordon), Paul Reubens (Penguin's Father)

Aka Batman 2 (Working title)

Tales from the Crypt 1989 USA 90mins
Directed: (*And All Through the Night* segment) Robert Zemeckis **Written**: Fred Dekker **Cast**: (*And All Through the Night* segment) Larry Drake (Santa) – John Kassir (Cryptkeeper)

Aka HBO's Tales from the Crypt

CHAPTER 7

Santa, Screams and Sequels
(The Silent Night, Deadly Night Saga)

Having taken a wintry slayride through the catalogue of proto-'Slashers', 'Slashers', spook-fests, schlock, dross, comic-horrors and various other categories of cool and cruel Yule offerings on big and small screens across up to and across the1980s, let us now consider a series of ho-ho-horrors that bleed across from the 1980s into the 1990s. The **Silent Night, Deadly Night** series of films (the original and its four – sometimes in little but title – sequels).

Released in America in November 1984, after the 'video-nasty' furore across the Atlantic in the UK had died down, **Silent Night, Deadly Night**[205] quickly became the most controversial Christmas Movie of all time Stateside. Why? ...Well, American film critics like Siskel and Ebert, and Leonard Matlin slaughtered it. The Parent-Teacher Association (PTA) fought to have it removed from cinemas and mums across the country picketed movie theatres and shopping malls in a massive moral knee-jerk reaction. Siskel and Ebert even read out the credits on their television spot chanting "Shame, shame" after every name. And what exactly caused all this moral outrage? ...Well, this otherwise fairly typical 1980s low-budget 'Slasher' that featured lots of gratuitous female nudity and bloody, gory, gruesome murders had the temerity to portray its loopy axe-wielding multiple-murderer in a Santa Claus suit and the distributors had the gall to release the movie close to Christmastime! "What's next?" outraged critic Leonard

205 Working title: **Slayride**

Matlin asked, "The Easter Bunny as a child molester?" (Well, it could be worse, I guess... What about a gormless, Saudi-oil-money-indebted, election-rigging warmonger as president?!).

I guess these mothers (I mean the picketing female parents, not the critics...in case you were mistaking my use of the term mothers as being the urban vernacular) had never seen the superior ***Tales from the Crypt (1972)***, ***To All A Good Night (1980)*** or ***Christmas Evil (1980)***. They must have slipped through the mesh of their net of moral indignation. I guess the outraged objectors saw the film as an attack on Christmas (and doubtless thereby on Christianity and its moral precepts). But Western commercialism and the cult of consumerism had surely already done much more to erode the religious roots of the festival and secularise it to the point that Santa had become as much the central figure as Jesus. Why, even as far back as 1965, everyone's favourite animated sadsack Charlie Brown was bemoaning the loss of the true nature of Christmas to crass commercialisation in the superb ***A Charlie Brown Christmas***. And many Christmas Horror Movies themselves seem to spring out of a negative reaction to the crass commercialisation of the festive season, which in many ways has turned the holidays into a stress filled consumer contest for many people. Moreover, as someone who generally enjoys both watching Horror Movies (including tinsel-tinged tales of terror) and Christmas, I know that the two are not necessarily antithetical.

Still, as a result of their outraged opposition, the parents and critics did manage to get Tri-Star Pictures, the film's original distributors, to remove all advertisements for the film from screens just six days after its release and to pull the film itself shortly afterwards thanks to all the controversy. ...And to give this pretty well written and directed, if not brilliantly acted 'Slasher' flick a bigger publicity boost than any number of press offices could have dreamt up; giving it the fillip of instant notoriety, ensuring its cult status and turning it into a must-see hit for a large sector of the movie-watching market on its video release! Indeed, without all the controversy stirred up by the moral backlash, it is doubtful that this film would have been viewed by anywhere near as many people as it has been; or for that matter have spawned four sequels of varying quality, all of which trade on the title and its notoriety. It would probably pretty much have died a relatively natural death, only resurrected occasionally by the interest of a geeky gorehound.

The film starts promisingly, as a family – mum, dad, five-year-old Billy and babe in arms brother – drive through snowy Utah countryside on Christmas Eve to visit grandpa, a patient in a mental institution. (So, there is already a history of mental health problems in the family!). When they see grandpa, he appears practically catatonic and just sits in his chair, unresponsive. However, when Billy is left alone with the "vegetable" as his parents go into another room to talk to the doctor, grandpa stirs and tells the youngster in a malicious tone, "Christmas Eve is the scariest damn night of the year...You see Santa Claus tonight, you better run boy; you better run for your life..." Because, according to grandpa, Santa is *really* out to punish naughty people, rather than to deliver gifts to good ones...and he doesn't just mean by putting a lump of coal in their stockings.

Naturally, this encounter fair puts the wind up little Billy – especially as grandpa resumes his catatonic state immediately as the doctor and his parents return, leaving them disbelieving

of the youngster's story. But Billy's newfound fears surrounding the jolly fat chap in the red suit trimmed with white fur are confirmed later when, on the road home, his parents' car is flagged down by none other than Santa, who quickly proceeds to shoot and kill Billy's father, then beat, rape and murder his mother. (And if Billy's initial experience with grandpa was traumatic, then this must have been absolutely devastating!) Fortunately though, Billy escapes by heeding his loopy grandpa's sterling piece of advice and running like the clappers.

Of course, the homicidal hitcher wasn't *really* Santa Claus, just a hold-up man in disguise it whose car had broken down. ("So it's not all phoney sentiment is it?" the garage attendant who is being robbed by Santa asks rhetorically, before adding" 'Lot of it's genuine greed!" His Santa-suited assailant then blows him away, before counting the desultory sum he has managed to secure in his murderous robbery and exclaiming, "Thirty-one bucks! Merry f*****g Christmas!"). But a five-year-old wouldn't know that, would he? – Especially after having had the bejeebers scared out of him by a scary nut-job of a grandparent!

Over the next 13 years in an orphanage run by nuns, memories and nightmares of his experience haunt and unbalance Billy; reinforced again and again by the draconian attitudes and punishment ladled out by the bitter, martinet of a Mother Superior. Her mantra of "Punishment is good" and the vicious physical castigations the frustrated old hag in habit metes out are cumulatively debilitating. And all the time, poor Billy still bears an irrational phobia about Santa Claus. So much so indeed, that he draws pictures of him slain with multiple daggers protruding from him, which get him into trouble. And when he is forced to sit on a visiting Santa's lap at Christmastime, although he is only 8, he leaps up and decks the dangerous (as he sees it) visitor with a great left haymaker!

At 18, the nice SisterMargaret helps Billy find a job as a store person in a local store, and things seem to be going better for the now fairly buff and handsome youth. (Indeed, a montage sequence accompanied by an awful country song...

♫♪♪ "There's always people who love you,
Who'll kiss you and hug you
On the warm side of the door" ♪♫♫

...depicts how well he is getting on; even getting google-eyes from a female co-worker called Pamela...

That is until it is Christmastime again! Then, the illness of the store Santa means that Billy is nominated as a replacement. "Try not to scare the little b*****ds," his manager advises him. (And when he whispers vicious threats to a little girl squirming on his lap to terrify her into obedience, the parents waiting in a queue with their children to visit the grotto misconstrue what's going on, praising how well he handles the kids).

However, worse is to come...for, on Christmas Eve (when the store manager sneers with little goodwill, "One more day and all this Christmas crap is history!"), after the store closes, the staff has a small celebratory party. ("It's over: time to get sh**-faced!" the festively-

challenged manager cheers). At the party Billy sees Pamela swept away by another co-worker who has a sprig of mistletoe. Billy sees them kissing. "You got a long night ahead of you" his boss jokes, as if Billy really is Santa, adding, "...you remember what Santa Claus does on Christmas Eve, don't ya? Go get 'em Santa, go get 'em!" ...But Billy's memories of what Santa does on Christmas Eve are different to most people's, and boy, does Billy go get 'em! (Flashbacks to the Christmas slaying of his parents are well used throughout this nicely constructed film!)

Starting with Pamela and her mistletoe-friend (who is actually a jerk who is trying to force his unwanted further attentions on her), Billy Claus strangles people with strings of Christmas lights, stabs and slashes them with a Stanley knife, claw-hammers them in the head, shoots them with a bow and arrow, decapitates them with an axe, impales them on hunting trophy deer heads, practices defenestration (throwing someone through a window without opening it first)[206]. And as he slays each victim, he declares them, "Naughty!" The idea of Santa as a punisher, first planted thirteen years previously by his creepy grandfather, still haunts the mentally unstable youth.

There isn't a great deal of grue and gore *per se* – although there is plenty of blood – but there are some gratuitous boob shots as the nutty North-Poler-by-proxy goes on his slay trip, as well as some quite dark humour. For instance, having viciously slain a young girl's babysitter[207] and her boyfriend who were making out while the toddler was in bed, when confronted by the tot herself (who rises from her bed thinking he is really the real Santa Claus – just like the child in *Tales from the Crypt (1972)*), upon being assured by her that she has been good all year, he not only spares her, but gives her a present too. (Ok, so the only thing he has to give her at the time is a bloody Stanley knife, but it's the thought that counts, right?!).

Nice Sister Margaret (one of the nuns from the orphanage) finds Billy's first victims, and is concerned about what might be happening to him. She convinces the cops who are investigating the slayings that Billy is probably heading to the orphanage to kill his 'naughty' nasty nemesis, the Mother Superior. However, an innocent, but unfortunately deaf visiting priest dressed in a Santa suit to surprise the orphans is gunned down by mistake when doesn't hear the shouted commands from the police. But eventually Billy too is blown away before he can complete his mission. ...Ominously though, the bloody axe he was carrying to avenge himself upon his habit-wearing tormentor falls at his younger brother's feet, and with beetling brow the younger brother glares at the Mother Superior (who in his eyes has been responsible for the death of Santa) and says quietly, "Naughty!"...

206

207 Played by scream queen and 'Queen of the Bs' from the mid-1970s Linnea Quigley, who was never afraid to bare a little flesh on screen and was probably at the height of her cult fame in the late 1980s in films like *Night of the Demons*, *Hollywood Chainsaw Hookers* and *Sorority Babes in the Slimeball Bowl-O-Rama* (all 1988).

Ok, so this undoubtedly B-movie ranking, cheaply made 96-minute[208] 'Slasher' was never going to be Oscar nominated. But it is well written by Michael Hickey (from a story by Paul Caimi) and pretty effectively directed by Charles E. Sellier Jr. with some nice, creepy flourishes (such as the montage of bobbing moving Christmas toys, fake snow, icons and paraphernalia in the toy store). Although no masterpiece, it is darkly comic fun, while the traumatised and damaged central character of Billy can inspire a certain degree of emotional ambivalence in the viewer.

Perhaps the outraged moral masses; the crusading PTA and their partisans, the picketing mothers of America, already had a bee in their bonnet about the commercialisation of Christmas and the growing secularisation of the season. As the film was R-rated, their children shouldn't have seen it and been traumatised by its images and sounds, as Billy was by the story events (supposedly their fear). But as it was, it was undoubtedly their actions that catapulted it to notoriety and cult-status, ensuring many more viewers watched it than would ever have been likely otherwise for a cheap-jack seasonal 'Slasher' and leading to its string of sequels. (The best laid plans of mice and men, eh?)

Anyway, one final note on this now legendary and quite effective festive B-movie – the super-syrupy-sweet 1950s style bubblegum-pop Santa song that is featured takes on a superb creepiness of its own in light of the story events and its onscreen presentation:

♫♫♫ "Santa's watching, Santa's creeping,
Now you're naughty, now you're sleeping.
Were you good for mom and dad?
Santa knows if you've been bad.
There might be a treat for you
In Santa's bag of toys,
But Christmas won't be fun and games
For naughty girls and boys." ♫♫♫

And in this age of remakes, having already churned out an inferior-to-the-original rehash of 1974's **Black Christmas** in 2006, rumblings of a remake of **Silent Night, Deadly Night** was announced early in 2007 for release in 2008, but no sign of it at the time of writing. And so to **Silent Night, Deadly Night Part 2** from 1987...

This 88-minute film, directed, edited and co-written by Lee Harry (in conjunction with associate producer Joseph H. Earle from a story written by them and Dennis Patterson and Lawrence Applebaum) is exceptionally exploitative – not just of the success, notoriety and name of its infamous cult predecessor, but of much of its footage too! (Not to mention the audience's expectations). Indeed, it was originally envisioned as simply a recut of the original, which had been pulled from cinematic release following the PTA protests and parental picketing of cinemas. That is why the producers selected an editor, Lee Harry, to nominally 'direct' the sequel. But Harry had broader ambitions and so wrapped his re-edit of **Silent Night,**

208 Or 85-minute, or even 79-minute, depending upon which cut you see

Deadly Night in a story which saw the brother (Ricky) of the original film's psycho Santa killer (Billy) recalling the events to a psychiatrist, after having taken up his brother's murderous mantle (though not the apparently oh-so-offensive Santa suit that his sibling wore!).

Naturally this gave the filmmakers a chance to rehash a lot of material from the original movie to illustrate the tale Ricky (now Caldwell instead of Chapman!) relates to the psychiatrist – apparently the 13th one involved in his case! Whereas the original movie used flashbacks quite creatively and intelligently though, to reinforce Billy's growing psychosis, this movie just uses them to cull its only worthwhile scenes and sequences. Indeed, almost 30% of **Silent Night, Deadly Night Part 2**'s running time is material from the original movie (and as it went on, the series would challenge the concept of sequels in other ways, with most of the remaining films being sequels in little but name, obviously looking to cash-in on the 'brand' and its notoriety!).

The scenes and sequences that are unique to **Silent Night, Deadly Night Part 2** are not really worth bothering with. To start with they are poorly conceived and lazily written: half the stuff that Ricky recounts he could never have seen or known as the events or incidents involved his brother not him! Also the direction from an inexperienced director is flaccid to say the least, and the acting is as abominable as a certain Himalayan snowman! The gruff, supposedly-scary voice with which the stooping Eric Freeman as Ricky declares his victims "Naughty" is just one example of why his performance features more ham than the family's table at Christmas teatime!

Anyway, for what it's worth, the plot sees Ricky relate how he was adopted by a Jewish couple (who "definitely did not get involved with Christmas!") where it seemed like he could settle into a normal life – or at least, as normal a life as anyone could living in LA. Even a "seizure" when confronted by the sight of nuns shopping and a Christmas-red curtain doesn't flip him out. But 5 years later, when he is a teenager and his step-dad has died, Ricky hits the road and ends up killing a "naughty" picnicker – an absolute arse who has been mistreating his girlfriend in the quest for sex. (This mirrors the details of Ricky's mum's demise, prompting the use of more flashback footage from the film's superior progenitor, even though at the time Ricky was a babe in arms and it is doubtful that he would actually have remembered anything of the incident!). When the bullying redneck loser goes to his four-wheel-drive for a beer, Ricky runs him over ...and not just once, several times – back and forth, back and forth. And the girlfriend's response to this gratuitous over-reaction on the part of a total stranger is simply to shrug and say "Thanks!" (I guess this was meant to be funny, but it comes across as simply unbelievable and limp).

Playing psychological cat-and-mouse games with the psychiatrist listening to his tales, Ricky goes on to relate the details of further slayings – of a thug beating a chap in an alleyway for non-payment of a debt (Ricky stabs a brolly through him then opens up the gory canopy through the body); of a couple of loud-mouthed losers interrupting his enjoyment of a movie with the girlfriend he "bumped into" riding his motorcycle. (They are loud and obnoxious and make slurping noises when he kisses his girl. We have probably all run across idiots like them in cinemas, and although we probably would not go quite as far as Ricky in

our reaction to them, I bet there are those among us who would have little pity on them. But even if we do momentarily think "Go get 'em tiger!" I do not subscribe to the belief that seeing a character in a film exact an incredibly over-the-top revenge is in any way likely to make a viewer do the same. Indeed, I am more o the opinion that seeing a character like Ricky slaughter such social undesirables is likely to be cathartic and help remove any frustration that viewers might feel).

When Ricky and his girlfriend Jennifer are walking one day a creepy, arrogant, bottle-blonde, ex-boyfriend of hers with a red car, who is dressed like a preppy starts hitting on her. His name is Chip and he is trying to start the car with an electric booster-pack. Enraged, Ricky starts to strangle Chip, then shoves one of the booster leads in his mouth and what do you get? … A fried Chip of course! (Though mysteriously, Ricky who is holding Chip's throat does not feel any of the electrical current…even though it is apparently strong enough to make Chip's eyes explode!). Moreover, when Jennifer screams out her objections to Ricky's over-reaction, he rips off the car's aerial and strangles her as well.

When a foolish cop tries to arrest him, Ricky shoots the officer with his own gun then wanders through the streets indiscriminately killing people. (which might be a bit too close to the truth of several real life instances to be presented so flippantly, perhaps…especially when the 'acting' is so hammy it oinks!). Eventually cornered at a roadblock, Ricky tries to shoot himself in the head, but he is out of ammunition – hence his capture and the interview with the psychiatrist, Dr. Bloom (and indeed this whole sorry film).

When we return to a shot of Ricky talking it is (unsurprisingly enough) to the corpse of the doctor, whom he has strangled with the tape from the reel-to-reel recorder the psychiatrist has been using to record the session. Then, like his brother before him, Ricky sets off after the evil old Mother Superior who mistreated the kids at the orphanage both were placed in following the murder of their parents by the sociopathic robber in the Santa suit. (She is played by a different actress with a different accent, but now has an unexplained facial disfiguration – presumably to try and hide the fact that she looks completely different to the way she does in the flashbacks, which are taken from the original film! Probably best as viewer just to assume she has leprosy or something!).

The Mother Superior is now wheelchair bound, but still manages to lead Ricky a merry old dance around her apartment when he tries to kill her. And like his brother before him, Ricky's murderous mission against the Mother Superior is his undoing. Yet again a sweet, goody-goody nun and the cops work out where Ricky is likely to be and they turn up to despatch him before he can exact his vengeance. Several bullets from the cops' guns knock Ricky through a French window and over the balcony so that he plummets several storeys to his death.

This film is little more than exploitative cobbled-together claptrap and would seem to leave no real room for a further sequel (or even a prequel)…but moviemakers are an inventive bunch (especially when there is potentially cash to be made…and enough notoriety in hand

to fuel a veritable franchise) and so a scant two years later, in 1989, a second sequel was released entitled *Silent Night, Deadly Night III: Better Watch Out!*[209] (But please don't ask me why the sudden switch to Roman numerals in the title, because I don't know…Zeitgeist, I guess).

Directed, co-edited[210] and co-written[211] by the director-editor of cult car chase movie *Two-Lane Blacktop (1971)*, Monte Hellman, the 90-minute *Silent Night, Deadly Night III: Better Watch Out* was much better than its predecessor – especially the surreal opening of the film (though the movie does run out of steam rather towards the end). The start of this, the third movie in the *Silent Night, Deadly Night* series, is both weird and effective; a nightmare sequence that is a surreal treat. In an antiseptic white room, which could be a high-tech hospital or laboratory, a beautiful, dark haired young woman, Laura, rises from the bed where she has been lying. This bed is situated across from a similar bed in the same room where the comatose psycho from the previous film in the series, Ricky Caldwell lies (though he is played by a different actor – thankfully!). The top of Ricky's skull has been replaced by a clear Perspex dome that reveals his brain. This is bolted on with a steel ring and has some gadgetry on the top linking directly into the brain. Stirring from his coma, Ricky too rises from his bed, the bloody fluid in the Perspex cranium sloshing around horribly. Ricky has a scalpel in his hand and threatens then chases Laura. She runs through corridors and rooms – all equally antiseptic, minimalist and white – but dreamlike, is constantly confronted by her Frankensteinian nemesis. He cuts her arm and red stains suddenly splatter his white hospital robe and the stain the pristine white walls in splatter patterns. Running down the brilliant white corridors, Laura is startled to see Santa Claus. His bright red costume with black belt and boots stands out in stark relief to the brilliantly lit blandness of the surrounding whiteness. He beckons. She follows. Entering another white room, Laura sees Santa sat on a throne in a colourful grotto surrounded by Christmassy bric-a-brac. Drawn to him, she climbs up on his lap and sits on his knee… But when Santa pulls out a large knife, Laura screams and wakes from the nightmare she has been sharing with the comatose Ricky in the room where the action began.

It transpires that Laura is a blind clairvoyant (and she would have to be blind to wear the awful 1980s-fashion skirt the filmmakers have dressed her in!). She is taking part in an experiment being run by Dr. Newbury to try and make contact with patients in comas. The doctor has saved Ricky (who, at the climax of the previous film, we saw shot a couple of times in the body by a cop, crash through a French door and fall a couple of floors off a balcony, but who we are now told was so badly shot up by the police that it blew half his head off! Continuity does not seem to be a strong suit!). Naturally the doc's experiment doesn't go according to plan: the psychic link is apparently two-way and reciprocal – Ricky can share Laura's memories experiences and dreams too. (Indeed, some of the most effective parts of the film consist in the viewer's confusion over what is real and what is hallucination or vision).

209 Aka *Blind Terror*

210 With Ed Rothkowitz

211 With Steven Gaydos, Carlos Lazlo and (executive producer) Richard N. Gladstein (who also plays a detective in the film)

Laura is picked up by her brother (imagining or hallucinating the death of the miserable nurse on the reception while she waits – only for her to be slain for real when old bubble–brain Ricky rouses himself. Perhaps our anti-hero has shared this vision of Laura's too and turns it into a self-fulfilling prophecy. Either way, Ricky slays a visiting hospital Santa who has wandered into his room drunk and taken the Mickey out of the prostrate psycho killer!). Laura, her brother Chris, and the brother's girlfriend Jerri (who Laura doesn't take to even though she has an equally awful sense of fashion!) are on their way to granny's for Christmas. Ricky follows (hysterically managing to thumb a lift despite looking like something from a nightmare or a late night sci-fi/horror show!). Knowing Laura's mind and able to access her memories, heads for granny's house, trying to get there before her visitors – a bit like the Big Bad Wolf in *Little Red Riding Hood* (though Ricky despatches the driver of the car he has hitched a lift in and a garage attendant *en route*).

Laura's granny, like Little Red Riding Hood's, welcomes the new guest – a huge woolly hat now hiding the Perspex dome, but still revealing the huge steel ring! She assumes that he has "a handicap" (just like her blind granddaughter) and she feeds him and treats him with kindness. Needless to say, this is not reciprocated. But while Ricky is slaying granny and getting ready for the guests to arrive, Dr. Newbury (played by Richard Beymer who played Tony opposite Natalie Woods' Maria in **West Side Story (1961)**) and a cop, Lt. Connely (played by Robert Culp from TV's classic **I Spy** series) try to work out where Laura (and therefore the escaped murderous loony tune too) is headed.

Unfortunately, the film plummets somewhat from this point – rather like Ricky over the balcony at the end of **Silent Night, Deadly Night Part 2**! Ricky terrorises and kills Chris and Jerri, while Laura gets Obi-Wan Kenobi-like messages from her dead granny about her "powers" and how to use them. The doc gets done in for his troubles, and although the cop shoots Ricky, old Perspex-dome still manages to crush the cop's throat with the barrel of a shotgun before Laura dispatches him. And how does she do that? Well, she probably saw the superior Audrey Hepburn thriller **Wait Until Dark (1967)** because, like Miss Hepburn's blind woman plagued by killers in that film, she ditches the lights, negating the sighted killer's advantage of sight and giving her an advantage in the dark world in which she lives permanently. Thus, plucky Laura is able to draw raging Ricky onto a spike just as the cavalry arrive in the form of further police in blaze of flashing lights and the blare of sirens.

After the initial fillip of the surreal opening, it all gets rather predictable, but is nonetheless quite good fun. However, the 'series' would take a whole new turn and a completely different direction with the next instalment **Silent Night, Deadly Night 4: Initiation (1990)**, directed and co-written by cult genre B-movie writer-producer-director Brian Yuzna (the man

responsible for some quite effective H.P. Lovecraft adaptations among other credits)[212] and Produced by Richard N. Gladstein (who also features in a supporting role).

Silent Night, Deadly Night 4: Initiation (1990) (aka *Initiation: Silent Night, Deadly Night 4* and *Bugs*) is an 'in-name-only' sequel that has nothing at all to do with Christmas (except in the associations of the title) and indeed nothing really at all to do with its three predecessors in the 'series.' It is something of a *Rosemary's Baby (1968)* style weird modern urban witches tale set in LA. Maud *Octopussy (1983)* Adams plays Fima, the coven leader. She tries to inculcate a would-be reporter, Kim, into the coven for a special task – to replace her sister (who plummeted from the roof in flames early on the proceedings) and fulfil the duty of bearing some kind of bug-baby-evil- thingamy-doodah-deity! (The coven seem to control and have access to cockroaches and larvae that range in size from normal proportions to 6ft superbugs – God knows how, why or from where!)...but it is not the logic that counts here so much as the effects, mood, tone and surreal lunacy of the piece.

The whole is a bit of a strange mish-mash hodge-podge of female emancipation, witchcraft jiggery-pokery gruesome effects and biblical backstories. Allyce Beasley who plays Agnes in the Bruce Willis Cybill Shepherd comedy-detective-rom-com TV show **Moonlighting** and Clint Howard, brother of **Happy-Days**' Ron who played Ritchie Cunningham and who is now a major Hollywood movie director and producer (think *Splash (1984)*, *Cocoon (1985)*, *Backdraft (1991)*, *Apollo 13 (1995)*, *The Grinch (2000)*[213] and *The Da Vinci Code (2006)*) co-star. Naturally, Brian Yuzna ensures that the project has both its fair share of gory-gooey-yuck effects, and a certain cultish kudos. And indeed, he would be back to produce and co-write the next instalment *Silent Night, Deadly Night 5: The Toymaker* one year later in 1991. This, the final film in the 'series' would at least return to Christmassy themes: whereas one gets the feeling that the fourth entry in the 'series' – reasonably effective though it may be in its own right and o its own terms – utilised the title only as an exploitation (to cash in on viewer expectations and the notoriety associated with the title).

The cheap and cheerful, 90-minute *Silent Night, Deadly Night 5: The Toymaker (1991)* directed and co-written by Martin Kitrosser is an adaptation of the *Pinocchio* story and comes across as some kind of weird hybrid; a crazy sort of *Pinocchio (1940)* meets *Puppet Master (1989)*! In it a strange old toymaker called Joe Petto (Gepetto, geddit?!) and his 'son' Pino (surely his surename should be Keogh! – Pino Keogh) terrorise a young boy called Derek at

212 Yuzna's credits include producing *Re-Animator (1985)*; writing, directing and producing *Bride of Re-Animator (1990)* (aka *Re-Animator 2*) and *Beyond Re-Animator (2003)*; directing *Society (1989)*; writing and producing *Silent Night, Deadly Night 5: The Toymaker (1991)*; writing and producing *From Beyond (1996)* (aka *H.P. Lovecraft's From Beyond*); directing *Return of the Living Dead part III (1993)* (aka *Return of the Living Dead III* and *Return of the Living Dead 3*); producing *Necronomicon (1993)* (aka *Necronomicon Book of the Dead* and *H.P. Lovecraft's Necronomicon Book of the Dead*) as well as writing and directing segments of this; directing *The Dentist (1996)* and *The Dentist 2 (1998)* (aka *The Dentist 2: Brace Yourself*); directing *Progeny (1998)*. Yuzna provided the story for the Disney smash *Honey I Shrunk the Kids* with Stuart Gordon – another cult genre director and writer who has often teamed up with Yuzna: Yuzna is slated to produce and Gordon write and direct the next instalment in the *Re-Animator* series, *House of Re-Animator*, currently aiming for a 2010 release.

213 Aka *How the Grinch Saved Christmas* and *Dr. Seuss's How the Grinch Saved Christmas*

Christmastime. First he is sent strange Christmas gifts that contain quite imaginative killer toys (like something The Joker from **Batman** might dream up), then he is kidnapped with malicious and nefarious intent.

Pino, it seems, has not aged a jot in twenty years, and his strange stiff gait when he walks might give you a clue to his actual nature if hadn't already guessed from the other *Pinocchio* influences. His 'father' Joe Petto, the eponymous toymaker and proprietor of an apparently quite traditional toy shop where Derek's mother takes him shopping, is all smiles and 'Mr. Nice Guy' with the customers; but he turns into a snarling, aggressive drunk when alone with his robotic 'son'. This is partly because of Pino's evil, inhuman antics, but also probably partly due to his own mental instability. It transpires that years before, he used to live in the house now inhabited by Derek's family. His pregnant wife was killed in an accident, and unable to become a father himself, he set about making a series of murderous toys to kill other people's children, which naturally resulted in extended incarceration. (Though, quite how he was able to return to the same community and set up shop as a toymaker and toy seller again – and not be recognised by anyone – is never explained!).

This film opens well, with an effective Yuletide slaying. It is early December and Christmas lights already appear on the suburban houses. Late at night the doorbell rings at the Thorne household but young Derek is the only one to hear it as mum and dad are having some festive frolics. Seeing them *in flagrante delicto* and otherwise engaged, Derek goes downstairs past the Christmas tree with its blinking lights and answers the door. No one is there...but a large gift-wrapped present has been left on the porch with a gift tag indicating that it is for him. "Don't open till Christmas," it warns. So, being a young kid, Derek takes it in and straight away sets about tearing off the wrapping paper. However, he is stopped in his tracks when his father yells at him "What are you doing?" Dad then chastises Derek, not only for opening the present, but also for being up late and most of all for opening the door. The youngster is sent back to bed...fortunately for him, before he unwraps the mystery gift.

Partway up the stairs though, Derek stops and looks back, watching as his dad is intrigued by movement within the gift's box, which he subsequently opens. Inside is a red ball or globe with a thick black equator. Two black spots are spaced below this black band and two white one above it. From the top of the ball a cylindrical extension rises with Santa Claus' face painted on it. The black spot extend (Santa's boots and legs) and the white ones similarly (his arms and gloves) and the head rotates to reveal a second Santa face on the back... But this one is a snarling, mean looking face with its mouth open and rows of pointy white teeth that snap open and shut while a blue arc of electrical current dances across them. The father is puzzled. Suddenly the arms and legs stretch out like squid tentacles, wrapping themselves around his head and neck and drawing the globe with its arcing electrical charge into his face. He staggers around in agony, trying to push and fight the lethal toy off. Then he falls, the toy detaching itself as he plummets head first onto a protruding fire poker. Surreal, wicked. A killer Santa toy that reverts to looking like an innocent red ball with a black band and a few spots!

There are other deadly Christmas presents too – a large "Larry the Larva" grub that kills someone in his car in quite a gruesome scene – and a second present delivered to Derek, which he discards in the dustbin, only for it to be filched by his neighbour's son. This one contains a pair of in –line roller skates that suddenly become rocket-assisted, thrusting the wearer into the path of an oncoming vehicle (though he survives, albeit hospitalised, badly battered and beaten with multiple broken bones). The funniest though are a whole sack full of toys – emptied by Joe (or is it?) dressed as Santa into the room where a baby sitter and her boyfriend are getting it on, when he goes to kidnap Derek. There's a robot arm (great fun when both babysitter and boyfriend assume it is the other doing naughty things they haven't done before!), soldiers, super-heroes, artillery, a snake and an evil alien-looking sci-fi car with spinning circular saw blades. A fun, gory scene.

And these aren't the only surreal scenes in the film. The final *grand guignol* sequence where the naked Pino robot – looking like an animate, life-sized Action Man – confronts Derek's mother and tries to copulate with her (despite, like Action Man, not having the re-quired equipment – even in plastic form!) is both weird and funny (intentionally so, I'm sure). Of course it makes no logical sense – the robot would never have been able to pass itself off as a real person looking the way he does in this scene – but then, it is not necessarily meant to make sense: this is pure nightmare; surreal, dream-logic![214] (When Brian Yuzna is involved you can always guarantee an interesting watch, even if the budget is low and the film is really exploitation schlock).

Anyway, Derek is naturally traumatised at witnessing his father's demise and will not speak thereafter He develops what his mother considers unreasonable fears of toys and Santa. (Fears that are probably exacerbated by a visit to a shopping mall Santa – one of 3 working shifts. Clint Howard, movie director Ron's brother who co-starred in the previous movie, makes a cameo as one of these mall Santas – about the only connection this film has with its immediate predecessor in the so called ***Silent Night, Deadly Night*** 'series').

A stranger who has been following Derek and his mother Sarah since the father's death, is one of the Santas and he swaps shifts to ensure that Derek visits him and sits on his lap (playing on a latent fear of paedophilia perhaps, as he seems to pose a threat to the family, honing in on – perhaps priming – Derek). Derek seems troubled, seeing the undue attention this Santa gives him while he is waiting in line – he stares at Derek constantly even as the little girl on his lap reels off a long 'gimme, gimme, gimme' Christmas list of all the present s this 90s child wants for Christmas. (Hers is obviously a modern, consumerist, commercial, secular celebration). Then, when Derek is finally on the Santa's lap, when his mother goes to take him away because he is being uncommunicative, she literally has to wrestle him away from the strange man in the red and white suit and false white whiskers. It is only later, in

214 Where would we be if everything was always measured with a logical yardstick? – Especially in Horror Movie territory! …We would stop and worry about the variable size of ***King Kong*** and wonder why, if they wanted to keep the fearsome ape away from their village, the native islanders built a door in their giant wall big enough for him to come through, instead of just sitting back and thrilling to the potent nightmare imagery, wouldn't we?!

an effectively shot scene when Sarah, who is alone, is chased and apprehended by the guy in a building's underground car park at night that the viewer becomes aware of a nice little twist in the tale.

It is nothing if not a strange one this; and although very silly in some ways, it is also quite effective in others. It is well shot, with peculiar very high and very low angles unsettling the viewer and highlighting the twisted natures of the eponymous toymaker and his robotic son. Various other shooting techniques also conspire to unsettle the viewer – the use of natural lighting with white sunlight blazing through windows, for instance,giving a weird over-exposed bleached-out look, not normally seen when most interior shots are carefully lit to give an even, balanced light. (And there is a wonderful credit: "Surrealistic visual design and effects by Screaming Mad George").

All in all then, this is a welcome little addition to a non-series 'series' of horror films, most of which having at least a touch of tinsel in their blood. And it is an indication that sometimes extended series can throw up something interesting ad not just repetitive same-old, same-old rehashes of the original premise! Even the advertising tag line is fun, referencing a massive Christmas Movie box office smash about a young boy at Christmastime from a couple of years earlier: "He's Home...But He's Not Alone."

Interestingly, probably the only major 'name' in the cast is longtime Hollywood legend Mickey Rooney (who plays Joe Petto, the toymaker and Pino's 'dad'). And perhaps his appearance in the film was, in itself, a sign that the times they were a-changing...for old warhorse Rooney had joined the furore surrounding the release of the first film in the series, *Silent Night, Deadly Night*, eight years earlier in 1984, when he wrote an open letter to the producers of that film stating that the "scum" who made it should be "run out of town" for sullying the sacredness of Christmas!

Ironically, it was the very notoriety that the protestors against the first film generated in having *Silent Night, Deadly Night* removed from the cinemas in 1984 that helped lead to its success when released on video, and the mixture of that success and notoriety that all but ensured that sequels were produced exploiting both. And while other – and in some instances much better – films were being produced that married festive themes with horror, it surely helped to solidify in the public mind the concept of the Christmas Horror as a sub-genre having a 'series' of films that exploited the notoriety of the original *Silent Night, Deadly Night*. And although the fifth film in this 'series' is the last (at least so far), rumours of a remake or revisiting of the concept of the original continue to abound. (At the time of writing, a new version of *Silent Night, Deadly Night* is in pre-production, with Franck Khalfoun slated as writer, David Foster and Ryan E Heppe as producers, and Brittany Renee Finamore, Shauna MacDonald and Robert Haley set to star; though obviously all is still rather up in the air and may well change, even if the project actually does make it to the screen).

Still, whatever happens with a remake or reinterpretation of *Silent Night, Deadly Night*, the 1980s saw the Christmas Horror Movie establish its identity and begin to proliferate as a recognised sub-genre. With the *Silent Night, Deadly Night* 'series' bridging the 80s into the

Alan-Bertaneisson Jones

90s, the new decade would see this kind of film firmly established in the public imagination and increasingly enjoyed by more and more viewers...and the turn of a new century would see the trend continue with more holiday horrors (and comedy horrors – the laughter of the innocents as much as the slaughter of the innocents in some cases!) taking us through the nasty nineties into the naughty noughties...and if Round John, Virgin showed up here, he'd be as likely to loses his life or his head as his cherry!...

THE FILMS

♫♫♫...Sleep in Heavenly Pieces...♫♫♫

Silent Night, Deadly Night 1984 USA 96mins
Directed: Charles E. Sellier Jr. **Written**: Michael Hickey (Paul Caimi – story) **Music**: Perry Botkin **Cast**: Robert Brian Wilson (Billy Chapman aged 18), Lilyan Chauvin (Mother Superior), Gilmer McCormick (Sister Margaret), H.E.D. Redford (Captain Richards), Danny Wagner (Billy Chapman aged 8), Linnea Quigley (Denise), Will Hare (Grandpa Chapman), Tara Buckman (Ellie Chapman – mother), Jeff Hanson (Jim Chapman – father), Charles Dierkop (Killer Santa), Toni Nero (Pamela), Jonathon Best (Billy Chapman aged 5)

Aka Slayride (Working title)

Silent Night, Deadly Night Part 2 1987 USA 88mins
Directed/Edited: Lee Harry **Written**: Lee Harry & Joseph H Earle (& Dennis Patterson & Lawrence Applebaum – story & Michael Hickey & Paul Caimi – characters) **Produced**: Lawrence Applebaum **Associate Produced**: Joseph H Earle & Eric A. Gage **Cast**: Eric Freeman (Richard 'Ricky' Caldwell), James L. Newman (Dr. Henry Bloom), Jean Miller (Mother Superior), Elizabeth Cayton (aka Kaitan) (Jennifer Statson), Darrel Guilneau (Ricky aged 15), Brian Michael Henley (Ricky aged 10), Corrine Gelfan (Mrs. Rosenberg), Michael Combatti (Mr. Rosenberg), Ron Moriarty (Detective), Nadya Wynd (Sister Mary)

Silent Night, Deadly Night III: Better Watch Out! 1989 USA 90mins **Directed**: Monte Hellman **Written**: Steven Gaydos & Richard N. Gladstein & Monte Hellman & Carlos Lazlo **Produced**: Arthur Gorson **Executive Produced**: Richard N. Gladstein & Ronna B. Wallace **Edited**: Monte Hellman & Ed Rothkowitz **Cast**: Richard Beymer (Dr. Newbury), Bill Moseley (Richard 'Ricky' Caldwell), Samantha Scully (Laura Anderson), Eric Da Rae (Chris Anderson), Elizabeth Hoffman (Granny), Laura Herring (Jerri), Robert Culp (Lt. Connelly), Richard C. Adams (Santa), Richard N. Gladstein (Detective)

Aka Blind Terror

Silent Night, Deadly Night 4: Initiation 1990 USA 90mins

Directed: Brian Yuzna **Written**: Woody Keith (Richard N. Gladstein & Arthur Gorson & S.J. Smith & Brian Yuzna – story) **Produced**: Richard N. Gladstein **Executive Producer**: Ronna B. Wallace **Consulting Producer**: Arthur Gorson **Cast**: Clint Howard (Ricky), Maud Adams (Fima), Allyce Beasley (Janice), Neith Hunter (Kim), Tommy Hinkley (Hank), Hugh Fink (Jeff), Richard N. Gladstein (Woody), Conan Yuzna (Lonnie)

Aka Initiation: Silent Night, Deadly Night 4 and Bugs

Silent Night, Deadly Night 5: The Toymaker 1991 USA 90mins

Directed: Martin Kitrosser **Written**: Martin Kitrosser & Brain Yuzna **Produced**: Richard N. Gladstein & Brian Yuzna **Executive Produced**: Ronna B. Wallace **Cast**: William Thorne (Derek), Jane Higginson (Sarah Quinn), Van Quattro (Tom Quinn), Mickey Rooney (Joe Petto), Brian Bremer (Pino), Neith Hunter (Kim), Clint Howard (Ricky), Tracy Fraim (Noah Adams), Conan Yuzna (Lonnie), Zoe Yuzna (Brandy), Richard N. Gladstein (Driver Dad)

CHAPTER 8

Santa Claws his Way to the Millennium

The grouping of films by the decade in which they were produced or released seems like such an arbitrary divide, and yet such classifications appeal somehow to the orderly impulses of the human brain. So, having seen how the **Silent Night, Deadly** 'series' segued across the 1980s into the early1990s, it is time now to consider the festive frighteners and other weird *Weihnachts* wonders served up as holiday treats through the rest of the 90s.
And what a decade it was!

If the 1970s saw the Genesis of Ho-ho-horrors proper, then the 1980s witnessed the beginnings of their proliferation, and saw them leave their mark (the mark of Cain some might argue!) on the public consciousness. What with the controversy and notoriety surrounding **Silent Night, Deadly Night (1984)**, which was exploitatively cashed-in upon by the producers and filmmakers who churned out a 'series' of, often in-name-only-sequels bearing that title and the emergence of big-studio Hollywood productions mixing Christmas with Horror (albeit often with a healthy dose of comedy thrown in), tinsel-tinged terror turkeys and Fright Christmases were here to stay, and the sub-genre started begetting like hard-to-pronounce characters from the Old Testament. And while some were 'naughty' and some were 'nice' and the quality of the product varied enormously – from 'the Good' to 'the Bad' with plenty of the downright 'Ugly' thrown into the mix too – one thing was for sure: if you wanted to watch something that wasn't sickly-sweet, syrupy, candy-cane holly-jolly holiday fare, you didn't have to; for those with more jaded palates and darker tastes, there was plenty of festive fare served up too.

Perhaps it was a return to older traditions...to quote the anonymous author of *Horror: A True Tale*[215], which may originally have been printed in a nineteenth century magazine, but was certainly included in *The Lock and Key Library*, a selection of the best Classic American Mystery and Detective Stories by Julian Hawthorne in 1909: "One tale led to another. Everyone was called on in turn to contribute to the public entertainment, and story after story, always relating to demonology and witchcraft, succeeded. It was Christmas, the season for such tales..."

On our cinema and television screens, some of the movies were Noël-centric, centring very much on Christmas and festive themes, while in others the holidays and their

215 Published in the anthology *Chillers for Christmas*, editor Richard Dalby, Guild Publishing, (London, New York, Sydney, Toronto) 1989.

associations were alluded to used only in part or in passing. A beautiful example of the latter can be seen in 1990's **Edward Scissorhands**, auteur-director Tim Burton's fantastical modern fairytale-cum-revisionist take on the Frankenstein Monster by way of Beauty and the Beast. In this superbly realised movie with superlative direction, performances, design and music, the up and coming Hollywood A-lister and Indie-darling Johnny Depp plays a man 'created' by a lonely old inventor (genre legend Vincent Price looking frail but making a grand job of a small cameo role). The problem is, the Inventor dies before he can complete his creation, the eponymous Edward Scissorhands, leaving the pale, black leather-clad creature (whose dark, tousled locks are reminiscent of the director's) incomplete, with huge, razor-sharp scissors in place of hands; implements with which Edward is always cutting himself by accident; at one and the same time, a blessing and a curse. A blessing because, when he is found – a lost and lonely soul in his dark, grey Gothic mansion on top of a hill overlooking a community of pastel-coloured homogenous homes – and taken into society by a kindly Avon lady, his prowess at topiary, pet grooming and eventually hair styling (along with the novelty value of his strangeness) make him a celebrity. A curse because, not only does he struggle with everyday commonplace things like eating, but his blades are a constant threat of danger to those he cares for and they prevent him from having any kind of normal physical contact with the girl with whom he falls in love (played with alluring, fairytale princess beauty by Winona Ryder in her pre-"I'll steal you a nice tie for Christmas' days[216] and sporting her naturally blonde hair for a change). And trouble is definitely in store when a callous, selfish, uncaring, jealous boyfriend (played by everybody's favourite 1980s screen geek Anthony Michael Hall of **16 Candles (1984)**, **The Breakfast Club (1985)** and **Weird Science (1985)** fame) looks first to utilise Edward's abilities, then set him up as a patsy and ultimately try and kill him.

This is a film of stark contrasts – Edward's dark, grey Gothic castle with the pastel-coloured community; the sallow-complexioned misfit with the radiant, vivacious beauty; Edward's quiet decency and inner humanity with the worst of human traits exhibited by the townsfolk; his imagination, creativity, gentleness and true, deep love with the shallow, deceitful, self-centre bigotry of his love rival – to name but a few. Double Oscar winner[217] Dianne Wiest, Oscar winner[218] Alan Arkin and Kathy Baker are on hand to lend sterling support and the story's action comes to climax at Christmastime when the members of the community that have been lauding Edward turn on him and chase 'the monster' through the streets, like the torch-bearing villagers in the classic Frankenstein movies of old, exhibiting all the worst characteristics of humanity, while their not-quite-human prey has exhibited only the best qualities of humanity (saving someone's life, self-sacrifice etc).

The film ends with another killing, though in self-defence, and with Edward once again banished by necessity to the loneliness of his dark Gothic mansion, separated from the girl

216 Sorry Winona, I couldn't resist the joke! But I think that you are a wonderful, talented actress, and not having heard much about you recently, I hope that you are very well and that we might have the privilege and honour of seeing you on our screens again soon in a Robert Downey Jr. style comeback from adversity, as you are without doubt a very fine actress and a very beautiful woman.

217 As Best Supporting Actress for **Hannah and Her Sisters (1986)** and **Bullets Over Braodway (1994)**

218 As Best Supporting Actor for **Little Miss Sunshine (2006)**

he loves and who has learned to love him – something both finally came to realise shortly before he was chased from the community by the baying crowds. Kim (Ryder) is helping her mother decorate the family Christmas tree, preparing for the season of Goodwill to All Men (which obviously doesn't extend to human-like creations with scissors for hands). Out of the window she sees snow and moves to the garden in wonder (for it has never snowed in the community before Edward's arrival). In the garden she sees Edward perched on a stepladder, his huge scissor-bladed hands a flurry of activity carving an enormous ice-sculpture of an angel; the 'snow' comprised of the tiny ice crystal by-products of his snipping. Entranced, the beautiful girl twirls in slow motion in the falling 'snow' reaching out her hands.

This film, which ends with the old woman who has been relating the story to a young girl snuggled up almost lost in a huge bed on a cold winter's night, being revealed as none other than Kim herself. And she knows that the unageing Edward is still alive in the old Gothic mansion on the mount overlooking the town because every winter it snows – something it never did before he came...and the snow is the icy by-product of his carving amazing, giant ice-sculptures in the attic of the old house; sculptures of Kim and of hands and of happy memories, much cherished; the products of love expressed in the only way open to Edward, through utilising his scissor hands – his blessing and his curse.

This is a sumptuous, gorgeous, poignant, moving, human film...and its Christmas-set sequence is neither gratuitous nor throwaway, but beautifully, knowingly and tellingly integral to its themes. It is brilliantly conceived and realised – and though performances, design, story (which Burton co-wrote with Caroline Thompson who wrote the screenplay) and music all coalesce brilliantly, the overall vision is undoubtedly the director's and Burton manifests this fairytale of 'Citizen Edward' on the screen with Wellesian relish and flourishes. This film represents 105-minutes of left-field heaven.

Unfortunately, not all filmmakers manage to realise their ambitions quite so successfully...and a casein point might be the same year's **Elves**, written and directed by Jeff Mandel. Although, to be fair, at least **Elves** is so appallingly bad it is entertaining! (And how! – it is a laugh-riot, guaranteed to leave your chuckle-muscle aching if you are of a particular bent and love truly terrible films. Some of these I find a riot – **Plan Nine from Outer Space (1959)** for instance – while others just drive me to distraction – **Wild Women of Wongo (1958)** perhaps – and while guffawing at the rank awfulness of **Elves** might not be to everyone's taste, I promise you, you will probably never have come across a film like this one before; the script, premise, storyline and dialogue are just *soooooooo* ludicrous and awful the only thing you can do is laugh, and the acting and effects are dire too. You will either think that Jeff Mandel should be strung up from the Christmas tree by his baubles – and probably most of the others involved too – or you will be eternally grateful for such devastating ineptitude and inflict this on all your mates – probably students – accompanied by copious amounts of celebratory alcohol!)

At only 89-minutes, thankfully **Elves** (advertising tagline: "They don't work for Santa anymore!") doesn't outstay its welcome too long, but it is surely one of the silliest Christmas Horrors ever conceived. Starring TV's own **Grizzly Adams**, hairy Dan Haggerty (all woolly

mane, beer gut and tobacco-stained beard because he is constantly puffing on a cigarette) and with Deanna Lund (who starred in TVs **Land of the Giants** in the late 1960s) as the mother, this bizarrely plotted spectacle sees a virginal, Christmas-hating teenage girl called Kirsten inadvertently raise an 'elf' from a state of dormancy when she and a couple of equally festively-challenged mates conduct a ritual in the woods near her house. Only this is no ordinary elf – oh no! (And perhaps the movie should actually have been called **Elf** rather than **Elves**, as you only ever see one of them ...Mind you, you wouldn't want to confuse it with Will Ferrell's far superior Crimbo comedy from 2003 called **Elf**, would you?!).

The elf that gets woken up in **Elves (1990)** is more like some evil goblin or gremlin than a rosy-cheeked, pointy-hat-wearing toy manufacturer of Santa's acquaintance. Mind you, that is because it is a member of an old race of vertically challenged magical beings, believed mythical by most, but sought out and captured in WWII by the fanatical Nazis and genetically engineered in the hope of creating a super-race of lethal soldiers! (Yes, you read that right – this is the backstory to this film's plot! So when the tagline says that they aren't working for Santa anymore and you wonder who they are working for then, the answer is minions of Adolf Hitler!) ...And there are more twists in the tail...

The virginal teenager's wheelchair-bound grandfather, an ex-Nazi scientist, having transported the elf to America when it became clear that the Nazis were losing the war and that the Thousand Year Reich was likely to be something of a fifteen minute wonder, has been guarding the creature's whereabouts ever since, as a group of Neo-Nazis seem hell-bent on continuing the experiment to create a Fourth Reich. And what is more, when the reanimated evil elf goes on the prowl and the Neo-Nazis turn up to try and put their nefarious plot into action, we learn that in order to complete the process and give birth to their army of genetically modified magical elfin-goblin warriors, they need to sacrifice a virgin's maidenhood to it before midnight on Christmas Eve to bear its offspring! (You can see where this is all going can't you...?) Trouble is, no ordinary, run of the mill, everyday virgin will do. Oh no. It has to be the virgin daughter of an incestuous relationship! ...And what do you think our heroine, who lives with her stridently Germanic mother and wheelchair-bound grandfather comes to learn? (You've got it!)

Have you ever heard anything so weird and perverse? And on top of that, she has a pervy younger brother who likes to look at her naked! Wouldn't you have just loved to be there when they pitched this one to the producers?! (And to know what drugs the producers were on to greenlight it?!).

Much of the film actually takes place in a shopping mall, which the teenage girl who works there as a waitress and some mates secret themselves in on the night before Christmas Eve

to spend some time making out. They don't count on an evil elf and a group of Neo-Nazis turning up and wiping most of them out though. Fortunately, for them, since the elf has already murdered the pervy store Santa who has tried to touch-up Kirsten, they have hired a new one – a hairy, overweight, alcoholic, chain-smoking ex-cop called McGavin (Haggerty – a kind of 'Santa-Grizz') – and "Santa" (as the Kirsten insists on calling him throughout) not only helps the prospective bride-of-elfenstein out of the mall, but eventually to defeat both the randy creature and Adolf's minions in the end too.

If this delightfully dire movie's plot hasn't already taken your breath away, then the dialogue the poor actors have to spout most certainly will. I think it best to let this film speak for itself, so to say, so here are some examples of the lines the poor cast have been lumbered with – I consider them trash-genius:

Kirsten: "We are the sisters of anti-Christmas...we bemoan Christmas as a petty, over-commercialised media event."

Friend: "What's bemoan?" "It means I didn't get any decent presents last year."

———————————————

Kirsten: "Let's go goof on Santa."

...And later, being interviewed by the police chief (following the murder of the Santa who touched her up): "He was a pervert and a drug addict and someone killed him. Isn't that the Spirit of Christmas?!"

Dr. Fitzgerald (an expert on myths, runes, elves, Biblical prophecies, WWII Nazi experiments in elf assassination squads and genetic experiments to produce a master race using the magical sperm of mythical creatures to impregnate virginal offspring of incestuous relationships on Christmas Eve
who McGavin consults): "Are you asking if I believe in elves?... ...No...but God did."

———————————————

And also (on the genesis of the elfin race):

Dr. Fitzgerald "Seems angels have been slipping down to earth and begetting with the women"

Kirsten's mum: (shouting) "The man in the study is your grandfather...*and* your father!"

Kirsten's brother: "Are we gonna be all right?"

Kirsten: "No Willy, gramps is a Nazi"

McGavin: "I've heard some crazy things today, but nothing crazier than that elf we both saw."

And:

McGavin: "What are you – a goddamned Nazi or something? Is that elf yours?"

Grandfather: "I have impregnated my own daughter to give birth to a girl suitable for the elf."

Every one is priceless! (Go on, get a T-shirt made!) ...And they even have the cheek to steal a line from a far, far superior George A. Romero zombie flick: One of granddad's Neo-Nazi chums says declares, "When there's no more room in Hell, the elves will walk the earth."[219]

I guess you will by now have some idea whether you are likely to love or loathe this holiday Ho-ho-horror howler; and either way, I reckon it has got to be worth your watching it once just to say that you have actually seen what has got to be a contender for the most preposterously plotted, bizarre, banal, crass, ludicrous Christmas-themed films of all time. (But that is entirely up to you of course) Be warned though, that although there is not an awful lot of gore in this film and the special effects (like the direction, writing and acting) are pretty much uniformly dire, there is one pretty harrowing scene in which the mischievous little monster of an elf fries Kirsten's mother in the bathtub with by throwing an electric radio in with her. (How on earth did Santa ever train them to make toys?!). I cannot see anyone sitting on the fence over this one (you will either think "I haven' had this much fun since 'Two Little Boys' was Christmas No.1"[220] or "Never mind the Christmas cards; whoever made *this* should be strung up...or have boiling oil poured over them from a huge cauldron!"

219 The line from ***Dawn of the Dead (1978)*** (aka ***George A. Romero's Dawn of the Dead*** and ***Zombies: Dawn of the Dead*** and ***Zombies*** and ***Zombie: Dawn of the Dead*** and ***Dawn of the Living Dead***) was, "When there's no more room in Hell, the dead will walk the earth." This was used as the film's advertising tagline.

220 Line taken from Mel & Kim's (Mel Smith's and Kim Wilde's) 1987 cover of 'Rockin' Around the Christmas Tree' released as a charity record to raise money for Comic Relief

...Which is exactly what happened to a group of way too 'Holly-Jolly' Christmas carollers in the next year's revisionist big-screen take on *The Addams Family (1991)*, directed by Barry Sonnefeld and starring Raul Julia as Gomez, Anjelica Huston as Morticia, Christopher Lloyd as Uncle Fester, Jimmy Workman as Pugsley, Judith Malina as Grandma, Carel Struycken as Lurch and a revelatory eleven-year-old Christina Ricci as Wednesday. It is a fleeting scene at the film's opening – the carollers all dressed in their bright, Christmassy winter finery, sing their classic carol (very beautifully) at the front door of the Addams's grey, spooky, isolated house. The music segues into a slightly revamped, wordless version of the classic television show theme as the camera zooms up the wall of the building to find the Addams family and lurch perched on a rooftop balcony with a cauldron of boiling oil and joyfully malicious grins upon their faces. Lurch tips up the cauldron spilling its boiling contents over the side (and although you don't see this, presumably all over the colourful, cheerful carollers!). A deliciously dark opening; but (unfortunately) the rest of the film, winningly shrouded in dark humour though it is, has nothing at all to do with Christmas.

More Crimbo-centric, though no less comical, was a 70-minute British TV production from the same year entitled **Bernard and the Genie**. This 1991 festive televisual treat was written by Richard Curtis, writer (or in some instances co-writer) of such hit comedy movie and TV hits as *Four Weddings and a Funeral (1994)*, *Notting Hill (1999)*, the **Blackadder** series, the *Bridget Jones* movies and *Love Actually (2003)* (to name but a few). And as you might expect with such a pedigree, it is quite a hoot. Its witty, intelligent, well-crafted script is well served with a cast headed by funnyman Lenny Henry, Alan Cumming and Rowan Atkinson, with several famous face cameos to look out for too, like 'Saint' Bob Geldof and ex-England footballer turned TV presenter and Walkers crisps ad-man Gary Lineker.

Set at Christmastime, the story follows the experiences of Bernard Bottle (Alan Cumming), a mild-mannered London Art Dealer who has just identified a lost masterpiece owned by two little old ladies who had no idea of its value and sold it at auction for £50million. But Bernard is a nice chap who believes in fair play and he wants to give half of the proceeds to the old ladies. His smarmy, grasping boss, Charles Pinkworth (Rowan Atkinson) has other ideas though. He sacks Bernard and keeps the money!

So, shell-shocked and jobless Bernard makes his way back to his London flat...only to find when he gets home that his girlfriend has left him to hop into bed with his best friend. It is not looking like being a good Christmas! The girlfriend practically clears out Bernard's entire flat, but she leaves behind a rather grubby old Arabian oil lamp that she gave him as a present on a previous Christmas. Bernard rubs the lamp to clean it, and...BANG!...an explosion puts him in hospital!

However, when our unlucky hero gets home again, he discovers that he has actually freed a genie from the lamp (Lenny Henry)...although Bernard doesn't believe this at first. He is soon convinced, however, by the genie's magic (though he quickly realises that he has to be

very careful exactly what he wishes for).[221] Nonetheless, he soon has his flat all fixed up ...and a sackful of gold coins and the Mona Lisa hanging on his living room wall!

And Bernard's new found friend's depression at learning that he has been trapped in a lamp for two thousand years is soon lifted when Bernard introduces him to the joys of 20th century living – like Big Mac burgers from MacDonalds, the ***Terminator*** movies and ice cream! The two of them hit the town, where the shops are all decked out for Christmas and Josephus tries to chat-up a pretty female assistant in a Santa costume (with hotpants!) at a store's Christmas grotto for Bernard.

But Bernard's troubles are far from over, as his evil ex-boss drops him into a pile of trouble with the police over art theft. However, when Josephus is arrested too, it is quite useful for Bernard having a genie to command and he is able to wish himself back in time to relive (and amend) the course of events to his satisfaction (and to the viewer's great amusement!).

There is a lovely extended sequence in this TV special in which Bernard tries to explain what the modern Christmas and Santa Claus is all about to the genie who has been imprisoned in a lamp for two thousand years. He tells him about Santa delivering presents (and how "he doesn't really") and about flying reindeer (that don't really fly) etcetera. But then later their conversation turns to the root of the celebration:

Josephus: "So tell me about this Christmas thing."

Bernard: "Well, it's become a very big commercial thing in recent times...but originally it was supposed to celebrate the birth of this chap called Jesus Christ who was born...well, about 2000 years ago."

Josephus: " Jesus you say? ...I *know* this guy! ...What did *he* do to get so famous?"

Bernard: "Well, he turned out to be the Son of God."

Josephus: "*No!* I thought he was kidding! ...I knew there was something special about him from the moment I first met him"

It turns out it was Josephus's brother's wedding Jesus "helped out with the wine" at! And Josephus advised Jesus that he could be a "big money spinner" in the restaurant business after witnessing him feed 5000 people with some bread and fish. ("But oh no, Goody-two-shoes was having none of it!"). Josephus also saw Jesus walk on water and "kick arse" when they turned the Temple into "a supermarket." But despite having his business ideas pooh-poohed by the Messiah, Josephus is still magnanimous, toasting Jesus on his birthday: "Happy Birthday Big J – a crap businessman but a great human being."

221 The genie, Josephus, actually warns him, "Say the words "I wish" with the caution you would normally reserve for "Please castrate me!""

This TV special is not at all scary and being a TV movie and made on a small budget, the special effects aren't mind-blowing – but then again, they are not what it is all about. But it does feature a genie and a wizard, and is definitely different and bit left field. It's about heart and friendship and fun. And it is about light-heartedly reminding us what Christmas is really all about (without bashing us over the head with it). I am sure that there are those for whom it will be a bit too foot-loose-and-fancy-free and who might think that it is perhaps in some way disrespectful (referring to Jesus so flippantly and humorously...like an inexperienced masseur, it may rub some devoutly stiff-necked viewers up the wrong way!), but I am certainly not one of them.

And the Brits weren't the only ones looking at Christmas from a different angle in 1991: although it is not scary either, the Canadians produced an entertaining 25-minute colourful animated festive featurette for television the same year called **Aliens First Christmas** (aka **'Twas the Night Before Christmas on Zalonia**) – a spin-off from an animated 1989 TV series entitled **Aliens Next Door**. Its style is reminiscent of Hanna-Barbera products (like **The Jetsons**) and the story sees the Zalonian neighbours of the first migrant family of Earthlings to settle on Zalonia (the Peoples) trying to understand the (to them) alien concept of the Christmas holidays and what they mean, and to help the Peoples celebrate an Earth-style festive season when an accident robs them of all their traditional Christmas trimmings.

Perhaps understandably, many of the traditions seem very strange to the Zalonians (they have no idea who "Mary Christmas" or "Christmas Carol" are!) and they do not always fully understand exactly what they are doing or why. Indeed, some of their attempts to recreate an Earth-style Christmas for their neighbours on Zalonia don't exactly have the desired effect... but what both families learn is just how much they care for one another – something that helps the Peoples to feel the true Christmas Spirit and helps their Zalonian neighbours, Mavo and Charlick, to understand the nature and importance of the festive season as celebrated by Earthlings. The nice twist to this tale though, is that it is the Peoples family, with their strange "Crossmoose" or "Kissmaas" or whatever it is festival who are the 'aliens' – the strangers in a strange land...or on a strange (to them) planet.

While **Aliens First Christmas** does feature aliens and another planet, which are reason enough for inclusion in our little seasonal smorgasbord of strange, spooky, weird and wacky

movies, 1991 did also see the release of one genuine full-on, all-out Horror Movie with a festering festive edge to it. **Campfire Tales (1991)** was a cheaply made 88-minute Horror compendium flick, one of the segments of which was a Christmas shocker. Directed, written and edited by William Cooke and Paul Talbot (who also Produced), this often grainy film does have a sleazy energy and cod campness about it that is reminiscent of some of the old horror comic books...even if the acting generally leaves a great deal to be desired and could only be described as variable at best (and cringingly risible at worst!).

An old derelict – played by Gunnar Hanson (Leatherface from **The Texas Chainsaw Massacre (1974)**) – asks three lads on a camp trip if he can share their fire for warmth, then relates four scary stories, mostly of the urban legend variety, to his enthralled, teen audience. One ('The Hook') is a variant on the old chestnut about a hook-handed lunatic tormenting a teenage couple making out in a car at a local lovers' lane. Another ('Overtoke') is about a group of students cruising for some weed, who score a hit of a drug that is incredibly addictive and which causes them to dissolve into **The Incredible Melting Man (1977)**-type ooze. One ('Skull & Crossbones') is a story of a pirate seeking treasure on a cursed island, who is confronted by zombie pirates that rise from the sea like in **The Island (1980)**. But the remaining one ('The Fright Before Christmas') is a decidedly anti-Santy Christmas tale.

Directed by Paul Talbot 'The Fright Before Christmas' story is introduce by the booze-swigging derelict with the words: "Ah, Christmas! What a wonderful day... But not always. Sometimes scary things happen... Even on Christmas. Well, last Christmas something happened around here that I wouldn't exactly call holy..." And from there we segue into the story, which sees a greedy, self-centred son, Steve, returning to his mother's on Christmas Eve for the holidays, arriving earlier than expected. His approach to the house, with its lights and garland, is menacing in itself, and the viewer suspects that his intentions are nefarious. (And how right the viewer is!).

Steve is an angry young man who makes it clear that there is no familial love in his heart: all he is interested in is his mother's money – what his inheritance will be upon her death. He is a selfish, greedy, grasping, loathsome individual. "You and Joey and the grandchildren will get a lot of money when I'm gone" his mother informs him; but Steve doesn't want to wait and he pushes his mother down the cellar stairs to kill her. Then, when his sister-in-law Cheryl telephones (because his brother Joey has fallen from a step ladder trimming the Christmas tree and needs to be taken to hospital) Steve volunteers to baby-sit for his young nephew and niece Chucky and Susie – the children with whom he would have to share his inheritance.

A real sense of threat permeates his time baby-sitting, as Steve chides the children for still believing in Santa Claus ("No one gives you anything. If you want something, you've got to take it."). But Steve does learn of a Christmas myth that is new to him. The children are playing Scrabble, and they tell him that according to a classmate, there is a second Mr. Claus – Santa's brother – and it is he who leaves coal in the stockings of naughty children. What is more, if someone has been *really naughty*, Santa's brother chops them up into pieces. His name is an anagram of Santa's, as they demonstrate using the Scrabble tiles: he is called Satan Claus.

Steve sends the children to bed and when Joe and Cheryl return saying that they will go round mother's the next day, Steve returns to the scene of his crime. He practices first, then calls his brother pretending to have found his mother's body and that she must have had an accidental fall. He asks Joey to call the police, and is surprised when shortly after the call ends, there is a knock at the door. When he opens the door though, no one is there. But a Santa hat and a stocking have been hung on the door's garland! Yes, its old Satan Claus himself, come to pay naughty Steve a visit, and when Steve sees him, looking like a cross between Santa and Death[222] he flees in terror. At one point, trying to climb out of an upstairs window to escape, he even sees Satan Claus' spectral, skeletal reindeer, which, although it is somewhat ridiculous, is also a suitably weird sight!

Naturally, SC mark II strangles Steve and rips out his heart, admonishing "You're a heartless bastard Steve." And just like the final panel in a horror comic strip, he leaves Steve's corpse with bloody gaping chest wound slumped on the porch against the front door wrapped in Christmas lights.

Definitely not a film for the squeamish (although the gooey, oozing putrescence that the drug addicts become in the 'Overtoke' segment is probably the most distasteful effect – especially when an unknowing cat happens along and licks at a puddle of the slime!), this production is cheap, tacky and certainly not A-feature material. ...But it does have its moments – both for giggles and flesh creeping thrills; especially for aficionados of sleaze (for whom the comparatively class delights of **Tales from the Crypt (1972)** may hold little appeal). And its Ho-ho-horror segment does provide a slightly different take than the run-of-the-mill psycho-Santa shtick.

But from cheap and sleazy big-screen fare to big-budget, live-action Hollywood block-buster territory: the next year, 1992, saw another Tim Burton movie raking in copious amounts of Christmas cash at the box-office (and via countless examples of cine-synergy from burger shops to toy stores and supermarket shelves). This time, unlike **Edward Scissorhands**, the whole film was set at Christmastime; though the usual bright holly-jolly candy-cane trim-mings stood entertainingly in stark contrast to the dark, Gothic-tinged design of the film's geographical setting – Gotham city. Yes, Burton's tinsel-tinged offering this time was the sequel to his dark revisionist vision of the comic book hero Batman (fondly remembered by most viewers from the camp 1960s TV phenomenon starring Adam West and Burt Ward as the Caped Crusader and his trusty sidekick Robin) in **Batman Returns (1992)**.

As with Burton's 1989 film **Batman**, Michael Keaton was back to very effectively don the mask, cape and black rubber suit with the built-in muscles. Only this time, rather than Jack Nicholson as arch-nemesis The Joker, the Batman would face a monstrously deformed son of a wealthy entrepreneur who was discarded at birth by his parents who were ashamed of his freakish appearance – Oswald Cobblepot, otherwise known as The Penguin. (Though a stunning Michelle Pfeiffer in skin-tight shiny black PVC as Selena Kyle aka Catwoman was also

222 An image that would be used again later when Death takes on the Santa-type role of *Terry Pratchett's The Hogfather* in 2006

a most welcome ingredient in this eye-catching Christmas confection). The real villain of the piece though, is a greedy, immoral industrialist and entrepreneur called Max Shreck[223] played by the always eminently watchable, if usually somewhat weird, Oscar winner[224] Christopher Walken.

Several scenes in the film take place in Gotham Plaza beneath the dark, brooding neo-Gothic city's huge, festively lit and decorated civic Christmas tree; and at one point a Christmas parade becomes a chaos of explosions and mayhem when the Penguin's circus performer minions attack as the mayor makes a speech to light the tree. But Christmas and its associations are more than just a colourful counterpoint in relief to the film's brilliant dark design. The city is in the grip of a crime wave (orchestrated by the Penguin to discredit the mayor and provide him with the opportunity to stand for election and apparently become its saviour. "The season when the citizens of Gotham city should be coming together, our whole society is coming apart," the mayor declares...which is just what Cobblepot and Shreck, the power and money behind humanising the monstrous misfit, have orchestrated.

As the film opens on a snowy Christmas Eve in a prologue set thirty-three years before the main action, we witness the birth of the deformed Oswald Cobblepot to parents who are among Gotham's most wealthy and respected citizens (similar to the Waynes, Batman Bruce Wayne's parents). But the Cobblepotts are appalled at their newborn baby's deformities (caused I is hinted by pollution generated by one of unscrupulous businessman Max Shreck's industrial sites) and pushing the newborn infant through the snow-covered park in a pram, they dump him over a small bridge in a basket that washes down the river to the penguin enclosure of a closed down amusement park. ("I was their firstborn," the Penguin later muses, "But they treated me like number two!").

It is in the penguin enclosure of the dilapidated amusement park and delving through the city's sewers that Oswald Cobblepot grows up to become the monstrous crime figure The Penguin, finally emerging from the city's sewers some thirty-three years later (the same age as Jesus when he started his ministry!) at Christmastime in a staged crime-stopping entrance to win public support for his campaign to stand as mayor and apparently offer Gotham city a new hope and release from the crime wave it has been in the grip of.

223 The very similarly named Max Schreck was a German actor who played the screen's first great vampire Baron Orlock in F.W.Murnau's seminal silent masterpiece *Nosferatu, eine Symphony des Grauens* (aka *Nosferatu* and *Nosferatur the Vampyre* and *Nosferatur a Symphony of Terror* and *Nosferatu a Symphony of Horror* and *Terror of Dracula*). In German the word schreck means "terror" and using a phonetically identical sounding name as the actor who played the screens primary (and primal) vampire for Walken's character is probably both a *homage* and very deliberate, as his supposedly upright, urbane businessman is actually the most evil character in the film – a kind of vampire who plans to build what will look like a power station to supply Gotham, but which will in fact leech off much of its energy then sell it back to the city at an inflated price. I guess it is no accident either that this high profile leech is the power behind the scenes in Oswald Cobblepot's campaign to become mayor of Gotham city.

224 As Best Supporting Actor for *The Deer Hunter (1978)* (title of original script – *The Man Who Came to Play*)

159

As well as fighting the Penguin and his minions and of course the unscrupulous, urbanely evil Shreck, Batman finds time to woo Selena Kyle and flirt most aggressively with her alter ego Catwoman. Indeed, it is through the unguarded repetition of lines spoken by Catwoman and Batman that beaus Bruce Wayne and Selena Kyle come to recognise each other as the magnetically attracted masked combatants they represent in their other guises. Fighting on a rooftop as Batman and Catwoman, the two suddenly realise that they are perched beneath a sprig of mistletoe. "Mistletoe can be deadly," the Batman muses. "But a kiss can be even deadlier," Catwoman responds. The lines are exchanged, though the speakers swapped, when Bruce Wayne and Selena Kyle dance in each other's arms at a festive ball.

Batman Returns, with a screenplay by Daniel Waters from a story by him and Sam Hamm, is a brilliant sequel to director Burton's previous **Batman** of three years prior. Direction is top notch, music (by Danny Elfman who also composed the fantastic score for **Edward Scissorhands (1990)**) wonderful, design brilliant and performances excellent (indeed, funnyman Danny De Vito – usually remembered for his role in TV's **Taxi** or many comedy films – is revelatory). This is megabucks Hollywood blockbuster entertainment at its best...and although it is not a Horror film as such, it is dark, brooding and fantastical (as you might expect from Tim Burton) and definitely deserves a mention in our merry menagerie. And Burton would be back again the next year with yet another Christmas classic and modern masterpiece...but we will come to that in a moment. Before then, I think one other American movie of 1992, albeit a movie made for television, deserves a quick mention. This was unquestionably a Horror movie (although being made for TV it was never going to be as graphic as the big screen opus based on the same supposedly true-life story). It is not set entirely at Christmastime, but it does have one creepy Christmas-set sequence.

The TV-movie in question is **Grave Secrets: The Legacy of Hilltop Drive (1992)** (aka **Grave Secrets** and **The Haunting of Hilltop Drive**). This 97-minute movie, starring Oscar winner[225] Patty Duke, David Selby (who played Richard Channing in the long running TV 'Soap' **Falcon Crest**) and David Soul (who became a small screen icon playing Detective Ken 'Hutch' Hutchinson in TV's 1970s ultra-trendy and cool *zeitgeist* cop show **Starsky and Hutch** and who had UK chart number 1s with 'Silver Lady' and 'Don't Give Up On Us' in 1977) is based on the same events that inspired the gore-drenched, special effects-laden 1982 Horror directed by Tobe Hooper[226] and written by Steven Spielberg[227] (with Mark Grais and Mark Victor).

It is the story of a family who spend all their savings on a new house (in Crosby, Texas) only to start encountering apparently supernatural phenomena that eventually drive them from the property, which it transpires, was built on an old graveyard (only the unscrupulous developers, not wanting to incur extra cost, desecrated the graves and never moved the bodies). What special effects there are in the movie are somewhat variable, but the performances

225 As Best Supporting Actress for *The Miracle Worker (1962)*

226 Director of seminal 'dirty', low-budget horror *The Texas Chainsaw Massacre (1974)*

227 Who also Produced with Frank Marshall (while long time associate Kathleen Kennedy was Associate Producer).

are pretty good on the whole; and the story of how the developers slap gagging orders on the homebuyers is all the more amazing for being true (whether you believe the supposedly true supernatural elements of the tale or not).

There is only one sequence set at Christmastime, but it is a telling one. Three weeks after the daughter Tina has contracted a strange cancer while living in the supposedly haunted house on Hilltop Drive, it is Christmastime and she has made a remarkable and unexplainable recovery in the hospital (which is naturally decorated for the festive season and sports a lovely Christmas tree and bright red Poinsettias). On Christmas morning in the house, where brightly wrapped presents are stacked under the beautifully decorated Christmas tree in the lounge, we see little granddaughter Carli opening her gifts. She is also presented with her big Christmas surprise – a ginger cat – much to her great delight.

The doorbell rings, interrupting the festive family present opening, and the neighbours bring more gifts (though they look ill – probably a side effect of living in their house) and they join in the celebrations. However, characteristic of the effective shooting of this film, the camera looks down on events from upstairs, through the stair banister railings; the shots are unsteady, surreptitious, moving (as if mimicking the point of view of an unseen, unknown and perhaps unknowable supernatural prowler). It is a lurking, outsider's view that the audience shares; an unsettling view as it is suggestive of being the privileged view of one of the supernatural entities the families believe are plaguing them. Definitely *not* the kind of *presence* anyone would want for Christmas. And thereafter things for the families on the haunted estate go from bad to worse…

But if **Grave Secrets: The Legacy of Hilltop Drive (1992)** was a TV-movie and featured only one sequence relating Christmas, the same could not be said of the next year's **The Nightmare Before Christmas**[228]. Sure, it only had a 76-minute running time and it was 3-D animation rather than live-action; but it had big-screen, big-budget quality written all over and all through it…and it was all about Christmas – kind of. Yes, aueteur of the *outré*, Tim Burton, was back – only this time *not* in the director's chair. Adapted from a Tim Burton story by Michael McDowell with a screenplay from Caroline Thompson and directed by Henry Selick, the brilliantly realised **The Nightmare Before Christmas** was produced by the scraggly ebony-haired Burton (and Denise Di Novi)[229]…but it bears all the hallmarks of a Burton project; and features another excellent score from Danny Elfman (who also provides lead character, Jack Skellington's singing voice; as well as the voices of Barrell and the clown with the tearaway face…and that is 'tearaway' not in the sense of ragamuffin, but rip off!). While Chris Sarandon (the cool, modern vampire Jerry Dandridge from **Fright Night (1985)**) provides Jack Skellington's speaking voice and the rest of the vocal cast includes Kevin McCallister's mum from the first couple of **Home Alone** movies, Catherine O'Hara, Albert Steptoe-like (in an American sort of way) William Hickey, Paul Reubens (best known as creepy, whacky kiddies' TV show and sometime movie character Peewee Herman) and American comic Greg Proops (oft time star of the UK TV version of **Whose Line Is It Anyway?**); with Ken Page, who

228 Aka *Tim Burton's The Nightmare Before Christmas*

229 And the 2006 released Disney 3-D version was produced by Don Hahn)

starred as Deuteronomy in both the West End and Broadway productions of *Cats* providing the voice of villainous Bogeyman, Oogie Boogie.

The Nightmare Before Chrismas is a fantastical, eerie, spooky, kooky, ooky, comical, musical flight of (mostly) stop-motion animated fantasy.[230] It features a dark palette with explosions of bright colour amidst the gloom; fluid, dynamic camerawork; gloriously comic-gory detail; a heavy influence of German Expressionism (e.g. lots of crazy, surreal angles) and some truly wacky and wonderful characters. The score and songs are tuneful and tastefully tasteless; the design is gloriously unique (and has led to a synergistic line in alternative Gothic Christmas decorations based on the Halloweentown characters); the lighting and cinematography superb; the script is delightfully and frightfully inventive and the animation is faultless. Indeed, the whole execution (so to speak) is exemplary.

The main setting is Halloweentown – a Goth's delight – and long, lanky skin-and-bones hero (-without the skin!), Jack Skellington (pumpkin king of Halloweentown) is despondent despite organising yet another successful scare-fest Halloween holiday. Everyone else in Halloweentown seems happy (even the appropriately 2-faced - trick or treat - mayor) and want to get started preparing for the next year's Halloween. But Jack craves a change, something different.

Walking in a dark, spooky wood at night, followed by his spectral pooch Zero (a ghostly dog with a red, glow-in-the-dark nose) Jack is lost in contemplation. Then, come the rising of the Jack-o-lantern sun, he finds himself in a neck of the woods he has never seen before. Surrounding him is a circle of tree whose trunks have doors in them painted with symbols that represent the various holidays. Attracted by the alien (to him) brightness and colour of the Christmas tree symbol painted on one tree trunk, Jack opens that door and is sucked through a snowy, dark vortex into the white blanketed world of Christmasland. There, amid the snow, he sees the bright colours and fairy lights of Christastown. Everyone is happy and singing; there are toys and candy canes and garish costumes; decorations and elves and fairground rides, and joy, and peace, and goodwill. Jack is intoxicated.

Returning to Halloweentown, Jack tries to convey his excitement to the motley collections of witches, werewolves, spooks, ghouls, goblins, monsters, mummies, mad doctors, demons, devils, creeps, vampires and various other denizens own gloomy domain. He tries to explain the joys of Christmas, including Santy Claws, but they don't really 'get it' – which isn't really surprising, because nor does Jack, completely. Still, Jack is determined to that the Halloweentowners *will* get it – and use it: he decides to purloin and democratise Christmas, because after all, it should be for *everyone*! (Well, everyone that is except Oogie Boogie, the soulless Boogeyman with the soulful voice!).

Now Jack has a secret admirer in Halloweentown – a raggedy Frankenstein creation of a rag doll called Sally, who has been all stitched up together by a chrome-domed mad doctor creator (who can literally lift his lid and scratch his brain!). She is always trying to poison him

230 Some of the ghosts are traditionally animated, for instance

and escape from his jealous clutches, but he always seems to get her back. Anyway, Sally has a premonition that Jack's plans will lead to disaster, but old bony bonce will not listen, and he sets her to stitching together a Halloweentown version of a Santy Claws suit for him. What is more, jack sets the Boogie Boys on a mission to go to Christmasland for him and kidnap Santy Claws. And following a mishap whereby they come back the first time with the Easter Bunny (!), they eventually succeed. All this while the rest of Halloweentown set to their misguided preparations to deliver a very scary Christmas! (I particularly like 'Jingle Bells' played as a funeral dirge by the undertaker band, and Sally's mad doctor creating skeleton reindeer to draw Santy Claws' slay!).

The trouble really starts though when gruesome, luminous green, soulless soul singing sackcloth spook, Oogie Boogie learns what is going down and gets his hands on the kidnapped Kris Kringle and it looks like Jack's plans may be coming apart at the seems (like his Frankensteinian admirer Sally does). Indeed, Sally is so worried about the impending disaster that Jack's Halloween-Christmas promises to be, that she tries to sabotage his take-off and prevent it. She pours a potion into the civic fountains creating a creeping pea-souper, but fortunately for Jack, Zero his apparition hound with the Rudolph-like glowing red nose comes to the rescue and leads his slay team.

But Sally was right, and Jack's spooktacular Christmas is quite literally a scream! — well several in fact — and not at all what he had expected or hoped, "mocking and mangling" the joyous festive holiday. So Sally sets out to try and free Santa from Oogie Boogie's grasp in the hope that he can save the day. Meanwhile Jack's slay is shot down by the military to stop his mockery of Christmas, and it looks as if there will be no Christmas at all. But the saddened pumpkin king of Halloweentown finally comes to his senses and decides that he must prevent the cancellation of Christmas he has so nearly caused. He determines to confront Oogie Boogie, get Santa back and give the world back its holidays in their rightful order and manner. Which he eventually does, following a dusey of a duel with the oozy, maggoty Oogie. And what is more, the lanky, bony one gets the girl in the end too! (Or is it the ghoul?!)

Whichever, this is towering entertainment of the top order, full of imagination with and technical and artistic wizardry to bring its quirky, dark, brilliant vision entertainingly to the big screen. Though not actually directed by Tim (***Beetlejuice (1988)/Batman (1989)/ Edward Scissorhands (1990)/Ed Wood (1994)/Mars Attacks (1996)/Big Fish (2003)/Corpse Bride (2005)***) Burton, his fingerprints and persona are all over it. It is not standard Christmas fare, but it is a unique and beautifully realised movie, with magnificent design and animation and a really terrific score. It is full of glorious detail; an audio-visual festive feast. But most of all, it is monstrously good fun! Will you enjoy it? ...Of corpse you will! ...And if I cadaver bet on that, I would!

Poor puns aside, however, the only other film I want to mention from 1993 is a (mostly) animated 21-minute B&W short, which is topped and tailed by live action sequences featuring iconic 'out there' beat generation author William S. Burroughs. It is called ***The Junky's Christmas***, and its horrors are social and drug-related rather than supernatural, but I figure it warrants a mention among our assorted Christmas misfits.

Directed by Nick Donkin and Melodie McDaniel, produced by Francis Ford Coppola and Francine McDougall and written by James Grauerholz (though the tale is Burrough's), the movie opens with the frail looking, elderly author sat beside an open fireplace across from a Christmas tree with presents beneath it. He takes down a book from a bookcase and begins to read in his lived-in voice one of the stories from his *Interzone* collection – *The Junky's Christmas*. The film then segues into a nicely realised Claymation animation of the story, which is about a drug addict called Danny the Carwiper, who sets out to find a fix on Christmas Eve...but ends up finding the Christmas Spirit instead.

With a 1940s setting, the B&W Claymation animation is excellent, with a gritty, *film-noir-meets-neo-realist* documentary feel to it as it depicts the cold, grey, miserable world of a New York junkie, and the tale itself is a real hum-dinger; emotional, with a real bite. And the film ends with another live-action sequence showing Burroughs sharing a festive, traditional turkey dinner with several friends. Always a rebel, the mischievous author attempts to carve the turkey with a switchblade!

This is a very unusual festive featurette to be sure, but one that somehow seems to catch the real magic of the Christmas Spirit without the need to resort to the kind of brightly coloured, tacky, holly-jolly, candy-cane, twee, syrupy-sweet, sugar-coated, sickness-inducing flights of festive fantasy that so many crass Yuletide cine-equivalents of fast-food-for-the-soul seem to lazily (or perhaps exploitatively – or both) rely upon.

Moving away from the USA and its Holly-jolly-wood Christmas confections though, across the Atlantic in Spain, filmmaker Álex de la Iglesìa provided a cinematic antidote to diabetes-inducing screen-fare in 1995 with the exceptional Christmastime-set comical horror about avoiding the Biblical Apocalypse, *El Día de la bestia* (English language international title *The Day of the Beast*), which director, de la Iglesìa, co-wrote with Jorge Guerricaechevarria.

This 103-minute movie's most amazing accomplishment is in mixing genuinely funny (often oil-slick black!) dark humour with genuinely disturbing elements of horror and some heavy-metal music and maintaining the quality and a brilliantly intriguing balance through-out the entire running time. It is a real gem of a movie and a rare find. It opens in a church, where a theologian priest who looks a bit like Charles Aznavour informs a colleague that he has deciphered a hidden message in Book of Revelations. This concerns the birth of the Anti-

Christ in Madrid on Christmas Eve (mirroring the birth of Christ) that very year. However, no sooner has he communicated the news of his discovery than his fellow priest is shockingly splattered when a huge stone crucifix topples and falls on him.

We next see the middle-aged priest, who looks so unassuming and mild-mannered, arriving in Madrid at Christmastime...but hysterically, he seems to depart from almost every expectation we have of priestly behaviour – stealing a wallet from the victim of a road accident he is meant to be administering to, for instance; stealing, pushing a robotic statue mime performer from his high pedestal so that he falls down the steps to the city's underground railway; shopping for heavy-metal/death-metal music! It is while doing the latter, that he meets a chunky, scruffy, bearded 'metal' fan with long, lank hair, piercings and tattoos serving in a shop. The two hit it off immediately (it never even occurring to the brain-fried taker of recreational chemicals and fan of heavy metal that his new buddy is a most unusual priest!). But the reason the priest is trying to commit as many sins as he can is because he wants to meet the devil...in the hope that he will be able to prevent the birth of the anti-Christ and thus save humankind from the Apocalypse as detailed in the Book of Revelations...He is in fact trying to become a Biblical double-agent.

Having taken to the priest, the scruffy metal fan secures him lodgings at his mother's apartment house, where a dotty old grandfather and a good Catholic girl from the country whom the metal-head fancies dwell (though being a good Catholic girl, she doesn't believe in pre-marital hanky-panky and is a virgin still). Looking for signs in the bustling seasonally decorated and lit city streets filled with Santa-hat-wearing shoppers that might lead him to the devil or the birthplace of the anti-Christ, the priest and his new mate get involved in all manner of crazy adventures, not least imprisoning a celebrity TV occultist in his penthouse flat to try and make him help them summon the devil. Although their plans are almost upset by the arrival of the somewhat sham occultist's girlfriend (played by Maria Grazia Cucinotta (a beauty who played one of the Bond girl villains in **The World is Not Enough (1999)**) and the fact that having drawn the pentangle the occultists tells them is necessary and acquired a quantity of LSD from the metal-head for their potion, they require virgin's blood. Fortunately the priest remembers the good Catholic girl from the country who is living at his mate's mum's house, and having secured some of her blood (using a syringe) – and having one ear blown off by the mum who thinks he is a murderer – they actually manage to summon a talking goat! (Or is it the effect of the hallucinogenic drugs in the bloody potion priest, sidekick and TV occultist imbibe...?)

Following a trippy, Harold Lloyd-style escape from the penthouse flat (involving clinging to a neon-lit Schweppes sign), the priest and his companion continue their quest – and the occultist helps them. There is an excellent scene in which the priest, fleeing the security guards from a lecture on Nostradamus he has interrupted, runs through a busy, festively-lit city centre pedestrian only shopping street as 'Jingle Bells' plays on the soundtrack. Pushing through the bustling crowds of last minute shoppers and those out to enjoy the holiday atmosphere, the priest – now a scruffy, unkempt mess with a bleeding, ragged mass of flesh on one side of his head (the remains of his ear) – suddenly sees the Three Wise Men in a gaily decorated grotto (in Spain they, rather than Santa, traditionally bring Christmas gifts for children). He

climbs up to them, thinking they are a portent, but the gun-toting security guards following him spot him. Fortunately, his metal-head mate sees the security guards and lets off several shots in the air from the pump-action shotgun he has acquired. This sends the crowds of Christmas shoppers into a frenzied stampede and although the priest survives the hail of gunshots from the guards, all three Wise Men are massacred!

Guided by the TV occultist (who has managed to work out from other signs where the birth of the anti-Christ on this unhappy anti-Christmas will occur), the three guardians against Armageddon finally do encounter the devil...on the girders of a building under construction (... Or is it still all a bad shared trip?)...and the anti-Christ (?) baby, newly born to a homeless couple, is killed along with its parents (although the metal-head is killed and the TV occultist badly burned in the process) allowing the rest of humankind to enjoy celebrating Christmas.

As I said though, this film's real achievement lies in maintaining a magnificent but delicate balance between its key elements: in keeping its pitch-black elements of dark humour funny throughout, while still delivering an intriguing and engrossing horror-thriller quest, through which the audience is prepared to continue suspending their disbelief. And part of the key to this lies in the very human, extremely empathetic and likeable (even when they are doing insane things!) characters that are so well served by their talented performers, writers and director. This film (correctly tagged "A devilishly dark comedy" by its advertising tagline) is a real festive treat (or is that a reel festive treat?) film fans with a somewhat jaded palette. It is darkly delicious and definitely to be savoured.

And this description would also suffice to describe another European opus released the same year – this time a French-German-Spanish co-production with an American star. Although not really either a Christmas Movie nor a Horror Movie *per se*, **La Cité des enfants perdus (1995)** (aka **The City of Lost Children** – English language international title and **Die Stadt der Verlorenen Kinder** – German title and **La Ciudad de los niños perdidos** – Spanish title and **La Ciutat dels nens perduts** – Catalan TV title) does feature a couple of splendidly nightmarish Christmassy scenes.

Written by Gilles Adrien[231], Jean-Pierre Jeunet[232] and Marc Caro[233] and directed by Marc Caro and Jean-Pierre Jeunet, **The City of Lost Children** is a magnificently evocative grim, modern fairytale with wonderful, dark, fantastical design by Marc Caro and Jean Rabasse (also the film's Art Director), costumes designed by Jean-Paul Gaultier and music from Angelo Badalamenti, who composed the music for David Lynch's **Twin Peaks**. It stars muscular American giant Ron Perlman (of TV's **Beauty and the Beast** and **The Magnificent Seven** and

231 Co-writer of *Delicatessen (1991)* and main dialogue writer for *La Cité des enfants perdus (1995)* (with additional dialogue by Guillaume Laurant and Jean-Pierre Jeunet)

232 French co-writer and co-director of *Delicatessen (1991)*; co-writer and director of *Le Fabuleux destin d'Amélie Poulain (2001)* (aka *Amélie* and *Amelie* and *Amelie from Montmartre* and *The Fabulous Destiny of Amelie Poulain*) and director of *Alien Resurrection (1997)* (aka *Alien 4*)

233 Co-writer and co-director of *Delicatessen (1991)* and *La Cité des enfants perdus (1995)*

the big screen's **Hellboy (2004)** and **Hellboy II: The Golden Army (2008)** fame) and diminutive, mug-faced Dominique Pinon, who plays a series of clones. In a nightmarish alternative world, a mean-spirited scientist who lives on an oil-rig laboratory with several clones, a female midget and a talking brain that floats in a tank, steals children from the mainland to hook up to his invention which is designed to supplant their dreams in his head (as, being a mean imaginationless creation, he cannot dream and he hopes that children's dreams will stop his premature aging). However, all of his attempts to experience a pleasant dream fail to reach fruition and quickly deteriorate into nightmares as he scares the children victims.

The film opens with a small child in a cot-like bed at Christmastime. It is snowing outside the bedroom window and a snowman is in the garden. Inside the warm, cosy bedroom with its Christmas tree, a mechanical toy soldier bangs cymbals together the toddler beside a cuddly chimp and a young child beams from his cot as Santa Claus descends the chimney via a rope and emerges into the bedroom. Then, confusingly, another Santa emerges too...then another...and another. The image begins to warp and slur, as if the vision of someone tripping on hallucinogenic drugs, and more and more Santas invade the room. Suddenly even a large pale reindeer is in the room dropping a festive faecal deposit and the whole thing has deteriorated into nightmare for the poor child clutching his teddy bear and howling in the cot. We soon discover that he is the latest victim hooked up to the scary villain's dream machine.

Later, the villain, Krank – a bald-headed, big-nosed, baggy-eyed, gaunt, sallow-faced Nosferatu-vampyre-looking villain[234] – tries to seduce a dream from his latest batch of innocent toddlers by dressing as Santa. In the middle of the night he turns on the light in the room with a festively decorated Christmas tree on his industrial oil-rig like home and sings along to a very Gallic Christmas song his diminutive, elf-like cloned brothers play on an old gramophone. They wave sparklers behind him as he sings along to the record, looming over the children's cots threateningly:

♫♫♫ "On this snowy Christmas night,
Clad in its mantle white,
Legions of tiny tots,
Kneeling by their cots,
Fight the slumberous air
To launch a final prayer.
Dear Santa, on this night of joys,
When you bring your bag of toys,
Meant for paupers and for king,
Don't forget my poor stocking.
The sandman's gone, the children sleep,
So you can play at chimney sweep ..." ♫♫♫

Unfortunately, the longer he continues, the louder and more threatening he gets, and even the armfuls of toys and gift-wrapped presents his cloned brothers bear cannot prevent

234 At one point he puts some spiky fish bones in his mouth to look like fangs to see if he can scare one child, or if the mite is as fearless as he appears

the children from descending into a tearful, howling. When one brother jostles the gramophone and Santa-Krank's Beard gets caught in the needle, jarring it onto a samba track (which his brothers try to sing and dance along to), the nasty villain snatches off his hat and beard, angry and defeated yet again.

The bulk of the film's story sees a muscular strong man street performer (Perlman) searching for his adopted baby brother who has been kidnapped for the evil scientist. He joins up with a young girl street waif thief (who works with a gang of child thieves presided over by conjoined twins, like Fagin's boys from Dickens' *Oliver Twist*) and a strange but touching relationship develops between them (reminiscent in some ways of the relationship between the young girl and the hitman in **Léon (1994)**).

When the strongman and the girl finally track the missing child down to the villains' oil-rig laboratory, the girl plugs herself into the dream machine that villain and toddler are plugged into and enters the nipper's Christmassy dream (like the one that opened the film) to save him and defeat the bald baddy.

This movie is a weird and wonderful concoction – dark, brooding, funny, touching, and absolutely bizarre. It is a grim (rather than Grimm) modern fairytale and an unmissable treat for anyone who is a fan of the fantastical. It comes across as Hans Christian Andersen meets Charles Dickens by way of Tim Burton and Terry Gilliam with a bit of **Dr Who** thrown in! (And if *that* doesn't tickle your taste buds, why on earth did you buy a book like *this*?!)

And so, from the sublime to the ridiculous... Back across the Atlantic in 1996 an ultra-cheap, micro-budget Independent Christmas Horror called **Jack Frost** was released (No, not the one starring Michael Keaton – that particular horror would be inflicted on audiences two years later!) This particular **Jack Frost** was an18 or R rated monstrosity that purported to be a Comedy-Horror – though if you were going to laugh, most of the laughter would be inadvertent, i.e. come at the expense of the filmmakers' ineptitude). Directed and written by Michael Cooney, from a story by Jeremy Paige (who also produced with Vicki Slotnick) – just so you know who to blame! – this dire piece of dismal dross is about a psychotic serial killer called Jack Frost who gets killed but comes back to life as a ferocious fanged snowman to continue his slaying spree. Jack is arrested by a small town sheriff, but en route to prison (and the chair) his transport crashes with a truck carrying a top-secret genetic material, which is being tested by the military. This turns the eponymous villain into a puddle of oozing goo, and eventually into a collection of live, metamorphosing, genetically enhanced water molecules... Which basically means that he can take on the form of a living murderous snowman that has his warped personality (a real nasty piece of work) or dematerialise into water (useful for escapes) at will.

Making his wintry way to the nearest town (where the sheriff who caught him lives), which gets cut off by a blizzard later that night, Jack sets about (as the movie poster's advertising tag line would have it) "Chillin' and Killin'" the residents in various might-have-been-humorous-if-remotely-credible ways and taunting his law enforcement nemesis.

To be fair to this film, it does utilise some nice camera angles and framing – as when three cops discuss the frozen body rocking in the foreground in a rocking chair, head tipped back. The chair is not rocking due to some supernatural force, we learn as the camera angle changes, but because one of the jaded cops has a foot on it, rhythmically swaying it and the corpse sat in it as they speak. And I guess, however absurd its slayings, they are at least knowingly depicted as absurd. There is even a Hitchcock *homage*: sexy Shannon Elizabeth (the hot European exchange chick in the first two **American Pie** movies – probably the only member of the cast you will know) meets her demise in the bathroom. ...Although I doubt even the great man Hitch could have pulled off a snowman rape scene successfully! (And I don't suppose he would have wanted to, or have been daft enough to have tried!).

A supposed FBI agent and the scientist who invented the genetic chemical turn up and try to take charge of the investigation/cover-up (or would whitewash be a more appropriate term?), but both end up getting killed. (...Although the agent shows up in the even more terrible sequel – but played by a different actor complete with a limp reason for his survival and change in appearance! ...But that comes four years later...)

It is left to the sheriff and his buddy Paul to dispose of the old mean-spirited-Frosty-from-the-wrong-side-of-the-tracks, and they do this by utilising...wait for it... a vat of anti-freeze, would you believe?! They discover this hurts the mutated killer snowman after some oatmeal containing anti-freeze is thrown at him. (The cop's bright young son has thoughtfully added the anti-freeze to the oatmeal so his dad won't catch cold chasing baddies around in the snow!!!).

There are some funny lines ("When I want philosophy I'll turn on Oprah", or as one jaded cop says when asked to cut down a victim of Snowman Jack's who has been hanged using a string of Christmas lights and chocked with baubles from the Christmas tree: "You don't reckon we should leave her up for the 12 days of Christmas then?"), but Christmas itself has no real significance to the action movie, other than providing an ironic counterpoint to the bloodletting and horror – the Season of Goodwill and all that – and, of course, a time when it is likely to have been snowing.

But the film's premise is just so absurd and outlandish; the performances so amateurish and the special effects so weak, that it is hard to find any real saving graces. Even the snow itself (never mind the decidedly-less-than-dynamic) snowman looks *soooo* fake. If the film had better production values and was able to afford better special effects, it might have managed to transcend the absurdity of its plot (though I seriously doubt it): it might just have pulled it off if it was all performed in a more professionally surreally camp manner (in the mode of a **Monty Python** sketch perhaps) though. Instead it ended up in **Attack of the Killer Tomatoes! (1978)** territory: and not even as effective as the movie that tried to make giant killer bunny rabbits terrifying (**Night of the Lepus (1972)**) and signally failed!

The filmmakers do get some nice mileage out of using Christmas songs as accompaniment, sounding quiet hollow, distant and kind of stretched like an old cassette tape (if you remember them and that kind of slow, slurred, off-key sound). Anyway, when the good folk

of Snowmonton have finally dissolved Jack the serial-killer snowman in the anti-freeze, they pour it all back into the bottles and bury them in an unmarked grave. (If only they had done the same with the reels of film, eh?!). I cannot see this unscary, unfunny Christmas Comedy-Horror melting anyone's heart and ending up on their list of festive favourites... But then again, what do I know? – I wouldn't have believed they would bother to make a sequel either, in which the abominable "mutant killer snowman[235]" would make a comeback to continue his "Icin' and Slicin'"[236]...But they did...and we will get to that particular abomination soon enough...

First though some more Holiday Horrors from 1996... and I don't mean **Santa With Muscles** starring Hulk Hogan as an evil millionaire who gets amnesia in an accident while wearing a Santa suit and believes himself to be the kindly elf when he wakes up! (Though that sounds pretty darned horrific to me!!!). **Satan Claus (1996)** – a cheap and tacky, mean and nasty, crass and crappy straight to video/DVD release was made in the US by some Italians – Massimiliano Cerchi produced and directed and Simonetta Mostrada wrote the screenplay, though the cast appear to be non-Italian.

In **Satan Claus**, a killer Kris Kringle is slashing his way across the Big Apple and "He Knows When You've Been Bad" (Or at least that is what the advertising tagline on the DVD box informs us!). This tinsely travesty opens with a street Santa wishing a woman he bumps into in the street (quite literally) a "Merry Christmas"...before lopping her head off with a machete, while "Ho-ho-ho-ing" with maniacal glee and singing 'Jingle Bells' as he stuffs said cranium in his Santa sack. The woman, it transpires, is the wife of the police captain who heads up the city's homicide squad (and a worse actor you will not have seen in many a long day! So bad indeed is Barrie Snyder that you will be in hysterics at his emotive reactions and the god-awfully-brilliant telephone conversations he holds with the taunting psycho Santa serial-killer. I haven't seen such a woefully funny cop performance since Ed Wood's **Plan 9 from outer Space (1959)** and the cop who scratches his face and pushes up his hat with his revolver while furrowing his brow in a vain attempt to convey earnest concern and worry. Priceless!).

The killer Kris Kringle in **Satan Claus** is on a quest it seems; in search of the perfect ornaments for his (or her) Christmas tree – body parts! We even get to see the rotund, Santa suited whacko hanging the gory bits collected from the victims (starting with the captain's wife's head) on said festive fir (which looks like it is somewhere down an alley dimly lit with festive red and green lights. (I think it is actually in the living room of a converted industrial building, but the film is so dark – probably to try and hide how cheap and tacky it is – and so poorly shot as to make the viewer almost lose the will to breathe, let alone follow the finer points – for want of a more accurate phrase – of its plot). Indeed, this movie is such a piece of exploitative trash that some of the acting in it is *soooo* bad that it would even be sub-standard in a pornographic movie![237]

235 The full title of the sequel is *Jack Frost 2: Revenge of the Mutant Killer Snowman*

236 This is the advertising tagline of the sequel

237 Take a bow Barrie Snyder!

Several further murders and loppings off of various body parts to decorate the gruesome Christmas tree ensue, and one of the initial suspects is a between-jobs thespian who, along with a mate, is selling stuff from a table in the park, dressed as Santas, to raise money for an orphanage. Naturally, one of the problems for the police – other than sheer ineptitude – is that the only description they can get of the miscreant is that of a fat, white-bearded chap in a red suit...and there are millions of those around because it's Christmas. The Santa-suited actor though, is the boyfriend of one of the female detectives on the case, and he ends up joining forces with a voodoo- spouting old black woman who apparently has some kind of psychic link with the killer. When asked why the killer is on this ghastly spree, the woman (Old Mamon) helpfully answers, "I'll tell you why...He may be the Devil!"

Anyway, amid the mounting number of Santa slayings and mystical musings, there is in an absolutely audacious 'cheat' ending, (one that would put Dick Dastardly to shame in **Wacky Races**!). it transpires that the male-voiced, big, rotund, butch psycho-Santa killer (even credited in the cast list as being played by a man) is in fact one of the female characters when finally unmasked!!!...About to fill her stockings by killing the police captain and actor, she is shot by the actor's detective girlfriend: The End...Oh, but believe me, not anywhere near soon enough!

Perhaps it was a sign of the changing times, but there were no protests and no moral outrage when **Satan Claus** was released (as there had been when **Silent Night, Deadly Night** was released in 1984). Or perhaps that was because **Satan Claus** was released straight to video/DVD and not in cinemas. Actually, it was probably a bit of both – by 1996 when **Satan Claus** hit the video store shelves, the Christmas Horror Movie was pretty well established and if not exactly welcomed by the buckle and holes on the Bible Belt, then perhaps the inevitability of its continued existence was grudgingly accepted. (Perhaps the potential protestors had learned a lesson from the **Silent Night, Deadly Night** saga, and realised that even if they wanted to object to an artistically bankrupt product like **Satan Claus**, by drawing attention to it they might well have the opposite effect than that they desired and actually promote the dire drivel!).

And 1996 was quite a year for trashy Christmas Horrors and psycho Santa 'Slashers' as, as if **Jack Frost** and **Satan Claus** weren't bad enough, Christmasochistic viewers also had the opportunity to seek out and watch the dismal double-header that was **Santa Claws** (aka **'Tis the Season**) and **Scream Queens' Naked Christmas** (aka **Naked Christmas**)! The former a fairly pathetic soft-core strip movie with a wretched tale of a nutjob Santa slayer pathetically performed at porno movie acting level stitching together the whip-off-your-kit go-go dancing scenes that were ultimately the film's main selling point and real *raison d'etre*. More honest, perhaps, if no more effective, **Scream Queens' Naked Christmas** was a companion piece that shaved away the supposed plot and just cobbled together none-to-titillating scenes of the girls who starred in **Santa Claws** dancing (badly, too horrible music) and divesting themselves of their habiliments...i.e. getting their kit off! In **Satan Claws** several murders of strippers starring in a Christmas movie that is being shot feature: **Scream Queens' Naked Christmas** is

supposedly the movie being shot in **Satan Claws**. Yes, 1996 was something of an exploitative *annus horribilis*[238] in the Christmas Horror calendar (though not the only one!).

Both films are credited as being written, produced and directed by John A. Russo and their one saving grace is the fact that they feature the delectable Debbie Rochon, who is quite a hottie...although the rest of the girls who get naked (perhaps that should be pronounced American redneck fashion i.e. 'neck-it') are not terribly good lookers and seem all to hail from Silicone Valley (i.e. I suspect mammary enhancements of the surgical variety!). **Santa Claws** has an 83-minute running time and **Scream Queens' Naked Christmas** (aka **Naked Christmas**) a 60-minute running time – and believe me, like pesky relatives who show up unexpectedly during the holidays with enough baggage for a month, both outstay their welcome!

The plot of **Satan Claws** (for what it's worth) sees a young man called Wayne (who years before shot his divorced mother and her Santa-suited lover dead when he caught them *in flagrante delicto*) now believing that he *is* actually the real Santa Claus himself. But Edmund Gwenn[239] or Dickie Attenborough[240] he most certainly is not! Secretly obsessed with his next door neighbour, an 'actress' who stars in low-budget blue horror movies, he commits murders with a three pronged garden claw to protect her from exploitation! As she is involved in making a shoddy little exploitation flick (**Scream Queens' Naked Christmas**!) Wayne sets about killing a number of the other 'stars'.

I guess one thing of note (for Horror Movie 'anoraks' at least) is that some of the cast of George A. Romero's original micro-budget Indie Horror **Night of the Living Dead (1968)** appear in this (although I honestly think that only die-hard fanatics would want to sit through this trash to 'spot' them, as it is less than risible; it is contemptible. I have indicated which ones they are in the film listings at the end of the chapter). Believe me, if I were Santa, the only thing I would have given anyone involved in this claptrap for Christmas would have been the sack! (...except perhaps Debbie Rochon who could sit on my knee any time and tell me what she wanted to fill her stockings this Christmas!). As far as I am concerned, both these movies amount only to a pile of steaming reindeer pooh! ...But if that's what puts the tinsel on *your* tree...!

Changing tack a little, although not a scary movie, 1996 also saw the release of a rather weird Russian Christmas flick with Sci-Fi leanings entitled **Novogodniye Istorii** (aka **Novogodnaiai istoria** and **New Year Story**[241]). Written and directed by Alexander Rogozhkin, this film is "an interesting mixture of various New Year traditions and cinematic conventions. It begins with a pseudo-documentary extract about the 1945 Yalta conference and the

238 Latin phrase meaning 'horrible year' – a phrase brought to prominence by the Queen in a speech made in 1992 following a year in which a fire gutted part of Windsor Castle, various royal relationships broke down and the press was splashed with paparazzi photographs of various unseemly antics of members of the Royal family

239 Who played Kris Kringle (Santa) in the original big screen version of *Miracle on 34th Street* in 1947

240 Who played Kris Kringle (Santa) in the remake of *Miracle on 34th Street* in 1994

241 Its English language international release title – Russian Christmas is celebrated at New Year

commitment of Churchill, Roosevelt and Stalin to collaborate on the anti-cosmic defence programme, designed to offer resistance against invasions from other planets," according to Birgit Beumer in her essay *Father Frost on 31 December: Christmas and New Year in Soviet and Russian Cinema*.[242] And it also features the animating of a puppet bridegroom and the transposition of a child into the shady celluloid world of an old spy film!

When a cosmic force is identified at a Moscow TV studio by the team set up to deal with alien invasion (3X-Omega), an actor dressed as Father Frost (the Russian equivalent of Father Christmas or Santa Claus) is mistakenly believed to be the extra-terrestrial interloper and ejected along with his Snow Maiden, Ania. However, as he is in fact the *real* Father Frost, he animates a model bridegroom so that Ania has a dance partner, and offers her a wish. Studio security guards overhear this and try to help formulate a suitable wish, while 3X-Omega men try to destroy the cosmic force with the use of concentrated energy (after receiving permission to do so from Russian President Boris Yeltsin, German Chancellor Helmut Kohl and US President Bill Clinton!).

Father Frost cannot be destroyed though, and as the girl and the security guards cannot think of anything Russia needs to wish for (as they can sort out all of her problems by sheer hard work! ...Communist principles die hard!) they give the wish to the bridegroom, who wishes for his bride to be animated also.

Ania falls in love with one of the guards and other reconciliations also occur (between a boy squatter, Vania, and one of the guards, for instance) and developments unfold thick and fast so that the plot is "complex to the point of being incoherent in places, and borders on the ridiculous in the use of stereotypes." While the modern child does not actually believe in Father Frost, President Yeltsin does and he refuses further requests for energy to try and destroy the alien in case it really is the real Father Frost the 3X-Omega men are trying to destroy.

Frankly, the whole thing sounds about as nutty as a Christmas fruitcake to me, but you might think otherwise.

Back across the Bering Straits but still in 1996, a "dirty," "grungy" Santa made an appearance in a low-budget Indie called ***Reindeer Games*** (aka ***The Girl in the Basement*** – video release title), which is not to be confused with the John Frankenheimer-directed film ***Reindeer Games*** starring Ben Affleck, Charlize Theron, Gary Sinise, Isaac Hayes, Donal Logan, Dennis Farina and James Frain (...and hardcore porn legend Ron Jeremy and Ashton Kutcher) released in 2000. An Action-Movie Crime-Thriller Con-job film, rather than a Christmas Horror, that movie (about an ex-con being recruited to rob a casino at Christmastime with a gang dressed-up in Santa suits) did at least open with shocking shots of five Santas variously shot and lying dead and bleeding in the snow; or charred and smoking with their lower half hanging out of a car windscreen; or sprawled across a table with a huge shotgun blast to the chest etcetera.

242 Published in *Christmas at the Movies*: *Images of Christmas in American, British and European Cinema*, edited by Mark Connelly, IB Tauris, London & New York, 2000

(The film then retrogressively details how their robbery went wrong and they all ended up that way, before delivering an extremely unlikely double-denouement twist. It got slaughtered by the critics, but I have to say, I kind of enjoyed it!).

But back to the 1996 *Reindeer Games*: this film, written by Efram Potelle (who also produced, edited, was assistant director, sound recordist and make-up artist, wrote the music for it, acted in it and cast it!), Kyle Rankin (who also produced, acted in it and cast it!) and Shayne Worcester (who also directed, produced and cast it!) is about a social outcast called Alec (played by Rankin) who has a troubled past and who cracks one Christmas. "Mr. Extreme Average," Alex fancies a waitress called Kate at the restaurant where he works in Portland, Maine. After finally landing a date with her, things don't go entirely well and the disturbed Alex eventually attacks and kidnaps Kate. He takes her to his basement where he keeps her in bondage. Kate tries to escape with her life as her co-worker tormentor begins a downward spiral into psychosis thanks to his tortured past. Needless to say, the whole thing ends in tragedy and death.

A cheerful little Christmas Movie this most definitely is not then, with its tale of incipient insanity quickly spinning out of control. But real life tragedy also struck, as director Shayne Worcester was shot dead in an attempted car-jacking in San Francisco just three years later, aged thirty. Opinions on ultra-low-budget Indies like *Reindeer Games* often vary, and this film is no exception with some people loving it and others loathing it; some believing that (like Santa perhaps) it delivers, while others berate it as unpolished and amateurish. I will leave t up to you to decide whether it sounds like your particular poison or not. However, if you *do* want to "join in all the reindeer games", as the song[243] goes, then this "cult classic" (according to the DVD box) might be right up your street.

Mind you, if Mockingbird Lane, Mockingbird Heights[244], is more 'your street' then 1996 also saw the release of the made-for-American-TV movie *The Munsters' Scary Little Christmas*, based upon the 1960s TV comedy about a family of Universal-style monsters (who consider themselves perfectly normal middle-class American citizens) – similar but different to the contemporaneous *The Addams Family*.

The Munsters had undergone something of a revival (or should that be a resurrection?!) in the late 1980s to early 1990s, with **The Munsters Today** (aka **The New Munsters**) hitting television screens for 73 episodes between 1988 and 1991 in America (starring John Schuck[245]

243 Rudolph the Red-Nosed Reindeer: lyrics by Robert May, music by Johnny Marks, first recorded by singing cowboy Gene Autrey in 1949

244 The home address of TV's **Munster** family (No. 1313 to be exact!)

245 Who played Sgt Charles Enright in the 1970s American TV crime show **McMillan & Wife**

as Herman, Lee Meriwether[246] as Lily, Howard Morton as Grandpa, Jason Marsden as Eddie and Hilary Van Dyke as Marilyn). And with films featuring both Christmas and Horror elements (and often comedy too) being produced regularly by the mid-1990s, it was no great surprise that the family headed by the Frankenstein Monster-like patriarch with the Count Dracula-ish Grandpa, the Bride of Dracula/Zombie-style matriarch and the Werewolf kid (grown-up daughter Marilyn was a beautiful 'normal' blonde – the black sheep of this particular family who considered herself rather strange looking and ugly, but whom the family loved in spite of her misfortune in the looks department!) should meet Santa Claus. Of course, the original (and incomparable) cast from the 1960s TV show – Fred Gwynne as Herman, Yvonne De Carlo as Lily, Al Lewis as Grandpa, Butch Patrick as young Eddie and Beverley Owen and later Pat Priest as Marilyn – had to be replaced again in the 91-minute 1996 feature written by Ed Ferrara and Kevin Murphy[247] and directed by Englishman Ian Emes. But *The Munsters' Scary Little Christmas* – which stars Sam McMurray as Herman, Ann Magnuson as Lily, Bug Hall as Eddie, Sandy Baron as Grandpa and Elaine Hendrix as Marilyn; supported by Mary Woronov,[248] Ed Gale[249] and Arturo Gil[250] – is generally reckoned by many to be an improvement on the revamped **Munsters Today** TV series.

In *The Munsters' Scary Little Christmas* Eddie is really negative towards the holidays, so his family try to rouse him from his depression and raise his spirits. His mother inspires him to enter a festive house decorating competition with her, and although (as you might imagine) their idea of festive decorations are unusual, inciting chagrin and annoyance from an obnoxious and competitive neighbour, this helps drag Eddie out of the doldrums. Meanwhile,

246 Who played Dr. Anne McGregor in the American TV Sci-Fi series from the 1960s **Time Tunnel** and Cat-woman/Miss Kitka in the 1966 *Batman* movie (with Adam West as Bruce Wayne/Batman, Burt Ward as Dick Grayson/Robin, Cesar Romero as The Joker, Burgess Meredith as The Penguin, Frank Gorshin as The Riddler, Alan Napier as Alfred, Neil Hamilton as Commissioner Gordon and Stafford Repp as Chief O'Hara). [Julie Newmar usually played Catwoman in the TV series – 13 episodes – though Eartha Kitt did play the character in 3 episodes]

247 Based upon characters originally created by Norm Liebmann and Ed Haas in a format developed by Al (Allan) Burns and Chris Hayward for the 1960s TV show

248 Who has appeared in films like Andy Warhol's & Paul Morrissey's *Chelsea Girls (1966)*, *Silent Night, Bloody Night (1974)* (aka *Death House* and *Night of the Dark Full Moon*), Paul Bartel's *Death Race 2000 (1975)* produced by Roger Corman and *Night of the Comet (1984)*

249 A dwarf actor who has often played one of Santa's elves on screen – in films like *Flight of the Reindeer (2000)* (aka *The Christmas Secret*), *Call Me Claus (2001)* and *Santa Jr. (2002)* – as well as being icon killer doll Chucky's stunt double in *Child's Play (1988)*, *Child's Play 2 (1990)* (aka *Child's Play 2: Chucky's Back*) and *Bride of Chucky (1998)* and appearing in Horror and Sci-Fi films like *Howard the Duck (1986)* (aka *Howard: A New kind of Hero*), *Spaceballs (1987)*, *Phantasm II (1988)*, *Chopper Chicks in Zombietown (1991)* [which also features an early role for Billy Bob Thornton], *Bill and Ted's Bogus Journey (1991)* and *Lifepod (1993)* a space-set remake of Alfred Hitchcock's *Lifeboat (1944)*

250 Another dwarf actor who has played Elves and dwarves and appeared in genre movies like *Spaceballs (1987)*, *Bill and Ted's Bogus Journey (1991)*, *Leprechaun 2 (1994)* (aka *Leprechaun II* and *One Wedding and Lots of Funerals*), *Ghoulies IV (1994)*, *Twice Upon A Christmas (2001)*, and *A Light in the Forest (2002)*, as well as acting as a stunt double in *Leprechaun 2 (1994)*, *Leprechaun 3 (1995)* and *Leprechaun 4: In Space (1997)* (aka *Leprechaun 4*)

Grandpa tries to help Santa out with his gift giving by concocting a magic potion for the jolly man... but is hindered in his efforts by a pair of pesky elves.

Overall, it is pretty much what you might expect from the weird, monstery Munster family with something there for mummies, baddies, boils and ghouls. And although I don't want to contradict old Ebenezer Scrooge, methinks there might be more of the grave than of gravy about this funny family's fun Christmas antics...and even if it is played for laughs, I think any Christmas Movie that stars a family of characters based on Universal monsters deserves a mention in our trawl through festive terrors and weirs Psychotronic Holiday film fare.

And finally for 1996, I would just like to mention in a bit more depth than in chapter 2 another made-for-American-TV production – **Beavis and Butt-head Do Christmas**. I am sure everyone is familiar with the smutty, adolescent MTV animated airheads who, if you gave them a brain cell for Christmas, it would die of loneliness. They have become iconic figures of the dumbed-down Generation X with their staccato smutty giggles and their 'the world can go to Hell on a hand cart' attitude, as they vegetate for hours in front of the telly, listening to the weirdest music on the contemporary scene, lusting after hot chicks while fantasising about the sex lives they will probably never have and bad-mouthing anything and everything square; expressing a kind of nihilism, unencumbered by anything – especially brains. Welcome to the MTV-generation. They represent less the rebel without a cause and more the rabble without applause! (OK, so they are horribly stereotypical; but they evidently strike a chord!).

In this, their Christmas special, as well as sections of viewers' letters to Santa Butt-head (with Beavis dressed in a reindeer costume, harnessed to a sleigh and at the wrong end of a bull-whip), a short, ironic 'pot-calling-the-kettle-black' discussion around "How come Santa Claus has that stupid laugh?" ("Huh-huh-huh!") and three gloriously awful Christmas-song videos[251], the main body of this episodic movie centres on two skits on Christmas classics – Beavis and Butt-head's takes on Charles Dickens' story *A Christmas Carol* and Frank Capra's movie ***It's A Wonderful Life***.

Both are funny reinterpretations and actually far from berating or belittling the originals, are knowing, appreciative *homages* to them. In both instances, like the lead characters in each, Beavis and Butt-head are given the opportunity to learn important life lessons at Christmastime and change their errant ways. But unlike Ebenezer Scrooge and George Bailey, the chances of Beavis and Butt-head doing this are about the same as a the proverbial snowflake's chance in Hell.

In the first riff on a Christmas classic (entitled 'Huh-huh-humbug' and inspired by *A Christmas Carol*), the boys are pulling the night shift at a burger restaurant on Christmas Eve

251'Merry Christmas (I Don't Want to fight Tonight)'by the Ramones (good song though!); 'Zat You Santa Claus?' by Buster Poindexter (which has got to be seen and heard to be disbelieved!); and 'Christmas in Hollis' by Run DMC, which, as ever, the decidedly un-dynamic duo of couch potatoes, watch on TV and passes comment on (e.g. "How come Christmas music always sucks?").

when the boss (admonishing Beavis for grilling a mouse instead of burger by mistake!) poses the rhetorical question, "What if *you* were the boss and had employees who were constantly screwing up?" Beavis immediately falls asleep on the job and dreams that he *is* the boss. He promptly gives himself the night off to go home and "spank the monkey" watching porn videos. However, his viewing of "Ebenezer Screw" is interrupted by Butt-head's emergence from the TV set as a Marley-esque spirit (Butt-head: "I'm some dead guy in chains...cool!"). He is followed at intervals by other "fartknocker" series regulars representing the Spirits of Christmas Past, Present and Future.

Frustrating Beavis considerably with their interruptions, the 'spirits' attempt to teach him a life-lesson for the festive season (Fat chance! Cos let's face it, if brains were dynamite, B & B wouldn't have enough to blow their ears off, would they?!). When the Ghost of Christmas Future tries to show Beavis what is likely to become of him unless he mends his ways, the doubting dimwit demurs and offers up his own alternative counter-version of the future with himself cast as a *Terminator* –style robot that blows away the burger shop's customers (not to mention the shop itself, and naturally, Butt-head's groin!).

Ultimately, confronted with a gravestone inscribed with the epitaph 'Here Lies Beavis. He Never Scored' (and eventually realising that it is in fact *his own* grave and not that of some loser who shares the same name), Beavis appears on the verge of actually *understanding* the meaning of his misadventure and committing to change. It is at this very instant though that our inarticulate anti-hero is woken by Butt-head from his Christmas Eve snooze in the burger bar and brought back to reality. As a result the lesson is lost, and an insouciant Beavis cheerfully reports instead: "Hey Butt-head, check it out...I just had this cool dream about the future, and uh you know what? The future is like um pretty cool – it's gonna be alright, cos I'm gonna be your boss and I'm gonna have a VCR and some porn." (...Well, 'you can lead a horse to water...' I guess!).

The skit on *It's A Wonderful Life* is equally as skewed and entertaining...even if our anti-heroes finally decide that Christmas is a real "Bum-hug."

Which brings us to 1997...and another animated feature. Ok, so this one isn't exactly scary either – but it does feature a monster, a witch, and a pretty well-portrayed evil enchanted pipe organ! The film in question is a Disney movie, and a sequel: it is *Beauty and the Beast: The Enchanted Christmas (1997)* (aka *Beauty and the Beast 2*), the direct-to-video sequel to Disney's smash hit animated feature from 1991, *Beauty and the Beast*.

A 72-minute American/Canadian-produced feature directed by Andrew Knight and written by Flip Kobler, Cindy Marcus, Bill Motz and Bob Roth, *Beauty and the Beast: The Enchanted Christmas* reunites much of the vocal talent of the original cast – Paige O'Hara as Belle (the Beauty), Robby Benson as Beast, Angela Lansbury as Mrs Potts, Jerry Orbach as Lumiere, David Ogden Stiers as Cogsworth – though there is a new Chip in the form of Haley Joel Osment instead of Bradley Michael Pierce, and Tim Curry (as villain Forte), Bernadette Peters (as the fairy Angelique) and Paul Reubens – Pee-wee Herman himself – (as Fife) are all new additions. As you would expect, overall the computer animation is quite bright, colourful

and cheery, but there are contrasting scenes that are dark and brooding – especially those featuring the Beast in a funk and the evil pipe organ (the Beast's ex-music tutor, enchanted just as the young Prince who was turned into a Beast is).

It opens with preparations being made for Christmas in Beast's castle on a snowy winter's night, with the servants now in human form – saved from their enchantment in the previous film by Belle. Mrs Potts recounts not only how the young Prince became cursed by a witch and turned into the Beast (and all his servants into dynamic implements) in the first place, but also how Belle managed to bring Christmas back to the castle and defeat an the evil pipe organ called Forte (formerly the Prince's old music teacher) who did not want the enchantment lifted because he enjoyed more power after being turned into an organ than as a music teacher before.

The Bolshi Beast banishes Christmas, but ballsy Belle sets out to fill the castle with festive cheer anyway, encountering dangers in a trip to the Black Forest to find a Christmas tree and facing the Beast's wrath along the way, until she finally manages to make Forte show his true colours so the Beast defeats him and with the help of a fairy decoration called Angelique, she finally manages to make the hairy, angry one who is not so hot at ice-skating appreciate the joys of the season resulting in a Merry Christmas for all. All of which is meant to fit in somewhere between the action of the original film, prior to Belle's falling for the Beast and releasing him from his curse with her love.

Despite some good sequences and a couple of half decent songs (even if they are not exactly Christmas crackers), this film, as you might expect, is not as good as the original and does suffer a little from sequelitis. And if the 'hap-happiest time of the year' holiday bonhomie is all a bit rich for your blood and sets you rather gagging, well never mind because 1997's other offering would be sure to put that right. For while **Beauty and the Beast: the Enchanted Christmas** was, while not exactly a beauty, still something less than a beast, **Turbulence (1997)** was a *Grand Guignol* rollercoaster ride of psychotic anti-Santy glee! If most of the filmmakers had been decidedly naughty in 1996, turning out crassly exploitative trash, those responsible for **Turbulence** in 1997 went a long way to redressing the balance.

Directed by Robert Butler (a jobbing rather than previously inspired TV director) and scripted by Jonathan Brett (hardly prolific or a name on everybody's tongue, despite an earlier Oscar nomination[252]) **Turbulence** boasted a couple of experienced producers in Martin Ransohoff[253] and David Valdes[254] and a top-notch cast on very fine form. The two main leads

252 For Best Short Film, Live Action for *The Dutch Master (1994)* which he wrote and produced

253 Ransohoff had previously produced (though not always single-handedly) films like *The Cincinnati Kid (1965)*, *10 Rillington Place (1971)*, *The Wanderers (1979)* and *Jagged Edge (1985)* among many others.

254 Valdes had previously produced (though not always single-handedly) several Clint Eastwood movies, like *Pale Rider (1985)* (Associate Producer), *Bird (1988)* (Executive Producer), *The Dead Pool (1988)*, *Pink Cadillac (1989)*, *White Hunter, Black Heart (1990)* (Executive Producer), *The Rookie (1990)*, *Unforgiven (1992)* (Executive Producer), *In the Line of Fire (1993)* (Executive Producer), *A Perfect World (1993)* and would go on to be a Producer for films like *The Green Mile (1999)* and the new version of *The Time Machine (2002)*

are Ray Liotta, playing Ryan Weaver (an escaped and recaptured convicted serial killer of young women – "The Lonely Hearts Strangler" – who is being transported across country with another prisoner on a commercial flight on Christmas Eve that is light on passengers because of the holidays by several Marshalls) and Lauren Holly, playing Teri Halloran (a plucky, pretty, intelligent and resourceful blonde flight attendant who must get the better of the, at first, charming, urbane nutter when all Hell breaks loose in mid air on the flight and he shows his true colours). They are supported by Brendon Gleason as the other prisoner (a crass bank robber), Hector Elizondo as the cop who originally arrested Weaver (and planted evidence to ensure a conviction), Catherine Hicks (the mum from *Child's Play (1988)*) as another flight attendant called Maggie, and Ben Cross, Jeffrey De Munn and Rachel Ticotin, among others.

This movie may not be to everyone's taste – a festive Action-Thriller-Cat-and-Mouse-Horror with comic moments, it is out and out entertainment, rather than gritty or realistic. As the Boeing 747 transporting the apparently charming and handsome sociopathic/psychotic serial-killer flies from New York to Los Angeles, decorated with tinsel and pretty, coloured fairy lights for the season, it is heading into a huge storm – in more ways than one. Nihilistic Weaver slaughters the Marshalls and several of the crew, locking the remaining passengers and crew up ad intending to crash the plane into downtown LA to go out in "a blaze of glory" rather than go to the electric chair. And the raging storm, with its thunder and lightning and buffeting winds, which tosses and flips the pilotless aircraft, causing its lights to flicker and flash, seems to be an externalisation of Weaver's chaotic, nihilistic, raging mind.

Teri, who is at first attracted to the handsome, urbane wacko (having just been dumped on Christmas Eve by her fiancé) comes to realise his true nature as he gleefully slaughters his way through the Marshalls, crew and passengers, laughing to himself like The Joker from the Batman films and TV series and singing snatches of Christmas songs and songs associated with Christmas (like 'Buffalo Girls' from Frank Capra's *It's A Wonderful Life (1946)*, which is the in flight film).

Liotta's is a fine, larger than life, bravura performance (right up there with Jack Nicholson's portrayal of Jack Torrance in *The Shining (1980)*[255] and Robert Shaw's turn as the obsessive Quint in *Jaws (1975)*); but Lauren Holly is every bit his match as his pretty, plucky nemesis who has not only to fight him off, but convince the tailing fighter pilot not to shoot the aircraft down (to avoid it ploughing into a populated area) and land the plane (talked down by another pilot – played by Ben Cross) too. (When she sets the auto-pilot to land herself without guidance from the pilot talking her down – having had to abandon a couple of attempts already as Weaver's meddling has almost crashed it into a hotel and a multi-storey car park on the edge of LAX – one male cop in the crisis control centre unbelieving declares, "She's only a stewardess for Christsakes!" To which, the proud female member of the crisis management team corrects pointedly and tellingly "She's a *flight attendant!*" Super, funny stuff!).

Yes it is far-fetched beyond belief...but the beauty of this film and its *real* achievement is, you just don't care! It is just so much fun that you happily suspend your disbelief and go

255 Aka *Stanley Kubrick's The Shining*

along for the (rather bumpy!) ride. It is a *Grand Guignol* rollercoaster of, sometimes quite gory, excess. And God bless it for that! It has very high production values; does what it does knowingly and incredibly well, never taking itself too seriously, and it represents 100-minutes of enormous entertainment value. In that, it is a far cry from the next film we will consider! – the following year's *Feeders 2: Slay Bells (1998)*...

Feeders 2: Slay Bells (1998) is a direct to video Independently made sequel to *Feeders (1996)*, a low-budget 68-minute Indie about two friends on a road trip who stumble upon a town where aliens have landing and are feeding on the locals. But early Peter Jackson[256] it most certainly isn't! In fact, it is much more like Edward D. Wood![257] ...And quite how this dismal dross was thought to deserve or warrant a sequel, the Lord only knows. However, as is usually the case, the sequel failed to live up to the standards of the original – believe it or not! – and the 80-minute *Feeders 2: Slay Bells* isn't just a dog, it's a *hound*! Never mind 'chestnuts roasting on an open fire,' the peddlers of this particular claptrap should have *their* nuts roasting on an open fire!

Yes, those pathetically realised[258] little alien gourmands are back again – only this time they invade Earth at Christmastime, so naturally it is up to Santa and his elves to save the planet! *Feeders 2: Slay Bells* was written by Mark Polonia, who also directed along with John Polonia; it stars Bob Dennis, John McBride, Patricia McBride, Courtney Polonia, John Polonia and Mark Polonia (so nepotism isn't dead) – just so you know who to blame!

And *Feeders 2: Slay Bells* wasn't the only turkey that put in an appearance at Christmastime in 1998...For a start there was the misfire that was *Jack Frost* (aka *Frost* – and yes, this time I *do* mean the Michael Keaton plays the musician dad who dies in a car crash at Christmastime but comes back as a snowman to spend some quality time with his kid film!). This film isn't a Horror – it's just pretty horrific! However, I figured it at least deserved a mention among our august (or should that be December?!) and not-so-august Weihenacht wonders. It's not that this particular snowman is abominable as such – after all the gorgeous Kelly Preston and the chubby, likeable Mark Addy, like Michael Keaton, are usually well worth a watch – but this is just far too twee: this snowman has no snowballs! Still, it is much better than the absolute abomination that was *Jack Frost 2: Revenge of the Mutant Killer Snowman* that would be released a couple of years later; not a sequel to *this big-budget Hollywood Jack Frost*, but to

256 The New Zealander *Lord of the Rings* trilogy and *King Kong (2005)* remake (aka *Peter Jackson's King Kong*) director made a gross-out Sci-Fi/Comedy 'Splatter-Movie' in 1987 called *Bad Taste* with similar storyline elements

257 Edward D. Wood Jr. is often cited as one of the worst writer-directors of all time, and his magnum opus *Plan 9 from Outer Space (1959)* starring (a few minutes of home movie footage of the already- deceased Hollywood Horror Movie legend; the original screen *Dracula* from Universal's film of 1931) Bela Lugosi, Tor Johnson, Vampira and Criswell is often cited as the worst film of all time. Idiosyncratic auteur Tim Burton made a wonderful B&W film about him in 1994 called *Ed Wood* starring Johnny Depp as the eponymous auteur. Marin Landau won an Oscar as Best Supporting Actor for his portrayal of the tragic Lugosi.

258 At one point, one character actually mistakes the extra-terrestrial menace with the Mario Lanza appetite for a Christmas toy!

the cheap and tacky Indie Christmas Horror released in 1996! But more of that in the next chapter...

I would just like to mention in passing another nightmare movie from 1998 in passing... the 95-minute feature **The Christmas Path**. This festive feature isn't a Horror Movie at all, and probably has no place in this book really. It is a fantasy about how a disillusioned teenager rediscovers the Christmas Spirit and helps to save the magical path of the title that enables Santa to visit Earth once a year and deliver his presents to all the good little girls and boys. But the reason I want to mention it is this... In this film, Santa no longer lives at the North Pole, but lives in outer space or in another dimension and is reliant upon a magical path maintained by faith to get to Earth. We see him as an almost **Zardoz**-like[259] floating-head diet at one point. So never mind psycho killers dressed in Santa Claus costumes...by the close of the 19990s Santa is conflated with God! (Where were the protestors?).

And this is no accident, for Santa has his own angels too(!)...and when the anti-social be-haviour of the teenage boy threatens to finally destroy the faith-fuelled Christmas path, Santa has to send an angel down to Earth to help the kid back onto the straight and narrow. Ok, so I am going to ignore the fact that despite wars, pestilence, famine, floods, murder, rape, the holocaust etc, it is the criminal actions of one teenage boy (he smashes a civic Christmas tree with a baseball bat, frustrated that he has no father and his family is poor when that appears to be the greatest sin in a modern, consumerist Western society) that threatens the existence of the path.

But what is more, the 'angel' that Santa chooses to send down to Earth is a fallen angel, cast out by Santa to a burning hot desert planet. He used to be Santa's favourite, but he tried to take over so Santa banished him. Doesn't this sound familiar? ...If Santa is a God stand-in, then this ex-favourite fallen angel must be Lucifer! – That's the 'angel' Santa-God sends to Earth to renew a teenager's faith and save the all-important cosmic path?! Jeez, this is one crazy, mixed-up movie!

If you are interested, it actually has a couple of half decent stars in Dee Wallace Stone (who played the mum in Steven Spielberg's **ET: The Extra-Terrestrial (1982)**) and Vincent Spano (who featured in the excellent **Good Morning Babylon (1987)** about the making of D.W. Griffith's epic silent masterpiece **Intolerance (1916)**) and Shia LaBeouf (who has recently starred in **Transformers (2007)** and **Indiana Jones and the Kingdom of the Crystal Skull (2008)**)...but even they cannot save this horrible mess. And to add a further layer of religio-mythical confusion, Vincent Spano, who plays Santa's ex-favourite fallen angel sent to Earth

259 **Zardoz** is a John Boorman Sci-Fi film from 1974 starring Sean Connery, Charlotte Rampling and John Alderton (!), which is set in the distant future when the human race has split into two distinct elements – pampered intellectuals with machinery and almost mystical powers called the Immortals and bestial savages called the Brutals. The former rule over the latter utilising a huge floating stone head icon, which the Brutals worship as a deity...until one of them learns otherwise and puts the cat among the proverbial pigeons. The film's title is taken from mixing parts of words from the title of a book one of the Immortals comes across in an old library; *The WiZard of Oz*.

to sort out Shia LaBeouf's troubled teen, actually looks like he would make a pretty good Jesus cast in a **King of Kings** style Bible Soap!

And so to the last film of this chapter; a chapter dedicated to a decade in which Christmas Horrors were pretty much an accepted alterative anti-Santy festive offering on the big screen and the small...whether through big budget movies produced by 'the majors' or low-budget Indie cinema releases – and be they from Hollywood, Britain or other international filmmaking centres; English language or foreign language offerings; straight to video releases; even small-screen made-for-TV productions. The final film of the 1990s I want to include is an American TV production: **The Christmas Angel: A Story on Ice**, which like **The Christmas Path**, was also produced in 1998. And, yes, once again an angel features – only this time it is the 'angel' or 'fairy' that sits atop the Christmas tree.

This little ice-capade centres on a story or fable told to a group of children by two adults (played by ex Eurovision Song Contest entrant for the UK, country singer, chart-topping pop star and movie actress co-star of **Grease (1979)** alongside John Travolta, Olivia Newton-John and the film's producer Chip Davis – who also wrote the "18ᵗʰ century classical rock" score with his band Mannheim Steamroller[260]). As the story is told to the children in front of an open log fire in a lounge decorated for Christmas with a Christmas tree in the corner, we segue into the action presented on ice by an impressive cast of skaters - including Olympic champion (1976) Dorothy Hamill, three times Men's Figure Skating World Champion and twice Olympic silver medallist (1994 and 1998) Elvis Stojko, 1996 US National Figure Skating Champion and 1996 Men's Figure Skating World Championship Bronze medallist) Rudy Galindo and US National Figure Skating Silver medallist in 1995 Tonia Kwiatkowski.

The story is so much hokum – an evil, dark clad, ugly masked monster called the Gargon steals a village's Christmas angel from the top of its Christmas tree thus threatening their festive celebrations. A young woman – accompanied by several toys that have come to life from under the tree – set off to the Gargon's demesne to rescue the angel and save the holidays. In the Gargon's icy kingdom inhabited by his slavish minions, the woman finally discovers that the monstrous Gargon is in fact a fallen angel himself and his ugly entourage disciples he has corrupted. Needless to say, all are saved by the end and the angel is returned to the village's Christmas tree and all have a holly-jolly 'hap-happiest time of the year'. ...But the film does feature a monster after all; and skating, costumes, sets, lighting are all pretty spectacular (and even the special effects in a stagy kind of way).[261]

And the final film, fittingly released in 1999 – the final year of the decade, the century and indeed the millennium, is a Hollywood millenarian blockbuster...one of several to hit the big screens as the 21ˢᵗ century approached and the millennium bug threatened to bring about the downfall of the world's computers and thereby the fall of mankind...which apocalyptic firework display turned out to be something of a damp squib, much overshadowed by the

260 An 18ᵗʰ century musical term for a crescendo

261 There are some strobe lighting effects though when the Gargon appears – something to be wary of for viewers who suffer from photosensitive epilepsy!

actual firework displays with which cities around the world ushered in the new year, decade, century and millennium!).

Directed by Peter (***Capricorn One (1977)***, ***Outland (1981)***, ***2010 (1984)***, ***Time Cop (1994)***, ***The Relic (1997)***) Hyams, the not-quite-as-fittingly-as-it-was-feared-it-might-have-been entitled ***End Of Days (1999)*** featured muscle-bound ex-cop Jericho Cane (Arnold Schwarzenegger) running around New York city trying to stop a blithely suave and urbane Satan (Gabriel Byrne) from securing himself a bride (Robin Tunney) and thereby bringing about Armageddon.

The action is set in the period between Christmas and New Year, with the end of the world set to occur at the stroke of midnight on New Year's Eve, allowing a whole host of clichés to be trotted out as the Satanic renaissance reflects and mirrors the birth of Christ (celebrated at Christmas with all the decorations and paraphernalia still in plain view).

The time at which it is set and the parallels with the birth of Christ are about all the film has to do with Christmas, and although this bastard offspring of an unholy-union of ***Rosemary's Baby*** and any one of a number of brainless Arnie actioners could have been so much better than it ended up being – Arnie gives a typical Arnie performance, Gabriel Byrne is pretty good and the likes of Udo Kier, Rod Steiger, Kevin Pollack, CCH Pounder and Miriam Margolyes offer sound enough support – it is still watchable enough in a mediocre manner to kill a couple of hours.

And so, like the damp squib of the much anticipated, media-hyped 'millennium bug', that brings us to the 21st Century and the new millennium! The 1990s consolidated the concept of the Christmas Horror and there would be no going back. Unfortunately, the fact that the sub-genre undeniably existed and continued to prove attractive to filmmakers and many viewers alike, was no guarantee of quality product. While there were some undoubtedly excellent festive frighteners and nutty noel confections produced, all too often it seemed filmmakers were being 'naughty' instead of 'nice.' Exploitative chancers foisting off festering festive turkeys on anti-Santy cine seekers at the drop of a hat (or a misleading advertising tagline or DVD/video box). But I guess that's the way the cookie crumbles – especially when left out for the jolly, fat gift deliverer with the bushy white beard, black boots and red suit trimmed with white fur, I guess. And believe me, the trend would continue into the twenty-first century too...

THE FILMS

Cruel Yules of the Nasty 90s

Aliens First Christmas 1991 Canada 23mins (Animation)
Directed/Written: Russ Harris & Jerry Reynolds **Produced**: Russ Harris & Jerry Reynolds & Michael N. Ruggiero **Music**: Jerry Reynolds **Cast**: Jerry Reynolds (Roger Peoples), Brett Sears (Fran Peoples), Rachel Rutledge (Mavo Zox), Will Gould (Charlick Zox)

Aka Twas the Night Before Christmas on Zalonia

Batman Returns 1992 USA/UK 126mins
Directed: Tim Burton **Written**: Daniel Waters (from a story by him and Sam Hamm, based on characters created by Bob Kane) **Produced**: Tim Burton & Denise Di Novi **Music**: Danny Elfman **Cinematography**: Stefan Czapsky **Edited**: Bob Badami & Chris Lebenzon **Design**: Bo Welch **Art Direction**: Tom Duffield & Rick Henrichs **Set Decoration**: Cheryl Carasik **Costumes**: Bob Ringwood & Mary Vogt **Cast**: Michael Keaton (Batman/ Bruce Wayne), Danny DeVito (Penguin/Oswald Cobblepot), Michelle Pfeiffer (Catwoman/ Selina Kyle), Christopher Walken (Max Shreck), Michael Gough (Alfred Pennyworth), Pat Hingle (Commissioner James Gordon), Paul Reubens (Penguin's Father), Vincent Schiavelli (Organ Grinder)

Aka Batman 2 (Working title)

Beauty and the Beast: The Enchanted Christmas 1997 USA 72mins (Animation)
Directed: Andy Knight **Written**: Flip Cobler & Cindy Marcus & Bill Motts & Bob Roth **Line Produced**: Susan Capigian **Music**: Rachel Portman **Edited**: Daniel Lee **Cast**: Paige O'Hara (Belle), Robby Benson (The Beast), Tim Curry (Forte), Angela Lansbury (Mrs. Potts), Jerry Orbach (Lumiere), David Ogden Stiers (Cogsworth), Bernadette Peters (Angelique), Haley Joel Osment (Chip), Paul Reubens (Fife), Kath Soucie (Enchantress)

Aka Beauty and the Beast 2 (US promotional title)

Beavis and Butt-head Do Christmas 1996 USA TV 60mins (Animation & Live Action)

Directed: Mike Judge **Written**: Kristofor Brown & David Felton & David Giffels & Mike Judge & Joe Stillman **Produced**: John Andrews & Mike Judge **Co-Produced**: Kristofor Brown & Susie Lewis Lynn & Nick Litwinko & John Lynn **Edited** (Neil Lawrence) **Cast**: Mike Judge (Beavis/Butt-head/Tom Andeson/David Van Driessen/Mr. Stevenson/Burger World Manager/ Principal McVicker/Bradley Buzzcut/Maxi-Mart Owner), Tracy Grandstaff (Daria Morgendorffer/Mrs. Stevenson/Cassandra), Adam Welsh (Stewart Stevenson), Kristofor Brown (Additional Voices)

Aka Beavis and Butt-head Christmas Special

Bernard and the Genie 1991 UK TV 70mins

Directed: Paul Weiland **Written**: Richard Curtis **Produced**: Jacinta Peel **Music**: Howard Goodall **Cast**: Lenny Henry (Josephus), Alan Cumming (Bernard Bottle), Rowan Atkinson (Charles Pinkworth), Sally Geoghegan (Waitress), Melvyn Bragg (Himself), Bob Geldof (Himself), Gary Lineker (Himself), Trevor McDonald (Newscaster)

Campfire Tales 1991 USA 88mins

Directed/Written: William Cooke & Paul Talbot **Produced**: Paul Talbot **Edited**: William Cooke & Paul Talbot & Roger Thomas **Music**: Kevin Green & Stan Lollis **Cast**: Gunnar Hansen (Ralph), Michael R. Smith (Satan Claus), Walter Kaufman (Joe), Barbara Jackson (Mother), Lori Tate (Cheryl), Josh Craig (Chucky), Sara Craig (Susi)

The Christmas Angel: A Story on Ice 1998 USA

Directed: Andy Picheta **Written**: Mark Valenti **Executive Produced/Music**: Chip Davis **Cast**: Olivia Newton-John (Female Storyteller), Chip Davis (Male Storyteller), Dorothy Hamill (Mom), Elvis Stojko (Gargon), Rudy Galindo (Gargon Sidekick), Tonia Kwiatkowski (The Christmas Angel), Liz Punsalan (Cat), Jerod Swallow (Male Doll), Calla Urbanski (Cat), Tiffany Chin (Marionette), Rocky Maerval (Woodcutter), Ryan Hunka (Snowman), Lisa Cricks (Teddy Bear)

La Cité des enfants perdus France/Germany/Spain 112mins

Directed: Marc Caro & Jean-Pierre Jeunet **Written**: Gilles Adrien & Marc Caro & Jean-Pierre Jeunet **Produced**: Félicie Dutertre & Maria Victoria Hebrero & José Luis Lopez & Arlette Mas & Svetlana Novak & Charlie Ossard & François Rabes **Co-Produced**: Elías Querejete **Music**: Angelo Badalamenti **Cinematography**: Darius Khondji **Edited**: Herve Schneid **Design**: Marc Caro & Jean Rabasse **Art Direction**: Jean Rabasse **Costumes**: Jean-

Paul Gaultier **Cast**: Ron Perlman (One), Daniel Emilfork (Krank), Judith Vitette (Miette), Dominique Pinon (Clones),

Aka The City of Lost Children (English language international title) and La ciudad de los niños perdidos (Spanish title) and La Ciutat dels nens perduts (Spanish Catalan title) and Die Stadt der verlorenen Kinder (German title)

El Día de la bestia 1995 Spain 103mins
Directed: Álex de la Iglesia **Written**: Jorge Guerrìcaechevarría & Álex de la Iglesia **Produced**: Claudio Gaeta & Andrés Vincente Gómez & Antonio Saura **Music**: Battista Lena **Cinematography**: Flavio Matínez Labiano **Edited**: Teresa Font **Design**: Jóse Luis Arrizabalagna & Biaffra **Costume**: Estíbalíz Markiegi **Cast**: Álex Angulo (Cura), Santiago Segura (José Maria), Armando De Razza (Cavan), Maria Grazia Cucinotta (Susana)

Aka The Day of the Beast (English language international title)

Edward Scissorhands 1990 USA 105mins
Directed: Tim Burton **Written**: Caroline Thompson (from a story by Tim Burton and Caroline Thompson) **Produced**: Tim Burton and Denise Di Novi **Music**: Danny Elfman **Design**: Bo Welch **Cinematography**: Stefan Czapsky **Art Direction**: Tom Duffield **Cast**: Johnny Depp (Edward Scissorhands), Winona Ryder (Kim), Dianne Wiest (Peg), Anthony Michael Hall (Jim), Kathy Baker (Joyce), Alan Arkin (Bill), Vincent Price (The Inventor)

Elves 1990 USA 89mins
Directed/Written: Jeffrey Mandel **Produced**: Mark Paglia **Associate Produced**: Dan Haggerty **Music**: Vladimir Horunzhy **Cast**: Dan Haggerty (Mike McGavin), Julie Austin (Kirsten), Borah Silver (Kirsten's Grandfather), Deanna Lund (Kirsten's Mother), Mansell Rivers-Bland (Rubinskraur), Allen Lee (Dr. Fitzgerald)

End Of Days 1999 USA 121mins
Directed/Cinematography: Peter Hyams **Written**: Andrew W. Marlowe **Cast**: Arnold Schwarzenegger (Jericho Cane), **Gabriel Byrne** (The Man/Satan), **Robin Tunney** (Christine York), **Kevin Pollack** (Bobby Chicago), **CCH Pounder** (Detective Margie Francis), **Miriam Margolyes** (Mabel), **Udo Kier** (Head Priest), **Rod Steiger** (Father Kovak)

Feeders 2: Slay Bells 1998 USA 80mins
Directed: John Polonia & Mark Polonia **Written**: Mark Polonia **Cast**: John McBride (Derek), Bob Dennis, Patricia McBride, Courtney Polonia, John Polonia, Mark Polonia

Grave Secrets: The Legacy of Hilltop Drive USA 97min
Directed: John Patterson **Written**: Gregory Goodell (based on the book by Ben Williams, & Jean Williams & John Bruce Shoemaker) **Supervising Producer**: Gregory Goodell **Music**: Patrick Williams **Cinematography**: Shelly Johnson **Design**: Roy Alan Amaral **Cast**: Patty Duke (Jean Williams), David Selby (Shag Williams), David Soul (Sam Haney)

Aka Grave Secrets and Haunting on Hilltop Drive (Working title)

Jack Frost 1996 USA 89mins
Directed/Written: Michael Cooney (from a story by Jeremy Paige) **Produced**: Jeremy Paige & Vicki Slotnick **Music**: Chris Anderson & Carl Schurtz **Design**: Deborah Raymond & Dorian Vernacchio **Costumes**: Marina Buckwald **Cast**: Scott McDonald (Jack Frost), Christopher Allport (Sam), Stephen Mendel (Agent Manners)

Jack Frost 1998 USA 101mins
Directed: Troy Miller **Written**: Mark Steven Johnson & Steve Bloom & Jonathan Roberts & Jeff Cesario **Produced**: Irving Azoff & Mark Canton **Music**: Trevor Rabin **Cinematography**: Laszlo Kovaks **Edited**: Lawrence Jordan **Design**: Mayne Berk **Art Direction**: Gary Diamond **Costumes**: Sarah Edwards **Cast**: Michael Keaton (Jack Frost), Kelly Preston (Gabby Frost), Joseph Cross (Charlie Frost), Mark Addy (Mac MacArthur), Joe Rokicki (Mitch), Ahmet Zappa (Snowplow Driver), Henry Rawlins (Sid Gronic), Dweezil Zappa (John Kaplan), Moon Unit Zappa (School Teacher – uncredited)

Aka Frost

The Junky's Christmas 1993 USA 21mins (Live Action & Animation)
Directed: Nick Donkin & Melodie McDaniel **Written**: James Grauerholz (from William S. Burrough's story) **Produced**: Francis Ford Coppola & Francine McDougall **Music**: Hal Willner **Cinematography**: Simon Higgins & Wyatt Troll **Edited**: Clark Eddy & Joel Pront **Design**: Andrew Horne **Costumes**: Marea Fowler **Cast**: William S. Burroughs (Narrator), James Grauerholz (Dinner Guest)

The Nightmare Before Christmas 1993 USA 76mins (Animation)
Directed: Henry Selick **Written**: Caroline Thompson (from a story by Tim Burton adapted by Michael McDowell) **Produced**: Tim Burton & Denise Di Novi **Co-produced**: Kathleen Gavin **Associate Produced**: Danny Elfman & Jill Jacobs & Diane Minter & Philip Lofaro & Don Hahn (Disney 3-D version released 2006) **Music**: Danny Elfman **Cinematography**: Pete Kozachik **Edited**: Stan Webb **Cast**: Chris Sarandon (Jack Skellington – speaking voice), Danny Elfman (Jack Skellington – singing voice/Barrel/Clown with the tear away face), Catherine O'Hara (Sally/Shock), William Hickey (Dr. Finkelstein), Glen Shadix (Mayor), Paul Reubens (Lock), Ken Page (Oogie Boogie), Greg Proops (Harlequin Demon/Devil Sax Player

Aka Tim Burton's The Nightmare Before Christmas and Tim Burton's The Nightmare Before Christmas in Disney Digital 3-D
(Promotional title for 3-D version released in 2006)

Novogodniye Istorii 1996 Russia
Directed/Written: Alexander Rogozhkin **Produced**: Sergei Livnev & Bakhyt Kilbaev **Music**: Vladislav Panchenko **Cinematography**: Andrei Zhegalov **Cast**: Alexei Buldakov (General Ivolgin), Anna Yanovskaya, Sergei Makovetsky, Leonid Yarmulnik, Semen Strugachev, Sergei Russkin

Aka Novogodnaiai istoria (alternative spelling) and New Year Story
(English language international title)

Reindeer Games 1996 USA 113mins
Directed: Shayne Worcester **Written/Produced/Casting**: Efram Potelle & Kyle Rankin & Shayne Worcester **Music/Edited/Makeup/Assistant Director/Sound Recordist**: Efram Potelle **Cinematograpy**: Laela Kilbourn **Cast**: Kyle Rankin (Alec Clark), Mary Skinner (Kate Regan), Efram Potelle (Religious Son)
Aka The Girl in the Basement

Santa Claws 1996 USA 83mins
Directed/Written: James A. Russo **Produced**: James A. Russo & Jack Smith **Music**: Paul McCollough **Cinematography**: S. William Hinzman **Cast**: Debbie Rochon* (Raven Quinn), Grant Kramer* [Cramer] (Wayne), John Mowod (Eric Quinn), Dawn Michelucci* (Angela Quinn), Marilyn Eastman* (Mrs. Quinn), Julie Wallace Deklavon* (Peggy Quinn), Christine Cavalier [Amanda Madison] (Laura Britton), Lisa Delien (Mary Jane Austin), Sue Ellen White (Debbie Darwin), Karl Hardman* (Bruce Brunswick), S. William Hinzman* (Director), Diana Michelucci* (Production Assistant), John A. Russo* (Detective)

Aka 'Tis the Season

* Denotes cast members who featured in George A. Romero's seminal zombie flick ***Night of the Living Dead (1968)***

Satan Claus 1996 USA 61mins

Directed/Produced: Massimiliano Cerchi **Written**: Simonetta Mostarda **Cast**: Robert Cummins (Santa Claus), Josie Rafty (Sandra), Robert Hector (Steve Sanders), Barrie Snyder (Capt. George Ardison), Daisy Vel (Lisa Reid), Roy Ashton (Ken Morse), Lauretta Ali (Maman), Nicholas Van Eeden (Jeff Molansky), John Romanetti (Sgt. Miller), Crystal Harold (Sharon)

Scream Queens' Naked Christmas 1996 USA 60mins

Directed/Written: James A. Russo **Produced**: James A. Russo **Cinematography**: S. William Hinzman **Cast**: Debbie Rochon* (Raven Quinn), Grant Kramer [Cramer]* (Wayne/Himself), Christine Cavalier [Amanda Madison] (Laura Britton), Lisa Delien (Mary Jane Austin), Sue Ellen White (Debbie Darwin)

Aka Naked Christmas

Turbulence 1997 USA 100mins

Directed: Robert Butler **Written**: Jonathan Brett **Produced**: Martin Ransohoff & David Valdes **Music**: Shirley Walker **Cinematography**: Lloyd Ahern II **Edited**: John Duffy **Design**: Mayling Chen **Art Direction**: Donald B. Woodruff **Costume**: Robert Turturice **Cast**: Ray Liotta (Ryan Weaver), Lauren Holly (Teri Halloran), Brendon Gleason (Stubbs), Hector Elizondo (Lt. Aldo Hines), Catherine Hicks (Maggie), Rachel Ticotin (Rachel Taper), Ben Cross (Capt. Samuel Bowen)

CHAPTER 9

The Wizard On-screen Wonders of Harry Potter

Ok, ok...I know the Harry Potter films are hardly Horrors – and they are not Christmas films either...But each one features a whole array of witches, wizards, magic, ghosties, ghoulies, beasties, monsters and critters; and each seems to get darker and more horrific than the last; and every single one of them so far has featured a Christmassy scene or sequence, or a snowy scene set around Christmastime and the lightning-scarred, round-spectacled one's festive holidays from Hogwarts Academy. So I thought that I would include a very brief chapter surveying the Christmassy scenes anyway – to break things up a little... as they so nicely usher in and transverse the millennial noughties, with their mega-budget, cutting-edge high-tech special effects; a veritable new mythology for the post-modern age, which cannibalises older, darker beliefs and traditions to rise again reborn like the phoenix from their remains. (Much as the modern, more secular Christmas has from its pre-Christian Pagan traditions; and much as the Christmas ghost story has in the form of the Christmas Horror film!).

I have no intention of describing who or what Harry Potter is or to go into great detail about the plots of each film. If you don't know these things already, you must have been living on Mars or somewhere for the past decade or so, as every book and each of the films based on them, has been read and seen by every man and his dog on the planet it seems, and have provided the redoubtable Miss J.K. Rowling, the franchise's author, with a means of practically printing money (and all power to her!). So this chapter will be quite brief.

The first time the half-Muggle[262] Quidditch[263] wiz with a destiny hit the silver screen was in 2001 in ***Harry Potter and the philosopher's Stone***[264], adapted for the screen by Steve Kloves (who has written the screenplays for all of the films except ***Harry Potter and the***

262Half human - Muggle being a wizard name form mere mortals

263 A sport from the books and films at which the eponymous hero excels

264 Aka ***Harry Potter and the Sorceror's Stone*** (in the USA) and ***Harry Potter*** (it's US working title)

Order of the Phoenix (2007) and who is back on board for ***Harry Potter and the Half-Blood Prince (2009)*** and ***Harry Potter and the Deathly Hallows: Part I*** currently slated for 2010 and ***Harry Potter and the Deathly Hallows: Part 2*** currently slated for 2011) and directed by Chris Columbus, who also directed the second Potter movie, ***Harry Potter and the Chamber of Secrets (2002)***.

Harry Potter and the Philosopher's Stone (2001) was a worldwide smash and set the stylistic bar high. Young newcomers[265] Daniel Radcliffe, Rupert Grint and Emma Watson played Harry Potter, Ron Weasley and Hermione Granger respectively (the launch to an astronomical career as mini megastars) amid a whole galaxy of British stars: among them Richard Harris (as Professor Albus Dumbledore), Maggie Smith (as Professor Minerva McGonagall), Robbie Coltrane (as Giant, Rubeus Hagrid), Julie Walters (as Ron's mum, Molly Weasley), Alan Rickman (as Professor Severus Snape), Fiona Shaw (as Aunt Petunia Dursley), Richard Griffiths (as Uncle Vernon Dursley), Ian Hart (as Professor Quirinus Quirrell/Voldemort), John Hurt (as Mr. Ollivander), Warwick Davis (as Professor Flitwick/Goblin Bank Teller), Geraldine Somerville (as Harry's mum, Lily Potter), John Cleese (as the Ghost Nearly Headless Nick), Zoë Wanamaker (as Madame Hooch) and the voice of Leslie Philips (as the Sorting Hat), with the odd non-Brit like Verne[266] Troyer, the American actor who played Mini-Me in the ***Austin Powers*** movies, thrown in (here playing Griphook the Goblin). This depth of star casting was a trend that would continue.

In ***Harry Potter and the Philosopher's Stone***, just after the big Quidditch match, we see Hogwarts Academy cloaked snow as Christmas approaches and witness the giant Hagrid dragging a huge Christmas tree towards the historic building for use in the Great Dining Hall. Inside the hall, we see one of the dwarf masters decorating the tree by floating baubles up to hang in its branches with his magic wand as Harry and Ron indulge in a game of wizard's chess at one of the long dining tables. Hermione comes to say goodbye to them as she is leaving Hogwarts along with most of the students to go home for the Christmas holidays. But Harry and Ron remain to spend their Christmas at the academy. On Christmas morning, Ron receives a woolly jumper knitted by his mum with a big 'R' on it as his Christmas present, while Harry receives from an anonymous benefactor a parcel containing a cloak of invisibility left in someone's care to pass on to him by his father whom he thought was killed with his mother in a car crash, but whom he learns was actually slain along with his mother by an evil wizard called Voldemort. The cloak of invisibility comes in very handy as Harry investigates the mystery he and his new friends have stumbled up at Hogwarts.

With J.K. Rowling's novels a worldwide phenomenon and the first Harry Potter film a box-office smash (as if there was ever any doubt!), a sequel very quickly followed. ***Harry Potter and the Chamber of Secrets (2002)***, written and directed by the same team as the first movie and featuring many of the same cast, plus new additions like Mark Williams (as Ron's dad Arthur Weasley), Kenneth Branagh (as Professor Gilderoy Lockhart), Miriam Margolyes (as Professor

265 Though Radcliffe had played a young David Copperfield in a TV adaptation of Dickens' novel in 1999 and appeared in the movie *The Tailor of Panama* released earlier in 2001.

266 Although in the credits his first name is spelt Vern.

Pomona Sprout), Gemma Jones (as Madam Pomfrey), Alfred Burke (as Professor Armando Dippet), Robert Hardy (as Cornelius Fudge), Julian Glover (as the voice of Aragog) and Shirley Henderson (as Moaning Myrtle). Unfortunately for the ex-leader of band Tenpole Tudor and post-Richard O'Brien[267] host of TV game show **The Crystal Maze**, Edward 'Ed' Tudor-Pole (who featured in films like *The Great Rock 'n' Roll Swindle (1980)*, *Absolute Beginners (1986)* and *Sid and Nancy (1986)*), the scenes he featured in as Mr. Borgin were cut.

In *Harry Potter and the Chamber of Secrets* we once again see a glorious long shot from a high angle of Hogwarts Academy sheathed in snow, with sleighs, each drawn by a single white horse, taking the students away to the railway station to catch trains back home for the holidays. The Great Dining Hall of Hogwarts is lit by flaming torches positioned along its sides, interspersed with decorated and fairylit Christmas trees, while a huge lit and decorated Christmas tree dominates the far end. High above the heads of Harry, Ron and Hermione (who sit plotting their next move in their current adventure at one of the long dining tables), magical dark snow clouds send snowflakes tumbling toward the ground indoors...but these vanish before reaching even head height, part of the academy's magical, mood-setting festive decorations.

In the third cinematic instalment in the series, *Harry Potter and the Prisoner of Azkaban (2004)*, again written by Steve Kloves, but this time directed by Mexican director Alfonso Cuarón,[268] there is less of a direct visual reference to Christmas. We still see glorious shots of a snow-covered Hogwarts, with Harry's white messenger owl flying through the snow to find Harry in the academy's clock tower. In one of the courtyards, Ron's twin brothers wearing bobble hats have built a snowman and they provide Harry with a magical map that traces the whereabouts and movements of everyone in Hogwarts.

Later we see Ron and Hermione at the edge of a wood in the snowy-blanketed countryside outside Hogwarts. Young Malfoy (a sly student from Slytherin House and opponent of Harry Potter's) accompanied by two of his hangers-on, arrives and starts to pick on Harry's mates. But when invisible snowballs start to pelt him and an invisible opponent tackles Malfoy, throwing him to the ground and dragging him along by the legs, he and his chums soon leg it themselves. The saviour is of course Harry, making further use of the cloak of invisibility he received as a Christmas present indirectly from his deceased father in the first film.

Harry puts the cape to further good use in the quaint nearby town with its Elizabethan buildings and snowy street, when he sneaks into the in to hear about the wizard convict Sirius Black who has escaped from the titular prison and whom he learns was a friend of his parents who betrayed them to Voldemort resulting in their death, and Harry's godfather, whom it is feared now seeks to harm the young half-Muggle wizard (though most of this information later proves to be untrue).

267 Writer and star of **The Rocky Horror Show**

268 Director of films like *Y tu mama también (2001)* (aka *And Your Mother Too* – US informal title, a literal translation) and subsequently *Children of Men (2006)*

Ron and Hermione are aware of their invisible friend's whereabouts when in the street by the trail of footprints that he leaves in the snow, and they see these running off through a group of carollers who are knocking over. They follow the footprints in the snow until they hear Harry sobbing and uncloak him to hear him relate what he has learned.

Although the usual trappings of festive season are not displayed – save for the carollers – in this particular film, the snowy winter scenery and snowman etcetera at least tip a wink to Christmas, and the usual galaxy of stars is once again enhanced. Following the death of Richard Harris, Michael Gambon donned the wizardly robes to take over (very successfully) as Albus Dumbledore, and the newcomers to the series added to the heady magic mix this time included Gary Oldman (as Sirius Black), Emma Thompson (as Professor Sybil Trelawney), David Thewlis (as Professor Lupin), Julie Christie (as Madame Rosmerta), Timothy Spall (as Peter Pettigrew), Paul Whitehouse (as Sir Cadogan), Pam Ferris (as Aunt Marge), Dawn French (as the Fat Lady in the Painting), her husband Lenny Henry (as a Shrunken Head) and Freddie Davis aka comedian-turned-actor Freddie "Parrot Face" Davies (as the Old Man in the Portrait).

The next year's instalment in the cinematic series, *Harry Potter and the Goblet of Fire (2005)*, once again adapted by Steve Kloves, but this time directed by Mike Newell (director of the smash hit Rom-Com *Four Weddings and a Funeral (1994)*) witnessed a return to see-ing the trappings of Christmas displayed – festively decorated Christmas trees and evergreen foliage in the Great Hall of Hogwarts – as well as the usual glorious shots of the snow-clad ancient academy. We see Harry invite a pretty oriental-featured girl with a Scots accent called Cho Chang (played by Katie Leung) to the Grand Ball being held at Hogwarts as part of the celebrations for visitors from Beauxbatons and Durmstrang Wizard Academies who have come to compete in The Triwizard Tournament. But Cho already has a date.

As everybody dresses in their finest robes (that resemble black jacket and white tie formal evening wear – except Ron's hand-me-down tatty old brown ones with flounces and ruffles, of course, making him look "Like Great Aunt Jessie!"), Hermione (whom Harry and especially Ron thinks is not coming because no one has asked her) makes a Cinderella-like entrance in a beautiful, shimmering pink satin ball gown, the date of the dishiest wizard at the party. It is down to Harry Potter and his pretty Indian partner to start the formal dancing in the Hall, which is not only festooned with Christmas trees and evergreens, but which is decorated with glorious ice-sculptings of Taj Mahal-like palaces. It is not long, however, until the formal Ball turns into a fairly raucous free-style party with rock music and bopping; while post party, Harry is haunted by cold, snowy nightmares of a clash with arch-nemesis Voldemort (prop-erly seen for the first time and chillingly portrayed – in a prosthetic mask that hides his nose, making him look lizard-like and creepy – by Ralph Fiennes).

As well as Ralph Fiennes, Brendan Gleeson (as Professor Alastor 'MadEye' Moody), Eric Sykes (as Frank Bryce), Roger Lloyd Pack (as Barty Crouch), David Tennant[269] (as Barty Crouch

269 Who was soon to take over from Christopher Eccleston as the new (and tenth) **Dr. Who** on British TV in 2005.

Junior), Frances de la Tour (as Madame Olympe Maxime) and Miranda Richardson (as Rita Skeeter) added to the celestial roll call (or should that be role call?!) this time round.

Harry Potter and the Order of the Phoenix (2007), adapted for the first time by a different screenwriter – playwright Michael Goldenberg instead of Steve Kloves[270] – and directed by David Yates,[271] features more directly Christmassy scenes than any other of the films in the series since the original ***Harry Potter and the Philosopher's Stone (2001)***.

When the student wizards are stopped from actually practicing magic at Hogwarts Academy by Dolores Umbridge (brilliantly played by Imelda Staunton), the new headmistress with an ulterior motive appointed by the ministry to replace Dumbledore, Harry and friends begin leading secret classes, aware that Lord Voldemort is not only back but mustering his forces and that they will need magic not only to protect themselves, but ultimately to join in the coming fight against the Dark Lord. By Christmastime, when the students go home t their families for the holidays, everyone has made good progress and they all thank Harry as they leave their secret location with its festively decorated Christmas tree. And wishing them all a Merry Christmas, Harry finally succeeds in securing a few intimate moments with the object of his affections, Cho; his friends Ron and Hermione recognising his feelings and leaving the two alone together.

As Harry's and Cho's conversation draws to an end, in a lovely moment, a sprig of mistletoe begins to magically appear above their heads, growing and blossoming into full white-berried existence. It is a cue for Harry's first onscreen kiss...which he accepts willingly!

Later, sat in front of an open log fire in his chamber, which has its own festively trimmed Christmas tree, a delighted Harry discusses his romantic clinch and Ron and Hermione. Then later, inside the innocuous looking terraced house on a snowy London street, that is owned by Sirius Black (whom Harry has learned is his true friend and guardian), Harry meets up with his friends again on Christmas Day. The Weasley family are there also, and we see a toy Santa figure magically flying past the trimmed tree on a little broomstick in the dining room where everyone is gathered. A roasted turkey is perched on one end of the table and we have seen the Weasleys and Hermione open some Christmas presents. Ron once again receives a festive, sweater with a big 'R' on it (as in ***Harry Potter and the Philosopher's Stone (2001)***), knitted by his mum...but this time he refuses to wear it, explaining why later on the stairs to his friends, when Hermione says, "I don't understand why you don't want to wear it Ron."

"Cos I look like a bloody idiot is why!" is Ron's rely.

But while the Weasley family, Hermione, Sirius and Harry are gathered in the dining room on Christmas morning, Arthur Weasley, bruised and cut but wearing a Christmas party hat, proposes a toast to Harry who earlier saved his life. All join in the toast.

270 Although, as has already been stated, Kloves has been reinstated to write the screenplay adaptations next three movies in the series.

271 Who similarly seems to be slated to direct the next three films also.

As well as Oscar nominated Imelda Staunton[272] providing a superbly toe-curling turn as pink-clad and pasted-on smile diabolical dictator Dolores Umbridge, new recruits to the sparkling Potter universe this time include another Oscar nominee, Helena Bonham Carter[273] (as Bellatrix Lestrange).

In contrast, ***Harry Potter an The Half-Blood Prince (2009)***, for which Steve Cloves was back aboard writing the screenplay, sees very little of Christmas – perhaps not surprisingly as events get darker and more pressing. However, since the storyline follows the school year, there is a sequence whereby Harry is spending Christmas at the Weasleys' home. It seems that he is just about to kiss Ginny Weasley (Bonnie Wright), when the house is attacked by Death Eaters who surround it with a ring of fire. Harry, Ginny and a couple of the adults break through the inferno and give chase, but as they cling together in a circle to give fight, they come to realise that they have been duped by a ruse and the Death Eaters, led by Bellatrix Lestrange (Helena Bonham-Carter) have actually burned down the Weasley home. Not the happiest of Xmases then!

Fine British character actor Jim Broadbent joins the cast for this outing (playing Professor Horace Slughorn), with all the usual stars still aboard.

True, the Christmas scenes in the Harry Potter films are but fleeting moments in the densely scripted episodes of this spectacular saga; but they are important ones – not least the most recent one where Harry, who has been awfully mistreated by his uncle and aunt since the death of his parents and prior to his attending Hogwarts, has found a 'family' of friends who care for him and about him. And although dark storm clouds are gathering, this nurturing love helps give our bespectacled hero with the lightning-fork scar on his forehead the strength to go on and face his destiny.

272 As Best Actress for ***Vera Drake (2004)***

273 As Best Actress for ***The Wings of the Dove (1997)***

THE FILMS

Pottering About Over the Christmas Hols

The films below are listed in chronological, rather than alphabetical order

Harry Potter and the Philosopher's Stone 2001 UK/USA 152mins

Directed: Chris Columbus **Written**: Steve Kloves (adapted from the novel by J.K. Rowling) **Produced**: David Heyman **Executive Produced**: Chris Columbus & Mark Radcliffe & Michael Barnathan **Music**: John Williams **Cinematography**: John Seale **Edited**: Richard Francis Booth **Casting**: Susie Figgis & Janet Hirshenson & Jane Jenkins & Karen Lindsay-Stewart **Design**: Stuart Craig **Art Direction**: Andrew Ackland-Snow & Peter Francis & John King & Michael Lamont & Neil Lamont & Simon Lamont & Steven Lawrence & Lucinda Thomson & Cliff Robinson (uncredited) **Set Decoration**: Stephenie McMillan **Costumes**: Judianna Makovsky **Cast**: Daniel Radcliffe (Harry Potter), Rupert Grint (Ron Weasley), Emma Watson (Hermione Granger), Richard Harris (Professor Albus Dumbledore), Maggie Smith (Professor Minerva McGonagall), Robbie Coltrane (Rubeus Hagrid), Alan Rickman (Professor Severus Snape), Tom Felton (Draco Malfoy), Julie Walters (Mrs. Molly Weasley), Zoë Wanamaker (Madam Hooch), Fiona Shaw (Aunt Petunia Dursley), Richard Griffith (Uncle Vernon Dursley), Harry Melling (Dudley Dursley), Ian Hart (Professor Quirinus Quirrell/Voldemort), John Hurt (Mr. Ollivander), Warwick Davis (Professor Flitwick/Goblin Bank Teller), Vern Troyer (Griphook the Goblin), John Cleese (Nearly Headless Nick), Geraldine Somerville (Mrs. Lily Potter), Leslie Philips (voice of The Sorting Hat)

Aka Harry Potter and the Sorceror's Stone (USA) and Harry Potter (US working title)

Harry Potter and the Chamber of Secrets 2002 UK/USA 161mins.

Directed: Chris Columbus **Written**: Steve Kloves (adapted from the novel by J.K. Rowling) **Produced**: David Heyman **Executive Produced**: Chris Columbus & Mark Radcliffe & Michael Barnathan & David Barron **Music**: John Williams **Cinematography**; Roger Pratt **Edited**: Peter Honess **Casting**: Karen Lindsay-Stewart **Design**: Stuart Craig **Art Direction**: Andrew Ackland-Snow & Peter Francis & John King & Michael Lamont & Neil Lamont & Simon Lamont & Steven Lawrence & Lucinda Thomson **Set Decoration**: Stephenie

McMillan **Costumes**: Lindy Hemming **Cast**: MAIN CHARACTERS AS ABOVE + Mark Williams (Arthur Weasley), Jason Isaacs (Lucius Malfoy), Kenneth Branagh (as Professor Gilderoy Lockhart), Miriam Margolyes (as Professor Pomona Sprout), Gemma Jones (as Madam Pomfrey), Shirley Henderson (as Moaning Myrtle), Robert Hardy (as Cornelius Fudge), Julian Glover (as the voice of Aragog) and Edward Tudor-Pole (Mr. Borgin – scenes deleted)

Aka Incident on 57th Street (fake UK working title)

Harry Potter and the Prisoner of Azkaban 2004 UK/USA 141mins.

Directed: Alfonso Cuarón **Written**: Steve Kloves (adapted from the novel by J.K. Rowling) **Produced**: Chris Columbus & Mark Radcliffe & Lorne Orleans **Music**: John Williams **Cinematography**: Michael Seresin **Edited**: Steven Weisberg **Casting**: Jina Jay **Design**: Stuart Craig **Art Direction**: Andrew Ackland-Snow & Neil Lamont & Steven Lawrence & Gary Tomkins & Alexandra Walker **Set Decoration**: Stephenie McMillan **Costumes**: Jany Temime **Cast**: MAIN CHARACTERS AS ABOVE *EXCEPT* Michael Gambon took over the role of Albus Dumbledore from Richard Harris who died + Gary Oldman (Sirius Black), Emma Thompson (Professor Sybil Trelawney), David Thewlis (Professor Lupin), Julie Christie (Madame Rosmerta), Timothy Spall (Peter Pettigrew), Pam Ferris (Aunt Marge), Paul Whitehouse (Sir Cadogan), Freddie Davis (Old Man in Portrait), Dawn French (Fat Lady in Painting) and Lenny Henry (Shrunken Head)

Harry Potter and the Goblet of Fire 2005 UK/USA 157mins.

Directed: Mike Newell **Written**: Steve Kloves (adapted from the novel by J.K. Rowling) **Produced**: David Heyman **Music**: Patrick Doyle **Cinematography**: Roger Pratt **Edited**: Mick Audsley **Casting**: Mary Selway & Fiona Weir **Design**: Stuart Craig **Art Direction**: Andrew Ackland-Snow & Mark Bartholomew & Al Bullock & Alan Gilmore & Neil Lamont & Gary Tomkins & Alexandra Walker **Set Decoration**: Stephenie McMillan **Costumes**: Jany Temime **Cast**: MAIN CHARACTERS AS ABOVE + Ralph Fiennes (Lord Voldemort), Katie Leung (Cho Chang), Brendan Gleeson (Professor Alastor 'MadEye' Moody), David Tennant (Young Barty Crouch), Frances de la Tour (Madame Olympe Maxime), Miranda Richardson (Rita Skeeter), Eric Sykes (Frank Bryce), Roger Lloyd-Pack (Barty Crouch)

Harry Potter and the Order of the Phoenix 2007 UK/USA 138mins.

Directed: David Yates **Written**: Michael Goldenberg (adapted from the novel by J.K. Rowling) **Produced**: David Heyman & David Barron **Music**: Nicholas Hooper **Cinematography**: Slawomir Idziak **Edited**: Mark Day **Casting**: Fiona Weir **Design**: Stuart Craig **Art Direction**: Andrew Ackland-Snow & Mark Bartholomew & Alastair Bullock & Neil Lamont & Martin Shadler & Gary Tomkins & Alex Walker **Set Decoration**: Stephenie McMillan **Costumes**: Jany Temime **Cast**: MAIN CHARACTERS AS ABOVE + Imelda Staunton (Dolores Umbridge) and Helena Bonham Carter (Bellatrix Lestrange)

Harry Potter and the Half-Blood Prince 2009 UK/USA 153mins.
Directed: David Yates **Written**: Steve Kloves (adapted from the novel by J.K. Rowling)
Produced: David Barron & David Heyman **Music**: Nicholas Hooper **Cinematography**:
Bruno Delbonnel **Edited**: Mark Day **Casting**: Fiona Weir **Design**: Stuart Craig **Art Direction**:
Andrew Ackland-Snow & Alastair Bullock & Molly Hughes & Tino Schaedler &Hattie
Storey & Gary Tomkins & Sloane U'Ren **Set Decoration**: Stephanie McMillan **Costumes**:
Jany Temime **Cast**: MAIN CHARACTERS AS ABOVE + Jim Broadbent (Professor Horace
Slughorn)

CHAPTER 10

The Naughty 'Noughties' – Keeping the 'X' in Xmas

Just as the 1990s fairly brimmed like a Wassail tankard with tinsel-tinged terrors, tasteless turkeys and Ho-ho-horrors Good, Bad and Ugly, so it would continue into the new Millennium. Some filmmakers continued to be Naughty – foisting unspeakable and outrageous horrors (of entirely the wrong kind) on those seeking out darker delights in the realm of festive movies; but others were Nice, providing just the kind of spinetingling mistletoe monstrosities those not looking to overdose on saccharine sentimentality needed and craved. Even old school Santa successes were revisited, remade and re-interpreted – from a live-action version of Dr. Seuss's *The Grinch Who Stole Christmas*, to a 21st century take on Bob Clark's seminal festive psycho 'Slasher' **Black Christmas**...and there is even talk of **Silent Night, Deadly Night** being resurrected (like a supernatural psycho 'Slasher' icon in the Jason Vorhees[274] or Michael Myers[275] or Freddie Kreuger[276] mode!). Though with the world now fairly awash with a Santa sack full of psycho Santa 'Slasher' flicks, I cannot see the PTA picketing the flicks this time round...if the production ever makes it to the screen – rumours about this remake have been

274 Star of the *Friday the 13th* series of 'Slasher' flicks (10 sequels I believe – including *Jason vs. Freddie (2003)* which pitted the 'star' and linking character of this 'series' of films against the 'star' and linking character of the *A Nightmare on Elm Street* 'series' in a Universal monsters of the 1930s and 40s style showdown *a la Frankenstein Meets the Wolf Man (1943)*. However, Jason Vorhees is not actually the murderer in the original film – his mother is.

275 Star of the *Halloween* series of 'Slasher' flicks (8 sequels I believe and a 2007 remake!). However, Michael Myers does not feature in *Halloween III: Season of the Witch (1982)*, which tried to take the 'series' in a whole different direction (unsuccessfully).

276 Star of the *A Nightmare on Elm Street* series of 'Slasher' flicks (10 sequels I believe – if you include *Freddy vs Jason (2003)* and *Freddy VS Ghostbusters (2004)* - and 2 TV series [**Freddy's Nightmares (1990)** and **A Nightmare on Elm Street: Real nightmares (2005)!**])

circling for what seems like ages, but waiting for it to make it to the cinemas is like waiting up to see Santa on Christmas Eve!

But who knows, by the time we finish our little slay ride through the merry mayhem on offer through the naughty 'noughties' so far – the films that are keeping the 'X'[277] in Xmas – maybe a new **Silent Night, Deadly Night** will be slashing its way across the silver screen in a Cineplex near you. For now though, let us pick up where we left of in 1996 – with the sequel to that year's **Jack Frost** (not the maudlin Michael Keaton misfire, remember – the one about the crook who gets turned into a murderous snowman when he falls foul of some experimental genetic goo being developed by the military). **Jack Frost 2: Revenge of the Mutant Killer Snowman (2000)**[278] – and the title is the best thing about the film by a long way! – picks up the tale a year after the events of the dire original. And in this even more dismal sequel, dozy evil scientists discover the unmarked grave of the killer mutant snowman, Jack Frost, and dig up the bottles of anti-freeze that he was dissolved in to reconstitute him. Despite some further genetic meddling though, their experiments don't seem to be working... until a cup of cocoa is spilled in the mix that is, and then Jack's back. But this time the reconstituted creature is able to metamorphose from snowman to water-molecules and back again. And what is more, this time he is impervious to heat and anti-freeze.

Blood from the wound of his arch-nemesis, Sheriff Sam Tiler, having mixed with his DNA, Jack can sense that the Sheriff is spending Christmas on a tropical island with his wife and another couple, and so he changes into water and crosses the Pacific to pop up on the island and start another murderous spree. But worse is still to come though...for not only does frosty Jack start offing all the talentless cast, he also gives birth! – to a whole horde of mini snowball creatures (that look like a kind of cross between shaven **Star Trek** Tribbles, **Critters (1986)** and **Gremlins (1984)** – but not as well realised in terms of special effects as any of them!). Moreover, agent Manners who was undoubtedly killed in the first movie, turns up as the island's security chief – only he is played by a completely different actor and in a cheat worthy of a tacky 1940s serial, wasn't actually killed, it transpires, just maimed (requiring 15 operations to rebuild his face; hence the new look, complete with dashing black eye patch).

The isolated islanders must find a way to rid themselves and the world of the murderous mutant icy interlopers before they can spread. So, realising that the genetic link forged by the exchange of bodily fluids in their last encounter would probably result in Jack sharing Sheriff Sam's banana allergy, they mush up all the yellow fruits they can find on the island and hunt down The murderous mutant snowman and his family – he has definitely grown a set of snowballs this time! – with high-powered water pistols filled with banana daiquiris!

This whole sorry mess looks like it was shot straight on to video by writer-director Michael Cooney (who had also directed the original movie which he co-wrote with Jeremy Paige,

277 The X certificate used to be the classification used by the British Board of Film Censors (now British Board of Film Classification) for films whose content (violence, sexual, otherwise unsavoury) was only suitable for audiences over the age of 18. The X certificate was replaced by the 18 classification in 1982.
278 Aka **Jack Frost II**

one of the producers of both films). The writing is awful; direction, lighting, performances, costumes, sets and (not very) special effects (NOT!) lamentable and excruciating. It is rank, amateurish trash of the worst order, and anyone who bothers to sit through this travesty, will probably want to hang the filmmakers and kiss the mistletoe, rather than vice-versa! So never mind 'auld acquaintance'[279], I would suggest rather that it is *this movie* that should 'be forgot and never brought to mind'![280] And although I am not usually a man of violent temperament, in this instance I would quite understand anyone who wanted to "thumpety-thump-thump, thumpety-thump-thump"[281] the makers of this particular 89-minute exploitation monstrosity (and its progenitor come to that!).

Better, but not brilliant by a long way, was the newest version of **The Life and Adventures of Santa Claus** released in 2000. This 80-minute animated feature based on *The Wonderful Wizard of Oz* author L. Frank Baum's novel, relates the same tale as the 50-minute 1985 Rankin-Bass made-for-TV Animagic version[282] and features all manner of mystical mythical creatures, including trolls, pixies, unicorns and wood nymphs. But the real baddies are the Awgwas – here portrayed as creatures made out of rock (that look like something out of the old 1930s Buster Crabbe **Flash Gordon** serials).

Robby Benson (the voice of the Beast in Disney's **Beauty and the Beast** films) provides the voice of the young Santa Claus, and Hal Holbrook vocalises the Great Ak – the leader of the pixie people who discover the baby Santa Claus in the woods and raise him among the fairy folk. The woodland backgrounds are more impressive than the actual animation though, and the whole thing looks kind of 'old school' for a 21st century production.

Better looking was the US-Canadian-produced digitally animated straight to video/DVD feature **Casper's Haunted Christmas (2000)**.[283] The plot of this updating of the famous comic book and TV "friendly ghost", sees Casper and his three unruly uncles, Stretch, Fatso and Stinkie, banished by Kibosh (the extreme ruler of all ghosts) to the sickeningly schmaltzy town of Kriss, Massachusetts (Kriss, Mass. Geddit?!). There, the uncles must refrain from scaring anyone (a tough task for them) and Casper must purposely scare someone (an equally tough task for him – but it is ghost law to do this at least once a year, apparently). If they fail, they will be banished to "the dark" for all eternity. We witness their progress as they impose themselves upon the goodwill of the Jollimore family; Noel, Carol and daughter Holly.

There are some genuinely effective and funny sequences – scenes from an old B&W werewolf movie set in a castle in a thunderstorm, which is being screened at a drive-in in

279 Lyric from 'Auld Lang Syne' traditionally sung on New Year's Eve

280 Ibid.

281 Lyric from the popular Christmas song 'Frosty the Snowman'

282 A Canadian/Japanese co-produced TV mini-series from 1994 was also based on the same L. Frank Baum book. It was called **Shounen Santa no daibôken** or **The Adventures of Young Santa Claus**

283 Aka *Le Noël hanté de Casper* (French Canadian title)

the opening sequence, for instance. The camera then pulls away from the drive-in screen to reveal the colourful contemporary setting beyond the limits of the drive-in screen. And later, the three uncles auditioning (unsuccessfully) for the roles of the ghosts in a festive production of Dickens' *A Christmas Carol* in the holly-jolly town of Kriss they are banished to is also funny. But there simply aren't enough of these, and other visual gags which reference, lampoon or pay *homage* to horror-thrillers like **Psycho (1960)** and **Scream (1996)**, must surely appear as a sop to any adults stuck watching this movie with children (surely its core target audience) as younger viewers will not[284] have seen the films that inspired them.

Although colourful and slickly animated, this feature is only really likely to give a real *Boo!*st to the Christmases of *die* hard, *dead*icated fans because, like the ghosts (who look more like they are made from marshmallows than ectoplasm) the whole thing is a bit bland and featureless. The original music is by Country legend Randy Travis (who some think sounds like he is suffering or dying himself!). So, while it may not exactly leave you colder than the carrot-nose on a snowman's face, this film is probably not going to cook your Christmas dinner either. ...Nor scare the bejeebers out of you, even though its stars are all ghosts.

Still, it stands more chance in that respect than the appalling **Christmas Tales of Ghostly Trails (2000)**, a kind of semi-documentary examination of hauntings related to the festive period. Produced, directed and narrated by Liam Dale (who at a couple of points sits beside a log fire dressed in a flouncy, ruffled shirt with frilly cuffs reading supposedly spinetingling ghost stories from a big, leather bound book to two children who simply look monumentally bored), this 60-minute British-produced, video/DVD release is amateurish hogwash. There are some nice location shots – of places in the Cotswolds for instance, and of buildings like Harvington Hall in Kidderminster, which Dale wanders around pointing out the interesting features of (like priest holes – relating how these inspired the nursery rhyme 'Goosey, Goosey, Gander'). But dismal, dreary Dale's voice lacks inflection and emotion, and he does not have the skill as a narrator to really draw the viewer into the mysteries he explores and animate their journey, making it dynamic and tense. ...And what is more, his voice has an off-putting nasal quality (Or should nat be a dasal quality?), which sounds like he has a cold that won't quite break out. Unfortunately though, it is the viewer who has paid good money purchasing this DVD who has caught the cold, so to speak!

But it wasn't all desperate and dire with the turning of the century. One big-budget Hollywood blockbuster featuring a festively-challenged, Anti-Santy monster was a real treat. Director Ron Howard's most recent take on Dr. Seuss's *How the Grinch Stole Christmas*, entitled **The Grinch** (in the UK) and **How the Grinch Stole Christmas** (in the US) was a monster hit and something of an immediate Christmas classic.

Elastic-faced, contortionist-bodied funnyman Jim Carrey, who shot to mult-million dollar fee commanding super-stardom in **The Mask** and **Ace Ventura: Pet Detective** in 1994, is almost unrecognisable under a mantle of green fur and latex facial prostheses; but still manages to deliver a cartoonishly brilliant bravura performance in the lead role. And while Christine

284 Or should not because of their classification

Baranski (Maryann Thorpe in the US TV comedy **Cybill** with Cybill Shepherd) looks like she could play a citizen of Whoville without any makeup, she and a fine supporting cast – which includes Jeffrey Tambor, Molly Shannon, Bill Irwin, Mindy Sterling,[285] Deep Roy,[286] and Clint, Rance and Jeremy Howard (!) – all provide able support. But special mention on the acting front has to be made of young Taylor Momsen who plays angel-faced Cindy Lou Who and Josh Ryan Evans who mimics Carrey wonderfully playing the 8-year-old Grinch: both are superb.

But fine performances apart, what is immediately really striking about this production is its 'look' (with Design by Michael Goldsmith, Art Direction by Lauren E. Polizzi and Dan Webster, Set Decoration by Meredith Boswell, Costumes by Rita Ryack and Cinematography by Donald Peterman) – it *is* just Dr. Seuss brought to life! (Although the story opens up the original material to provide the Grinch with a backstory and a love affair that wasn't in the Dr. Seuss original!). Produced as well as directed by Ron Howard[287] (along with Brian Grazer) and with a screenplay by Jeffrey Price and Peter S. Seaman, this is a spectacular, unique feast of festive film fun for the whole family: it is funny, touching, quirky, odd and just out-and-out entertaining; a fantastic way to welcome in the new millennium.

But although the central character in **The Grinch** was an Oscar the Grouch-like monster and it was set in a fantastical land (which further Dr. Seuss tales like *Horton Hears a Who* teach us is microscopic), the film itself wasn't exactly a Christmas Horror. It was too family-orientated for that. But full-on festive frightfests were not far away. 2002 saw the release of two in the form of the low-budget Holiday Horrors **Christmas Nightmare**[288] and **The Christmas Season Massacre** – both American-produced Indies. And unfortunately, both pretty much reindeer pooh!

Christmas Nightmare (2002), co-written and edited by Vince Di Meglio (who also Directed) and Tim Rasmussen (who also Produced), has quite an apt title in one sense...well, the 'night-mare' part anyway! It actually starts off pretty well (and if it had been a short in which the – I am loathe to call them this because they are so poor! – 'actors' never spoke a line, it might have been quite effective. But alas! No)...but it soon deteriorates (as soon as the actors start speaking lines in fact) into an ill-thought-out **The Shining (1980)**-wannabe.

Its storyline, for what it is worth, sees a couple who have witnessed the murder of a presidential candidate a few days before Christmas whisked off by Feds to an isolated 'safe house' in the country. Only the agents get the wrong house, and they end up installing themselves and their witnesses in a house where, back in 1947 on Christmas Eve, a man brutally slaughtered his two daughters and hanged himself. The female witness begins to see visions of the

285 Dr. Evil's agent-cum-henchwoman Frau Farbissina from the *Austin Powers* movies.

286 The Oompa-Loompas from *Charlie and the Chocolate Factory (2005)*

287 Ritchie Cunningham from cult 70s TV show **Happy Days** who has gone on to become a celebrated director and producer, numbering films like *Splash (1984), Cocoon (1984), Backdraft (1991), Apollo 13 (1995), A Beautiful Mind (2001), Cinderella Man (2002)* and *The Da Vinci Code (2006)* among those he has helmed.

288 Aka *The Damned* and *The Damned Within the Shadows* (in the UK) and *Lake of Fire* (working title)

murdered girls and her husband thinks that she is a sixpence short of a Christmas pudding… until the agent protecting them starts acting mighty strange as he becomes possessed by the spirit of the vengeful killer…

What can I say? It is cheap, cheesy, tacky and ultimately pointless…with some of the most atrocious 'acting' outside of a porno flick! Personally, I would rather find a lump of coal in my stocking than a copy of this claptrap! It opens and closes with the festive carol 'it Came Upon a Midnight Clear'; only it wasn't clear with this particular *Christmas Nightmare* haunting it – the outlook was cloudy, bleak and barren!

And so to *The Christmas Season Massacre (2001)*. At least this straight to video/DVD release has the courtesy of only being 70 minutes long (20 minutes shorter than *Christmas Nightmare*)! Written by Eric Stanze (who also Executive Produced, Edited and starred in it) and Jeremy Wallace (who also Directed and Produced it – with Mark W. Kettler) its plot is fairly standard sub-standard Santy 'Slasher' fare, made on a micro-budget with next to no talent. A geeky young loner loser called "One Shoe McGroo" gets a pirate eye-patch (and not even a cool black one, but one with a sparkly Christmas tree on it!) from his parents for Christmas instead of the new shoes he desperately needs. Teased by his school chums, he flips his lid, kills his parents and disappears swearing to get even with the classmates who humiliated him.

Over the years the classmates who were McGroo's tormentors have all been killed except for six of them. One of the remaining six gathers them all together at Christmastime in McGroo's old house to confront and kill the homicidal maniac bogeyman from their past before he can kill them… But it ain't that easy! An array of gory killings utilising tools and implements a-plenty to keep gore-hounds happy follows – with one ex-school chum even getting his member dismembered! There is quite a bit of *homage* paying to earlier (and better) 1980s 'Slashers' – which, on the whole works fairly well and is probably the best thing about the film – but the attempts at comedy are frankly calamitous.

The last classmate left alive at the end is one of the original bullies and he still has the loony killer's missing shoe! He drives a spike into Groo's head, impaling his brain…but somehow McGroo gets right back up – spike 'n' all! – and quite literally blows his tormentor's guts out with a shotgun. Then, in a funny if nonsensical little finale, our bogeyman revisits the house where he previously raped a woman at Christmastime disguised as her husband, whom he had killed. It is Christmas again…only this time, there is a toddler opening presents and he is dressed as a pirate. He only has one shoe – and a joyous father with blood trails from the spike in his head, joins the joyful mother to watch junior open his Christmas present – a pirate eye patch with a sparkly Christmas tree! They are the perfect and contented all-American happy family unit!

This movie is probably an acquired taste – it's an under-cooked turkey full of overdone ham – a taste that most people will probably have no wish at all ever to acquire! …Even the advertising tagline shows utter incompetence, mixing tenses like a temporally jet-lagged time-traveller: "Twas the night before Christmas…and everyone's dead." But if you are a bit

of a cheap Indie splatter fan and a completist viewer who doesn't care too much about quality, then you might want to catch it I guess. For my part though, I would much rather watch 2001's one remaining entry, the intelligent and witty US-produced heretical Indie Comedy **Blasphemy the Movie (2001)** (aka **Blasphemy**).

This movie makes it in mainly because it features several deities, and the horror of a family murder. It is quirky, irreverent fun – but broaches some pretty big concepts (though its deliberate lack of respect will be shocking and challenging to some; perhaps thought-provoking and entertaining to others). It is about a Hispanic-American man called Martin Gacia, who has been brought up as a Catholic in a very devout family, telling his parents that he does not believe in God– that he is an Atheist (though he still intends to enjoy celebrating Christmas with his family in a secular fashion). The film follows the consequences of his declaration.

The film opens with Martin's voice-over narration saying, "Christmas Day, and I'm staring down the barrel of a .38 snub nose. Hey, I don't remember asking Santa for this!" We see him kneeling on the floor in living room of his parents' house. The gun which is being pointed at him is held by someone behind the camera position. His parents are sat behind him on a sofa, one to either side. Religious statues and icons punctuate the Christmas decorations. The film related in an extended flashback shows how Martin got himself into this pretty pickle, with his voice often heard in voice-over commentary. The action begins the day before on Christmas Eve, when Martin visits his parents to inform them that he is an Atheist. Needless to say, this does not go down well, and much angst and argument proceeds. Until eventually, Martin's father kicks him out of the house and bans him from attending the family Christmas gathering the next day.

As it transpires, Martin's crisis of faith started early and was linked, if not to Christmas, then certainly to the desire for gifts: "As a kid, I really tried to understand it all. But I just couldn't keep track of who was a virgin, who was a saint and who was an Our Lady. All I knew was that I'd been praying for a new set of Hot Wheels and none of these statues were delivering." His doubts grow, and he explores other religions through reading about them. But he finds the same things lacking or wanting in all of them, concluding that there is in fact no God. (When he tells his parents this, his shocked, disbelieving father's immediate initial response is to ask, "You *gay* too?" Magic). It is all too much for his folks.

The rest of the film is intercut with some funny interjections, and irreverently depicts various versions of God and other iconographic characters from other world religions, as well as from the Christian faith – Jesus, Buddha, Mohammed, Lord Krishna, Abraham, Jehovah's Witnesses! Their appearances allow John Mendoza, the film's writer-director to make satirical points as Martin elucidates upon his position (but result in a sketch-show type episodic narrative).

Certainly the humour is meant to shock – and it gives a commentary on the nature of the human condition as much as on the nature of the deities depicted; an irascible Jihad-proclaiming Mohammed; a spaced out, hyper-chilled Buddha; a flambouyant, bright blue Krishna crashed out on a sofa with a pizza watching events unfold on a celestial TV set. These

Gods are like students! It is wilfully shockingly flippant: Jesus works out in a gym like some shallow, brainless looks-are-everything contemporary buff dude. "I tried helping the poor and I got nailed – literally!" he declares. But there are also interesting questions and issues raised and Martin cannot reconcile faith in an organised religion with logic; he cannot have blind faith; cannot take a leap of faith. Yet his absolute commitment to believing in no God is itself a kind of faith – a leap of faith in the supremacy of logic!

When a loopy, devout aunt gets to hear of Martin's Atheism, she is so outraged that she is prepared to kill him to save his soul! She it is, we discover, who was holding the gun in the film's opening shot. It is not her gun, it is Martin's dad's; but when he wavers in threatening his son with it at the Christmas Day family gathering – his love for his son outweighing his outrage – the dotty Aunty grabs it. She is determined to exorcise the demon she is convinced has possessed Martin – even if it means killing Martin in the process – and so she sets to her task with holy water and scripture while the rest of the family watches and the dog tucks into the roast turkey.

When Aunt Patricia has completed her processes and following a pregnant silence, Martin nonchalantly and dismissively asks, "Can we eat now?" Mistake. His aunt pulls the trigger and blows him away. Blackness. And Martin's voice-over, as if confirming that he was right and there is no afterlife, "...And that was the end of that!"

Still, at least he didn't try t claim there is no Santa Claus!!!

And on that sobering though, let us switch our attentions from a low-budget but effective Mexican-American Christmas-set Indie comedy, to a decidedly-lower-budget, Mexican-American-set Christmastime Horror flick that actually hails from Denmark! Yes, you read it right, 1992's ***One Hell of a Christmas*** (aka ***The Claw***[289]), despite being set somewhere in Tex-Mex territory, is Danish and features a predominantly Danish cast and crew – even though its writer-director, Shaky González[290], is actually Chilean by birth. But Danish though it may be, this particular ant-Santy Christmas confection is anything but sweet.

Shaky has obviously been brought up on a diet of Sam Raimi, Robert Rodriguez and Clive Barker, as ***One Hell of A Christmas*** aspires to be a kind of ***The Evil Dead (1981)*** meets ***El Mariachi (1992)*** by way of ***From Dusk Till Dawn (1996)*** and ***Hellraiser (1987)*** (with a dash of ***Carlito's Way (1993)*** and ***House (1986)*** thrown in like Tabasco sauce for added flavour). But this Shaky, unlike he British chart topper of the 1980s, definitely isn't capable of giving a Merry Christmas to everyone![291]

289 US DVD release title

290 An appropriate first name if this production is anything to go by!

291 Shakin' Stevens (aka Shaky) was a Welsh rock 'n' roll singer who styled himself after an early-ish, post-Country Elvis Presley. Real name Michael Barratt, Shaky had no fewer than 33 top 40 hit singles, making him one of the most charted and biggest selling acts of all time! In 1985 he had a UK No.1 hit single with the song 'Merry Christmas Everyone' (which re-entered the charts again in 2007, peaking at No. 22).

The plot sees a prisoner paroled at Christmastime after 2 years in jail determined to pick up his life and stay on the straight and narrow to set a good example for his 5-year-old son. Unfortunately though, his druggy-low-life best friend (who has been diddling the missus while he was away!) has tripped across a mystical black claw while scoring some chemical Christmas celebrations for his friend's release and he has some big ideas for obtaining power and money. Trouble is, the claw – which gives off a black powder (definitely not "snow"... or "angel dust" for that matter!) that bestows super-human strength on anyone who snorts it – is from the Devil's little finger...and he wants it back! So he sends some demon spirits to Earth to kill whoever he thinks might have it.

These demon lackies reanimate a dead whore the parolee has done-in under the influence of the evil black nose candy – so much for the straight and narrow and setting a good example! – and she sets out to do for him what he did for her (when he *did-for* her!). Looking like one of the aforementioned *Evil Dead* and with an atrociously dubbed demon voice, this *ghoulfriend* sets about trying to turn the parolee into cranberry sauce; forcing him to get a bit clever with a cleaver and take up some Christmas carving of his own!

The demons even possess the toy cowboy that his son has received as a Christmas present, swelling the toy into a fully-grown, man-sized ghoulish gunfighter. And when dad sees him off as well, the toy cowboy's sidekick is brought to life next - a 6ft tall Wile E. Coyote look-alike called Wolfy! ...Or is it all a hallucination brought on by booze and the strange black-powder nostril-tickling narcotic? (And what's the moral? ...'Evil is addictive like drugs'? ...'Don't sniff at the Devil'? Who knows?! All the advertising tagline tells you is "Better Watch Out, Better Not Die" – which, sound advice though it is, is pretty much as hollow as this movie).

The film is not entirely devoid of panache – some of the scenes are in fact reasonably effective ; for instance, an air of tension and surreal danger is well wrought when, during a thunder storm, the hapless hero hears a musical Santa singing 'Jingle Bells' and creeps through the dark house with a sense of paranoid foreboding to find out what is going on. The sound of 'Jingle Bells' playing a second time – this time weirder, as it slurs out of a radio whose batteries are running down – actually sets the scene up perfectly. Unfortunately, that build up all kind of falls apart and dissipates when the horror he is confronted with is the resurrected prostitute in prosthetic face make-up, or the killer cuddly toys!

But if you think *One Hell of a Christmas* is a poor movie, believe me, (to paraphrase Al Jolson), you ain't seen nothin' yet![292] The straight-to-video/DVD Canadian-produced, micro-budget, Z-grade Indie Horror *Binge & Purge* (aka *Binge and Purge* and *Catwalk Cannibals*), which was also released in 2002 would beat it into a cocked hat (or a red Santa hat with a white bobble come to that!) in the 'honoured place in the Hall of Shame' stakes! This Brian Clement written, directed and edited debacle (for which he also had a hand in makeup and

292 Jolson's first words as Jackie Rabinowitz/Jack Robin in the film that is usually regarded as certainly the first widely seen 'talking picture' were: "Wait a minute, wait a minute, you ain't heard nothin' yet" (a line the conceited crooner is reputed to have used again rather cheekily to quieten an enthusiastic audience at a concert one time when he followed the 'world's greatest tenor' Enrico Caruso onto the stage!).

as a Foley artist[293] in case you want to know where firmly to lay any blame!) is truly terrifying in its bargain basement conceit and hubris.

It is set at Christmastime in the near future when America has become a police state and opens with what appears to be a fly-on-the-wall (or camera-in-the-car) TV documentary-cum-entertainment programme following two cops in a cruiser on night patrol. In the words of the writer himself, "Strange murders have begun to plague the capital city. The police chief assigns two officers to look into the disappearance of a young fashion model and the officers themselves promptly disappear. Fearing for the reputataion [sic] of his department, and hoping that two of his problems take care of each other, the chief enlists the aid of a trio of private detectives he deems expendable. The group's investigation leads them to an evasive fashion designer and his circle of enigmatic models. What they uncover is not just a simple murder, but a complex web of corruption, mass killing, deceit...and cannibalism. But this threat does not come from without, it comes from within..."[294]

What is actually uncovered in this mega-gory, visceral splatter-schlock offering from Canadian aspiring-auteur[295] and George Romero-wannabe, Clement, is a Neo-Nazi plot for world domination predicated upon a supposed high-class fashion designer (though the budget barely allows for Christmas decorations to set the scene, let alone believable *haute-couture*!) turning his models (although those same budget restrictions could only run to mingers!) into cannibalistic killers who spread flesh-eating zombiedom and thus herald the Apocalypse! Cue plenty of sucking and slurping of eviscerated organs and viscera! (Indeed, the only really effective things in the whole movie are some excellent sound effects; whether part of the gross-out cannibalistic festive feasting, or the tinny renditions of Christmas classics like 'Silent Night' and 'We Wish You A Merry Christmas' that accompany the action at various points, sounding like festive shower songs sung by Daleks from **Dr Who**, far away and in a shower!). Gore-fans and 'splatter-heads' might find some value in **Binge & Purge**, but I would suspect that most viewers – even fans of shoestring-budgeted do-it-yourself-in-your-own-back-garden style straight-to- video/DVD Indie Horrors – will find it all unbelievably absurd and frankly fairly abysmal on the whole.

Which description could pretty much fit another 2002 offering from the United States, entitled **A Light in the Forest** too. For although this updated, revisionist fairytale that rein-terprets and gives an alternative take on much of our Christmas tradition, features a couple of well known names in Lyndsay Wagner (who played Jamie Somers in the original TV version of **The Bionic Woman**) and Carol Lynley (who starred in films like **The Shuttered Room**

293 They use a selection of devices to create sound effects in post-production dubbing sessions.

294 From a synopsis on the *Internet Movie Database (IMDb)* at http://uk..imdb.com

295 If quality is no barrier

(1967), [296] ***The Poseidon Adventure (1972)*** and ***The Cat and the Canary (1979)***), even Dr. Rudy Wells[297] couldn't save it!

Directed by John Carl Buechler (who also co-wrote with Frank Latino and Gary LoConti), the film opens with a pre-credits sequence of illustrations in a book of fairytales, which segues into live-action as a voice-over commentary sets the scene. In some grimmer-than-the-Brothers-Grimm mystical fairytale time, an ugly, evil king kidnaps and threatens to kill some forest sprites. "Once upon a time, long, long ago" the commentary begins, "when the world was young and magic was everywhere...The evil King Otto and the darkling elf Hoiman had finally succeeded in capturing several of the spirits of Christmas."

Naturally, the question immediately springs to mind...If this is a mystical long, long ago time of *Lord of the Rings*-style evil elves and magic, how could there be a Christmas? – Because the birth that Christmas celebrates only occurred around 2000 years ago! And how did Christmas come into being without the (actuality or myth – depending on your beliefs) of a birth of Christ? I guess this is just further evidence of the secularisation of the celebrations and the season: Christmas now exists as an entity in its own right, no longer uniquely dependent upon the Christian religion, its traditions more or less independent of belief in church lore.

Anyway, the captured fairy folk, Miss Mistletoe, the Pine Queen and Poinsettia Patty are rescued by a Peter Pan-like forest sprite called Holly Boy, who flies in as a green ball of light and does the old Dougie Fairbanks/Erroll Flynn bit. But not to be beaten, King Otto and his evil henchman-elves (complete with mandatory pointy ears) recruit the help of an ugly old witch called Hazel (Yep Witch Hazel!). She tricks Holly Boy, poisoning him (although being an 'evergreen' immortal, he cannot actually die and the poison hardens his heart and turns him into a statue instead)...until such time as a great sadness can reawaken him. (Mind you, this seems like something of a Pyrrhic victory, as the evil ones are put to sleep too, only to wake when Holly Boy does in order to carry on their epic battle. I guess they are hoping that they will have a better plan by then!).

Anyway, while the sadness of plagues like the Black Death ravaging the planet, or the decimation of indigenous Native Americans and their culture, or WWI or WWII, fail to generate enough sadness to stir the jolly green juvenile, when a young girl of mixed-racial parentage whose circus performer parents died in a training accident in Europe, sheds a few tears because the girls at her new high school get bitchy, before you can say, "Robert's the sibling of one of your parents!" (or even "Bob's yer uncle!") the statue comes back to life!

The girl now lives with her Grandmother in Hollywood where the Holly Boy statue was located (Holly Wood, geddit?!), so the sprite decides to help her out and ease her sorrow.

296 Aka ***Blood Island***

297 The scientist who saved both Steve Austin (Lee Majors) and Jamie Somers (Lyndsay Wagner) after they were involved in horrific accidents, turning them into ***The Six Million Dollar Man*** and ***The Bionic Woman*** in smash hit 1970s TV shows.

Along the way he also discovers that one of her teachers is a reincarnation of the Pine Queen; that property developers are threatening Holly Wood and that King Otto has come back to life and taken over the school headmaster. Naturally, by the movie's conclusion everything ends up exactly as you might expect, and even Holly Wood is saved to remain sacrosanct and unmolested.

Unfortunately though, apart from a bit of pretty pukka witch, elf and evil king makeup, this mixed-muddled-mish-mash of a movie is about as bankrupt as Northern Rock Building Society before it was temporarily nationalised by the British government early in 2008! Even the usually entertaining scenes of bitchy teenage schoolgirls were flatter than the day-old beer you wake up and find in a glass somewhere strange on Boxing Day morning!

Of course, the only things frightening about this family-friendly grim festive fairytale are its mendaciousness and mediocrity. Somewhat more effective, if also signally unscary, was the same year's made-for-American TV movie *A Christmas Visitor*, directed by Christopher Leitch, written by George Samerjan and David Saperstein and starring the ever-dependable William Devane (who played Secretary of Defense James Heller in **24** and Gregory Sumner in the Lord only knows how many episodes of **Knots Landing**). He is ably supported by Meredith Baxter (who played the mother of Michael J. Fox's character in **Family Ties**), Dean McDermott and Reagan Pasternak.

Although relating a modern tale – of a family which has not celebrated Christmas for a decade after the Christmas Eve loss of a favoured son in the First Gulf War of the early 1990s – this is ostensibly an old-fashioned Christmas ghost story played out in a mildly melodramatic and sudsy TV Soap style. For when the dad picks up and brings home a young, uniformed soldier with nowhere to spend the holidays one snowy Christmas Eve, not only does he help bring Christmas back to the Boyajian household and the hearts of the bereaved, he actually turns out to be the ghost of their dead son (though he looks different than in life, naturally... or the whole family would have recognised him right away, wouldn't they?!).

In stark contrast, old-fashioned is something that the made-for-video/DVD animated feature *Santa Claus Versus the Christmas Vixens (2002)* would never be accused of being! This hip, post-modern, urban animation from America, written by Kirk Bowman (who also directed, edited, produced, wrote the music, was the cinematographer and supplied the voice of the TV announcer) and Michael Q. Schmidt (who also headed the vocal cast playing Santa Claus) it relates a very modern (satirical) tale. In Schmidt's own words, "Late on Christmas Eve, 4 girlfriends want to travel to Las Vegas only to discover that their car has broken down. Despondent, they find that they may have won a brand new car as a Television promotion. They drink to their good fortune and wait for the studio's "Santa" to arrive, only to have him be a no-show as midnight approaches. When the real Santa arrives, they are hurt and angry and vengeful. No small wonder they take out their frustrations on the innocent Saint Nick."[298] Horror it isn't – but I felt somehow compelled to mention it as it is so far out of left field that I thought I could sneak it under the catch-all Psychotronic umbrella; though whether

298 From a synopsis on the *Internet Movie Database (IMDb)* at http://uk..imdb.com

or not, "What ensues is a hilarious comedy of errors with poor Santa getting the worst end of everything" (Ibid.) I will let you decide for yourself.

And the following year saw the release of another ultramodern live-action 20-minute short, which purports to be political satire and which once again emanated from the United States. *How the Pimp Saved Chrismas* written by Barry L. Levy and Matt Baotright-Simon (who also directed as well producing alongside Jim Round) claims to be based on a "children's book" written by Tito Gazelle...but it is in fact a rude, crude, crass adaptation of Dr. Seuss's *How the Grinch Stole Christmas*, complete with foul language and scenes of a sexual nature. I think the term Psychotronic certainly covers this one!

It opens with a shot of a Santa figure in a snow globe, then snow falling as a voice-over reads the poem which scrolls up:

"To the kids who think Christmas gifts come from malls,
Here's a story your folks might not recall.
Santa Claus and his reindeer, this tale everyone knows,
But indeed there's another about a pimp drug pusher and hoes..."

We then see Santa (here known as Kracker K. Klaus) making out with a drug-addict hooker (Rooty the Red-Nosed Crack Ho – played by a man!) in a motel room. When Santa dies following a BJ from Rooty (with lots of "Ho-ho-ho-ing" on the part of the white-bearded one before his sudden demise!) Rooty persuades her Pimp (the Grinch equivalent here) to take Santa's place. But he only agrees because he will get to go into lots of white folks' homes legally in Ho-ville, breaking and entering "like a silent, deadly fart" and stealing all their possessions.

However, as he is doing this, he is confronted by an 8-year-old, one-legged orphan boy on a crutch who is called Billy Joe Ho. The pimp is moved by the plight of the angelic youngster who only wants a leg for Christmas (and you can tell by his tearful mumbling: "Cute-arse m****r-f****r...one-legged m****r-f****r..."). So he runs through Ho-ville High Road like George Bailey in *It's A Wonderful Life (1946)* wishing all the buildings a "Merry Christmas" and he puts his eight hoes to work delivering Christmas presents.

It looks like his conversion may be halted when his Pimp-mobile breaks down, but his mate Fros T. the Snowman (dressed all in white with a red scarf, black hat and coke pipe!) turns up in his ice cream van and feeds Rooty the Crack Ho enough cocaine to make her nose glow red. Pumped-up, she has enough energy to tow the car round so that the Pimp and his Hoes can finish the job...even if they do get some of the presents mixed up. (Little Billy-Joe gets a huge silver vibrator, for instance; but that is all right, because he assumes that it is a bionic leg!).

"Santa ain't at the North Pole," a final couplet informs us, "He's down in the ghetto with a big dose of soul." And yes, this featurette is cheap, gross, crude, crass and tasteless...but it is at least quite spirited, with a certain verve and vivacity and was never I feel intended to win any Oscars...nor for that matter, the hearts of many God-fearing, church-going middle-aged, middle-class folk living on the buckle of the Bible Belt, I feel. It comes across rather

like a student film project. I guess you will know whether you are likely to love or loathe it – I cannot envision much in the way of middle ground either way!

Slightly longer at 60-minutes, and aimed entirely at the opposite end of the audience spectrum (i.e. children), the same year, saw the release of another animated festive feature... but this one once again had a distinctly modern twist. *A Wobot's Christmas (2003)* – the name derives from a child's mispronunciation of the word *Robot's* Christmas – is set in some sci-fi future, complete with robots, rocketships and a **Jetsons** style space city. This hovers over the planet Earth, which has become nothing but a scrap heap for waste (much along the lines of 1980s cyber-punk Dystopian future environments). A young orphan called Zak, who has never learned the true meaning of Christmas even though he works on the orphanage production line producing toys that he will never receive or get to play with, hates the holidays (with little wonder perhaps!).

Zak is the butt of the other kids' jokes because of a Jonathan Woss-like speech impediment that means his R's sound like S's (hence the film's title). But one day, when he is meant to be taking a defective robot to the scrapper's, he demurs (feeling rather defective himself) and soon he has met a whole new bunch of friends in the city's garbage bins and they are all dumped on the junkyard planet below. There, they learn that the self-proclaimed ruler of Scraptown has a devious plan to brainwash the children at Zak's orphanage and use them as soldiers to take over the city above on Christmas Eve.

Appalled by this evil scheme, Zak and his "wobot" friends flee Scraptown and find refuge in the desert with a kindly old hermit robot who teaches the misfits the true meaning of Christmas by relating the story of the Nativity and Jesus's mission to bring hope to the hopeless and unwanted. And inspired by this, Zak and his Wobot friends (they adopt the mispronunciation as their group name) realise that the holidays are worth saving and they tool up **Transformers**-like into a spaceship that looks like an angel (in silhouette), to thwart the evil plan. And although this does not turn out to be "as easy as Pi – 1.34" (as one of them opines) they do naturally manage to win out in the end. ...And who knows? – Perhaps having successfully become the hero of the piece for all those nasty kids who wouldn't let him join in any reindeer games (speaking figuratively), perhaps Zak got to put his feet up that night with some nice Chwistmas cwackers and some cheese!

While this isn't the best CGI animated feature you will ever see – it has a plastic look and lacks texture – it is none the less bright, colourful and bold with some humorous touches (not least lampoons of, or *homages* to the **Star Wars** films, *Top Gun (1986)* and TV shows like **Different Strokes**. There is a strong vein of humour – like the wrapping machines that sing Christmas raps! – and plenty of Christmas tunes throughout. And one of the villains looks like he has stepped straight out of a Tim Burton movie, with his big, metal-domed head and stack lenses in front of one eye.

But 2003 was not all about Psychotronic films aimed at either end of the audience spectrum – a couple of *bona fide* Christmas Ho-ho-horrors were released too. One even made use of a phrase that had come into circulation describing the seasonal 'Slasher' that had

begun to proliferate for its title. ***Psycho Santa (2003)***, written and directed by Peter Keir was an extremely- low-budget (and unfortunately an extremely-low-talent) straight-to-video/ DVD release produced in the United States. At 72-minutes, you will probably be surprised to learn that it is a portmanteau movie with four story segements. Each has minimal dialogue – though the linking story of a couple driving to a Christmas party with him relating the tales of how a killer Kris Kringle has been offing locals over the years has lots of pointless dialogue to make up for this.

The Satanic slaughtering Santa is apparently unkillable, and each of the husband's tales relate how he has claimed victims in the past. For instance, in one he kills a pair of women who have gone to visit a friend at her log cabin in the woods at Christmastime – but not before they discover that the Christmas presents the missing friend has left beneath the tree are in fact *her* cut up into little pieces and gift-wrapped by the Santa-suited slayer! (Oh, and not before the ugly one with the pierced nipples has sudded herself shower of course!).

Another segment relates how two burglars who break into a blind woman's house at Christmastime and kill her just for fun, get their come-uppance when they bump into Santa; and another delivers a kind of riff on George A. Romero's ***Night of the Living Dead (1968)***, when a brother and sister on their way to a relative's for the holidays, end up lost in the woods when their car breaks down. But unlike most people who are dying for a visit from Santa at Christmas, the people in this town die *from* a visit from Santa!

You know how the whole thing is all going to end way, way before the 72-minutes is up, so I don't feel guilty in the least spoiling the supposed surprise *dénouement* : the woman who has been listening to all these tales on the trip in the car suddenly worries that she might have left behind some of the Christmas presents she intends to give out, so she has hubby stop and check the boot... And what do you know...Yep, you are miles ahead of the game too, aren't you?! Still, this one is definitely and out-and-out Ho-ho-horror – however old-fashioned it may feel, being a throwback to the cheap and tacky, grungy 'Slashers' that had their heyday (or is it slayday?!) in the 1980s.

Much more modern, more inventive, better realised and indeed superior in every way, was the year's other all-out festive frightener, ***Dead End (2003)***. An American-French co-production, this 85-minute tricky treat boasted French writer-directors in Jean-Baptiste Andrea and Fabrice Canepa, a predominantly French crew, but an American cast; not least Ray Wise who had played dead Laura Palmer's father Leland in David Lynch's surreal cult TV thriller of the early 1990s, **Twin Peaks**.

The plot sees Frank Harrington (Wise), his wife, teenage son and daughter, and the daughter's boyfriend load up the family car and set out on Christmas Eve to his mother-in-law's home to celebrate an extended family Christmas, just as he has done, reluctantly, every year for the past twenty years. But this year, when all the usual in-car fighting and bickering has died down and the other family members have fallen asleep, Frank decides to take a shortcut. Leaving the freeway, he finds himself on a long, straight road driving through an immense, dense starlit forest. Suddenly, a mysterious woman dressed all in white and clutching a baby

appears in the road and Frank screeches to a halt just missing her. No one can get her to speak at first, but when she finally does, not only does she tell one of them that the baby is dead, but she then vanishes into the forest, reappearing periodically later on. Worst of all though, her arrival marks the start of a nightmare. One by one, the travellers are murdered and driven away in a mysterious black hearse-like car with no visible driver! Every road sign points to a destination they never seem able to reach, and as the group disintegrates in panic, fear and insanity, some long-buried secrets emerge.

In a short pre-credits sequence, we see the family loading up the car for the Christmas Eve trip. Dad is already in a bad mood, as gift wrapped Christmas presents and a homemade chocolate and pumpkin pie (that wise-ass teenage son, Richard says "smells like ass") are loaded. Then, as the journey proceeds, Christmas, with its usual associations of family union, Peace on Earth and Goodwill to All Men, is used as a lovely counterpoint to the dysfunctional Harrington family's collapse in the face of terror.

Things start off recognisably enough, with mum leading the singing of 'Jingle Bells' in one of those trapped-in-a-car-together-on-a-long-trip false and forced joviality ways, with everyone joining in except typical rebellious teen 'rebel without applause' Richard, who would much rather listen to rock music on his walkman. But it is not long before any sense of family harmony is severely stressed and eventually shattered by the apparently supernatural occurrences (which Richard thinks "reeks of alien activity") that befall them. Some glorious, classic lines emerge as the family's plight escalates. " Talk about a Merry f*****g Christmas!" dad, Frank, exclaims at one point. Then, as the disintegration sets in, "...And I thought last year's Christmas was bad!" "What was wrong with last year's Christmas?" mum demands, somewhat surprised and hurt. "Well, let's see," dad replies, "...EVERYTHING!"

Later, when mum and dad are arguing, their nerves on edge from the terrifying situation they find themselves in, his anger can eventually be given full vent: "I know it's the season of giving, but I just don't give a s**t right now about any of that, alright! *I just wanna get off this goddamned road!*" And as dark secrets emerge (teenage daughter Marion is pregnant, Richard smokes pot, dad is having an affair, mum has had one in the past – with his best friend and one of the kids isn't even his!) the events actually drive mum completely over the edge. Amid all the death and spooky mayhem, she slips into loopy denial trying to block out all the horror and act as if nothing unusual is happening. "What a wonderful Christmas," she says in that tone of voice a condescending adult uses to a young child, or someone they are condescending to. "Yeah, right!" dad snorts. Then, when she sees what appear to be dead people in the woods watching them, she coos, "Why are they so sad? – It's Christmas Eve!"

And *what* a Christmas Eve it turns out to be! This is an excellent, offbeat horror; tight, taut, tense and edgy – but also extremely funny. It features atmospheric music, some great cinematography, from strange camera angles to high, aerial establishing shots of the car travelling along the mysterious road through the apparently endless forest, its headlights lighting the road ahead as it ventures on into the haunted night. The performances are good all round, though Ray Wise is the standout. And all in all, this sharp, immensely entertain-

ing little horror that uses Christmas and its associations (especially with family) as a witty counterpart to its twisty, tricky plot.

But the plot of **Dead End (2003)** probably seems next door to commonplace compared to the wacky, modern comic book style story of our next entry, **Bikini Bandits Save Christmas (2004)**. This is the first animated feature for a group of (usually) bikini-clad, gun-toting super-vixens whose franchise started out its life on the internet in short films before progressing to micro-mini-budget exploitation video/DVD fare. The heady mix of sexually crass humour, sex scenes, violence, foul language and hip-hop music has helped them to garner cult status.

The whacked-out storyline of this edgy, urban, comic book and manga[299] influenced animation sees the swimsuited stars trying to rescue Santa (who it turns out is actually the father of one of the Bikini Bandits) from a black voodoo-dabbling gangsta's and the evil G*Mart corporation, which plans a corporate takeover of Christmas and all things Christmassy.

It stars Schoolly D and Maynard James Keenan (of the bands Tool and A Perfect Circle) and features music from the Misfits. The animation by Paul Thiel is certainly bright, colourful and at times flashy – coming across much like an adult comic book or graphic novel – but its style is variable (at times reminiscent of 70s exploitation movies and their poster art, at others like animated Japanese television programmes...like **Yu-Gi-Oh** for example). And they are crafty (probably turning a budget restriction into a choice of artistic style) as little is actually animated (i.e. moves) – most of what is onscreen at any one time remains still, static; only small areas are actually animated and move: more often than not it is the editing – cutting from one image to another – that gives this film any kind of dynamism. It does also features frames in frames (sometimes moving), and even text in frames, which adds to the comic book feel.

This "...Christmas tale full of tail!!!" (DVD box tagline) features zombie strippers, voodoo magic, sex, nudity, foul language (about every other word, so be warned!), graphic violence, wicked stereotypes and (credit where it is due) a few quite nice touches. I particularly liked the Mikey Galactic song at the end about the alternative festive holiday "Kwanzaa" (created in the 1960s and mostly celebrated by African Americans) to replace Christmas. There is also some food for thought and a few socio-political points made. For example, a black urban youth called "Bitch" convinces Santa that Christmas is "outdated, exclusionary and racist." And following his interaction with the urban youth of today and the bikini bandits, Santa's has a new sleigh – a souped-up cherry-red '69 El Camino on skis instead of wheels. The appearance of Father Christmas (who was ousted from public affection and replaced by Santa Claus in the last corporate takeover of Christmas in the 1820s according to this film) as a mohawked, Travis-Bickle-from-**Taxi Driver (1976)**-inspired super-hero type was pretty cool and made me chuckle too.

I cannot help feeling though, that the creators of this film, and indeed the whole concept of the Bikini Bandits, are somewhat juvenile. It seems they aspire to be some kind of Russ

299 Japanese comic book style illustrated literature and art form that is produced for and appeals to an adult (as much as a teen and child) audience

Meyer/Quentin Tarantino/Trey Parker & Matt Stone wannabes who are desperate to cream a quick buck. I have nothing against paying homage to 1970s exploitation movies, or parodying **Charlie's Angels** type female action teams – even with a hefty dose of sex, explicit violence, crass humour and foul language thrown in – I would just prefer to see it done better, is all. Because when it finally comes down to it, this film just isn't really all that good, cult status or not. The blurb on the back of the DVD cover says, "Yule drop a Yule log when you see this!"... and you might well do! It is definitely not one to slip on the DVD player after Christmas dinner with granny and all the kids around! ...Unless you think they will enjoy seeing a drunk and depressed animated Santa getting a lap-dance in a strip club called the "Butt Hut". Indeed, I get the distinct impression that it would probably seem a whole lot funnier and more entertaining through a haze of wacky-baccy and/or alcohol!

With a title like **Spacemen, Go-Go Girls and the True Meaning of Christmas**, you might expect the 33-minute short Canadian film released the same year as **Bikini Bandits Save Christmas** to be in the same vein...and very broadly speaking it is...or at least a similar vein. (Except of course that it is a live-action presentation rather than animated). It too is cheap, tacky, rude, crude, crass and juvenile – "We're from Uranus" (pronounced 'your anus') one of the space visitors proclaims to an Earth woman. Naturally he receives a slap across the face!

Written and directed by Brett Kelly, the plot is simple: aliens come from the planet Uranus to steal Earth's resources and it is up to a group of Go-Go dancing Private eyes to stop them! It is ultra-ultra-cheap though – the aliens have silver sashes and party boppers on their head! – but it does show great affection for and pay nostalgic *homage* to past sci-fi staples like the Buster Crabbe **Flash Gordon** and **Buck Rogers** serials of the 1930s and 40s and the films of Ed Wood, for instance.

For anyone who is interested (though I expect that would be precious few), **Spacemen, Go-Go Girls and the True Meaning of Christmas** is available on DVD[300] as part of a double bill with **Spacemen, Go-Go Girls and the Great Easter Hunt** from 2005.

Back across the border in the USA, and also released in 2004 (though straight-to-video/DVD despite having three decent star 'names' on board in Annabella Sciorra,[301] Carey Elwes[302] and the Gorgeous Rachel Leigh Cook[303]), **American Crime**, directed by Dan Mintz and written by Jack Moore and Jeff Ritchie saw a pretty TV news reporter (Cook) believing that she has tripped across the trail of a serial killer who leaves video tapes he makes of the movements

300 The DVD is entitled *Space Men, Go-Go Girls Double Feature* and as well as the two short features, it contains some extras like Go-Go Girl auditions!

301 Who starred in films like Spike Lee's *Jungle Fever (1991)*, *The Hand That Rocks the Cradle (1992)*, Abel Ferrara's *The Addiction (1995)* and *The Funeral (1996)*, and *Cop Land (1997)*

302 Who starred in films like *The Princess Bride (1987)*, *Glory (1989)*, *Hot Shots (1991)*, *The Crush (1993)*, *Robin Hood: Men in Tights (1993)* and *Kiss the Girls (1997)*

303 Who starred in films like *She's All That (1999)*, *Get Carter (2000)* and *Josie and the Pussycats (2001)*

of his potential victims. This occurs when she is investigating the death of a local stripper, but she has trouble convincing the police. Then, as the staff of the TV station celebrate at their Christmas party, she receives an unexpected Christmas present – and probably one of the most unwanted presents you could imagine: a videotape from someone who has been following her movements...like those she and her crew have seen of the serial killer's victims!

Unfortunately, although this film starts off well with a quirky, arty opening titles sequence, and the initial plot direction is intriguing, it fairly plummets shortly thereafter. The director's control is obviously shaky (at best) and Cary Elwes' performance as the strange host of another investigative crime TV show is nothing short of laughable at best. Even if you do start to watch this movie, you may not stay around for the dodgy *dénouement*, it sinks so low!

But at least ***American Crime*** starts off well...that I more that can be said for the same year's ***Trees 2: The Root of All Evil (2004)***! This film is just a shocker from start to finish (and I mean in terms of quality, not scares!)...though some of the (supposedly) special effects are at least funny. It is the sequel to a micro-budget straight –to-video/DVD Indie spoof of ***Jaws (1975)*** called ***Trees*** that was written and directed by Michael Pleckaitis and released in 2000. In that film, killer "Great White Pine" trees terrorise a town set in a mountain forest close to its Memorial Day celebrations. ***Trees 2: The Root of All Evil (2004)***, again written, directed, produced and edited by Michael Pleckaitis, is set at Christmastime and has a plot as preposterous as ***Elves (1990)***. It spoofs ***Jaws 2 (1978)*** and this time round the lethal trees are deadly and non-deciduous; they are evergreens with attitude. No, not crazed conifers, but – you are way a head of me aren't you? – yes, you've got it, they're killer Christmas trees!

I realise that it is meant to be a comedy rather than an out-and-out Horror Flick and indeed some of the killer Christmas tree effects are funny (in that way-sub-Ray-Harryhausen, old-school kitsch, animated sort of way). They have luminous green eyes, three legs that they hop or scoot around on like Triffids[304] on angel-dust and arm-like branches. They look about as scary as those battery-operated, singing plastic novelty Christmas trees with faces that appear in the shops every October onwards, or the killer giant bunny rabbits in ***Night of the Lepus (1972)***! The CGI images of them attacking the town *en masse* like a forest fomenting revolt are awful and an absolute howl as a result. (I bet even MacBeth never had to put up with anything like this when Birnam Wood came to Dunsinane!). Trouble is, none of this (I guess) intentional awfulness saves the film from being a poorly made inane bore. You will drop your needles of indifference long before the end and a few glimpses of deliberately shoddy, silly effects will in no way compensate for the direness of the overall package. Though I guess seeing Santa (or at least a citizen in a Santa suit) speared through the chest by a branch of one of the might put a smile on the face of the most jaded viewers!

Still in 2004 and still in America, another sequel saw Santa slain too – well sort of. But this one was a far superior film to ***Trees 2: The Root of All Evil*** – despite being the fifth entry in this particular series (or perhaps franchise would be a better description. The film was ***Seed***

304 Walking, carnivorous alien plants from the novel *The Day of the Triffids* by British sci-fi author John Wyndham, made into a film in 1962 starring Howard Keel and a British TV series in 1981 starring John Duttine.

of Chucky (2004),[305] the fourth sequel to the original cheap 'n' cheerful late 80s possessed-toy 'Slasher' shocker *Child's Play (1988)*. Unusually for Hollywood, the sequels to this particular movie seem to have gotten bigger, costlier and more inventive as time has passed, with the latter ones coming across as post-*Scream (1996)* post-modern Horror-Comedies. This one was co-produced by Romania and the US.

Although none of the previous films in the series had featured Christmas – perhaps surprisingly given the central character and anti-hero, Chucky, is a doll (even if a doll possessed by the spirit of a homicidal maniac!) – *Seed of Chucky* made a point of doing so...at least in one super scene. (Well, as Chucky says, "The family that slays together, stays together.")

A white screen fades in to reveal black boots walking through snow accompanied by festive music on the soundtrack. "So, you don't believe in Santa Claus?" a voice says as a change of shot reveals that the black boots belong to Santa who is entering a snow-clad cemetery with his red toy sack slung over his shoulder. The voice was his and he continues talking into a mobile phone as he strides between the headstones that pepper the graveyard, poking up out of the snowy ground. "Well trust me honey," he says, the false beard of his costume drawn down under his chin, "Tonight I'm gonna make you believe."

A medium shot provides a closer view of British actor Jason Flemyng[306] in the Santa suit. "Wait till you see what Santa's bringing you, you naughty girl!" he continues, talking to his girlfriend on the mobile phone. But he is stopped in his tracks when his conversation makes it obvious that his girlfriend is dumping him. "Wait, you're breaking up with me on Christmas Eve?" he asks with incredulity; continuing, "You've got to be F*****G kidding me!..."

As he speaks, a close-up on the toy sack on his back reveals the sharp blade of a knife cutting through the red material. Santa begins to trudge on through the snowy cemetery, but a noise makes him turn, and he sees a trail of toys that have fallen from his sack into the snow. Exasperated, he heaves a sigh before kicking out at and stomping on the toys, taking his frustration out on them.

A Chucky doll (*The* Chucky doll!), its faced scarred from all his previous battles in former films, sits propped up against a headstone in the background staring at Santa; but he snaps his head to the front when the not so jolly, red-suited figure looks at him. Unsure whether he has seen the doll move or not, Santa kneels in front of it, peering into its immobile plastic face. But Chucky's Bride, Tiffany, can be seen over Santa's shoulder creeping up on him from behind. Chucky blinks startling Santa, but before he can react, Tiffany has thrown a slinky round his neck garrotte-like and is strangling him. At the same time, Chucky whips out a knife and slashed it across Santa's stomach sending the padding there flying. "I knew it!," Chucky exclaims, "You're not real!"

305 Aka *Child's Play 5*, *Bride of Chucky 2* and *Son of Chucky* (all working titles)
306 Who has starred in films like *Deep Rising (1998), Lock, Stock and Two Smoking Barrels (1998)* (aka *Two Smoking Barrels* in the US), *Snatch (2000), The League of Extraordinary Gentlemen (2003)* and *Layer Cake (2004)*

Chucky then slashes the man in the Santa costume across the throat so that he pitches over into the snow, lying on his back gurgling in his own blood. "You were never real!" Tiffany chides, before demanding, "Do you know what that kind of disappointment can *do* to somebody?!"

"Do you have *any* idea how that can *F**K* with your mind?" Chucky explodes as he stabs the dying man in the Santa suit, repeating the question again and again as he stabs.

But as this is happening, the camera pulls back to reveal thick leads plugged into the backs of Chucky and Tiffany. They are animatronic special effects dolls on a film set, and Jason Flemyng is playing himself shooting a film called (**Chucky Goes Psycho**) based on the infamous possessed doll serial killers! "Cut, cut, cut" shouts the director from off-screen.

Ok, so Chucky doesn't *actually* kill the *actual* Santa in **Seed of Chucky**...but it is a brilliant, funny, superbly executed (so to speak!) scene that toys (there we go again!) with viewer expectations a treat. And indeed the whole film is a knowing, witty, fun post-modern pastiche. Written and directed by Don Mancini, **Seed of Chucky** once again stars Brad Dourif as the voice of Chucky and Jennifer Tilly as both the voice of Brittany and herself (kind of). And as well as Jason Flemyng, Brit actress (and ex-member of pop group S Club 7) Hannah Spearitt, makes a pre-**Primeval**[307] appearance. The whole thing is great fun.

But **Trees 2: The Root of All Evil** and **Seed of Chucky** weren't the only representatives of sequels in film series' to hit the screens with a Christmas theme in 2004. One further US movie did that too. This time a made-for-US TV production...and this one united two separate earlier franchises or series. Shot in Sofia, Bulgaria, **Puppet Master vs. Demonic Toys (2004)** (aka **Puppet Master 9** and **Demonic Toys 3**) was produced for The Sci-Fi Channel and tried to do the same thing for two low-budget B-movie Horror series that the previous year's **Freddy vs. Jason (2003)** and the current year's **AVP: Alien vs. Predator (2004)** were trying to do for other, higher profile Horror/Sci-Fi franchises or series.

Now some people, I know, really look forward to sampling a selection of various cheeses at Christmastime. Well, if you're one of those people, you might want to add this movie to your Christmas shopping list! Because this sub-B-movie cheesefest is one of the cheesiest festive horror flicks you're ever likely to see! This is as much *fromage* as *homage*! Don't get me wrong though; by cheesy, I mean that it wilfully, playfully and knowingly lays on the hokum for laughs rather than for terror...and in the case of 80s icon Corey Feldman (star of such films as **The Goonies (1985)**, **The Lost Boys (1987)** and **Licence to Drive (1988)**) it comes with an awfully thick slice of rather tasty ham to boot!

Back in the 1980s and early 1990s, both the **Puppet Master** and **Demonic Toys** franchises were begun by Charles Band's Full Moon production company – and both were relatively successful low-budget horror hokum owing a huge debt to **The Devil-Doll (1936)**. They had planned to link the two franchises much earlier, but due to financial problems and so forth,

307 British Sci-fi TV show featuring time portals, dinosaurs and aliens

both went their own separate ways (***Demonic Toys*** linking up with the ***Dollman*** films which starred ***Trancers'*** Tim Thomerson as a tough alien cop who chases his arch-enemies to Earth, only to find that on this planet they are doll-sized; and ***Puppet Master*** churning out a whole string of sequels and prequels). When The Sci-Fi Channel did finally manage to get the two franchises together for this made-for-TV festive romp, it naturally meant that the violence quotient that both had been noted for (and the profanity count) had to be toned down from the precursors (some of which were 18 or R rated for theatrical release). But even so, what resulted was a nostalgic tongue-in-cheek festive cheesefest for devoted fans.

The plotline sees four of the puppets created by Andre Toulon[308] (Blade, a skelton-faced hook and knife wielder; Six Shooter, a six-armed cowboy gunslinger with miniature pistols; Pinhead, a huge muscle-bound strongman with a tiny head; and Jester, a killer clown with a face made up of spinning disks) in the hands of Robert (Feldman), the great, great grand-nephew of the original Puppet Master, and his cute teenage daughter Alexandra. They have fixed up the puppets (who suffered damage in their previous adventures) and have rediscovered the secret formula for bestowing life upon. But spoilt-brat, rich-bitch toy manufacturer, Erica Sharpe (whose father sold his soul to a demon to please her) has been spying on them and wants the formula (and the puppets) for her own nefarious ends. She is played by Vanessa Angel, who starred in the TV series **Weird Science** and the Farrelly Brothers' comedy ***Kingpin (1996)***.

Sharpe is in concert with a demon called Bael that can bestow life on toys (her henchmen are an evil-faced baby with the personality of a murderous, wise-mouthed, bad-ass who can shoot himself across the room at an enemy using fart-power; a razor-toothed Teddy Bear and an evil Jack-in-the-Box with an ear-drum-shattering shout – the Demonic Toys). A couple of days before Christmas, Sharpe has the best selling 'must-have' toy of the season in the shops – Chucky-ish "Christmas Pal" dolls. But Bael offers to help her turn the 9 million dolls she has sold or distributed to the poor already into psycho demonic killer-toys so she can take over the world[309] if she will kill the last member of the Toulon family (whose ancestor duped him previously).

But the plot is not really what this film is all about. It's all about entertainment and fun. So, while Feldman and Angel make ham roles, the toys look pretty cool (at least until they move about, as the movement is often very jerk!) and the Demon Bael even gets to dress up as Santa when he pops up out of Hell through a hole in the floor of Erica's basement first thing Christmas morning waiting for the blood sacrifice and the "greatest slaughter of innocents of all time."

Some may find this all-but-unwatchable and pretty much below contempt; others will probably relish its broad, almost slapstick humour. It is certainly not one for those viewers

308 Killer marionettes that can be brought to life with a secret elixir, which must contain Toulon blood, to carry out assassinations on command

309 A very similar plan to that in ***Halloween 3-Season of the Witch (1982)*** – the only one of the ***Halloween*** series of films not to centre on, or indeed even feature the character of Michael Myers

looking for gritty realism, scares and chills. (Just as much as it is not one for those looking for the usual or standard sugarcoated, holly-jolly, sweet 'n' bright-as-a-candy kind of Christmas flick). But if you are fond of fondue, you might just want to tuck right in!

In sharp contrast to the small-budget and relatively low-key aspirations of 2004's **Puppet Master vs. Demonic Toys**, the next year's hug-scale, massive-budget Hollywood blockbuster **The Chronicles of Narnia: The Lion, the Witch and the Wardrobe (2005)** from Walt Disney Pictures looked to take the whole world by storm (much as **Snow White and the Seven Dwarfs** had done in 1937, and Hitler tried to do without the same level of success in 1939!). This 143-minute fantasy awash with cutting-edge special effects followed hot on the heels of Peter Jackson's absolutely spectacular 11-Oscar-winning[310] **The Lord of the Rings: The Return of the King (2003)**, which completed the Tolkein trilogy he launched upon a startled cinema-going world with the 4-Oscar-winning[311] **The Lord of the Rings: The Fellowship of the Ring (2001)** and continued with the 2-Oscar-winning[312] **The Lord of the Rings: The Two Towers (2002)** – the watershed, **Star Wars**-style phenomenon of their day (even up against the continuing episodes in that historic screen saga!). This was a monumental achievement and an extraordinarily high standard to try and compete against or maintain. And while it fell short of this, **The Chronicles of Narnia: The Lion, the Witch and the Wardrobe (2005)** was nonetheless an Oscar winner[313] and a spectacular success in its own right.

True it is not really a Christmas film, and not really horrific (although it does feature all manner of mythical beasties, and Tilda Swinton's White Witch was truly chilling!); but among all the mythical creatures in Narnia, Santa does make an appearance. The Pevensie children – WWII evacuees from the London Blitz, who discover a portal to a magical land in an old wardrobe in their uncle's country house – are fleeing across a frozen lake when they see a sleigh heading their way. Fearful that it is the wicked White Witch who wants to keep the land in a wintry thrall and kill them off pursuing them, they make a desperate dash for the woods. But it turns out to be Santa Claus with some presents for them that they will find useful in their fight against the Witch.

This is a lovely scene and very well directed so that its *dénouement* (for anyone who is unfamiliar with the book) is a nice surprise twist. But alas, our brief visit to the land of big-budgets and high quality entertainment is all too brief a one, and back among the living-brain-dead in the land of no-budget Indies, we come face to face with **Waning Solstice**.

310 It won in the categories for Best Picture; Best Director (Peter Jackson); Best Writing, Adapted Screenplay; Best Visual Effects; Best Editing; Best Music, Original Score; Best Music, Original Song; Best Achievement in Sound Mixing; Best Art Direction, Set Decoration; Best Costume Design; Best Makeup (winning in all the categories it was nominated in).

311 It won in the categories for Best Cinematography; Best Visual Effects; Best Makeup and Best Original Music Score (and was nominated in 9 other categories)

312 It won in the categories for Best Sound Editing and Best Visual Effects (and was nominated in 4 other categories)

313 It won in the category for Best Achievement in Makeup (and was nominated in 2 other categories)

This US-produced shoesring all-but-one-man-show was directed by Shane Will – who also co-wrote and produced it (with Mark Lowry), and edited it. It is set around Christmastime in contemporary America, juxtaposing shots of Christmas lights and decorations with scenes of gory slayings.

The story concerns an 11th century witch-hunter and Mediaeval Inquisitor who, having failed to completely destroy a witch, summons a demon into him, forsaking his eternal soul, to keep him alive until such time as she is resurrected and tries to rule the world again with her demons. And when a teenage Californian occultist's power-hungry girlfriend sets about rousing and raising the witch, it is time for a showdown.

Unfortunately this film is an amateurish and inept, over-reaching waste of 82-minutes. It is awful; the nadir. Watching this film is like finding a huge, great, black lump of coal in your stocking on Christmas morning; or finding that the guy in the Santa suit whose lap you have just sat on as an 8-year-old girl is Gary Glitter! Do yourself a favour – avoid this one like you tried to those big, soppy wet-kisses you did from your Granny as a kid when she came to stay for the holidays. Believe me, watching this would be as bad as your Granny lobbing the tongue in!

So how about a 78-minute Canadian-American Christmas Comedy-Horror starring an ex-American Football Player and World Heavyweight Wrestling Champion (who defeated Hulk Hogan to win the title) as a demon Santa Hell bent on slaughter instead? ...Yeah, I thought that it sounded pretty dire too! But in fact, **Santa's Slay (2005)**, starring ex-Atlanta Falcons, Los Angeles Rams and Carolina Panthers player, and ex-wrestling World Champion Bill Goldberg, rather surprised me. Let's face it, it was never going to compete with **The Lord of the Rings** trilogy on the Oscars front; but it is actually reasonably well made on the whole and darkly funny to boot, tickling the chuckle-muscle throughout, and with an absolutely hysterical killer opening scene. It is somewhat gory in places, but otherwise campy, comic book fun with a refreshingly dark, if somewhat juvenile, sense of humour, and a truly, bizarrely inventive plot. In fact, what with Bill Goldberg and all those other ingredients, I think it has cult written all over it!

In **Santa's Slay**, Santa is the son of Satan (hence the name is an anagram) conceived by the virgin Erika – the world's only other virgin birth – in some dark past in the lands of the Norsemen (Vikings). There, in the frozen middle of the winter Santa likes to set out on a slay ride and slaughter some people just for kicks; so the frightened Christian converts get together and hold Masses for Christ (Christ-Mass, geddit?) asking God to send an angel to deliver them from the evil one. And in 1005, in answer to their prayers, God does indeed send don one of his angels, who challenges Santa to a curling contest! The stakes? – the angel's soul (he will suffer in Hell through all eternity at the hands of Santa's father Satan if he loses) against Santa having to clean up his act and be a good boy for a thousand years, turning his mid-winter slaying day into a joyous day of celebration, delivering presents to all the world! ...And *that's* how *that* legend got started! (And this whole tale is related in the movie via a 3-D animated puppet sequence, reminiscent of the old Rankin-Bass TV Christmas Specials, like **Rudolph the Red-Nosed Reindeer (1964)** and **Santa Claus Is Comin' To Town (1970)**).

Trouble is...it is now Christmas 2005, and the thousand years is up, so it is a decidedly pissed-off demon Santa who is visiting this year (still dressed in his red Viking robes and riding a longship-styled sleigh pulled by a single white buffalo (or Helldeer as he appears on the cast list!) and rocket assisted! This Satanic Santa does not have not giving on his mind, but *taking* – the taking of lives! And in as gory and gruesome a manner as he can muster!

This is amply evidenced in the show stopping pre-credit sequence at the Christmas dinner of the decidedly dysfunctional Mason family. As the family sit around the table in their festively decorated home with its trimmed and fairy-lit Christmas tree, father (played by an uncredited James Caan) says to his wife Victoria (played by Fran Drescher who has a voice like cats gargling gravel while being neutered with a rusty carving knife!) as the turkey arrives: "You know what I was thinking angel?...I was thinking, 'Dear God, don't let this bird taste like a shoe, like it did last year. Let it be tender and moist just for once.'"

To which, she crudely replies (in that voice and accent of hers that has the same effect on most people as fingernails being dragged down a blackboard): "Yeaaah moist, that would be nice...It's called foreplay!"

And not to be outdone, her husband ripostes: "I don't want to screw the bird, I want to eat it!" (Top family! Top table manners! Top laughs!).

Then one of the air-head, bubble-brained daughters, while saying Grace, offers thanks that the "loving family can be together this X-mas," adding, "Thank you for not making us poor, or...Samoan!" (Priceless). All this to the accompaniment of holly-jolly Christmas music on the soundtrack. Like opening up and decanting that 30-year-old bottle of vintage port you have been saving after everyone else has gone to bed on Christmas Eve, it is devilishly divine. This whole scene had me in stitches!

Then as the 'joyous' family gathering deteriorates even further into petty bickering, carping and bitching, there is suddenly a thump or two on the roof and a falling of soot down the chimney into the fireplace. Red clad legs appear, and Santa having dropped down the chimney and got his feet on the floor, smashes the stone fireplace to emerge into the room in soot-covered red Viking tunic, a picture of pure malevolence. In a gruff, mocking growl, he announces rather sardonically, "Yes Virginia, there *is a Santa Claus!*" Then, with that he joyously sets about slaughtering the entire family!

James Caan's character never does get to find out if the turkey is moist this year; and Drescher's gets her just dessert for that horrible voice (including having her hair set on fire)! And the son played by Chris Kattan (who starred in **Corky Romano (2001)** and probably deserves to die for that alone!) meets a horrible end too! After which, 'Joy to the World' strikes up as the movie moves into its opening credits.

This is a purely (and probably puerilely) priceless opening scene. Unfortunately though, the movie doesn't quite manage to keep up this standard all the way through.

Santa slays his way through town in a comically gory fashion, hunting down the angel (who is played by **I Spy**'s Robert Culp) who he lost the bet to a thousand years ago (and who we learn renounced his powers to marry a human).

Santa's Slay (2005) is far from perfect to be sure, but it is a lot of fun. And the casting of Goldberg in the central role actually comes off a treat. There are a lot of hit and miss jokes and one-liners amidst the gory-comic mayhem; and some really funny use of swearing. In one instance, a cantankerous, miserable old woman in a shop reprimands the shop owner for wishing her a "Happy Holiday" by insisting: "Don't use that political [PC] crap with me. It's Christmas; wish me a Merry Christmas." Then, when he does, the miserable old cuss replies, "Thank you, and go f**k yourself!" Similarly, on Christmas morning in an anonymous household, two kids aged about 10 and 12, who are dressed in festively-patterned pyjamas with a large gift wrapped present in front of each of them, say as their sweet looking mother and very old grandparents watch on:

"Can't wait to see what shit we got!"

"Can we open our motherf******g presents now?"

"Course" their mother replies sweetly, not batting an eyelid at his cussing.

Then, when the two boys eagerly tear into their gifts from Santa, both presents explode, blowing their heads clean off!

The sweet little old granny, obviously shocked to the core, exclaims simply, "F**K!"

Some of the jokes are decidedly juvenile (there are characters called Dick Zucker and Tess Tickler, for instance, which could come straight out of an old **Carry On** film), and some do misfire a bit. But, hey – they come so thick and fast it doesn't really matter. A few of the characterisations also leave a little to be desired too; but then, I guess they were never really the point, were they? All in all what you have is a gloriously fun, alternative piece of comic-horror Christmas fare crying out for cult status. So, if you fancy seeing Santa portrayed as a killer demon who "hasn't always been that loveable poster-boy for Coca-Cola" or hurling the star from a Christmas tree like a Kung Fu weapon at a fleeing victim, then this may just be the movie for you. It is certainly great fun without actually being all that great.

And while our American cousins were holding up their end of the 'special relationship' between we English-speaking (more or less!) nations by preventing an ancient demon Santa from getting a foothold in the modern world, we Brits were holding our end down this side of the Atlantic saving the whole world from an extra-terrestrial threat. Ok, so we had more than a bit of help from a different extraterrestrial in the (new, regenerated) form of **Dr. Who**... but what the hey!

The Christmas Invasion (2005) was a one-hour, stand alone Christmas Special for the phenomenally successfully resurrected seminal BBC Sci-Fi show. It saw a new doctor (the tenth) emerge in the form of talented Scots actor David Tennant, taking over from equally talented Christopher Eccleston in the first 'regeneration' in the new series. Eccleston, who had already had considerable success on the big screen in films like **Shallow Grave (1995)**, **Elizabeth (1998)**, **eXistenZ (1999)** and **28Days Later (2002)** had helped breed new, high-tech blood into the old format, propelling it into a worldwide synergistic, franchise-fomenting success; but felt that his job here was done and it was time to move on. Tennant took up the mantle, becoming in many people's eyes the best 'Doctor' ever.

In this, the firs feature episode in which he starred, his recently regenerated Doctor lies semi-conscious, recovering from his ordeal, in a bedroom in the flat of his Earthly assistant Rose Tyler's mum for most of the running time. Which is unfortunate, for although it is Christmas Eve, the time of 'Peace on Earth and Goodwill to All Men' it is most certainly not a silent night! it may well be the night before Christmas and all through the house not a creature was stirring...but in space the same was most definitely not true. For a huge spaceship full of aggressive, ugly Klingon-like bonehead warrior aliens called the Sycorax, were headed straight for Earth and looking to conquer and consume the entire planet!

The Doctor's assistant Rose Tyler (played by pretty Brit pop singer-turned-very-able-actor Billie Piper), her mother Jackie (played by Camille Coduri), her boyfriend Mickey (played by Noel Clarke) and the British Prime Minister Harriet Jones (played by Penelope Wilton) who had already had dealings with both the Doctor and other alien aggressors, tried their best against gun-toting killer robot Santa Clauses and killer alien Christmas trees (much better realised than in the previous year's **Trees 2: The Root of All Evil**, needless to say, but not as gory as those still to come in **Treevenge (2008)**!) but to no avail. It was the newly regenerated Doctor who became the world's saviour once again in the end, seeing the Sycorax off with their tales tucked between their legs. (Though as they retreated, the British Prime Minster had them blown to smithereens, prompting the Doctor to question whether it was actually the aliens who needed protection from humankind, and seeing him slyly destroy the career of the Prime Minister he had once helped into office).

And while the Doctor's derring-do was deciding the day against plastic masked slaying Santa robots, alien killer Christmas trees and snarling, bony-bonced extra-terrestrials, we Brits were also turning out a half-decent straight-up, full-on low-budget Indie festive Horror in the form of the 81-minute long **The Toybox (2005)**. Written and directed by Paolo Sedazzari and starring no one you will ever have heard of (probably), this is obviously inspired by Edgar Allen Poe's *The Fall of the House of Usher* (the central family's name is even Usher), but it also throws witchcraft, enchantment, folklore, superstition and the glorious British countryside of East Anglia into the mix – each adding to the rich flavour like all the fruits and spices in a traditional Christmas pudding.

Growing up, the Usher children read about and develop a special affinity for local two characters of local folklore: a witch called Celeste Noir and a murderous cannibalistic outsider

called Jake the Midfolker[314] who slaughters people with a hook. Berenice Usher believes that she is the reincarnation of the witch and tortures her brother Brian (by locking him in the toybox of the title for hours on end) until he sees things her way. As a result though, Brian becomes emotionally dependent upon his sister, feeling betrayed and turning to composing nihilistic, punkish music when she leaves to go off to university, in the hope of finding fame, fortune and escape with his band.

When Berenice comes home from university for the holidays one Christmas Eve with her boyfriend Conrad in tow, he not only has to endure meeting her folks (an all too familiar situation for almost everyone!), but he quickly picks up on the undercurrents of dysfunctionality that have obviously long been bubbling beneath the oh-so-British, stiff-upper-lipped, tea-with-the-vicar, middle-class surface veneer of their family façade. Indeed, the film's standout sequence is a family dinner the evening before Christmas Eve when the Usher family begin to tear each other to shreds in an oh-so-British as the excrutiatingly embarrassed Conrad watches on, trapped.

The undercurrents of self-destruction have obviously existed for many years (and been swept under the carpet, or kept in the closet where skeletons belong)...but there is an element of performance about their release. Maybe the fact that a stranger is there to 'judge' helps everything break the surface and erupt in what is surely one of the best fish out of water dinner scenes since **Eraserhead (1977)**. And the family 'dirty washing' that gets washed in public over this holiday includes revelations of perversions and immorality as well as hints of incest and insanity! And all the while, at the same time, some kind of supernatural forces seem to be afoot: father is receiving strange letters with clown motifs on them; Brian is seeing visions of clowns and a glowing-eyed character that may be Jake the Midfolker appears to be striding through the beautiful East Anglian countryside toward the Usher house and a final, terrible confluence and destiny.

Is the eventual 'fall of the house of Usher' (replete with insanity and bloody slaughter) a result of supernatural forces, or of psychological ones fed by superstition? Either way, mum, dad and granny are offed with a hook and Berenice locked in the toybox with a gnawing* of rats as batty brother Brian flips his lid and makes like Jake the Midfolker, whose spirit may literally or may figuratively have possessed him! ...And when Conrad returns from the railway station where Berenice dropped him after an argument to make up with his girlfriend in spite of her strange family, he ends up dead, bleeding into the pristine whiteness of the idyllic snow too! In the end, only Berenice survives, rescued from the rats in the toybox by the local vicar, who calls the police. And when they finally arrest bonkers Brian, following his bloody seasonal slay ride, the nutty-as-a-Christmas-fruitcake ne'er-do-well happily wallows in the longed-for celebrity (even if it is as a result of infamy rather than fame).

For a low-budget feature, this production boasts some excellent performances (not least from Suzanne Bertish who plays the vampish, lascivious mother) and both lighting and

314 He is so called because he is neither a Norfolk man nor a Suffolk man (the counties with a strong local rivalry that comprise the bulk of East Anglia – with the county of Cambridge to their west and Essex, which is sometimes, but not always considered a part of the region to their south), but an outsider.

camerawork are classy in the naturalistic and expressionistic scenes (especially the steadicam work, which at times is purposely very unsteadicam!). As well as providing a good reason for getting Berenice home from university with her boyfriend, the seasonal setting, the time of family gatherings and goodwill to all, also provides a beautifully ironic counterpoint to the disintegration of the Usher family. Amid festive decorations, Christmas trees and gift-wrapped presents, warped presentiments a-plenty arise, and it is little wonder that this movie won a couple of festival accolades.[315].

[**A collective noun invented by the author!]

And accolades are, in my humble opinion, what the made-for-Spanish TV feature, ***Películas para no dormir: Cuento de navidad (2005)*** (aka ***Films to Keep You Awake: The Christmas Tale***[316]) deserves too.

This TV-movie, one of six made in 2005 and 2006[317] as a modern reincarnation of an old Spanish TV series of 'films to keep you awake' – is an absolute gem (though all six are of a very high standard indeed, and well worth a watch if you ever get a chance).

Written by Luis Berdejo and directed by Paco Plaza, ***Películas para no dormir: Cuento de navidad*** is at one and the same time a joyous nostalgic romp and a cruel contemporary tale of lack of childish innocence. Set in a Spanish seaside town in 1985, it is replete with fond, nostalgic memories and innumerable *homages* to pop-culture (for instance, it references the hit TV show **'V'** and contemporaneous hit films like ***The Karate Kid*** and ***Ghostbusters*** all from 1984) as well to the slew of B-movie (and below!) George A. Romero-inspired zombie flicks that were prevalent at the time by directors like Italian Lucio Fulci, and Spaniards Jess Franco and Jorge Grau. (Though, interestingly enough, not so much Spain's own earlier and unique zombie creations from the 1970s, the ***Blind Dead*** Knights Templar zombies of Amando de Ossorio!).

The plot sees five friends (four boys and a girl) who are on Christmas holiday from school discover a woman in a Santa Claus suit in the bottom of a dried up well in the woods near their home. When a couple of them go to report this to the police, they learn that she is a dangerous bank robber who used her Santa disguise to make her getaway among the crowds of Christmas shoppers and multitude of Santas. So, aborting their mission to free her from the well with a length of rope (causing her to break a leg when they beat her over the head to knock her back in the hole!) the not-so-innocent little darlings decide to starve and torture their captive into revealing the whereabouts of her haul (which they want for themselves). Indeed, the film so

315 Best Independent Feature award at the UK Festival of Fantastic Films and a Jury Award for Best Foreign Film at the San Fernando Valley International Film Festival

316 English language international release title

317 The others, all 2006 and all under the general title *Películas para no dormir* (*Films to Keep You Awake* or *6 Films to Keep You Awake*) are *La habitación del niño* (*The Baby's Room*), *Para entrar a vivrir* (*To Let*), *Adivina quién Soy* (*A Real Friend*), *La culpa* (*Blame*) and *Regreso a Moira* (*Spectre*)

ties-in its vision with their warped, inhumane pre-pubescent naïve wickedness, that any adults seen throughout have their faces obscured.

But the kids' perspective seems even further skewed and crazy when, thinking they have killed their captive, a couple of the youngsters who like watching trashy zombie videos, attempt to revive her utilising the seemingly loopy ritual they have seen in one of those films. ...But it appears to work! And the naïve (rather than innocent) kids think that they have created a stalking zombie killer, because the bedraggled bank robber's appearance – dirty, driven, crazed, hobbled etc. – so resembles the on-screen monsters they so delight in having put the willies up them. (The whole extended sequence when the woman escapes from the pit and follows her tormentors, axe in hand, to the closed because it is out of season amusement park where they lead her, is beautifully realised; with the viewer never entirely sure if the woman *resembles* a zombie because of the effects of her ordeal and her single-minded determination to seek vengeance if it's the last thing she does, or if she has actually somehow *become* a zombie, validating the kids' impossible-seeming child's eye view of events).

The kids though, armed and prepared having seen their schlocky zombie flicks and being fully cognizant of the crazy 'rules' for despatching such a supernatural adversary (a pointed weapon through the left eye into the brain!) set about despatching their own 'undead' nemesis with nary a batted eyelid. (Nor for that matter a moment of doubt, or remorse toward what might be a fellow human being who is suffering...albeit a not very nice one!). Is such inhumanity the price for believing in 'fairytales'? And if so, like zombies, isn't Santa Claus just a make-believe, fairytale 'make character? (Indeed in this film, the 'zombie' *is* Santa Claus!...Or at least the bank robber they think is a zombie is dressed as Santa Claus. An axe wielding, hobbled, dirty, single-minded, bent-on-murderous-revenge Santa Claus to be sure. But hey, with what provocation! ...And the darling little dears – the supposed innocents who are about to be slaughtered – are greedy, money-grasping little 'naughty' boys and girls themselves, aren't they?).

This rich, entertaining, funny little film perhaps has a lower gore-quotient than many splatter-heads would ideally crave. But it does boast some nice performances, some brilliantly evocative direction and cinematography, and it is a wonderful wander down Nostalgia Lane tied up with an intriguing contemplation of some really interesting themes around childhood, innocence, greed, Christmas, fairytale make-believe and the *real* world (if we can ever be sure exactly what that is). It is a whole Santa sackful of wicked, cruel fun! (Especially for fans of old Z-grade zombie flicks and other 1980s nostalgia nuts) – though it will probably have Mary Whitehouse's cadaver spinning in (if not rising from) its grave! Fans of Horror films, especially Christmas Horrors, should definitely seek this out: those in Mrs. Whitehouse's camp should probably give it a miss and do whatever it is they do to have themselves a Mary little Christmas instead! I personally think anyone who misses this cruel Yule terrorvision treat must be (Christmas) crackers!

The only other monsters worth a mention I know of knocking about our screens during Christmas 2005, were lurking in the TV listings across the Atlantic in America in the Cartoon Network's excellent animated TV series **Foster's Home for Imaginary Friends**. The 25-minute Christmas Special entitled **A Lost Claus** saw 8-year-old Mac's faith in the existence of Santa

shaken and all the colourful, surreal imaginary friends deposited at Madame Foster's foster home trying to convince him of the existence of the jolly fat man with a penchant for white fur trimmed red clothes and big black boots.

Naturally his own irrepressibly mischievous imaginary friend Bloo (full name Blooregard Q. Kazoo – a kind of living blue security blanket with attitude) tries to trick extra presents for himself out of the home's financial director Mr. Herriman. (Though he does this by trying to fake a series of spiritual visitations *a la* Dickens' *A Christmas Carol* and hysterically confuses Jacob Marley with Bob Marley impersonating a ghost in a red, yellow and green Rasta hat and dreadlocks!). Needless to say, when the real Santa shows up re-confirming Mac's faith and delivering lovely presents to all the other imaginary critters in this bright, colourful, madcap, wacky, imaginative, irrepressible funfest of a cartoon, irascible Bloo ends up with a mountain of presents, as he wanted, but each one turns out to be a big black lump of coal!

"Just you wait fat man," he howls to the heavens, threatening hollowly, "One day I shall have my vengeance!"

And vengeance is probably what any unsuspecting viewer who watches the no-budget, no-brainer from Austria called **Silent Bloodnight** from 2006 will want...especially if they thought that, with a name based on a famous Christmas carol, they were going to get a Christmas Horror! Because **Silent Bloodnight** has *nothing* to do with Christmas at all (and very little to do with Horror for that matter! ...Except perhaps your horror at having watched such god-awful rubbish!).

The American-produced **Stalking Santa (2006)** on the other hand – a comedy mockumentary written by Daryn Tufts (who also co-produced), directed by Greg Kiefer (who also executive produced along with **Star Trek**'s and **TJ Hooker**'s William Shatner, who is also the narrator!) – while not a Horror movie, is most certainly about Christmas. A summary anonymously posted on the Internet Movie Database (IMDb)[318] describes it as follows:

"Millions of people believe in him. Thousands claim to have seen him. But only one man is foolish enough to try to prove his existence. Self-proclaimed "Santologist" Dr. Lloyd Darrow will stop at nothing to take on government conspiracy, corporate suppression and fake mall Santas, all in pursuit of the world's oldest yuletide enigma. With emotional (and financial) support from his perplexed wife Barbara, dysfunctional devotion from his needy intern Clarence, and despite growing resentment from his 12-year old son Keith, Lloyd is determined to reveal the truth. It's an obsession that lands him finding out Santa-linked phenomena such as the hieroglyphics of Egypt, the Roswell crash and the Town Center Shopping Plaza in Polka City, OH (to name a few); and an obsession that just might cost him his family, his sanity and his self-respect."

Sounds plumb crazy enough to me to warrant a mention!

318At http://uk.imdb.com/title/tt0811082/plotsummary

But I think we are back on safer territory altogether though with the same year's inferior Canadian-American remake of a seminal 1970s bona-fide classic. Yes, **Black Christmas**[319] was back...2006-style; written and directed by Glen Morgan (an **X-Files** and **Millennium** writer, as well as the man who scripted **Final Destination (2000)** and **Final Destination 3 (2006)** among others). It featured Andrea Martin (who had played sorority sister Phyllis in the 1974 original) as housekeeper Mrs. Mac, and pretty much as lovely a group of sorority sisters as you are likely to see in the shape of actresses Katie Cassidy, Michelle Trachtenberg (who played Buffy's sister Dawn from the TV series **Buffy**), Lacey Chabert (who played Claudia in **Party of Five** on TV as well as Penny Robinson in **Lost in Space (1998)** and Gretchen Wieners in **Mean Girls (2004)**), Mary Elizabeth Winstead (who played John McClane's daughter Lucy in **Die Hard 4.0 (2007)**[320]), Kristen Cloke and Crystal Lowe. Unfortunately though – and perhaps because it is aimed at a younger, teen audience than the original adult shocker (who filmmakers perhaps feel want more of a rollercoaster ride experience than an intellectually stimulating entertainment) – this dumbed-down, wham!-bam! flash-in-the-pan MTV generation festive frightfest, while enter-taining enough in its own way, is still a mere shadow of its progenitor.

That having been said, however, it is still a pretty well shot 'horse of a different colour'; a gory, jokey, pacy show-it-all and explain-it-all, 'Tales from the Crypt' or 'Vault of Horror'-style gruesome funfair ride. It has no room for building tension and suspense because that is not a part of its plan. While the plotline remains broadly very similar to the original – a group of so-rority sisters at a snowy American university campus are picked off one by one by a deranged killer (or in this case killers!) who make disturbing phone calls to them - almost from the outset, the audience is made aware that Billy Lenz murdered his mother and her lover in the house that is now the sorority house and has been incarcerated in an asylum as criminally insane ever since. In this film there is no question that any of the main, sane characters might be the killer, as there was in the original; the only twist comes in discovering that Billy's sister Agnes (whom he witters on about in his phone calls as he did in the original) is also a maniacal, monstrous killer and the pair work in tandem.

One of the things that is lost in this version, (which insists on showing and explaining Billy's backstory and rationalising everything) is the very uncomfortable sensation that as a viewer perhaps you never would fully comprehend or understand what was happening and why. Although we see Billy neglected – and worse – as a child (kept for years in an attic by a cruel, uncaring mother who killed his father and used him to satisfy her perverse sexual urges, while doting upon his baby half-sister who was fathered by her lover), this depiction in some ways trivialises his experiences; it rationalises the irrational. Although we can comprehend that the experiences could have an adverse affect on the processes of his mind, by kind of experiencing them by proxy, i.e audio-visually onscreen, and *not* being driven murderously insane ourselves, it all seems a little *blasé* and we lose something in the concretising of the experience into images that would perhaps have been better served by our imaginations.

This sense of not fully understanding exactly what was going on made the end of the original film a real shocker, when we realised that, for all her courage and intelligence, Jessica Bradford

319 Aka **Black X-Mas** (promotional shortened title) and *Noël Noir* (French-Canadian title)
320 Aka **Live Free or Die Hard**

had *killed the wrong person* – her own boyfriend – and *the real killer was still in the attic of the house where she lay sleeping, drugged by the doctors*...a very black ending for that particular **Black Christmas**!

In its own lighter, dumbed-down, throwaway fashion though (be this a sign of the times; or a sop to the supposed sensibilities of the target audience; or both), the remake is still reasonably well done on its own terms. The gruesome murders see the killer collecting (and sometimes chewing on!) the victims' eyeballs ...and this leads to a gruesome visual play on Christmas traditions at the film's conclusion – When the killers' Christmas tree is seen in the attic of the sorority house, decorated with human eyeballs hanging from their optical nerves, instead of the similarly shaped Christmas baubles that hang from most people's Christmas trees! This visual pun more than anything else, closely ties the film to the old horror comic books previously mentioned, being exactly the kind of gruesome visual 'pay-off' or punchline that used to deliver to the morbid delight of many a vile juvenile reader.[321]

Being as generous as I can (and much more so than many critics I have read) the one thing that I really did not like about this remake was the fact that it became something of a pastiche of other 'Slasher' genre entries, and by the end, its decidedly human killer, Billy Lenz, became somehow apparently demonically superhuman and Michael Myers-ish.

This movie certainly will not be to everyone's taste (much like the cookies Billy Lenz makes out of the mother he murders – in response to her calling his half-sister Agnes her "Little cookie" whom she could "eat all up"). But for those who know what to expect (and relish that) and what not to (and don't care about that), it will represent a pacy, humourous, gory, fun, irreverent, Christmas slay ride! More than anything, I just hope no one gets any ideas about how a Christmas tree should be decorated from it!

For those who cherished Bob Clark's original 1974 **Black Christmas** so much and had half an inkling what the filmmakers of 2006 would do to it that they decided not to watch the remake – to go cold turkey as it were! – there were other dark pleasures to be had onscreen for Christmas 2006. One of these was a British TV adaptation of author Terry Pratchett's *Discworld*[322] tale *Hogfather*. Adapted for the small screen and directed by Vadim Jean and starring (among others) Michelle Dockery as Susan (Death's granddaughter!), David Jason (star of **Only Fools and Horses** and **A Touch of Frost**) as Albert (Death's manservant), Marc Warren (Danny Blue from **Hustle**) as an assassin called Mr. Teatime,[323] Tony Robinson (who played Baldrick in **Blackadder**), Nigel Planer (who played the hippy Neil in **The Young Ones**), David Warner and Joss Ackland, it is (if

321 The impression that many a parent, or other upright, respectable adult had of those youths who read such graphic (and in their eyes sick) literature, I am sure. And I am proud as punch to have numbered myself in the ranks of those avid readers in my misspent youth!

322 Pratchett has written a whole series of comic-Sci-Fi novels centred on a flat world held aloft by four elephants, who in turn stand on the back of a giant turtle floating through space. These satirise the human condition and society with incisive and adorable aplomb.

323 Pronounced Tee-at-tim-may

not wholly successful) a brave, visually arresting and entertaining attempt to bring Pratchett's work to the screen.

Strictly speaking, ***Terry Pratchett's Hogfather*** is not a Christmas piece at all, as the corresponding celebration on Discworld is "Hogswatch," which, instead of Father Christmas or Santa Claus, has a red robed, sleigh riding, mid-winter present deliver called the "Hogfather," whose sleigh isn't drawn by reindeer, but by hogs. For the people of Discworld, he is an icon of hope centred on the seasonal solar cycle, for his mid-winter festival celebrates the rebirth of the sun and the coming of spring. But spectral figures who audit reality find it hard to cope with human imagination and faith, and so they hire an assassin (a respectable trade on Discworld with its own guild!) to kill the Hogfather.

Mr. Teatime, a ruthlessly successful assassin is given the job, and he evolves a plan involving ancient magic and the Tooth Fairy, that will give him power over the imaginations and faith of all children and rob the Hogfather of their belief. So it is up to the skeletal figure of Death, who learns of the plot, and his granddaughter Susan, who is incognito as a childminder, to save the day. So Death dons the red robes and turns his hands to the Hogfather's job (with rib tickling if not guffaw-inducing results; not least the visual incongruity of Death dressed as Santa!) while his granddaughter tries to find and rescue the Hogfather.

I don't think that *any* onscreen adaptation was ever going to satisfy everybody...but nonetheless, this is well worth a watch and even though it is not intended to be scary as such, with Death doubling as a Santa stand-in on an alien world, it definitely deserves inclusion in our colourful collection of off-kilter Crimbo flicks. ...As does the French-produced big-screen comical-shocker ***Sheitan (2006)***,[324] directed by Kim Chapiron (and written by him and his father Christian). He was also a producer, along with Éric Névé and the film's star Vincent Cassel.[325]

Although international star (and Cassel's wife) Monica Bellucci also features (in a 'fictional' B&W vampire flick featured within the movie), the film's other main stars were little known (even in France at the time); they do give fine performances though.

Starting off looking like a study of contemporary urban lowlifes, shot in flashy MTV style at a Parisienne nightclub on the night before Christmas Eve where a small group of multi-cultural youths get into a fight resulting in their being kicked out and one getting smashed over the head with a bottle, the film soon takes a completely new direction. The three male youths are invited by a beautiful, sexy barmaid who has a friend in tow to drive to the countryside and spend Christmas at her house there. Robbing a petrol station they acquiesce, but once in the country, they encounter a strange-looking, goat-like, grinning host called Joseph (Cassel, giving an unusual and excellent performance).

324 Aka ***Satan*** (English language and international release title, and literal translation)

325 Star of films like ***La Haine (1995)*** (aka ***Hate*** – in the USA), ***L'Appartement (1996)*** (aka ***The Apartment***), ***Les Rivières pourpres (2000)*** (aka ***The Crimson Rivers*** – in the UK), ***Irréversible (2002)***, ***Ocean's Twelve (2004)***, ***Ocean's Thirteen (2007)*** and ***Eastern Promises (2007)***.

Joseph's obese and equally strange wife is heavily pregnant, expecting to give birth on Christmas, and the redneck local yokels all seem deformed and inbred, like something out of a H.P. Lovecraft tale. But the promise of sexual liaisons ensures that the lads remain. (Although, when one declines one sexually predatory local girl's advances, she masturbates the dog that he has brought along instead!).

Indeed, the whole atmosphere gets ever more perverse and threatening, especially over a Christmas Eve meal (which is a very visceral affair with lots of slurping and lascivious carnality in the feasting) when Joseph not only challenges the guests' beliefs, and tolerance with stories of devil worship (relating a story about how a man did a deal with Satan to have incestuous intercourse with his sister and bear the devil's child by her, the child being born at Christmas in a mockery of the birth of Christ) and questions of racial tolerance; but later in the night when he actually beds one of the male youths.

Religious references and allusions abound – not least in the shape of Joseph and his (mis-) appropriately named pregnant wife, who appear to correspond to some perverse and diabolical mockery of the creation and the birth of Christ, and seem to manifest the blasphemous couple in the terrible tale he has related). And indeed, as it turns out, the freaky yokels are all one big happy family looking to celebrate Christmas with a new birth (which is shown and is both gross and hysterical!) and partake in a bloodbath as they require someone's eyes for a special doll for the baby (and they even have a nifty homemade tool to extract them!).

But is it all real? Or is it all an hallucination in the fevered, drug and drink-addled, possibly concussed, brain of an irredeemable youth smashed over the head with a bottle in a pre-Christmas nightclub fight? Watch it, if it sounds like the kind of ant-Santy Christmas cocktail you think you would enjoy, and see for yourself. It is probably different to any other dark, but funny Christmas-set comical-horror tale you will ever see – its weird recipe resulting in a strange, heady brew with a distinctly Gallic flair and flavour, balancing comedy and terror and sustaining intrigue. You may end up with as many questions unanswered as answered...but then, you can always go back to the beginning and watch the whole thing all over again...and again...and...

Or you could decide instead to watch another superior Christmassy cracker of a Ho-ho-horror from overseas – the not-so-merrily-monickered Korean fantasy *Hansel and Gretel (2006)*. This beautifully shot, eerily little opus is only loosely connected to the Grimm fairytale, in that it centres on some siblings who live in a fairytale-like house in a fantastical forest where the sugary sweet surface confection hides some mysterious grim magic.

Though not a house made of gingerbread and confectionery, the house where the children live boasts brightly coloured sweets and cakes for every meal and it is eternally Christmas! The couple whose car crash see them stumble upon this kiddies' dreamland (and dentists' night-mare!) come quickly to realise that all is not right – and in several ways the film echoes the "It's A Good Life" third section of *Twilight Zone: The Movie (1983)* directed by Joe Dante and starring Kathleen Quinlan and Kevin McCarthy – for both feature fantasy worlds created by children to escape the horrors of their real lives. However, whereas in the *Twilight Zone: The Movie* segment this capability was as a result of telekinetic powers, in *Hansel and Gretel* it is

thanks to the Korean conception of Santa Claus who actually has the power to grant children's wishes (apparently without concern when this can lead to psychosis, terror and murder!). But then again, from the flashback we witness of the kids' previous life in "a miserable orphanage... which makes *Oliver Twist* seem cheery"[326] in comparison.

Hansel and Gretel is a beautifully shot and crafted movie with an eerie, dark heart lurking beneath the sugary sweet confectionary of its surface imagery. It is a real Claus-traphobic treat! ...And though geographically only a few thousand miles from the good old US of A, it is cinematically a million miles separated from our next offering, the hugely entertaining (albeit on a micro-mini budget that doesn't allow it to be artistically particularly competent) ***Two Front Teeth (2006)***.

This movie, whose advertising tagline was "Sometimes...Christmas Bites", will have some thinking rather that it sucks! But others who can forget the limitations of the budget and are happy to go along with the lunatic inventiveness, or who are happy to celebrate trash art, will undoubtedly love it. (Indeed, "How can you not want to see a movie that has Ninja Nuns and Kung Fu Santas?" asks one fan[327] in his comments on the Internet Movie Database www.imdb.com).

But Ninja Nuns and Kung Fu Santas aside for now, the plot of this whimsically weird Indie entry sees Gabe Snow, a tabloid writer not of *X-Files* but of *X-mas Files*, continuing an investigation into a dark Yuletide conspiracy, despite pressures from his editor and wider ridicule. Gabe is haunted by his own ghosts of Christmas Past – he has a Santa phobia after his parents were slain at Christmastime when he was a boy – and convinced that a the airline crash (seen in hysterical cheapo animation complete with burning corpses and splatter effects) was caused by a mysterious flying creature with a glowing nose (!), he has tracked down the man who found the mysterious and magical radiant reindeer schnozz. But even he is not prepared for what else he discovers...

That Santa has an evil, vampiric rival (Clausferatu – the Tooth Fairy!) who is looking to take over the holidays and unleash darkness, evil, murder and mayhem (even more so than last minute Christmas shopping!) on the world.

Fearing that Gabe is getting too close to the truth and needing the magical powers of the aforementioned glowing reindeer proboscis to finalise the hostile take-over, the Satanic Santa unleashes his own army of evil elves to claim the prize (and turn the white Christmas of anyone who gets in their way a bloody shade of red).

The Silent Knights – that troupe of Ninja Nuns – shows up to help out and the whole thing ends up with a martial arts showdown between Santa Claus and Clausferatu for the right to run Christmas – either as the traditional beery cheerfest of Peace, Love and Good Will to All Men or as a not so jolly Hellish Holiday.

326 Quote from Kim Newman's review on the Rotten Tomatoes website (http://uk/rottentomatoes.com/) posted on 25 Dec 2008
327 robtjonz1952 from the United States

Although some of the costume, make-up and other effects are (perhaps foreseeably) variable on this film's budget, the sheer lunacy of the script and situations and the energy of the performances will delight some viewers (some people love a nice bit of ham at Christmas). I doubt you will have seen anything else much like it before – this madcap Christmas horror comedy certainly hails from way out in the left field.

And while we are in left field territory, a couple of animated features suitable for inclusion in our Merry Christmas menagerie of monsters and lunacy showed up the next year, in 2007. Both were American, but one was feature length at 82-minutes, while the other was more of a featurette, clocking up a running time of only around 25-minutes. But neither belonged to the maudlin, syrupy-sweet school of kiddies' Santa Cloys movies, and so they were both fairly welcome for anyone with a taste tending toward the Christmas tart.

The first of these animations I want to consider is the feature length one, ***Elf Bowling the Movie: The Great North Pole Elf Strike (2007)***, co-directed by Dave Kim and Rex Piano and written by Martin Olson. This CGI animated movie features the vocal talents of Joe Alaskey (who played the hapless chubster who almost became Christmas dinner for a family of cannibals in ***Lucky Stiff (1988)***) and is based on a popular video game. In it Santa starts life as a pirate – Santa Maria Clausowitz Kringle, captain of the "Filthy Toe"! But when guilt finally sets he, he tries to make recompense for his past by delivering toys from the booty he has plundered over the years to orphans. However, when his evil half-brother Dingle Kringle is caught cheating in a shipboard bowling contest, both Kringle's are cast adrift by the crew.

Frozen when they land near the North Pole, they are thawed out by an elf using his magic and the elves believe that a legend and prophesy they have about a mythical leader called Whitebeard has been fulfilled. These magical miniature toy manufacturers have stockpiled mountains of their wares over the years, having no distribution system, and that is where Santa comes in. Beating Dingle in the game of elf bowling they have created to decide who will rule the roost, all seems set fair to more or less evolve into the traditions with which we are all so familiar. But Dingle and his penguin accomplices stir up all sorts of labour troubles trying to usurp his brother (because Elves can only work when they are happy). Indeed, the whole concept of Christmas comes under threat when Dingle takes over and move the whole operation to the warmer climes of Tahiti... But its Santa to the rescue (with the aid of one of the island's giant living stone statues) and an elf bowling rematch.

It is bright, bold, brash, colourful dynamic and utter lunacy. Slightly rude and crude in places, it is absolutely bonkers but fairly good fun nonetheless. I guess you will have to be rather a non-traditionalist to enjoy the mendacity and sheer cheek of it...but hey, if you weren't I doubt you would be reading this book, would you?!

Although the only really strange creature in this feature is the living rock statue-cum-bodyguard, I figure it is weird and wacky enough to warrant a mention. However, it cannot hold a light – or even a pretty string of Christmas ones – to the shorter CGI animated feature, ***Shrek the Halls (2007)*** – a one-off short Christmas Special addition to the mega-successful big-screen ***Shrek*** franchise that has already produced three cinematic features.

This beautifully CGI-animated film (What else would you expect?) from DreamWorks really nudges the funny bone continually throughout...and starts right from the very first shot. The film opens with lovely rolling green hills being sprinkled with a falling of snow... Or does it? As the camera pulls back, you realise what you're actually seeing is a baby ogre's green bum being powdered with talc! Great start!

And all the regular fairytale Shrek-buddies are back to celebrate the festive season. The entertainingly annoying Donkey – brilliantly voiced as ever by Eddie Murphy is absolutely stoked that it is Christmas. But not Shrek (who is as grumpily-voiced as ever by Mike Myers of the **Wayne's World** and **Austin Powers** movies fame. The grumpy green ogre is grouchier than ever. But it I s not merely that being an ogre, he does not like Christmas; it is the fact that now he has a family (and a wife who wants a proper, traditional family Christmas) he is rather on the spot as he has not got a clue what to do! As an ogre and a loner, he has never celebrated the Yule before.

So, while Donkey bounces around singing songs like 'Santa Claus is Comin' to Town' and getting all excited, Shrek decides to go to town and borrow a book to learn how to give his family the perfect Christmas that he has promised them. However, as the Shrek family set about creating their perfect Christmas (Shrek style!) on Christmas Eve – with a rat in place of a turkey; inflated toads for balloons, and straightened out red and white stripy snakes bent into candy canes – who should show up and invade the family festivities but...well just about *every other* fairytale character that has ever appeared in any of the three films! – Pinocchio, the Gingerbread Man, the Three Little Pigs, the Three Blind Mice; even Donkey, his dragon wife and their cross-breed Dragon/Donkey children, the Dronkies.

Of course, all the interlopers (as Shrek sees them) want is to help the ogre out and join in the experience of a perfect Christmas with Shrek's family. But following an unusual angle on *The Night Before Christmas*[328] as related by the Gingerbread Man (in which Santa Claus looms up like some man-eating giant monster to chomp on the little fellow left out to sate his hunger with a glass of milk!) and some slapstick animated tomfoolery, what they end up doing is wrecking the halls rather than decking them. And as a result, Shrek turns into a grouchy old ogre again "Bah! Humbug! To you!" he shouts, "That wasn't Christmas; that was Chaos!"

But when Shrek complains that he only wanted a perfect family Christmas, his wife Fiona reminds her husband that their wacky assortment of friends "*are* our family." She concedes, along with Donkey and Puss in Boots, that they never really asked Shrek what *he* wanted in terms of a festive celebration. Though when the grumpy green one kind of apologises (-ish!) too, his ever-ebullient equine pal is quick to try and wipe the slate clean: "Oh, Christmas is all about big fights," he says; adding "My old mum used to say 'Christmas isn't Christmas till somebody cries!'" (Though in this case, that may be the viewer – with laughter!).

As everyone gathers around in friendly communion, the film ends with Shrek reciting his own version of *The Night Before Christmas* – featuring a dashing green-skinned Santa in a red

328 The poem first published by Clement C. Moore in 1823 and correctly entitled *A Visit from St. Nicholas*

suit trimmed with white fur, who lets rip with a smoggy green cloud of nuclear ogre breath in a enormous belch which transforms the whole scene into an ogre's idea of the perfect Christmas! ...Which only leaves our pot-bellied, gruesome green friend to wish everyone a "Smelly Christmas to all, and to all a gross night!" before we are into the final sing-along finale song:

♫♪♫ "Shrek the Halls with Puss and Donkey,
Tra-la-la-la-la, La-la-la-la..."♫♪♫

This bright, colourful, dynamic, beautifully realised CGI animation represents great, festive franchise fun (in a festering, green, orge-ish sort of way!). And this top-notch animation takes its winning characters back to the basics that made the original big-screen **Shrek** movie such a refreshing hit in 2001. And it scores another big success as a result.

Less successful was 2007's 99-minute big-screen Hollywood adaptation of a Susan Cooper novel, one in a seires, that was shot mainly in Bucharest, Romania with a predominantly British leading cast (though Alexander Ludwig, the young actor who played the hero, is in fact Canadian). **The Seeker: The Dark is Rising (2007)** (aka **The Dark is Rising**) is about a teenage American boy whose family has moved to Britain, discovering over an eventful Christmas holiday period that only he can discover the key to prevent an evil presence plunging the world into Darkness.

It seems that fans and devotees of the original source novels feel that, in trying to distance the film from the Harry Potter series (something the scriptwriter reckoned they was trying to do in making drastic changes to the source material), the filmmakers have rather thrown out the baby with the bath water...and indeed ended up with a special-effects and spectacle laden, not too great Harry Potter rip-off anyway! As someone who has never read the books, I cannot say. But I did find the film somewhat disappointing.

I think perhaps that casting was one reason: much as I admire most of his work, Christopher Eccleston (star of the first new series in the renaissance of TV's **Dr. Who** and films like Brit director Danny Boyle's **Shallow Grave (1995)** and **28 Days Later (2002)** and Canadian *auteur* David Cronenberg's **eXistenZ (1999)**) simply did not seem to be able to manifest the weight of threat required here. But also scripting was somewhat flaccid, and the look of the supposedly-English village where the action is set was particularly off kilter (perhaps because of being actually shot in Romania).

It appears that the director tried to cover up the film's shortcomings by throwing lots of unusual camera angles, gliding steadicam shots, nice lighting and cinematography and copious amounts of special effects at the screen. But while the image often *looks* pretty good, the overall effect of the whole is still left wanting. It remains devoid of any real sense of *gravitas* or conviction.

The film opens at the end of the school term, when the children are breaking up for the Christmas holidays. Will Stanton who turns 14 as the holidays begin, starts to see cryptic cyclical symbols and senses something strange. As everyone around him prepares for Christmas, he is

told in confidence by the lady of the local manor and her entourage of servants and colleagues that they are a mystical order of champions. Theirs is the cause of Light in an ages old battle against Darkness. They insist that Will is one of them – the Seeker, who has special powers to search out the symbols of Light that can help defeat the powers of Darkness. And, as the films title makes clear, the Darkness is rising again to try and take control of the world after 1000 years of powerlessness since the last elemental battle. Darkness is represented by a horse riding elemental known as 'The Rider' (Eccleston), while Ian McShane (star of TV's **Lovejoy** and **Deadwood**) and big Scot James Cosmo line up among the (apparently seemingly pretty powerless) Old Ones, to oppose him in the name of the Light.

As The Rider's powers increase over the 5 days from Will's birthday to Christmas, he seeks to obtain the symbols of Light that Will learns to find, threatening the youth and turning family and the (much older) beautiful girl he has an understandable crush on (and who is dating one of his brothers!) against the lad. (Mind you, Will is finding it hard enough dealing with adolescence, let alone the super strength his 'calling' has given him and the ability to step in and out of various historical times searching out the symbols he seeks – never mind the savage snowstorms, ice storms and floods the Rider unleashes on the village at Christmastime in his lust for power and in his quest to bring darkness to cover the face of the whole world!).

There is some familial applecart upsetting along the way and Will discovers that he is the youngest of twins, and that his elder twin brother went missing as a child. The Christmas setting is therefore meant to add poignancy, not only with regards to the breakdown of relationships in Will's family, but as a counterpoint to the mounting threat to the world as a whole from the forces of Darkness...but quite frankly it just seems to come across rather as something of an aside!

I guess it is alright if you are looking for something to fall asleep in front of after a big Christmas dinner of roast turkey... Although in such circumstances it is probably less the vengeance of The Darkness that you will be worried about, than the revenge of the Brussels sprouts!

2007 was not a complete wash-out on the live-action festive frightener front though, as fortunately the American-produced 98-minute tense, gory, psychotic Christmas Ho-ho-horror-Thriller *P2 (2007)*, written and directed and produced by some French cinematic *enfants terribles*, but starring an American cast, showed up to grab viewers by the baubles!

Penned by Franck Khalfoun[329], Alexandr Aja[330] and Grégory Levasseur[331] (from a story by Aja and Levasseur); produced by Aja, Levasseur, Erik Feig and Patrick Wachsberger; and directed by Franck Khalfoun, *P2* (whose title refers to a sub-ground parking level in a New York office building) is a straight-up, full-on out-and-out Cruel Yule Horror film on which to end this slayride of terror and fantasy. Set on Christmas Eve, its story sees a hard-working businesswoman working late at her Park Avenue office in New York City, trying to close a deal at the last minute even though she has a family Christmas Eve meal in Jersey to get to.

Apparently the last one to try and leave the building, her executive BMW motorcar that is parked in the underground parking levels won't start. But the friendly, handsome security guard who is watching over the building from his office in the sub-level parking area offers to help. Only things are not exactly what they seem at first, and soon the security guard is drugging the businesswoman with a chloroform-soaked rag.

She wakes up groggy, chained to a chair in the security guard's office, dressed in a low-cut white dress and with lipstick, having not had either on before. The lonely, sociopathic and psychotic security guard acts as if there is nothing untoward about his actions and invites his captive to share a Christmas dinner he has prepared with him, having already laid out the table in the small, festively decorated office with candles, glitter, wine glasses, a single red rose, the works! What ensues is a tense, taut game of cat and mouse, with occasional eruptions of truly gory and shocking, bloody violence as the woman tries to escape the clutches of the murderous psychopath who has abducted her.

The empty, hollow-sounding building with its dark sub-level parking and teasing festive music playing in it, makes for a very effective setting, and although the actions of the protagonists do not always ring entirely realistic, the performances are nonetheless pretty strong, and the eruptions of gruesome violence when they occur are truly horrific (from the guard repeatedly smashing a car into a co-worker of the woman's whom he has seen trying to grab and kiss her in an elevator while wearing silly novelty reindeer horns and being the worse for drink after the office Christmas party; to the way that the woman kills the guard's vicious Rottweiler when he sets the dog on her; to her stabbing the guard in the eye. These are definitely not moments for the squeamish. Especially the shots of the unfortunate co-worker's demise...for as the psycho security guard repeatedly rams a car into him as he is duct-taped to an office chair, crushing

329 Who also provides the voice of the Newsman and previously starred in *Haute tension (2003)* (aka *Switchblade Romance* – English language international title, and *High Tension* – US title) as well as currently penning the script for the remake/reinvention of *Silent Night, Deadly Night* that is in pre-production.

330 Co-writer and director of *Haute tension (2003)* (aka *Switchblade Romance* – English language international title, and *High Tension* – US title) and the 2006 remake/reinvention of *The Hills Have Eyes* (based on the original Wes Craven movie released in 1977).

331 Co-writer of *Haute tension (2003)* (aka *Switchblade Romance* – English language international title, and *High Tension* – US title) and the 2006 remake/reinvention of *The Hills Have Eyes* (based on the original Wes Craven movie released in 1977), which he was also Assistant Director on.

him against the wall of the building's parking lot, we first see his stomach hanging out of his abdomen and then his head pulped against the wall!

And finally for 2007, we have a quite Claus-traphobic little chiller entitled **Wind Chill**, Executive Produced by George Clooney and starring Emily Blunt, Ashton Holmes and Martin Donovan. Unlike many of its contemporaries, this horror film does not rely on stalk 'n' slash antics or splattering gore across the screen (though I have nothing against that); it is much closer in tone to more old school haunted house movies.

It is set at Christmastime and centres on a couple of college students (Blunt and Holmes) on a 6-hour drive home to Delaware for the holidays through a snowy, forested and some-what mountainous landscape. Only the girl comes to realise that the boy is not exactly what he seems and he does not live in Delaware at all, so all sorts of nasty suspicions arise and their less-than-harmonious relationship-right-from-the-outset, becomes even more antagonistic... especially when the car I run off the road when the boy takes a shortcut off the highway across a little-travelled pass. The car is stuck in a snowdrift, the temperatures are freezing and the girl understandably has grave concerns.

It transpires, however, that the boy has set up the supposed share-a-lift-home tactic just to meet and spend some one-to-one time with the girl because he fancies her, but she is attractive and popular and he, being something of a nerd, lacks confidence to meet her otherwise. This notwithstanding, the girl's grave concerns are not redundant for, stuck in the frozen wilderness, the couple start to see mysterious apparitions and become involved in a series of supernatural events. All of which seem linked to the repeated appearances of a ghostly police officer whose entrance is always heralded by 'Rockin' Around The Christmas Tree' playing on the car radio.

The film is fairly effective despite being very talky and confined (and I kept finding myself being distracted wondering about details like, why if it is *soooo* cold, we hardly ever see con-densation on their breath). It also features an inordinate amount of exposition very late on, which seems almost tagged on out of necessity than endemic to the tale (and which doesn't really completely explain everything anyway). It is worth a watch and does create a nice sense of fairly strange atmosphere, but it is far from being a classic.

The film features several ghosts and the storyline eventually reveals **(don't read the rest of this paragraph if you don't want to spoil the film's denouement!)** that the stretch of highway that the students have been forced off the road on is notorious for crashes as, back in the 1950s (when 'Rockin' Around The Christmas Tree' was originally a hit) a twisted cop used to force cars off the road and take advantage of and kill their occupants. Witnessed by a group of retired Catholic monks who felt a sense of guilt at not reporting the incident, in one accident the cop himself is trapped in his wrecked patrol car, which has caught fire, but rather than rescue him, the monks rip out his radio to prevent him from calling for help and let him burn to death in the wreckage. Ever since, his vengeful, wicked spirit has haunted the highway causing further crashes – usually most Christmas Eve's – and even caused the monks to freeze to death en masse in their retreat. It is so much hokum, but like the curate's egg in *Alice's Adventures in Wonderland,* it's good in parts. It is the kind of film whose trailer probably sets up expectations the film itself cannot wholly deliver on or maintain.

And while we are on the subject of trailers...though I am not sure exactly when it was produced or posted, I would also like to mention a very, very short production – a 1-minute 16-second trailer I have just seen on YouTube.[332] It is entitled **A Christmas Gory** and consists of a mock trailer for a film of that name, brilliantly cut together as if advertising a seasonal Horror using clips from one of the most lovely, funny, brilliantly evocative and nostalgic Christmas films of all time, **A Christmas Story (1983)**. (Incidentally, directed by Bob Clark, who gave the world one of the seminal and best Christmas 'Slashers' to date (still!) **Black Christmas (1974)**). **A Christmas Gory** is magnificently done – an absolute hoot. My congratulations to whoever edited it.

And just to pick up at this point on a few other little gems I have tripped across online (though I have absolutely no intention of attempting to catalogue or critique all the short, often entirely amateur, snippets and skits posted on various sites all over the internet – not that I have anything against DIY dudes (and dude-esses); I just need to set some myself limits and so I have decided to concentrate on feature-length films with a few extra stocking-fillers thrown in. And in my view, the absolute pick of the bunch is without doubt director Jason Eisner's 16-ish minute gore-splattered, multi-Film Festival award winning treat from Canada **Treevenge (2008)**.[333]

This is the movie that **Trees 2: The Root Of All Evil (2004)** *could* have been and *should* have been; and although a couple of the human performances are a little variable, on the whole it is a high quality production whose makers are obviously genre fans. The wonderfully scripted film is beautifully shot (just see the opening shots of a forest of snow-topped pines and axe that looms into ominous view), at times gut-bustingly funny (How many films have you seen where trees, quaking with fear or quivering with indignation at their treatment, talk squeakily to each other with subtitles appearing on screen?) and ends (after a well developed build-up) as a blood-soaked splatterfest, paying tribute to several genre influences en route.

The supremely silly storyline sees one of the traditional human habits around celebrating Christmas – decorating evergreen trees – from the point of view of the furious foliage, anthropomorphising the pining pines and giving them voices, as they face an annual ritual of being chopped down by humans, dragged off from their families, humiliated by being sold slave-like then stuck indoors in homes and draped with sparkly, spangly fripperies, then left to die before being discarded! But you can only push a fir tree so far! The bloody climax sees the fed-up firs get the needle and turn over a new leaf on Christmas morning, seeking splattery vengeance against humankind – poking out eyeballs, carrying out operations with axes and even squishing infants' heads. And if the terrific, Triffid-like Christmas trees don't do for you directly, it's likely their antics will split your sides when seen onscreen!

In a different vein completely, 2008 also saw the immensely looooooooooooooooong-in-development (7 years!!!!) cinematic project by the Oklahoman based rock band Flaming Lips finally released. This Christmas 'baby' is surely worth a watch, even if just because of its unusual genesis and gestation! And perhaps the perception of it as the band's 'Christmas baby' is very apt, for **Christmas On Mars (2008)** centres around the events that transpire as the first human baby (albeit a test tube baby) is about to be born on Mars.

332 www.YouTube.com

333 Can be seen at www.twitchfilm.net

An event that should perhaps be celebrated as a great historic moment in the history of humankind is, however, somewhat overshadowed. Why? Well the colonisation of the Red Planet has all but been abandoned, and the remaining crew, isolated on the lonely, distant desert world are fighting both technical and mental failings: the latter even to the point of suicide, when one crew member (who is meant to be playing Santa in the colony's Christmas pageant) runs out of the station *sans* space-suit and expires horribly!

It seems that the community is disintegrating and losing hope. But fortunately, a benevolent alien visitor (who looks like something from a 1940s or 1950s cheesy Sci-Fi film) turns up. He remains entirely silent, but sagely allows the humans to explore their own conceptions, even as they manipulate him – he is recruited to replace the deceased crewmember and play Santa in their pageant – and as a result, through a combination of this astral visitor (angel with a silent message?) and the birth of a baby at Christmastime, hope is renewed; there is a Renaissance of humanity. (Indeed an apt message for Christmas!).

As well as being cobbled together over 7 years (and it is remarkably cohesive, especially in terms of its visuals baring this in mind), this film was decidedly low-budget. However, the filmmakers have made this very much one of the film's virtues, imbuing it with the kind of revel-in-its-own-cheap-inventiveness sense of fun that formed such a brilliant part of John Carpenter's **Dark Star (1974)**. So, despite paying *homage* at times to big budget spectacles like Stanley Kubrick's **2001: A Space Odyssey**, it was never this film's intention to emulate the visual style of such illustrious predecessors and progenitors. This is a quirky, trippy, *avant-garde* movie, which is more concerned with the mind, the imagination and the soul than with mere visual spectacle and verisimilitude. (Perhaps in that respect it is closer to sci-fi writing than sci-fi cinema; although this has been a virtue of other illustrious cinematic influences too e.g. Andrei Tarkovsky's **Solaris (1972)**).

With an effective ambient 'spacy' soundtrack from The Flaming Lips, and shot mainly in black-and-white – although with sudden bursts into colour sequences – and boasting both some excellent sets for the budget and some fantastically evocative images (e.g. space reflected in the visor of a space suit overlaid with a vagina!), this quirky space-opera is one far-out trip. The sight of the cheesy alien, for instance, arriving in his glowing spaceship, which then shrinks to the size of a pill that he swallows (we carry our own spaceships around inside us – our imaginations!) - which sequence inspired the film's advertising tagline, "Eat your own spaceship" – is cool.

Ok, so some of the acting perhaps leaves a little to be desired[334] (and even I wouldn't claim that this is as a deliberate result of a conscious decision to incorporate elements of the Brechtian to the project) – what the hey! ...Just let go and go along for the ride. After all, this extra-terrestrial Mystery Play is probably one of the strangest Christmas films you will ever see.

Much more conventional in terms of style, and decidedly easier to categorise as a result, is the other Christmas 2008 release – this time from the UK – the festively-themed horror chiller, **The Children**. This is an effective, low-budget taboo-breaker that is well written and beautifully

334 Members of the band Wayne Coyne (who also wrote and co-directed) and Steven Drozd feature in starring roles (see cast details in the film listing at the end of the chapter)

shot, with its demonic-seeming murderous rampages presented not in gloomy darkness, but against the pristine whiteness of a snowy landscape (all the better to see the scarlet stains of blood against!).

The film sees a one irksome middle-class family (mum, dad, teenager daughter and two tweenies) visiting their friends, another irksome middle-class family (mum dad and two young-sters) in their posh, isolated home just after Christmas in order to stay and celebrate the New Year (much to the dissatisfaction of the teen, who will miss a friend's party). However, one of the visiting children seems slightly unwell and it is feared that he may have picked up a minor infection. Soon though, all the minors are infected – and whatever it is that is affecting them, turns them into rampaging, compassionless, feral murderers. (Nice!)

Sure, the film has overtones of *Village of the Damned (1963)*, *The Omen (1976)* and even *Night of the Living Dead (1968)* (and as with the latter we never actually learn what is causing the problem – although there is speculation relating to things like the MMR inoculation etc). But where it really scores is in its build up of tension, some strong performances (not least from the well-cast kids), fairly believable characters and dialogue (although there is a bit of the usual hokey silly decision syndrome), some excellent and shocking gore, and the breaking of taboos (killer, 'possessed' children; parents having to kill their own kids etc.).

Starring a group of Brit actors probably mostly better known for appearances on the small screen (in TV series like **Hollyoaks** and **Holby City**[335]) than the big screen, and directed and written for the screen[336] by Tom Shankland (who had directed the psycho serial killer mystery thriller *W Delta Z* aka *WAZ* the previous year), *The Children* – whose advertising tagline was "You brought them into this world. Now…they will take you out" – was a very pleasant unpleas-ant Christmas surprise.

Meanwhile, on TV – having attended a Christmas party aboard the RMS Titanic the previous year (in an episode of **Dr. Who** entitled **Voyage of the Damned**, originally screened on Christmas Day 2007), Dr. Who turned up on Christmas Day once again, in a seasonal special entitled **The New Doctor**. Set over Christmas Eve and Christmas Day 1851, allowing for a traditional, snowy depiction of a festive Victorian London, this episode saw the Doctor confronted with what at first appeared to be a future regeneration of himself (hence the title), with David Morrissey giving a spirited performance in the role.

It is not long, however, before he discovers the truth – the Cybermen are invading, and (as-sisted by an immensely intelligent and strong-willed woman who is rebelling against the rigid class and gender restrictions of British society of the time, which prevent her from achieving her full potential) are looking to enslave the Earth's population…starting by bringing the leaders

335 Jeremy Sheffield appeared in 43 episodes of **Holby City** as Alex Adams; Steven Campbell Moore appeared as Evan White in 8 episodes of the first season of **Ashes to Ashes**; Hannah Tointon appeared in 20 episodes of **Kerching!** as Tamsin and 26 episodes of **Hollyoaks** as Katy Fox; Rachel Shelley appeared in 54 episodes of **The L Word** as Helena Peabody (although genre fans may well have seen her in *Lighthouse (2000)* and/or *The Bone Snatcher (2003)*.
336 From a story by Paul Andrew Williams

of London's workhouses under their control so they can kidnap and use all the poor, deprived children placed in those establishments as slaves to create a King Cyberman (an iron giant "dreadnought" which we see rise from the Thames and bestride the city like a behemoth at the climax of the show).

Dervla **Ballykissangel** Kirwan makes a brilliantly cold villainess, her red Victorian dress against the snowy backdrops like a stain of blood, her dark eyes exuding malevolence; while the new-style relentlessly stomping Cybermen (one with his brain on display via the transparent segment in his helmet) add a moribund menace for those they confront.

With plenty of humour and no little pathos – the Doctor is never going to let children be kidnapped, turned into slaves and then murdered at Christmas; 'The New Doctor' learns of his true identity and the loss of his wife to the Cybermen before regaining his son who has been enslaved from them – this is a fitting, sci-fi Crimbo special episode of the once low-budget, cult geek classic of British TV, which has now managed to regenerate itself (Time Lord-like?) into a big-budget mass-media spectacle.

Finally for 2008, we come to some short movies and clips that appeared on the internet. I do not intend to even attempt to tackle an exhaustive tour around all such presentations. There are of course many, many other similar shorts that you can access online...but I will leave you the joy of hunting them down for yourself. Though I warn you, their quality can vary enormously. I want to mention just three that tickled my fancy.

Perhaps owing a bit of a debt to the *All Through The House* Christmas segment of the Freddie Francis directed1972 British/American anthology horror film **Tales from the Crypt** that starred Joan Collins – Christopher Ameruoso's 7-minute short **Silent Night Bloody Night (2008)**, [337] also offers a festive frisson. Although little more than a skit really, it is well made and sees a businessman, Max (Steve Valentine), give his sexy girlfriend Frankie (Lindsay Crolius) a sexy red set of Santa Claus underwear as a Christmas present before telling her that he cannot spend Christmas with her as he needs to leave on business.

Before he leaves though, she dons the lingerie and gives him head!...No, literally! – when he opens the festively wrapped gift box she presents him with, it contains the head of the wife, Charlene (Shelley Martinez) he has conveniently neglected to tell her about!

And not only is Frankie upset, she is unbalanced...and she gives Max the chop. Again, *literally!* – with an axe! Nice!

The 45 second long **Have A Scary Christmas (200?)** – which I also tripped across on YouTube[338] - is a very succinct genre-homage snippet. As 'Silent Night' plays on the soundtrack, we see various genre fave characters involved in twee Christmas antics – Darth Vader walks through a snowy forest, Freddie Krueger snips flowers, Jason Voorhees cuts down a Christmas

337 Which can be viewed at http://www.youtube.com/watch?v=tjmKW8EvyDo although it is also available on DVD

338 At http://www.youtube.com/watch?v=LTyJ01vZg3w

tree with a chainsaw, Dracula rises from a coffin to join in the celebrations. Naughtily, Chucky from the **Child's Play** movies causes a young nipper to fall off of a seesaw and injure himself… but fortunately the mummy is on hand to bandage his knee. While Hannibal Lecter wearing his restraining mask helps cook the turkey in the kitchen, the black haired ghost girl from the **Ring** movies passes a gift out of the TV set and a werewolf howls at the full moon from the roof, perched on its haunches beside the satellite dish. Great fun if very fleeting!

The only other short I want to mention is one I tripped across a trailer for online.[339] This is a 10-minute Icelandic festive frightfest entitled **Unholy Night** directed and edited by Árni Þór Jónsson. I really want to see this movie, which sees an evil Icelandic version of Santa – "the scary outlawish Yule Man from Icelandic folk tales"[340] – lead his 12 cohorts (Peeping Tom, Meathook etc., the children of a cannibalistic ogre called Greela used to scare children into behaving and staying indoors out of the murderous cold over the harsh Icelandic mid-winter Christmas period) in a series of homicidal attacks on a group of participants in an experimental rehab clinic who are looking to face up to and rid themselves of their inner demons! The film is set following the first attack, and from the trailer it looks like it could be a gory, dark gem.

So onto the final year of the first decade of the 21st century. 2009 saw **Doctor Who** return to the small screen with another adventure (the final one for the 10th Doctor, David Tennant). But although screened at and set around Christmastime, this tale featuring the re-generation of the Doctor's non-Dalek arch-nemesis – the Time Lord known as the Master – looking to conquer the world and indeed the universe.

Meanwhile, on the big screen and obviously with a darned big budget Robert Zemeckis's digitally animated 3-D adaptation of Dickens' **A Christmas Carol** for Disney starring rubber-faced funnyman, Jim Carrey, was released… amid a great deal of media ballyhoo and ringing as many box-office cash register bells as Christmas bells. But, as it turns out, it is a fine, surprisingly faithful adaptation, with Jim Carrey giving a sensitive and restrained performance as Scrooge (at all ages of his life) as well as assaying the roles of the 3 Ghosts of Christmas that visit him on Christmas Eve. And it has its spooky moments too (not least when the head of Marley's ghost appears as a door knocker and at one point spits out half its teeth).

The Ghost of Christmas Yet To Come is the dark presence you would expect – and the brilliant 3-D visuals add a whole new dimension to events (pun intended) as the ghosts whisk the miserly old skinflint TARDIS-like on trips through time and space to illustrate the errors of his curmudgeonly, un-Christmassy ways.

However, while this extremely creditable and hugely entertaining big-budget spectacle rang box-office bells around the world, a couple of other, much less costly opuses were doing the rounds too. Both hailing from the States and set in LA, the first of these is a very low-budget slasher affair entitled **Deadly Little Christmas (2009)**. A sort of rehash of the **Halloween** territory, but set at Christmastime, the film sees a young boy murder his family, then follows the

339 At http://www.zikzak.is/unholy-night/

340 From a synopsis at the above website address

ensuing bloody events 15 years later. Although I have not yet seen this movie, I understand the main problems with it are its derivative nature (it's a bit of a hackneyed hacker!) and the poor quality of the performances

Fortunately, however, the Indie film sector by no means let the side down, and the decade (and this book) are able to end on a particularly high note thanks to the second of our LA set, Indie Ho-ho-horrors.

On Halloween weekend 2009, I attended the Gorezone magazine's Weekend of Horror '09 Film Festival at London's Prince Charles cinema (just off Leicester Square, where they were erecting a large screen and outdoor seating for the premier of Zemeckis's *A Christmas Carol*), and among the many movies I saw screened, was the UK premier of an absolutely glorious (Or should that read gore-ious?!) little gem of a festive shocker from the USA – Sean Cain's low-budget, Indie horror *Silent Night, Zombie Night (2009)*.

Set in LA a week before Christmas, the film sees it's three central characters (who are caught up in their own emotional turmoil as the a cop suspects hat his wife, who is leaving him, has been having an affair with his partner) thrown into a veritable zombie holocaust. For reasons unknown and unexplained, out of the blue citizens start becoming infected and turning into crazed, flesh-crazing zombies that feast on the living. Soon, the cop, the wife and the partner find themselves locked up together in the partners second floor apartment and confronting both the disintegration of their relations and of human society – all against the backdrop of what should be 'the hap-happiest time of the year."

The zombie and gore effects in this movie are beautifully realised, completely belying its budget, and the director doesn't over-egg the Christmas pudding (so to speak). No comic-book zombie snowball fights – though there is a huge amount of comedy as the whole film plays out like the bastard son of *Butch Cassidy and the Sundance Kid* and *Night of the Living Dead*. Instead of simple tomfoolery, we are given wonderfully well written (by Sean Cain) and beautifully portrayed characters (Office Talbot played by Jack Forcinto, his wife Sarah played by Nadine Stenovitch and partner Andy Hopper played by Nash Jackson...and they are adults for a change, not teens!), with just enough counter-pointing with the festive season to give touches of both humour an poignancy.

The zombies in this movie are a mixture of the lumbering buffoon undead of Romero's *Dawn of the Dead*[341] *(1978)* (which do allow for some very funny slapstick) and the fast, feral posthumous predators of the 2004 remake,[342] which provide a distinct edge of danger. No explanation is given for the variable effect of the 'infection' – as in Romero's seminal *Night of the Living Dead (1968)*, the uncomprehending humans can only conjecture.

One of my favourite examples of the gory humour in this movie comes when Officer Talbot is picking off lumbering zombies with his pistol from the window of the apartment. A huge

341 Aka *Zombies; Dawn of the Dead* (UK release and video release title) and *George A. Romero's Dawn of the Dead* (USA full release title) and *Dawn of the Living Dead*
342 Also entitled *Dawn of the Dead*, but aka *Zack Snyder's Dawn of the Dead* (USA long title)

slobby, blob of a zombie, looking like the kind of white-trash trailer-park dweller you might expect to see appearing on **The Jerry Springer Show**[343], lumbers up the road wearing a tight fitting Santa suit, that barely covers his jelly-belly. Talbot takes careful aim and plugs him right between the eyes, and then utters (as if to kill the myth of the Merry Christmas) "No Virginia, there ain't no Santa Claus."[344]

While one of the most touching – though perhaps melodramatic – moments of the movie sees Talbot witness a man who has had to kill his own son after he was bitten and became a zombie, turn his gun on himself on Christmas morning and blow his own brains out rather than (as he explains in a melodramatic speech) face the future without the wife and family he has lost to the zombies' Holiday Holocaust. In the true spirit of this beautifully crafted film, however, the potentially OTT elements are entirely undercut as the sounds of Jingle Bells are heard as the man pulls the trigger! Magic.

And this is entirely indicative of the way this intelligent treat of a film utilises humour most effectively t undercut some of its horrors and repeatedly throw unexpected things in from left field.

At the time of writing, I am not even sure if **Silent Night, Zombie Night** will get a general release here in the UK, but if it doesn't then be sure to look out for it on DVD, because if you have persisted with reading this book for this long, then I am assuming that your tastes are likely to incline more towards Elm Street than Coronation Street, in which case this film will be right up your street! And I say a huge "hurrah!" to all involved in its production for allowing me to end my little festering festive slayride on such a cracking high note.

Looking back to where we started – oral and then literary representations had long established a tradition of connecting Christmas with the eerie and spooky. Perhaps thanks to the Victorians rekindled interest in the Christian festivities and the emergence of the cinema at the close of the Victorian era, though accepted classics like Dickens' *A Christmas Carol* made the transition to (silent) screen readily enough, the re-emergence of twee traditions in concert with censorship of the moving image ensured that such depictions of Christmas remained for some time restrictive to the cinema reconnecting Christmas with terror and the horrific.

But eventually the very disparity between the two polar opposites of all things Christmassy (the holly-jolly season of peace on Earth and goodwill to all men) and anything horrific came to represent an irresistible visual and conceptual counter-point; the very seed bed of ironic representation. And so the macabre, gradually and by degrees, began to creep inexorably in to certain cinematic productions to sate certain particular viewer tastes...until such time as the sub-genre of Christmas Horror films can be spoken of with blasé acceptance.

343 I am sure that actor Chris Gabriel who plays him is a lovely bloke – no insult intended.
344 Turning on its head the famous editorial written by journalist Francis Church in response to a young girl's letter of query sent to the *New York Sun* newspaper in 1897 in which Church affirmed the existence of the gift-giving red-suited elf.

By the end of the 20th century, though it had taken several decades for filmmakers to cotton onto the heady mix of Christmas and Horror as a potential (select) crowd pleaser, once they did, they eventually realised that not only could they slaughter the sacred cow of the twee Christmas, but at times turn it into mincemeat as well!

There is no doubt that festive frighteners are now a recognisable sub-genre, and it would appear that they are here to stay! Indeed, that Big Daddy of festive rabble rousers, **_Silent Night, Deadly Night_** even seems almost about ready to be resurrected and rejoin the fray itself (though rumours of a remake-cum-reinvention of this particular cinematic opus have been rife for several years. (And at the moment, it is still lurking menacingly, somewhere in the foreboding, misty shadows of Development Hell...like the shrouded, faceless, skeletal figure of the Ghost of Christmas Yet to Come?!).

But as Christmas becomes a more and more secular celebration for more and more people[345], and Christianity perhaps begins to lose the stranglehold it has had over the mid-winter festivals and celebrations it so successfully co-opted from older religions in the past, now in this technological age, one of the ways we seem to have chosen to return to, or perhaps more correctly to try and reinvent the Christmas ghost story is through Horror films.

And though many may still frown upon these particular entertainments (and many of the ones produced are more terrible than terror-full) in this age when we seem to have taken some of the 'sin' out of cynical, festively themed Horror movies (the Ho-ho-horrors and Anti-Santy films, as I have facetiously termed them) seem often to provide for some, something cathartic; an antidote to the maudlin syrupy sentimentality of most mainstream cinematic Christmas confections.

In the final analysis, the fact is that many people find these kinds of films fun. The delights they offer are certainly darker than the norm, to be sure. But why shouldn't fans of such films be allowed to celebrate Christmas in the way that they choose in this age when so many have already been questioning for so long the blatant commercialisation of the festival, especially in modern, consumerist Western societies (where the profit-makers continue to battle with the prophet-makers); as well as the apparent moral ambivalence of celebrants.

When it comes down to it, I guess it is a case of you celebrate and enjoy Christmas your way and let me celebrate and enjoy it mine – just so long as no one is actually hurting one another! Sounds fair, doesn't it?

Well, boils and ghouls, that's about it. I hope you have enjoyed our little slay ride across the screens (big and small) of various nations, as much as I have enjoyed, researching it, writing it and of course watching as many of the sometimes wonderful but quite often awful (though not always any the less entertaining for that!) films in this veritable seasonal smorgasbord of ham-filled roles, trashy turkeys and occasional tasty treats. I hope this book, with its wander through many related but signally unscary wacky wassails along the way, at least gives you a giggle. And

345 I see this year there have been several Christmas carol concerts and entertainments devoid of any mention of God organised, which one vicar on BBC Breakfast television described as akin to _Alice in Wonderland_- like "unbirthday parties" !

perhaps provides some clues as to whether or not you are likely to enjoy certain films. Or even perhaps whether or not those you are looking to buy them for as presents might enjoy them. With any luck, it might just put you onto a few little gems that you didn't know were out there waiting for you to watch them.

Not all of the filmmakers we have encountered along the way have been exactly 'nice' to their audiences (some have been downright 'naughty'! – exploiting square-eyed seekers of darker delights with which to tickle our jaded taste buds over the Yule in order to con a quick buck out of us). But who knows what (no longer) forbidden fruits the future might hold now that the Ho-ho-horror Movie has found its feet, well and truly got its claws into Santa and is here to stay (...and slay)?

I am sure that I have not managed to catch every Christmas-themed movie of the macabre that has ever been produced. And I am darned sure there are many others I could have included under the ill-defined (but that's what makes it so useful) rubric of the Psychotronic! I only apologise if I have missed one of your particular favourites. But anyway, here's wishing you a very scary Christmas! I hope you have a very Happy Horrorday...And in the words of Jerome K. Jerome (author of *Three Men In A Boat*) on the subject of Christmas and spooky thrills and chills (even if in the introduction of *Told After Supper* 1891, Leadenhall Press, he was referring to stories rather than movies):

"It is a genial, festive season, and we love to muse upon graves, and dead bodies, and murder, and blood!"

And *almost* in the words of Mr. Irving Berlin – from the lyrics of an extremely well known song (most famously sung by that incomparable Old Crooner, Bing Crosby of course):

♫♫♫…I'm dreaming of a fright Christmas…♫♫♫

THE FILMS

♪♪♪…Slashing through the snow on a One-Horse Open Slay…♪♪♪

American Crime 2004 USA 92mins
Directed: Dan Mintz **Written**: Jack Moore & Jeff Ritchie **Produced**: Jeff Ritchie **Music**: Kurt Oldman **Cinematography**: Dan Mintz **Edited**: Todd E. Miller **Design**: Mara E. Spear **Costume**: Mandi Line **Cast**: Annabella Sciorra (Jane Berger), Cary Elwes (Albert Bodine), Rachel Leigh Cook (Jessie St. Claire)

Bikini Bandits Save Christmas 2004 USA 63mins (Animation)
Directed: Paul Thiel **Music**: Mickey Galactic & The Misfits & A perfect Circle **Cast**: Schooly D Maynard James Keenan (Father Christmas)

Binge & Purge 2002 Canada 83mins
Directed/Written/Edited: Brian Clement **Music**: Justin Hagberg **Costume**: Sarah Kramer **Cast**: Tanya Barnard (May), Stephan Bourke (Vanzetti), Fiona Eden-Walker (Number 11), Brian Clement (Fascist Officer)

Aka Binge and Purge (alternative spelling) and **Catwalk Cannibals** (UK DVD Title)

Black Christmas 2006 Canada USA 94mins
Directed: Glen Morgan **Written**: Glen Morgan (based on Roy Moore's 1974 screenplay) **Produced**: Marty Adelstein & Marc Butan & Steven Hoban & Glen Morgan & Dawn Parouse & Victor Solnicki & James Wong **Executive Produced**: Bob Clark & Mark Cuban & Scott Nemes & Noah Segal & Todd Wagner **Music**: Shirley Walker **Cinematography**: Robert McLachlan **Edited**: Chris Willingham **Casting**: John Papsidera **Design**: Mark Freeborn **Art Direction**: Tony Wohlgemuth **Set Decoration**: Mark Lane **Costumes**: Gregory Mah **Cast**: Katie Cassidy (Kelli Presley), Michelle Trachtenberg (Melissa), Lacey Chabert (Dana), Kristen Cloke (Leigh Colvin), Andrea Martin (Barbara 'Ms. Mac' MacHenry), Crystal Lowe

(Lauren Hannon), Robert Mann (Billy Lenz – aged 20 & 35), Dean Friss (Agnes – aged 16 & 22)

Aka Black X-Mas (US short promotional title) and Noël Noir (French-Canadian title)

Blasphemy: The Movie 2001 USA 106mins
Directed/Written: John Mendoza **Produced**: Jennifer L. Liu **Edited**: Terry Kelly **Design**: Katherine Bulovic **Cast**: Carlos Leon (Martin Garcia), Irene Olga López (Angela Garcia), Tony Perez (Robert Garcia), Karmin Murcelo (Aunt Patricia), Ian Abercrombie (Zeus), Steve Broussard (Jesus), Jack Huang (Buddha)

Aka Blasphemy

Casper's Haunted Christmas 2000 Canada/USA 84mins (Animation)
Directed: Owen Hurley **Written**: Ian Boothby & Roger Fredericks (based on characters created by Joseph Oriolo & Seymour Reit) **Produced**: Byron Vaughns **Music**: Randy Travis **Edited**: Andrew Duncan **Art Direction**: Dean Sherriff **Cast**: Brendan Ryan Barrett (Casper), David Kaye (Narrator), Graeme Kingston (Fatso), Terry Klassen (Stinkie), Scott McNeil (Stretch), Tegan Moss (Holly Jollimore), Colin Murdock (Kibosh), Tabitha St. Germain (Poil), Lee Tockar (Snivel), Sam Vincent (Spooky)

Aka Le Noël hanté de Casper (French Canadian title)

The Children 2008 UK 84mins
Directed: Tom Shankland **Written**: Tom Shankland (from a story by Paul Andrew Williams) **Produced**: Alan Niblo & James Richardson **Music**: Stephen Hilton **Cinematography**: Nanu Segal **Edited**: Tim Murrell **Casting**: Gary Tavy & Amanda Tabak **Design**: Suzy Davies **Art Direction**: Kevin Woodhouse **Cast**: Eva Birthistle (Elaine), Stephen Campbell Moore (Jonah), Jeremy Sheffield (Robbie), Rachel Shelley (Chloe), Hannah Tointon (Casey), Raffiella Brooks (Leah), Jake Hathaway (Nicky), William Howes (Paulie), Eva Sayer (Miranda)

Aka The Day (working title)

The Christmas Invasion 2005 UK 60mins (**Dr Who Christmas Special**)
Directed: James Hawes **Written**: Russell T. Davies **Produced**: Phil Collinson **Music**: Murray Gold **Cinematography**: Ernie Vincze **Edited**: Liana Del Giudice **Design**: Edward Thomas **Costume**: Louise Paige **Cast**: David Tennant (The Doctor), Billie Piper (Rose Tyler), Camille Coduri (Jackie Tyler), Noel Clarke (Mickey Smith), Penelope Wilton (Harriet Jones)

A Christmas Nightmare 2001 USA 90mins

Directed: Vince De Meglio **Written/Edited**: Vince De Meglio & Tim Rasmussen **Produced**: Tim Rasmussen **Music**: Mike Peters **Cinematography**: Matt Steinauer **Costume**: Melissa De Meglio **Cast**: Hugo Armstrong (Agent George Simmons), Tiffany Baker (Alice Anderson), Jeff Coatney (Lyle Wallace), Charlie Finelli (Edward Anderson), Audrey Lowe (Veronica Wallace)

Aka The Damned and The Damned Within the Shadows (UK) and Lake of Fire (working title)

Christmas on Mars 2008 USA 83mins

Directed: Wayne Coyne & Bradley Beesley & George Salisbury **Written** Wayne Coyne **Cinematography**: Bradley Beesley **Edited & Visual Effects**: George Salisbury **Music**: The Flaming Lips **Cast**: Steven Drozd (Major Syrtis), Wayne Coyne (Alien Super-Being), Steve Burns (Major Lowell)

The Christmas Season Massacre 2001 USA 70mins

Directed: Jeremy Wallace **Written**: Eric Stanze & Jeremy Wallace **Produced**: Mark W. Kettler & Jeremy Wallace **Music**: Ven Rivoli **Cinematography**: Todd Tevlin **Edited**: Eric Stanze **Cast**: D.J. Vivona (Ernie Campbell), Jason Christ (Dorcas Cunningham), Chris Belt (Danny Carpenter), Michael Hill (One Shoe McGroo), Michael Wallace (Issac Hitzik), Melissa Wallace (Lana Hooper), Eric Stanze (Boom Boom)

Christmas Tales of Ghostly Trails 2000 UK 60mins (Documentary)

Directed/Produced: Liam Dale **Written**: Sue Hosler **Cinematography**: Jud MacFarlane **Cast**: Liam Dale (Presenter)

A Christmas Visitor 2002 USA 88mins

Directed: Christopher Leitch **Written**: George Samerjan & David Saperstein **Produced**: Paul D. Goldman & Frank Siracusa **Co-produced**: George Samerjan & David Saperstein & Christopher Leitch **Music**: Charles Bernstein **Cinematography**: Ron Orieux **Edited**: Michael Brown **Design**: Eric Fraser **Art Direction**: Evan Webber **Cast**: William Devane (George Boyajian), Meredith Baxter (Carol Boyajian), Dean McDermott (Matthew), Reagan Pasternak (Jean Boyajian)

The Chronicles of Narnia: The Lion, the Witch and the Wardrobe 2005 UK/USA 143mins

Directed: Andrew Adamson **Written**: Ann Peacock & Andrew Adamson & Christopher Markus & Stephen McFeely (adapted from the book by C. S. Lewis) **Produced**: Mark Johnson & Philip Steuer **Executive Produced**: Andrew Adamson & Perry Moore **Music**: Harry Gregson-Williams **Cinematography**: Donald McAlpine **Edited**: Sim Evan-Jones & Jim May **Casting**: Sameer Bhardwaj & Pippa Hall & Liz Mullane & Gail Stevens **Design**: Roger Ford **Art Direction**: Jules Cook & Ian Grace & Karen Murphy & Jeffrey Thorp **Set Decoration**: Kerrie Brown **Costumes**: Isis Mussenden **Cast**: Georgie Henley (Lucy Pevensie), Skander Keynes (Edmund Pevensie), William Moseley (Peter Pevensie), Anna Poppelwell (Susan Pevensie), Tilda Swinton (White Witch), James McAvoy (Mr. Tumnus the Faun), Jim Broadbent (Professor Kirke), James Cosmo (Father Christmas), Liam Neeson (Voice of Aslan), Ray Winstone (Voice of Mr. Beaver), Dawn French (Voice of Mrs. Beaver), Rupert Everett (Voice of Fox)

Dead End 2003 France/USA 85mins

Directed/Written: Jean-Baptiste Andrea & Fabrice Canepa **Produced**: James Huth & Sonja Shillito & Gabriella Stolenwerck & Cécile Telerman **Music**: Greg De Belles **Cinematography**: Alexander Buono **Edited**: Antoine Vereille **Casting**: Amanda Koblin **Design**: Bryce Holsthousen **Costumes**: Deborah Waknin **Cast**: Ray Wise (Frank Harrington), Lin Shaye (Laura Harrington), Mick Cain (Richard Harrington), Alexandra Holden (Marin Harrington), Billy Asher (Brad Miller), Amber Smith (Lady in White)

Deadly Little Christmas 2009 USA

Directed: Novin Shakiba **Written**: Jeremiah Campbell & Novin Shakiba (from an idea by David S. Sterling) **Produced**: David S. Sterling **Music**: Jason Perry **Cinematography**: Orestes Gonzales **Edited**: Jason Peri **Cast**: Barbara Jean Barrielle (Margaret), Charlotte Barrielle (Young Taylor), Anthony Campanello (Steve), Eric Fischer (Det. Hughes), Leah Grimsson (Noel), Monique La Barr (Taylor), Scarlett Shae (Young Noel)

Elf Bowling the Movie: The Great North Pole Elf Strike 2007 USA 82mins (Animation)

Directed/Produced: Dave Kim & Rex Piano **Written**: Martin Olson **Music**: Chris Anderson **Edited**: Dave Kim **Art Direction**: Jongwoo Hong & Don W. Kim **Cast**: Joe Alaskey (Santa Claus), Sean Hart (Lex the Elf), Tom Kenny (Dingle Kringle)

Aka Elf Bowling

Foster's Home for Imaginary Friends: A Lost Claus 2005 USA TV 25mins (Animation)

Directed: Craig McCracken **Produced**: Vincent Aniceto **Written**: Lauren Faust **Music**: Jennifer Kes Remington & James L. Venable **Cast**: Sean Marquette (Mac), Keith Ferguson (Blueregard 'Bloo' Q. Kazoo/Fireman), Tom Kane (Mr. Herriman/Santa ClausII), Tom Kenny (Edouardo/Manager), Phil LaMarr (Wilt/Santa Claus I/Moishe)

The Grinch 2000 USA 104mins

Directed: Ron Howard **Written**: Jeffrey Price & Peter S. Seaman (based on the children's book by Dr. Seuss) **Produced**: Brian Grazer & Ron Howard **Music**: James Horner **Cinematography**: Donald Peterman **Edited**: Daniel P. Hanley & Mike Hill **Casting**: Janet Hirshenson and Jane Jenkins **Design**: Michael Corenblith **Art Direction**: Lauren E. Polizzi & Dan Webster **Set Decoration**: Meredith Boswell **Costumes**: Rita Ryack **Cast**: Jim Carrey (The Grinch), Taylor Momsen (Cindy Lou Who), Jeffrey Tambor (Mayor Augustus Maywho), Christine Baranski (Martha May Whovier), Bill Irwin (Lou Lou Who), Molly Shannon (Betty Lou Who), Clint Howard (Whobris), (Josh Ryan Evans (8-year-old Grinch), Deep Roy (Post Office Clerk), Verne Troyer (Band member), Anthony Hopkins (Narrator), Rick Baker (Puppeteer)

Aka How the Grinch Stole Christmas and Dr. Seuss's How the Grinch Stole Christmas

Hansel and Gretel 2007 South Korea 117mins

Directed: Pi-Sung Yim **Written**: Pi-Sung Yim from a story by Min-sook Kim **Cinematography**: Ji-yong Kim **Edited**: Sun-min Kim **Music**: Byung-woo Lee **Cast**: Jeong-myeong Cheon (Eun Soo), Shim Eun-kyung (Young Hee), Young-nam Jang (Soojeong), Ji-hee Jin (Jung Soon), Kyeong-ik Kim (Youngsik), Hee-soon Park (Deacon-byun), Eun Won-jae (Manbok)

How the Pimp Saved Christmas 2003 USA 20mins

Directed: Matt Boatright-Simon **Written**: Matt Boatright-Simon & Barry L. Levy **Produced**: Matt Boatright-Simon & Jim Round **Music**: Michael Cohen **Cinematography**: Andrew Sachs **Edited**: Jim Round **Cast**: Matt Boatright-Simon (Pimp), Jim Round (Fros T. Snowman), Brad MacDonald (Rooty the Red-Nosed Crack Ho), Ray Bourginon (Santa Claus), Pamela Porter (Flasher Ho), Cindy Lam (China Ho), Jenn Bass (Ginger Ho), Robin Wendell (Cumstayn Ho), Starr Jones (Pepper Ho) Maria McCann (Cherry Ho) Cassy Montgomery (Lissom Ho)

Jack Frost 2: Revenge of the Mutant Killer Snowman 2000 USA 91mins.
Directed/Written: Michael Cooney **Produced:** Jeremy Paige & Vicki Slotnick **Music:** Chris Anderson **Cinematography:** Dean Lent **Edited:** Shawn Paper **Set Decoration:** Megan Suzanne Nelson **Costume:** Antonia Romeo **Cast:** Christopher Allport (Sam Tiler), Eileen Seeley (Anne Tiler), Chip Heller (Joe), Marsha Clark (Marla), Scott MacDonald (Jack Frost), Ray Cooney (Colonel Hickering), David Allen Brooks (Agent Manners), Sean Patrick Murphy (Captain Fun)
Aka Jack Frost 2 (short title)

The Life and Adventures of Santa Claus 2000 USA 80mins (Animation)
Directed/Produced: Glen Hill **Written:** Hank Saroyan (based on the novel by L. Frank Baum) **Music:** Misha Segal **Art Direction:** Andre Clavel **Cast:** Robby Benson (Young Santa Claus), Dixie Carter (Necile), Hal Holbrook (Ak, Master Woodsman of the World), Jim Cummings (Old Santa), Carlos Alazaraqui (Wisk), Melissa Disney (Gardenia)

A Light in the Forest 2002 USA 95mins
Directed: John Carl Buechler **Written:** John Carl Buechler & Gary LoConti & Frank Latino **Produced:** Gary LoConti & Talieh Safadi **Cinematography:** Thomas L. Calloway **Casting:** Patricia Rose **Design:** Jordan Steinberg **Art Direction:** Chris Davis **Costumes:** Esther Lee **Cast:** Lindsay Wagner (Penelope Audrey), Danielle Nicolet (Britta Reingelt), Edward Albert (King Otto/Ridgewell), Alexandra Ford (Witch Hazel), Carol Lynley (Grandma)

The Next Doctor 2008 UK 60mins (**Dr Who Christmas Special**)
Directed: Andy Goddard **Written:** Russell T. Davies and (Cybermen characters) Kit Pedler & Terry Davies **Produced:** Susie Liggat **Music:** Murray Gold **Cinematography:** Ernest (Ernie) Vincze **Edited:** Richard Cox **Design:** Edward Thomas **Art Direction:** Stephen Nicholas **Costumes:** Louise Page **Cast:** David Tennant (The Doctor), Dervla Kirwan (Mercy Hartigan), David Morrissey (Jackson Lake), Velile Tshabalala (Rosita) + archive footage of all 9 previous docors (played by William Hartnell, Patrick Troughton, Jon Pertwee, Tom Baker, Peter Davidson, Colin Baker, Sylvester McCoy, Paul McGann and Christopher Eccleston)

One Hell of a Christmas 2002 Denmark 94mins
Directed/Written: Shaky González **Produced:** Thomas Stegler **Music:** Søren Hildgaard & Thomas Lester **Edited:** Thomas Ravn **Casting:** Shaky González & Marcella Lindstad & Thomas Stegler **Cast:** Tolo Montana (Carlitos), Thure Lindhardt (Mike), Eric Holmey (The Devil), Zlatko Buric (Ibrahim), Pat Kelman (Englishman), Maiken Gravlund (The Mother),

Rickie Thorsberg (The Son), Claus P. Jensen (Cowboy Jack), Lasse Skou Lindstadt (Wolfy/Demon)

Aka The Claw (US DVD title)

P2 2007 USA 98mins
Directed: Franck Khalfoun **Written**: Alexandre Aja & Grégory Levasseur **Produced**: Alexandre Aja & Erik Feig & Patrick Wachsberger **Music**: tomandandy **Cinematography**: Maxime Alexandre **Edited**: Patrick McMahon **Casting**: Mark Bennett & Robin Cook **Design**: Oleg Savytski **Art Direction**: Andrew Hull **Set Decoration**: Liesl Deslauriers **Costumes**: Ruth Secord **Cast**: Wes Bentley (Thomas), Rachel Nichols (Angela), Simon Reynolds (Mr. Harper), Philip Akin (Karl)

Películas para no dormir: Cuento de navidad 2005 Spain 71mins
Directed: Paco Plaza **Written**: Luis Berdejo **Produced**: Julio Fernández **Music**: Mikel Salas **Cinematography**: Javier G. Salmones **Edited**: David Gallart **Casting**: Pep Armengol **Art Direction**: Gemma Fauria **Costume**: Glòria Viguer **Cast**: Maru Valdivielso (Rebeca Expósito), Christian Casas (Koldo), Roger Babia (Peti), Pau Poch (Tito), Daniel Casadellà (Eugenio), Ivana Baquero (Moni)

Aka Films to Keep You Awake: The Christmas Tale (English language International title)

Psycho Santa 2003 USA 72mins
Directed/Written: Peter Keir **Produced**: Renee Riordan **Associate Produced**: Eric Spudic **Music**: Steve Sessions **Cast**: Krystal Stevenson (Alice), Jason Barnes (Santa), Jeff Samford (Ron), Michelle Samford (Jess), Sequoia Rose Fuller (Sarah's Friend), Rachel Michelle Gnapp (Sarah's Friend), Lucien Eisenbach (Burglar), Theodore Ward (Burglar), Gayle Elizabeth (Blind Woman), Steve Sessions (Detective), Robert Lanham (Father), Kelly Comeaux (Victim), Jaims Weinbrandt (Pothead), Dylan Cole (Boy), Kimberley L. Cole (Mother), Erik Spudic (Josh)

Puppet Master vs Demonic Toys 2004 USA 88mins
Directed: Ted Nicolaou **Written**: C. Courtney Joyner & Ted Nicolaou (based on characters created by David S. Goyer & David Schmoeller) **Produced**: Bob Perkis & Jörg Westerkamp **Executive Produced**: Charles Band & Sven Clement & Jeff Franklin & Jan Körbelin & David Kushner & Philip Von Albensleben **Music**: Peter Bernstein **Cinematography**: David Worth **Edited**: Terry Kelley **Design**: George Costello **Art Direction**: Ognyan Ognyanov **Costume**: Ralytska Laskova **Cast**: Corey Feldman (Robert Toulon), Vanessa Angel (Erica Sharpe),

Danielle Keaton (Alexandra Toulon), Silvia Suvadova (Sergeant Jessica Russell), Anton Falk (Bael), Nikolai Sotirov (Julian), Velizar Binev (The Mayor)

Aka Demonic Toys 3 and Puppet Master 9 (working title)

Santa Claus Versus the Christmas Vixens 2002 USA
Directed/Produced/Music/Edited: Kirk Bowman **Written**: Kirk Bowman & Michael Q. Schmidt **Cast**: Michael Q. Schmidt (Santa Claus), Mary Jane Paige (Bad Girl #1), Savvy Brown (Bad Girl #2), Lillian Fox (Bad Girl #3), Sidney Cian (Bad Girl #4), Kirk Bowman (TV Announcer)

Santa's Slay 2005 Canada/USA 78mins
Directed/Written: David Steiman **Produced**: Sammy Lee & Matthew F. Leonetti Jr. & Brett Ratner & Doug Steadman **Music**: Henning Lohner **Cinematography**: Matthew F. Leonetti **Edited**: Steven Polivka & Julia Wong **Casting**: Carmen Kotyk **Design**: Todd Cherniawsky **Art Direction**: Myron Hyrak **Set Decoration**: Jim Murray **Costumes**: Victoria J. Auth & Mary Hyde-Kerr **Cast**: Bill Goldberg (Santa), Douglas Smith (Nicholas Yuleson), Emilie de Ravin (Mary Mac Mackenzie), Robert Culp (Grandpa), Dave Thomas (Pastor Timmons), Saul Rubinek (Mr. Green), Rebecca Gayheart (Gwen Mason), Chris Kattan (James Mason), Fran Drescher (Virginia Mason), Alicia Lorén (Beth Mason), Annie M. Sorrell (Taylor Mason), James Caan (Darren Mason – uncredited)

Seed of Chucky 2004 Romania/USA 87mins
Directed/Written: Don Mancini **Produced**: David Kirschner & Corey Sienega **Music**: Pino Donaggio **Cinematography**: Vernon Layton **Edited**: Chris Dickens & Ilinca Nanoveanu **Casting**: Kate Plantin **Art Direction**: Judy Farr **Costumes**: Oana Panescu **Cast**: Brad Dourif (Voice of Chucky), Jennifer Tilly (Voice of Tiffany/Herself), Billy Boyd (Voice of Glen/Glenda), Redman (Himself), Hannah Spearritt (Joan), Jason Flemyng (Santa)

Aka Bride of Chucky 2 and Child's Play 5 and Son of Chucky (all working titles)

The Seeker: The Dark is Rising 2007 USA 99mins
Directed: David L. Cunningham **Written**: John Hodge (based on a Susan Cooper novel) **Produced**: Marc Platt **Music**: Christophe Beck **Cinematography**: Joel Ransom **Edited**: Geoffrey Rowland & Eric Sears **Casting**: Jina Jay & Amanda Mackey Johnson & Cathy Sandrich Gelfond **Design**: David Lee **Art Direction**: Bill Crutcher & Julia Dehoff & Alexandru Roxana & Vlad Vieru **Costumes**: Vinilla Burnham **Cast**: Alexander Ludwig (Will Stanton/

Tom Stanton), Christopher Eccleston (The Rider), Ian McShane (Merriman Lyon), Frances Conroy (Miss Greythorne), James Cosmo (Dawson), Amelia Warner (Maggie Barnes)

Sheitan 2006 France 94mins
Directed: Kim Chapiron **Written**: Kim Chapiron & Christian Chapiron **Produced**: Vincent Cassel & Kim Chapiron & Éric Névé **Music**: Lê Nguyen **Cinematography**: Alex Lamarque **Edited**: Benjamin Weill **Casting**: Gigi Akoka **Design**: Marie-Hélène Sulmoni **Cast**: Vincent Cassel (Joseph), Olivier Bartélémy (Bart), Roxanne Mesquida (Eve), Nicolas Le Phat Tan (Thai), Leila Bekhti (Yasmine), Ladj Ly (Ladj), Monica Bellucci (La belle vampiresse)

Aka Satan (English language international title & literal translation)

Shrek the Halls 2007 USA 25mins
Directed: Gary Trousdale **Written**: Gary Trousdale & Sean Bishop & Theresa Cullen & Bill Riling (based on characters from William Steig's book *Shrek!*) **Produced**: Teresa Cheng & Gina Shay **Music**: Harry Gregson-Williams **Edited**: William J. Caparella **Design**: Henrik Tamm & Peter Zaslav **Cast**: Mike Myers (Shrek), Eddie Murphy (Donkey), Cameron Diaz (Princess Fiona), Antonio Banderas (Puss in Boots), Cody Cameron (Pinocchio/The Three Pigs), Gary Trousdale (Santa), Conrad Vernon (Gingerbread Man)

Silent Night Bloody Night 2008 USA 7mins
Written/Directed/Produced & Edited: Christopher Ameruoso **Produced**: Inna Korobkina & Dave McCoul **Cinematography**: Dave McCoul **Cast**: Lindsay Crolius (Frankie), Steve Valentine (Max), Shelley Martinez (Charlene)

Silent Night, Zombie Night 2009 USA 83mins
Written & Directed & Edited: Sean Cain **Produced**: Sean Cain & Wes Laurie **Music**: Mario Salvucci **Cinematography**: Jim White **Cast**: Jack Forcinto (Frank Talbot), Nadine Stenovitch (Sarah Talbot), Andy Hopper (Nash Jackson), Lew Temple (Jeffrey Hannigan), Vernon Wells (Paul Irwin), Felissa Rose (Elsa Lansing), Chris Gabriel (Santa Zombie), Derek Houck (Happy Holidays Zombie)

Spacemen, Go-Go Girls and the True Meaning of Christmas 2004 Canada 33mins
Directed/Written/Produced: Brett Kelly **Cinematography**: Nicole Thompson **Cast**: John Collins (Prime Minister of Canada), Anne-Marie Frigon (Dixie Pixiestick), Brett Kelly (Spaceman #1), Jody Hauke (Protector of Uranus), Renee Mora (Ann Atomic), Sonia Myers (Viv VaVoom), Jodi Pitman (Spaceman #2), Brinke Stevens (Candy Can Cans), Miles Finlayson (Mugger), Mark Courneyea (Businessman), Thea Nikolic (Soviet #1)

Stalking Santa 2006 USA 82mins
Directed/Cinematography: Greg Kiefer **Written**: Daryn Tufts **Produced**: Rick McFarland **Co-Produced**: Daryn Tufts **Executive Produced**: William Shatner & Greg Kiefer **Music**: Kem Craft **Edited**: Travis Eberhard & Marty Patch & Paul Tuft **Design/Art Direction**: Kathy Eckenbrecht **Cast**: William Shatner (Narrator), Chris Clark (Dr. Lloyd Darrow), Daryn Tufts (Clarence Onstott), Lisa Clark (Barbara Darrow), Mary Patch (Haunted Santa)

Terry Pratchett's Hogfather 2006 UK 189mins (TV in 2 parts)
Directed/Written: Vadim Jean (adapted from Terry Pratchett's novel) **Produced**: Rod Brown & Ian Sharples **Executive Produced**: Robert Halmi Sr. & Robert Halmi Jr & Elaine Pyke **Music**: David A. Hughes **Cinematography**: Gavin Finney & Jan Pester **Edited**: Joe McNally **Casting**: Emma Style **Design**: Ricky Eyres **Costumes**: Jane Spicer **Cast**: David Jason (Albert), Marc Warren (Teatime), Michelle Dockery (Susan), David Warner (Lord Downey), Tony Robinson (Vernon Crumley), Nigel Planer (Mr. Sideney), Ian Richardson (Voice of Death/Narrator)

Aka Hogfather

The Toybox 2005 UK 81mins
Directed/Written: Paolo Sedazzari **Produced**: Simon Mason **Music**: Miguel d'Oliveira **Cinematography**: Roger Eaton **Edited**: Simon Mason & Ian Seymour **Design**: Sarah Croot **Art Direction**: Ian Courtney **Costumes**: James Hamilton-Butler & Georgie Ichikawa **Cast**: Alexander Abadzis (Jake the Midfolker), Suzanne Bertish (Madeline Usher), Claudine Spiteri (Berenice Usher), Elliott Jordan (Brian Usher), Craig Henderson (Conrad), Christopher Terry (Rod Usher), Heather Chasen (Eleanora Usher), Peter Ellis

Trees 2: The Root of All Evil 2004 USA 101mins
Directed/Produced: Michael Pleckaitis **Written**: Jim Lawter & Michael Pleckaitis **Co-producer**: Jim Lawter **Music**: Tom Destefano **Cinematography**: Andrew Gernhard & Chuck Gramling **Edited**: Andrew Gernhard & Michael Pleckaitis **Design**: Ree Torrence

Costumes: Lois LaFrance **Cast**: Ron Palillo (Dougie Styles), Brandi Coppock (Agent Bentley), Kevin McCauley (Ranger Cody), Phil Gardiner (Max Cooper), Mary Ann Nilan (Helen Cody)

Treevenge 2008 Canada 16mins

Directed/co-written/Edited: Jason Eisner **Produced**: Rob Cotterill **Cinematography**: Jeffrey Wheaton **Music**: Adam Burke & Slasher Dave & Darius Holbert & Austin Ince & Fredrik Klingwald **Cast**: Mike Cleven (Crew Boss), Sarah Dunsworth (Cadence Macmichael), Lex Gigeroff (Tree Lot Boss), Glen Matthews (Yuppie Man), Kristin Slaney (Yuppie Woman), Jonathan Torrens (Jim Macmichael)

Two Front Teeth 2006 USA 85mins

Directed: Jamie Nash & David Thomas Sckrabulis **Written**: Jamie Nash **Produced**: Jamie Nash & David Thomas Sckrabulis & Rob Content **Cinematography & Edited**: David Thomas Sckrabulis **Cast**: Johnny Francis Wolf (Gabe Snow), Megan Pearson (Noel Snow), Michael Brecher (Ed – Chief Editor), Joseph L. Johnson (Pete), Josh Buchbinder (Clausferatu), Colin Barnhill (Santa Claus)

Unholy Night 2007 Iceland 10mins

Directed & Edited: Árni Þór Jónsson **Written**: Ottó Geir Borg & Ómar Hauksson **Design**: Halfdán Pedersen **Cast**: Ari Matthíasson, Ísgerður Elfa Gunnarsdóttir, Laufey Elíasdóttir, Rúnar Jakobsson, Stefán Hallur Stefánsson, Þorri Jensson, Agnar Einar Knútsson

Waning Solstice 2005 USA 82mins

Directed/Edited: Shane Will **Written/Produced**: Mark Lowry & Shane Will **Music**: Chad Ebbitt **Cinematography**: Sam Hamer & John Lands **Costume**: Josh Check **Cast**: Joe Burttram (Martin Del Rio), Amy Berry (Katie/Demon Queen), Chris Yost Bremen (Kevin), Scott Brotherton (Glenn), Josh Check (The Mongrel), Stan Haley (The Father), Mario Magana (Feature Zombie), Heriberto Montez (Eddie), Allison Rich (Lisa), Sandra Vargas (Simone), Joe Yanez (Robert)

A Wobot's Christmas 2003 USA 60mins

Apologies folks, the DVD did not have any credits on – and I have not been able to track them down! All I know is that it is from PorchLight Entertainment.

Have Yourself A Scary Little Christmas